WOMEN IN GERMAN YEARBOOK

18

EDITORIAL BOARD

Claudia Breger, Indiana University, 2001-2004

Gisela Brinker-Gabler, State University of New York, Binghamton, 1992-2003

Helen L. Cafferty, Bowdoin College, 1992-2003

Jeanette Clausen, Indiana University-Purdue University Fort Wayne, 1995-2004

Susan L. Cocalis, University of Massachusetts, Amherst, 1992-2003

Ruth P. Dawson, University of Hawai'i at Manoa, 2001-2004

Myra Marx Ferree, University of Wisconsin, 2001-2004

Sara Friedrichsmeyer, University of Cincinnati, 1999-2004

Marjorie Gelus, California State University, Sacramento, 2001-2004

Katherine R. Goodman, Brown University, 2001-2004

Atina J. Grossmann, Cooper Union, 2001-2004

Nancy Kaiser, University of Wisconsin, Madison, 1998-2003

Ruth Klüger, University of California, Irvine, 2001-2004

Barbara K. Kosta, University of Arizona, 2001-2004

Renate Möhrmann, Universität zu Köln, 1998-2003

Georgina Paul, University of Warwick, 2001-2004

Arlene Teraoka, University of Minnesota, Minneapolis, 1995-2002

PAST EDITORS

Marianne Burkhard, 1984-88

Edith Waldstein, 1984-87

Jeanette Clausen, 1987-94

Helen Cafferty, 1988-90

Sara Friedrichsmeyer, 1990-1998

Susanne Zantop, 1998-2001

WOMEN IN

Feminist Studies in German Literature & Culture

GERMAN

Edited by Patricia Herminghouse & Ruth-Ellen Boetcher Joeres

YEARBOOK

18

University of Nebraska Press, Lincoln and London

© 2002 by the University of Nebraska Press. All rights reserved. Manufactured in the United States of America. Published by arrangement with the Coalition of Women in German. ∞
ISBN 0-8032-4806-7 (Cloth)
ISBN 0-8032-9832-3 (Paper)
ISSN 1058-7446

CONTENTS

Acknowledgments vii
Preface ix

The New Scheherazade 1
Lilian Faschinger

Identity through Imagination: An Interview with Lilian Faschinger 18
Ellie Kennedy

***Everything Will Be Fine*: An Interview with Fatima El-Tayeb** 31
Barbara Kosta

Local Funding and Global Movement: Minority Women's Filmmaking and the German Film Landscape of the Late 1990s 45
Barbara Mennel

Eighteenth-Century Libertinism in a Time of Change: Representations of Catherine the Great 67
Ruth Dawson

Suffering, Silence, and the Female Voice in German Fiction around 1800 89
Anna Richards

The Reception of the Bluestockings by Eighteenth-Century German Women Writers 111
Hilary Brown

Nineteenth-Century German Literary Women's Reception of Madame de Staël 133
Judith E. Martin

**Capturing Hawai'i's Rare Beauty:
Scientific Desire and Precolonial Ambivalence
in E.T.A. Hoffmann's "Haimatochare"** 158
Valerie Weinstein

**Amalia Schoppe's *Die Colonisten*
and the "menace of mimicry"** 179
Judith Wilson

Else Lasker-Schüler: Writing Hysteria 202
Jennifer Redmann

**Ethnicity and Gender in Else Lasker-Schüler's "Oriental" Stories:
"Der Amokläufer" ("Tschandragupta") and "Ached Bey"** 225
Herbert Uerlings

**Arthur Schnitzler's *Fräulein Else*
and the End of the Bourgeois Tragedy** 248
Bettina Matthias

About the Contributors 267
Notice to Contributors 271

ACKNOWLEDGMENTS

The coeditors would like to thank the current Editorial Board for their welcome assistance in reviewing manuscripts, their participation in our on-line discussions, and their general support and encouragement. We also gratefully acknowledge the assistance and advice of the following individuals in reviewing manuscripts submitted for publication in the *Women in German Yearbook*.

Sigrid Bauschinger, University of Massachusetts, Amherst
Kirsten L. Belgum, University of Texas, Austin
Nina A. Berman, Ohio State University
Wilhelm Braun, University of Rochester
Jo M. Catling, University of East Anglia
Gail Finney, University of California, Davis
Gerd Gemünden, Dartmouth College
Julia Hell, University of Michigan
Todd Herzog, University of Cincinnati
Maria-Regina Kecht, Rice University
Marcia Klotz, University of California, Irvine
Todd C. Kontje, University of California, San Diego
Angela Lin, Vanderbilt University
Margaret McCarthy, Davidson College
Richard McCormick, University of Minnesota
Elizabeth R. Mittman, Michigan State University
Magda Mueller, California State University, Chico
Sydney Norton, St. Louis, Missouri
Brent O. Peterson, Ripon College
Ricarda Schmidt, University of Manchester
Lorna Sopcak, Ripon College
Susan Tebbutt, University of Bradford
Margaret Ward, Wellesley College
Meike G. Werner, Vanderbilt University
W. Daniel Wilson, University of California, Berkeley
Karin A. Wurst, Michigan State University

Special thanks to Victoria Hoelzer-Maddox for manuscript preparation.

PREFACE

The time during which this volume of the *Yearbook* has been prepared is one that, at least for its American editors and contributors, has been marked by much that has made us uneasy and despairing. It began with the continuing struggle to come to grips with the huge gap created by the death of Susanne Zantop. It became strange and frightening with the events of September 11, 2001. And it has continued with the horrors not only of the ongoing violence in the Middle East but also of the increasing American military and other involvement in Afghanistan and elsewhere. Perhaps all of this is still too raw to be written about within the context of the scholarly work we do, but we must nevertheless acknowledge this dis-ease in and around us. We continue to miss Susanne. We are perhaps more aware than ever of the tenuous contingencies involved in our presence—both as individuals and as citizens of various nation-states—in this unsteady world.

And perhaps for that reason, it is reassuring to look at the contents of this year's *Yearbook*, which presents in many ways the familiar eclectic mix of interests marking the study of gender in German literature and culture. There is the customary historical section in which articles focus on topics such as reception, the representation of women, and more or less forgotten German women writers from previous centuries. In an echo of the feminist emphasis on the value of the spoken word and the importance of personal narrative, there are interviews with two contemporary artists of written and filmic texts. There is the ongoing discussion of the ways in which male writers construct female characters. There is the aim of maintaining historical consciousness along with an engagement with present-day feminist concerns. Much of this is recognizable, but as is always the case with feminist inquiry, the multiple approaches to the subject of gender and culture/literature show evidence of an apparently infinite range of interpretative possibilities. If anything continues to be too rarely in evidence, it is an involvement with the specifics of race—in its presence or its absence—in the feminist scholarship of German Studies. We hope that that gap will be recognized and addressed and rectified in the future.

As has often been the case in previous volumes, this one begins with the present day: with an examination of two contemporary artists

who have a connection to Women in German. Lilian Faschinger, an Austrian writer, was invited as the special guest at the October 2002 Women in German annual conference; she is represented here by an excerpt from her first novel, *Die neue Scheherazade* (ably translated by Jeanette Clausen), and by an interview conducted with her by Ellie Kennedy. Fatima El-Tayeb, an Afro-German filmmaker and writer who was the invited guest at the 2001 annual meeting, is presented here in two ways: via an interview conducted with her by Barbara Kosta, and in an analysis by Barbara Mennel of the financial and cultural-political intricacies involved in recent filmmaking by minority women in Germany.

The rest of this volume offers an impressive array of discussions about and approaches to the feminist study of German literature and culture. In each instance, there is the familiar and the different. Ruth Dawson's historical and analytical review of representations of Catherine the Great in the context of contemporary discourses of libertinism and gender therefore does not limit itself to literary texts but includes visual representations as well. Anna Richards' look at five German novels that appeared around 1800 offers a useful discussion of those novels but approaches them as New Historians might, by focusing on the contextualizing element of contemporary medical writings that deal with women's illness, both psychic and physical. Her focus on silence as a component of illness and, paradoxically, self-expression provides a framework, and her discussion of Therese Huber's novel gives an interesting counterpoint that helps us realize once again how futile it is to believe in universal categories.

Two reception studies follow. They again present a familiar pattern in their examination of the ways in which women writers have been read by others. But in this case, the view is pan-European. Hilary Brown discusses the Bluestockings and their influence on the German writers Sophie von La Roche and Julie Clodius, while Judith E. Martin illustrates the long-term effects of Madame de Staël on German writers from the *Romantik* to the *Vormärz*. The complexities of intertextuality are evident in both articles, where the emphasis is on subtle nuances rather than overt borrowings.

The contributions by Valerie Weinstein and Judith Wilson reflect the familiar feminist pattern of investigating the representation of the "female" (in a rarely discussed E.T.A. Hoffmann short story) and examining little-known texts (here a novel by Amalie Schoppe, a nineteenth-century writer who is barely remembered). Weinstein and Wilson, however, extend their focus to include more recent feminist interests in analytical categories beyond gender: in these cases, namely,

the German pre-colonial imagination and the ways in which German writers represent it in its intersections with gender and class.

Jennifer Redmann's examination of Else Lasker-Schüler has much in common not only with the companion piece by Herbert Uerlings, who does a close reading of two short Lasker-Schüler stories, but also with Anna Richards' study of writing, illness, and gender in eighteenth-century German texts. Redmann's focus, in fact, is hysteria, that overarching label for a variety of nervous illnesses. Her piece touches upon issues raised in other contributions to the *Yearbook*: her interest in the case history as a non-traditional literary genre recalls Richards' use of medical studies, and her blending of the autobiographical with the literary reminds us of the omnipresent feminist interest in the importance of the personal narrative in the study of gender and women. Uerlings' multifaceted reading of the Lasker-Schüler short texts also echoes the broader cultural-studies interest in matters of the other, in this case the "Oriental."

Wrapping up this chronological section is an article on an Arthur Schnitzler story published in 1924. At the same time, however, it circles back to the eighteenth century, with which this part of the volume begins. Bettina Matthias's interesting interpretation of Schnitzler's *Fräulein Else* puts it into the context of bourgeois tragedy, and her integration of her analysis of the Schnitzler piece with a commentary on *Emilia Galotti* reminds us of continuities while at the same time pointing to the differences and the nuances that make a simple comparison impossible.

* * *

Volume 18 marks the last year in which Patricia Herminghouse will serve as coeditor of the *Yearbook*. Her many years in that position—she began her coeditorship in 1994—have given the *Yearbook* the great benefit of her expertise and perspicacity, and it is difficult to imagine continuing without her. She has, however, other projects that are occupying her increasingly, not the least of which is her upcoming presidency of the German Studies Association. And it should be especially noted that the *Yearbook* had her able assistance for a year beyond her intended departure from this position. That she was willing to stay on after the death of Susanne Zantop to train the new coeditor, Ruth-Ellen Joeres, is deeply, fervently appreciated.

It is fitting that this last issue coedited by Pat is not only varied in its multiple approaches to the study of gender and writing/art, but also in the geographical range of the contributors, who not only represent all levels of the academy but who come from Australia, Canada,

Germany, Austria, England, and a number of American states. And in both their diverse concerns and their differing localities, they echo the broad interests and wide-ranging contacts of Pat Herminghouse herself, whose scholarly and professional activities make her as widely known in Germany and other parts of Europe as she is on this side of the ocean.

With Volume 19, work on which has already begun, the *Yearbook* welcomes the newly appointed coeditor, Marjorie Gelus, Professor of German at the California State University at Sacramento. With her assumption of the coeditorship, Marjorie will mark a geographical shift for the *Yearbook* from the east to the west coast. Ruth-Ellen will continue to hold on to the middle (west). But the *Yearbook* will, as always, remain free-ranging and interested in the familiar as well as the innovative work in our field.

As always, the editors are grateful to those who have assisted in the production of the *Yearbook*, which depends on the support of our home institutions, the University of Minnesota and the University of Rochester; on the considerable help of the Minnesota editorial assistant Nicole Grewling; and on Victoria Hoelzer-Maddox, to whose continuing attentiveness and dedication we owe the professional appearance of each volume.

July 2002

The New Scheherazade

Lilian Faschinger

The New Scheherazade (*Die neue Scheherazade,* Paul List Verlag, 1986) is Lilian Faschinger's first novel. As in the original *Thousand and One Nights,* Faschinger's narrator tells stories to escape death, if not literal death at the hands of a wrathful King Schahriar, then figurative death in the stifling existence of an Austrian wife. The novel, which Faschinger has called "my contribution to postmodernism," features her characteristic humor and treats many of the themes found in her later works: the latent fascism in Austrian society, the uses and misuses of psychoanalysis, and the role of the Catholic Church in the oppression of women, among others. The narrator, whose kinship with and distance from her literary ancestor are symbolized by her different-colored eyes (the legacy of an Austrian father and an Iranian mother), recounts adventures in which she and other fictional characters interact with "real," historical figures (such as the artist Christo, author Gertrude Stein, and actor Clint Eastwood) as well as with characters from movies or literary works, rock musicians, the narrator's own family and friends, and even cartoon characters. A self-interrupting narrative continually calls the narrator's authority into question. Scenes from everyday life suddenly merge with fairy tale motifs (Snow White, Bluebeard) or switch from narrative to drama. As the narrator comments (15), "...there is no significant difference between thought and deed, between imagination and reality." The excerpts included here are from the first few pages of the novel, where the narrator explains her situation and gives us her family history, and two later sections, one describing the first love of the narrator's Aunt Steffi (as she herself would have told it, had she ever done so), and the other imagining the artist Christo confined in an asylum for abnormal criminals. The narrator's musings on love take her to the confessional; the excerpt ends with a line that also occurs in *Magdalena the Sinner* (*Magdalena Sünderin,* 1995): "What do you mean by repent?" (JC)

The clock struck eleven. "It's midnight already," said the Count, for he was a terrible liar.—Ödön von Horváth, *The Eternal Philistine*

Don't stop talking. Keep your articulatory organs—vocal cords, tongue, lips—in motion, forming sounds. It's a life and death situation. Form sounds with the help of your upper lip, form sounds with the help of your hard palate, form sounds with the help of your larynx, form sounds with the help of your incisors. Silence is not golden, silence is death. Your mother has been silent a long time, for she lost an eyetooth. I'm not a mother, I'm a daughter, I'm not yet silent. Overtones, undertones, inter-tones, nuances. I'm talking/writing for my life, which he wants to take from me, King Schahriar. The stones for the stoning have been piled into a pyramid, the horses for the dragging have been harnessed, the water for the drowning has been drawn, the knives for the quartering have been whetted, the noose for the hanging has been knotted. As long as I keep talking/writing, they listen; as long as I keep talking/writing, he does not talk, does not command the palace guards to kill me with their beautiful scimitars.

So in my case it is not a question of pathological, uncontainable garrulousness, but a compelling necessity, pure self-defense, a ruse contrived by my sister Dunya and me to prevent the eradication of our sex. We dreamed it up in our shared bedroom, lying on our bellies between the white lacquered furniture, the pink batiste curtains, the shirred lampshades, and all the large stuffed animals, our sweethearts, whom we ride on and rub ourselves on until sparks fly. We stood up, lifted our nightgowns up to our breastbones, looked at each other and stroked each other. No, these tender skins are not here to be sliced by scimitars. It must not happen that white-rimmed wounds gape open and all the red juice trickles out like sawdust from dolls. Dunya and I, the two Austro-Persian dolls that Schahriar and his brother play with until they get bored and cut them open. — We also weighed a second possibility for saving ourselves, namely absolute surrender, but promptly rejected this possibility as useless. Employing this method was of no use to the thousands of our sex already slaughtered. They did their best to moan, whimper, and foam ecstatically at the mouth, but Schahriar and Schahseman were not deceived and ordered the maidens' heads to be cut off. When it comes to pleasures of the flesh, no one can pull the wool over their eyes. They can instantly tell the difference between feigned eye-rolling and eye-rolling caused by genuine passion, correctly distinguish the drool of ecstasy from labored salivation, and if fingernails dig into their masculine flesh, they sense at once whether it is occasioned by the

heat of sex or by pure malice. And when such a thing comes to their attention (and sooner or later it always does, at moments when the maidens' deceptive energies flag, when they become careless or no longer feel like putting on an act for the brothers), they fly into a rage, roll their huge black eyeballs, foam with wrath and send orders for execution echoing through the palace. Kill this woman! KILL THIS WOMAN! KILL KILL KILL THIS WOMAN WOMAN WOMAN WOMAN (with an echo effect gradually dying away).

My sister Dunyazade Moser and I, Scheherazade Hedwig Moser, are biracial: Irano-Austrians, Austro-Persians. Our father, Hans Moser, born in Kirchdorf, Carinthia, attended the College of Construction Technology in Villach. After finishing his course of study, he signed a contract with a construction company and went to Shiraz in Persia for several years to build irrigation plants. He decided to do this because his best friend, Rudy Gutschier, had recently emigrated to Australia (to Brisbane? Wagga Wagga?), infecting him with talk of big opportunities and big money. He was going to fence in the land at the foot of Ayers Rock, he said, to start a sheep-breeding business, and he would drive past groups of amazed aborigines, at first in a rattletrap truck, later in a new one, throwing them cans of beer that he would bring by the case in his truck to down while driving. He said in Australia there were no cops to stop drivers and make them take an alcohol test. Then he would marry a beautiful Australian woman of Irish extraction—with skin as white as snow, cheeks as red as blood, hair as black as ebony, and with violet eyes—who would be the very image of Liz Taylor, and they would live happily ever after. In reality, the land at the foot of Ayers Rock was unsuitable for sheep breeding; if anything, it might have been parceled out for lopsided tennis courts. In reality, Rudy Gutschier worked as an underpaid auto mechanic, suffered from a chronic disc ailment, and got married, not to an Irish Liz Taylor, but to an Australian woman of Lower Bavarian ancestry with long teeth and a receding chin who gave him four children with long teeth and receding chins. The photos that the Australian Gutschiers send home to Mother Gutschier, who sends back money in exchange for them, show the four children lined up according to height in front of a timber house painted white. For decades, Mother Gutschier has lived in spirit with her family in Australia, and more intensively so in the last few years since Father Gutschier died. Rudy is her only child. She has never seen her four grandchildren because she can't afford the flight, since she constantly sends her money in envelopes to her family. Old Mrs. Gutschier is a frail woman with watery eyes, white hair, and a sly expression that

becomes melancholy when she talks about her family. Strolling passersby who lean on her fence looking at the trees laden with big red apples are beckoned into the house by her long, crooked index finger. She urges them to sit on the upholstered bench in the kitchen, serves them a bitter digestive liqueur in murky little green glasses, plunks stacks of color photos down in front of them, pictures of the four grandchildren baring their long teeth in laughter, tells stories about her family, and weeps. It may happen that she takes the hands of the passersby in her delicate hand and fingers their knuckles. Nibble nibble like a mouse, who knows how many corpses are already crammed into the kitchen and pantry? My father, who picks Frau Gutschier's big red apples in the autumn and stores them in our cellar over the winter, claims that once, while looking for a pail, he opened a cupboard door in the hallway and a well-preserved corpse fell toward him like a board. With a big red apple in its mouth. But, he said, I thought to myself, Frau Gutschier is a poor lonesome soul and probably doesn't have long to live. And that's why I propped the corpse up again, leaned it against the rear wall of the cupboard, closed the door, and said no more about it. Then I climbed back up the tree and picked some more apples.

Breathe.
Breathe.
Draw breath.
And spare your vocal cords, speak softly, drink milk. Telling stories is stressful and the kings don't like raspy voices. They don't want any sounds of a Jew's harp, no clanking of milk cans, no asthmatic rattling—what they want is the twittering of warblers, the whispering of wind, the sounds of Aeolian harps. If it becomes too raspy, they grow surly and call the palace guards with their scimitar-death.
To take up my father's story: He met my mother by chance in Shiraz. He was strolling through the center of town and accidentally stepped on her chador, her long veil. My mother, thus abruptly halted, falls down. Since she has been holding her chador in place with her teeth, as Persian women shoppers customarily do when they have both hands full, she breaks one of her eyeteeth in the fall. Thus begins a great love. Hans Moser helps Farah Kaschoggi, née Emami, to her feet and as he immerses his blue gaze in her black eyes, reluctantly removes it again, and lets it glide over the little nose, the crimson cheeks, the half-open cherry lips with a row of pearly teeth and the red rivulet trickling from the corner of her mouth, he is done for. And Farah too, who gratefully leans on his strong arm covered with blond fuzz, knows at once that this is the kind of fateful meeting that is granted only to a few—besides

Tristan & Isolde and Paolo & Francesca, probably only Clark Gable & Vivien Leigh. She quickly calculates when she is due to ovulate. She's glad that she had her hymen replaced. A minor operation that represents a modest secondary source of income for a number of physicians in the Islamic world. From this first, seemingly interminably slow exchange of glances, this first fleeting encounter, there followed many things, among them my existence and that of my sister Dunya as well as the unique colors of our eyes. My right eye is blue, my left one yellow. Dunya's right eye is yellow, her left one blue. The two blue eyes are the legacy of our Carinthian father, the yellow eye color goes back to my maternal grandmother, a Kurdish woman with the murderous eyes of a big cat and yellow-brown hair. She came from a village at the top of a pass on the Turkish/Persian border, where bundles of hay were stacked to dry on the flat roofs of the houses. Later she joined a Kurdish liberation movement group and was mistakenly shot by a member of another Kurdish liberation movement group. Dunya and I are proud of our different-colored eyes. They are even complementary colors. You would have thought that people would be captivated by this two-tone color scheme. And a few were indeed beguiled, but basically, this idiosyncrasy brought me nothing but problems. It started at the Villach passport office as I was entering the color of my eyes in my application for an Austrian passport. Inspector Raspotnig looked up from his Remington typewriter as I truthfully indicated right side blue, left side yellow. Not only is she a bastard, but also a filthy half-blood, a miserable mixed-race woman; Austro-Persian, Irano-Austrian, that's worse than Mestiza, Mulatto, Creole, or Zambo, he thought to himself, smiling outwardly. I can be glad that my children are pure-blooded, even if little Brigitte does have the pseudo-croup and little Peter has a harelip. And here she comes with one blue eye and one yellow one to cause trouble for us. Don't cause trouble, he said into his smile. Then he pulled me to the window and called other inspectors, senior inspectors, and office employees to evaluate my eyes. But that's quite impossible! exclaimed Fräulein Angelika Antonitsch, the office secretary, secreting a watery fluid in her excitement. There, you see how far-sighted they were to impose a limit on foreigners at Austrian universities! said Senior Officer Steiner, and sat down, composed a confidential letter, had Fräulein Antonitsch make six copies, filed the original, and sent one copy each to the criminal investigation department, the office of the federal chancellor, the military medical service department, the secret police, Interpol, and the Iranian Embassy in Vienna. We would be a laughingstock if we couldn't solve the foreigner problem! he hissed between clenched teeth. These Yugos, Muftis, and Dagos cause nothing but trouble. Now I

finally have something in hand that I can use against them. Yellow and blue, ridiculous. —At the time, I lived on Leonhardstraße and in the period that followed, I was subjected to many reprisals by the state government. The gentlemen from the secret police, for example, did not hesitate to trip me on the sidewalk or punch holes with their gun barrels in my laundry drying on the clothesline. A man in a gray-brown trench coat showed his badge to the building custodian, Frau Christa T., and asked her about my habits. Frau T. invited him in for a cup of coffee, which the official drank while her cat strolled up and down the table flicking her tail across his face. We don't know anything specific, she whispered. But it is all very mysterious: she grows white sweet peas on her balcony. Strange music emerges from her apartment. Sometimes she takes two steps at a time on the stairs. She sits on the balcony watching the swallows flying. She laughs for no reason, continuously. Frequently she presses the stop button in the elevator and stops briefly between two floors. She gets brown packages, letters with unfamiliar postmarks, and visits from handsome men who look as if they have no gainful employment or life insurance. Black lingerie hangs on her clothesline. And one more thing: she talks/writes incessantly. Constantly carries paper and a cassette recorder around with her. Talks/writes as if it were a life and death situation. As if she dared not stop. As if she were afraid. As if she had a guilty conscience. The gentleman has taken notes and puts his ballpoint pen in his jacket pocket in satisfaction. Frau T., you have been a great help. The first duty of the state is, after all, to protect its citizens from undesirable elements, from shady goings-on, and to enforce decency, decency, decency. Frau T. lowers her eyes decently. The gentleman gets worked up and spits while speaking. Decency and order. Citizens of the Austrrian Rrepublic. Securrity firrst and forremost. Wherre would we end up. What would we do. How would it look. Wherre would we be. Fatherrland and Home of Grreat Men. Proud and uprright. Unafrraid. (Clutches his heart.) The forreignerrs. The Jews. Throw them out. Out. Public good and nation and state and nation. The Amerricans. Thrrow them out. Nation. (Clutches his heart again. Curtain).

...

The balcony door is open, there's an intense yellow light outside, the föhn blowing in makes it difficult for me to talk/write on my sofa. You can hear it thawing, it's dripping, many drops are falling. The blackbirds and greenfinches don't need Frau Gutschier's coffee cakes any more, they can find things on the snowless ground. Everything is unnatural, it's much too early for spring, the sap is rising much too early, the forsythia is sprouting much too early, everything is clueless,

rejoicing cluelessly over the supposed arrival of spring, which is not the arrival of spring but a trap set by Nature, causing all living things to fall into a spring frenzy, a delusion of spring happiness. A yellow daffodil stands in a vase in front of me, intensely yellow like the light, an unnatural flower, produced in the greenhouse to simulate spring and to fade quickly. This intense, dripping, mild, windy weather is nothing but a perfidious simulation. The singing of the girls' choir from St. Ursula's Boarding School that wafts in through the open balcony door is only one more part of this plot to simulate spring. The forsythia is sprouting in Styria, much too early in the year, and every day the residue from 162,000 liters of jet fuel burned by the planes flying over Styria falls onto the forsythias sprouting in Styria. The warmth, the light, the singing, the rising of the sap are unnatural to the nth degree, an infamous pretense, a vicious hoax. Nature awakens in every clueless living thing an anticipation, a desire that she will kill off when she lets the real springtime, cruel April, burst forth. The real spring that will devastate all of Styria with the vehemence of the Turkish invasions, of invasions by the Huns. All the miserable spring truth of our time will come to light, the perversion of Nature ruined forever by human beings: swarms of butterflies will hatch out from their cocoons, bursting open the head and breast section of the pupa case. Blood plasma and air will be pumped into the still limp wings, the wings will stretch out. In seven hours they will fly, the crippled butterfly swarms, the butterflies with deformed limbs, shortened feelers, stunted wings, distorted patterns of color and markings. Simultaneously, the human beings' mutated, perverted feelings will hatch out and set about their work of destruction like the Huns, like the Turks. People will fall on one another with their newly hatched spring feelings and destroy, ruin, devastate one another, unto their innermost beings. They will feel expelled into the springtime in pairs, feel the juices rising within them, and standing in fields of snowdrops, in meadows of crocuses, they will begin their work of mutual destruction that starts with so-called love and ends with sheer incomprehension, with outright hatred. The destruction of feelings takes place in perverted Nature, the destruction of hope takes place very speedily, since feelings are immediately infected by Nature's perversion. That's why it is better to avoid Nature during the awakening and the consummation of so-called love, better to withdraw into plain everyday surroundings that do not awaken such expectations, such anticipation, only to disappoint them in a frightful manner, better to turn away from degenerate Nature and deliberately take the opposite path, the path to objectivity, to hopelessness and dashed expectations. I'm angry at myself for having had Aunt Steffi's FIRST LOVE begin in the midst of Nature,

for having her tell of the sea, the sunset, all these scenic backdrops of Nature that accelerate the decline of so-called love, these set pieces of the shoddiest kind that immediately infect all budding feelings with an element of lightheadedness that eventually brings them to a miserable end. By no means should I have introduced a figure wreathed in rays of light, for the demise of every budding thing is contained in such a wreath of rays. I should have had the story begin differently, in a lab, for example, an experimental chemistry lab with a lot of chromed and white surfaces. For example, Aunt Steffi could have gone into such a lab, it could have been the Institute for Biochemistry, for example, to drop off a translation, for example, that she had prepared for a research assistant at this institute. For example, it could have been about the development of micro- or macro-aggregates in blood supplies more than twenty-three days old, describing the size of these micro- or macro-aggregates and their measurements. Aunt Steffi surely would not have fully understood all the chemical processes described in this scientific abstract and would have asked the research assistant to clarify them for her. The assistant would have been glad to do it. He would have led her into the room that housed an instrument used to measure the size of these aggregates, turned it on, and explained to her how it worked. He would have explicated what is meant by unit of measurement and by measure resolution, would have shown her a U-shaped glass tube used in this experiment and a networked cascade filter. She would have asked precise questions, he would have given precise answers. So they would have conversed in complete objectivity, would certainly not have sunk their gaze into the other's unfathomable black/blue/yellow eyes, would not have cast their eyes upon noses / striking profiles / crimson cheeks / energetic chins / cherry lips / sinewy hands / pearly teeth. They would have scarcely looked at each other, so absorbed would they have been in the text describing various methods of microfiltration of blood. Neither would have had the slightest sense of that unmistakable feeling that this was the beginning of a great love. So, no hopes would have been awakened, no expectations, and thus from the very beginning there would have been a legitimate hope, a legitimate expectation of something that would not end in sheer incomprehension, in outright hatred. In this way, Aunt Steffi would not have succumbed to Nature's deception, to the Fata Morgana of the warm seasons. But circumnavigating the cliffs of spring and summer by entering a chemistry lab for the purpose of dropping off a translation was not possible for her, because she had never learned a vocation, not even that of infant nurse or hairdresser, let alone the highly specialized profession of translator; rather, she had been put to work at the earliest possible age on her

parents' farm. The farmers in Kirchdorf claimed that every worker was urgently needed and usually didn't even let their children finish the eighth grade. The director of the elementary school for grades one through eight was understanding toward the farmers and readily released them, the daughters especially, for field work. Aunt Steffi, who liked school, was incapable of resisting this conspiracy instigated by the farmers and the director. It's true that the farmers and the director didn't look like Schahriar and Schahseman, but the director's traditional brown Carinthian suit, the farmers' leather knee-breeches concealed the olive-skinned kings, who had long since decided that farmers' daughters should absolutely not learn to read and write or acquire a language, but instead should mutely light the fire in the hearth and not let it go out, mutely carry milk cans, render hogs' blood, and lie down under them. The farmers and the director did not cry "Surrender or death!" and did not roll their eyeballs, nor did they draw scimitars. Beheading, chopping into pieces, stoning, drowning, or quartering the daughters was not necessary, for within a few years the daughters died of their own accord, expired from digging potatoes, mucking out stalls, churning butter, pickling, trying to prove they were competent farmers' wives. Dead, they went back and forth between kitchen and bedroom, as smiling corpses they ladled dumplings onto the farmhands' plates. As dead women, they suited the farmers perfectly, who confessed their little necrophilia with light hearts at the end of Sunday worship services or May devotions, for they knew that their pastor would gladly forgive them this sin against Nature, since he secretly shared their beliefs on bringing up daughters. (This cleric's estate supposedly contained, among other things, a silver cigarette case engraved with the nearly illegible, finely chiseled words Only Dead Daughters Are Good Daughters. I am inclined—for reasons that I prefer not to pursue further here, but that are related in the broadest sense to the church authority's resistance to ordaining women as priests—to the opinion, contrary to that of the overwhelming majority, that this assertion is not a rumor slanderously promulgated by that anarchist and destroyer of monuments Andreas Sablatnig, but the truth.) So, it was in Büsum in Schleswig-Holstein that Aunt Steffi, the unsuspecting Steffi, was tricked by treacherous Nature, who appeared with all possible backdrops conducive to so-called love and surrounded her on all sides. Only much later, after a glimmer of Nature's many treacheries had dawned on Aunt Steffi, did she grow shrewder: Her first encounter with Ödön Eröd, with whom she found BELATED HAPPINESS, took place in his watchmaker's shop, in a closed room full of ticking clocks—kitchen clocks, watches, pendulum clocks, alarm clocks, pocket watches. And what could be farther away

from deceptive Nature than these undeceivable clocks, what could be more objective and serious than measuring time? The meeting place was thus absolutely ideal for a BELATED HAPPINESS that began in the complete absence of hopes and expectations and therefore prompted hopes and expectations that were all the more justified. Aunt Steffi had sought out the master watchmaker Ödön Eröd because her wristwatch had been running backwards for several days. It was accurate to the minute, but in reverse. This gave Aunt Steffi the creeps and she had to make a great effort to keep from imagining that the plants in her garden with half-open blossoms had closed again after this event, that the sun was rising in the west and setting in the east, that cars were driving backward, that everything was moving as if in a film that was being rewound. Ödön Eröd repaired the watch on the spot to calm Aunt Steffi's fear that time had started running in reverse. The thought that she might be young again is terrifying to Aunt Steffi. She doesn't like that which is new and young; she has a sense for that which is older, that which has evolved slowly. She absolutely does not want back the firm, smooth skin that she had as a girl, she's fond of her sagging skin that is crisscrossed with wrinkles as if by a grid. She experiences a feeling of personal dignity, a sense of her own worth when she sees her reflection in the mirror, the wispy, almost white hair that she does not color, the yellowed, carious teeth that she does not have pulled and replaced by dentures, the drooping grayish flesh of her cheeks that she does not rouge, the bloodless lips that she does not paint or widen. It doesn't bother Uncle Ödön that Aunt Steffi puts her age on display, because it corresponds to his concept of a BELATED HAPPINESS. Firm, unattainable flesh that is impervious to his grasp doesn't interest him, he wants to leave traces, indentations, pressure marks, wants to sink his hands into aging, kneaded flesh that has been through the mill, flesh that gives way. —Aunt Steffi and Dunja are still sitting over coffee, Aunt Steffi is still talking about Büsum and Kalle Waalkes. But she doesn't tell HOW SHE LOST HER INNOCENCE, she has never told anyone. It will be reported here for the first time in authentic form: Kalle is twenty years old, healthy and strong, and at the boarding school he has no opportunity to come in contact with women. Up to now he has had to make do with the bodies of his schoolmates, so the prospect of exploring a girl's body fills him with rapture. Steffi is IN LOVE, INNOCENT, and in the mood for all kinds of experiments. Kalle is resourceful by nature, but their quest for an undisturbed location is very difficult. His father's fisherman's cottage is small, at least two family members sleep in each room. The dunes are not solitary enough. Had Aunt Steffi told the story, she would presumably have said: So we go

out into the ocean, a hundred meters—for the North Sea is shallow there—out until the water is up to our necks. Then we turn toward each other and strip off our bathing suits. I hold my bathing suit and Kalle's swim trunks in my left hand and watch over Kalle's shoulder as the black fabric is swished back and forth in the water by our movements. I would have liked to drop the bathing suits and cling more tightly to Kalle, but my sense of duty keeps me from it. So ever since then, the color black under the surface of water has been linked to my sexuality. Our bodies look greenish and compressed in the water, the bodies of sea animals. Cold white fingers glide on cold skins. The buoyancy lifts my breasts. I lose my innocence and Kalle doesn't notice; the blood mixes with the water in a red cloud. The water sloshes into the farthest corners of my womb, fills my uterus like a pipette, like a goldfish bowl. I am light, Kalle lifts me with his movements. We stand on the sandy bottom, feel the water washing sand away under our feet, head back to shore, our lips blue with cold. From then on we go into the ocean several times a day, all summer long. And you know, Dunya, Aunt Steffi would have said, had she told Dunya over coffee the story of how she lost her innocence, which she did not do, because of a NATURAL sense of modesty, an innate shyness about raising the DELICATE topic of sexuality in the presence of a presumably UNSPOILED young girl, you know, Dunya, this experience of losing my INNOCENCE in the water had a formative effect on me and, looking back on my later sexual behavior, influenced my later sexual desires in the most lasting way. Sexual encounters, if they were to be satisfying for me, had to take place in water if at all possible; at the very least, the atmosphere of the ocean had to be credibly evoked.

...

I'm lying on the sofa, reading/writing the letter that Christo wrote me from the Asylum for Abnormal Criminals, located near the Botanical Garden in Paris's fifth district: Scheherazade, my amber eye, my lapis lazuli eye, what are you doing? Hedwig, my sweet gold leaf, my precious lucky ivory cube, I miss you. Ach, my little Persian pomegranate, my little Austrian sweet cider pear, it's been such a long time since I've seen you. I long desperately to wrap you up—not in ordinary wrapping paper; I want to shroud you in aluminum foil, in tissue paper, in hand-made, deckel-edged paper, in the finest rag paper. The resident psychiatrist, a Freudian and a member of the French Academy of Sciences, calls my obsession with wrapping abnormal and believes he has cured me of this neurotic disorder through eighteen months of psychoanalysis. After our last session he said: Once again the genius of my revered teacher has been most brilliantly substantiated, despite

decades of hostilities from all sides. Now that I have listened to you during so many sessions, my dear Christo, with steadfast attentiveness, free of prejudice, self-serving objectives, and personal opinions, the unconscious desires and fantasies that are concealed behind your wrapping obsession have become clear to me. Our joint process of working through your problem intellectually and, above all, emotionally/affectively was worth the effort. My having allowed you to wrap me so many times in institutional letterhead was not for naught. Once again it has been proven that psychic phenomena are never accidental, but conditioned by the patient's life history, and that the decisive motivations of human behavior are unconscious. Allow me to recapitulate briefly: The decisive positive turn in your case came about through a memory that was ultimately recalled after great emotional resistance, the extraordinarily significant memory that your mother, for reasons of a strongly developed sense of hygiene, used to diaper you unusually often, namely two to three times an hour. The discovery of this significant fact supports the conclusion that for you, feelings of love, caring, security, indeed, even eroticism are linked to the process of being wrapped, as well as—based on your unconscious activation of this passive role—of doing the wrapping. You are only able to express love through wrapping or packaging; sexual desire is awakened in you exclusively by wrapping or packaging. What is interesting about your case, my dear Christo, is that you have instinctively chosen the right way to make this wrapping and/or packaging obsession harmless, namely by sublimation. Your case, my dear Christo, is in more than one respect nothing less than a triumphal affirmation of my revered teacher's insights. As long as you practice your art of wrapping, that is, transform your obsession into art, you will not trespass the boundaries of accepted social behavior. However, when narrow-minded, moronic, incompetent social institutions like the Paris Building Control Department forbid you to practice your art, you are robbed of the essential outlet for your neurotic obsession. Driven into a corner, you are forced to seek release through unlawful acts—and wrapping persons up against their will is indubitably an unlawful act. My dear Christo, I will report your case to the French Academy of Sciences and try to convince my colleagues that you are unjustly languishing in this institution. My intention is to present to the Supreme Court a petition signed by as many colleagues as possible, with the goal of achieving an early release for you. In addition, I will do what I can to provide you with an internationally recognized official authorization that, for the sake of your psychic well-being, permits you to wrap every object that you wish to wrap—a demand that, it seems to me, is not inappropriate. After all, you are a

victim, a martyr of society, my dear Christo, you deserve my support and admiration. —That, my little wood pigeon, my little cotton-candy cloud, is what Dutronc, the resident psychiatrist told me. So perhaps I'll be free soon. Then, my marzipan maiden, my halvah angel, we will go to England together, for I have great plans. You must understand that the inmates of this institution are without exception creative, talented, imaginative individuals whose inspirations absolutely must be pursued with regard to the future of my artistic career. After my release I'd like to start by translating into action the suggestions of Rodney Stewart, my cellmate, a young office worker from Newcastle-upon-Tyne. Rodney is confined within this institution, but in my opinion he is not a malicious criminal, but a sick person. He suffers from a special form of pyromania for which psychopathology has not yet found a name, since his is the first known case of this kind, which I would like to call soccer stadium pyromania. Just as I can hardly refrain from wrapping up passersby, it is equally difficult for Rodney to pass a filled soccer stadium—in a pinch a simple half-filled soccer field will do—without setting it on fire. The resident psychiatrist believes that this tendency is related to the fact that at the tender age of two years, Rodney was taken by his father to soccer matches at least twice a week, but hated having to watch and cheer them. When he was four, his father made him recite all the rules of soccer from memory and sent him to kindergarten in a soccer uniform. Later, to please his father, he had to study the careers of all the great English soccer players since the sport began; he had to know exactly from when until when they had played for which team under which coaches and how much the transfer fee was when they were traded to another team. He even had to know the names and birthdays of their wives and children. Dutronc is working on a petition for him too. After critically weighing all the factors he has reached the conclusion that, in the interest of his psychophysical stability, Rodney Stewart should not be forbidden to set soccer stadiums on fire. This, he says, the affirmation of the personal uniqueness of one's fellow-man, is where tolerance begins. At any rate, at age fourteen, Rodney rebelled for the first time against his father's tyrannical behavior and set fire to a small stadium in Newcastle-upon-Tyne. The blaze, which was extinguished after several hours, claimed one death and seven injured. Since that time, Rodney has set fire to stadiums in Leeds, Bradford, Nottingham, Wolverhampton, and Birmingham, but only the Birmingham fire turned into a large-scale catastrophe. On the continent, too, he made attempts to ignite several stadiums, especially in Holland, Belgium, and northern France. He was caught while systematically drenching the area under the Rouen soccer stadium's grandstand with gasoline. He's been here ever since and we

have become good friends. It was his idea for me to wrap some of the larger stadiums in England after my release, an idea that I think is splendid. Of course it won't be simple to get permission to do this, but with Dutronc's help and the support of the French Academy of Sciences, it could work out. It is possible that in making this suggestion, Rodney was also thinking of himself and his own release; it is possible that he has plans of his own (paper burns exceptionally well), but that is not my concern. I'm interested in finally being able to carry out monumental wrapping projects again, without constantly having to make do with trifles—however stimulating those may be for a change of pace. My honey-pot, my kefir-cup, how I look forward to seeing you. Are you well, is Schahriar causing you problems, does he pursue you? As long as you keep on talking/writing, he can't do anything to you, be assured of that. Concerning your actions during my absence: you know that I'm different from Schahriar, I don't demand surrender or faithfulness. Do as you think best, and be there when I'm released. I can't say that I've been ill-treated here; the food is acceptable, we're allowed to read and sometimes to converse with each other. There are some very interesting people here, among them one of Rodin's former models, a nobleman directly descended from Louis XIV, a young Vietnamese spray-paint artist, and—you won't believe it—Jim Morrison of the Doors. His grave is in Paris, but he isn't dead, he's here, in the Asylum for Abnormal Criminals in the fifth district, has been here since 1972. They took him into custody during one of his European tours for a minor infraction—I think it had something to do with radical exhibitionism—and he has long since served out his sentence. But he fiercely resists being released and plans to stay here to the end of his days. So far, he's been successful—he helps out the guards and administrators and is very popular with them. My little marmot, my little desert fox, I dream of embracing and wrapping you. Write to me. Christo. — You know, I'm different from Schahriar, I don't demand surrender or faithfulness, writes Christo. Christo is clever. He knows that I'm most likely to surrender myself to him if he doesn't demand surrender or faithfulness, that I'm most likely to be true to him if he doesn't demand it. He who demands faithfulness gets what he deserves if we are unfaithful. After Schahriar and his brother had been betrayed by their wives, they set out to look for someone who had had the same experience. On the shore of the salt sea they happened upon a sleeping Djinn, a fire spirit, with a maiden in his power. The maiden showed the two kings a pouch with seventy-five signet rings strung on a cord. These rings, said the maiden, were pledges from seventy-five men who had given themselves to her while the Djinn was sleeping. It had done the spirit no good to have her

locked in a crate. Precisely because she was locked up, she had concentrated all her thoughts on how to trick him, and her uninterrupted thinking had opened up possibilities to deceive him. That's obvious, I think to myself, pressure to be faithful necessarily brings unfaithfulness with it. It's a shame that the concept of faithfulness exists, I think to myself, if the concept of faithfulness didn't exist, there would be no opposing concept of unfaithfulness, and everyone would be spared a lot of trouble. Reality is a creation of concepts, I say, and rejoice at so much sudden simplicity of thought. If one could keep the concepts within limits, one would have a clearly defined world. There are too many concepts; misery comes from a deluge of concepts. We should let matters rest with the naming of things and not bandy abstractions about. Abstractions are highly flammable, there is danger of explosions in the vicinity of abstractions. Faithfulness and unfaithfulness. Am I faithful? In thought, word, and deed? Yes and no. Least of all in thought. What would Christo say if he knew what went on with Clint Eastwood and me, with Andrew Lennon and me, with the Hopi Indian Tom and me, with John the Baptist and me? If he knew what had happened between them and me, what I experienced with them, what I imagined? He wouldn't say anything, he'd be reasonable. He has his tales to tell too, he'd be an accomplice. If the concept of faithfulness didn't exist, people could lie together in the half-darkness and tell each other stories about the exciting affairs they had in thought, word, and deed. Such stories would take nothing away from anyone, indeed, they would be an enrichment of life together. One would tell a story, the other would listen attentively, nod approvingly, smile affirmingly, shake his head sadly. Being accomplices: a more beautiful thing than love and faithfulness. How gratifying it would be if one could tell the person one lives with about one's simultaneously imagined happiness, of unhappiness experienced with another lover, if one could describe the simultaneously loved other's profile and limbs. (For there is no significant difference between thought and deed, between imagination and reality.) But we have been denied this freedom from the very beginning, this expressing of truths, half-truths, and untruths, we have been denied these benevolent love thoughts and love deeds, we have been punished for them, crammed into twosomeness-pens, crowded into twosomeness-stalls, surrounded on all sides by walls, by wire cages of guilt and pangs of conscience. Where do the concepts "my wife" and "my husband" come from, who created the conditions for jealousy through these concepts? Who took from us the freedom to love and be loved, who aided and abetted men like Schahriar? It's the Christians, the black Catholic birds with their perfidious inventions of the falls from grace

who have poisoned candor for us, the priests brandishing their stinking incense who make us choke on what we want to say, don't let us express it, it's the old priests with their un-used sexual organs drying up like roses that never blossomed who spoil love for us, it's the heavenly hosts of deans, of vicars and assistant vicars, of deacons and bishops who watch their acolytes jealously, maliciously planting in them the loathing of the flesh that they feel themselves, it's the confident interpreters of scripture, the commentators who know the truth better than anyone else, who shrink the world and our feelings for us and who think they know what is righteous, it's the blood-red cardinals who speak enviously of sins of the flesh, it's the archbishops with their sunken eyes who have never felt an innocent desire and begrudge it everyone else. The world is choking on their prohibitions, it will perish from their senseless postulates in an orgy of destruction in which every libido held in checkmate will be liberated.— The Inquisitor sits in the confessional booth of the village church in Kirchdorf and asks lustfully: Scheherazade Hedwig Moser, is your flesh weak? Have you sinned carnally in thought, word, or deed? Have you sinned? Have you sinned? How often? When? With whom? How many times? When? With whom? How often? When? With whom? Yes, I have sinned, I say joyously and candidly, almost continually, practically every day of the week, I say, what a joy sins are, I say joyously and candidly. You must recite the rosary, my daughter, rosaries and more rosaries, the Inquisitor says mildly, without showing his wrath. As a punishment, I will rip your rosary apart and you will pick up the beads, over and over again, the Inquisitor says mildly. You will have to crawl around the church on your knees, my child, more than once, I fear, the Inquisitor says mildly. You will have to eat my entire supply of communion wafers, I fear. I'll sit across from you at the table and make sure that you actually eat all the wafers. And for dessert you might also have to eat your confirmation candle, I don't see any other way, the Inquisitor says mildly, and all the pictures of saints that the deacon gave you over the years for attending church. I will do nothing, I say joyously and candidly, I'll merely say a few rosaries to give thanks for the existence of carnal sins, this great happiness. The Inquisitor casts aside his mild manner as he does his priest's robes when going to bed and says, gnashing his teeth: so, you are hard-boiled, my daughter. That does not surprise me, for we had trouble with your mother too, that heathen. In your case, eating the confirmation candle and the pictures of saints will not do the job, I fear. You will also have to consume the bouquets of chrysanthemums that the sacristan has placed to the left and the right of the altar, and if your hard-boiled nature has still not subsided, you will also eat the purple

altar cloth for Good Friday. And I can tell you now that its gold-threaded fringes are not very digestible, he says triumphantly. Don't talk nonsense, I say. So, what's it to be, Inquisitor, I ask, do you want to hear my confession or not? Shall I tell you the sinful stories of Andrew Lennon and me, Clint Eastwood and me, the Hopi Indian Tom and me, and John the Baptist and me, or not? Tell me, my daughter, says the Inquisitor. It will do you good to lighten your conscience. You know that God forgives everything if only you repent. Think of Maria Magdalena. What do you mean by repent, I say.

<div style="text-align: right;">Translated by Jeanette Clausen</div>

Identity through Imagination: An Interview with Lilian Faschinger

Ellie Kennedy

Introduction

Lilian Faschinger will be familiar to many *Yearbook* readers as the special guest at the October 2002 Women in German conference. A love of mobility and an intermittent need to escape the patriarchal atmosphere of Austria have led her to take advantage of every opportunity to travel, including lecture tours and periods as writer-in-residence at various universities. During her first Canadian reading tour, in October 2001, she was kind enough to agree to the following interview, which took place at Queen's University, Kingston.

Born and raised in postwar, provincial Austria, the young Lilian Faschinger was frustrated by the oppressive atmosphere, lingering fascist attitudes, and widespread discouragement of female self-expression in her homeland. Literature, both in English and in German, was a source of inspiration and escape for her. A high-school exchange year in Connecticut in 1969 (during which she acquired a US high-school diploma) cemented her love affair with the anglophone world and its culture. Returning to Austria, she took a degree in English and History followed by a PhD in medieval English literature at the University of Graz. While working there as a part-time lecturer in English, she also made a name for herself as a literary translator, in particular with a translation of Gertrude Stein's monumental experimental novel *The Making of Americans,* which garnered for Faschinger and her collaborator Thomas Priebsch the prestigious Austrian National Prize for Literary Translators.

Lilian Faschinger has been a free-lance writer since 1992 and has received several prizes and grants for her work. Since publication of her first original book in 1983, she has penned four novels, a handful of plays, and several volumes of short stories and poetry. Her novels especially are characterized by imaginative construction, biting wit, and a challenging narrative style.

Best-known among Faschinger's *oeuvre* is her 1995 novel *Magdalena the Sinner* (*Magdalena Sünderin*), which has been translated into sixteen languages so far (seventeen, if US and British English are counted separately!). It tells the story of Magdalena, a feisty, if breathtakingly naïve young Austrian who embarks on a pan-European quest for true love and her own identity. Not only does every love affair turn sour, but her treatment at the hands of various men turns her into a serial murderess. The bulk of the novel comprises Magdalena's confession/life-story, as told to an Austrian country priest whom she has first kidnapped, gagged, and tied to a tree.

Also featured prominently in the interview is Faschinger's most recent novel, *Vienna Passion* (*Wiener Passion,* 1999). This work chronicles the trials and tribulations of Rosa, a Bohemian serving maid in *fin de siècle* Vienna. Interpolated is a story of our own times: an unlikely love-affair between the Afro-American Magnolia, visiting Vienna to study for the role of Anna Freud in a musical, and her hypochondriac, mother-fixated singing teacher Josef. Further topics explored in the interview include Austrian identity, feminism, literary influences, identity through narrative, the picaresque, modes of women's oppression, writing as therapy and as survival, reader reactions, and Faschinger's current and future projects.

Interview

Ellie Kennedy: *Frau Faschinger, welcome to Canada! After several years in Paris, with spells in the US and elsewhere, you recently set up home in Vienna. Magdalena, the protagonist of your highly successful novel* Magdalena the Sinner, *refers to Austria as: "the homeland where I never felt at home." Where, if anywhere, do you feel "at home"?*

Lilian Faschinger: I don't feel at home anywhere. My options are to stay in my own country and to feel like a stranger, or to go abroad, where one is also a stranger, but where the feeling of alienation is not as painful because it is natural. And that is why I have sometimes preferred to live elsewhere. But since you ask me where I feel at home, I would say in writing. Through writing one can create or recover a home, and only when I'm writing do I truly feel at home.

Your novels exhibit a pronounced love-hate relationship with Austria. Magdalena, for example, hates Austrian society but loves the pastries! What do you love and hate about Austria?

My attitude toward Austria is ambivalent. That country has its positive aspects, and when one has traveled as much as I have, one realizes that other nations have their own problems. I keep returning and now, after many years away, I am once again living in Austria. I can stand it better in Vienna [than in Graz], but for a while it really was the case that I had to leave my country in order to survive as an artist—or to survive at all. For me, it's all connected with the Nazi era and with the fact that this oppressive atmosphere remained and cast a shadow over my entire childhood and youth. When the war was over, many politicians and functionaries were simply allowed to keep their positions of power. I hated that and I still hate it now, just as I hate the parochial, Catholic tradition that offers women little or no chance to express themselves artistically—or to express themselves at all. It is precisely this combination of Catholicism and Nazism that spoiled life for a thinking person, especially for a thinking and artistic woman in the 50s and 60s. Such was my childhood. The situation didn't change too much with the protests of 1968 because in Austria the old ways of thinking still exerted too much influence, so that the protest movement didn't take hold to the same extent that it did in, say, France, or even Germany.

Because the Austrian nation has never tackled the problem of its own Nazi past, Elfriede Jelinek has said that Austrian identity, insofar as such a thing exists, represents in fact a non-identity.[1] How would you respond to that?

I would agree. First there was this huge monarchy, which, despite its diverse cultures and languages, was associated with a universal identity, that of the Hapsburg dynasty and of Catholicism. I believe, by the way, that the foundation for fascism was laid during this absolutist monarchy. After that the country was decimated, reduced to a tiny geographical area, and even before the second World War, there was no longer a real "Austrian identity." The annexation to the German Reich constituted an attempt to regain this lost identity, but the attempt went horribly awry! So after 1945 a new self-image had to be built up slowly, because the feelings of being powerless and diminished were obviously very strong. Worst of all, the artistic community no longer existed, as all those people had either emigrated or been murdered.

Your protagonists, too, experience difficulty in building their own identities....

These women have no identity and are trying to create one by means of their imaginations. There is an incredible void in the lives of many

women born during or shortly after the war, and I believe that one way of filling this identity gap is by taking an indirect route through the imagination. When the imagination is used, unconscious processes are also taking place that in part go through the generations and back to the foremothers, the mothers and grandmothers. That means that when one fills that void with so-called imagination, one can arrive indirectly at a reality or a history that actually existed.

As narrated characters, Magdalena the Sinner *and the protagonists of* Vienna Passion *do allow the male gaze to determine their respective identities. However, as narrators of their own life-stories, they ultimately determine their own self-portrayals. Like your protagonists, I'm in my early thirties. Do you believe that women of my generation have a better chance of shaping identities for themselves, independently of conventional images of femininity?*

It's difficult to say. I'm a Marxist in this respect—I believe that an economic substructure determines the ideological superstructure, which means that the formation of identity is dependent on economic and political circumstances. Women have made many gains, and they also support one another more than was previously the case. Of course there are rivalries, but women are more likely to understand that gains can be greater and more easily won when they join forces. In that respect it won't be too easy to take it all away from them, but that depends on future developments. If certain radical political developments should come about, a retrograde step is perfectly possible. That's evident in a particular segment of society, I think. Besides those younger women who insist on their freedom there's a parallel group seeking a thoroughly conventional existence—they don't necessarily go out to work but prefer to marry instead and have the so-called protection of a man.

Feminist literature in Austria has been important—trail-blazing, even—in recent years. What does your work have in common with that of Jelinek, Streeruwitz, Frischmuth, etc., and how is it different? Do you see yourself in any way as part of a literary movement?

Certainly there are commonalities, due simply to the fact that we were born in the same place around the same time, following a particular and extremely significant situation, i.e., the Nazi era. That means that all these women writers had to create their own identities through artistic means—through writing. But how each woman does that is different and very personal. The basic theme is the same, but the approach varies. Also, since I have lived abroad so much, and since I barely keep any

contact with other Austrian women writers, I do not feel like a member of a group or movement.

You do tackle Austrian themes, however....

Yes I do, but I try to place them in a very broad context. My books are always about borders—inner borders but also external, geographical ones—and about crossing or at least pushing boundaries. Writing that limits itself entirely to Austrian themes doesn't interest me much. Moreover, many Austrian authors—particularly male authors—used to come across as whiny, and I found that distasteful. For a while a realistic, tragic folk-literature style was popular, but I found it uninteresting. I have to be able to work with my imagination, like Frischmuth, for example. The use of humor as a weapon is also important to me.

Who are your favorite authors?

As a scholar of English literature I have been concerned primarily with English-speaking authors, particularly Gertrude Stein and Virginia Woolf. Also, writers such as T.S. Eliot and Beckett have been influential for me, especially in the formal-aesthetic sense. As for Austrian literature, I am drawn to the life and work of Ingeborg Bachmann. Like me, she comes from Carinthia, from a similar background, and as a woman born in 1926 she had a very difficult time of things. She, too, used writing to attack the status quo, but growing up under National Socialism, as a woman moreover, she faced too many obstacles and evidently she could not overcome them through writing. She tried voluntary exile, because for her, as for me, it was impossible to live permanently in Austria. And I believe that her tragic end in Rome can be seen as a direct consequence of this attempt [to overcome the aforementioned obstacles], which at that time for a woman from that country and that generation was doomed to failure.

So I would name Bachmann as an influence, and then Thomas Bernhard. He's a man, yes, but he's also someone who has tackled these same themes with a combination of anger, wit, and penetration. Plus he has a tremendous power of expression, and that impressed me as a young woman. He was the first one to address directly this combination of Catholicism and Nazism. He saw and described things as they really were. This was exactly the combination that I had to attack in order to effect my own escape and to overcome the obstacles I'm talking about. However, one never knows if one really has escaped. It's an ongoing process.

Did you find yourself thinking of the picaresque—or the German Schelmenroman—*while writing your novels?*

Well, as a trained literary scholar I was of course familiar with the genre, but I don't believe I was directly aware of it while writing. With *Magdalena the Sinner* I didn't sit down specifically to write a picaresque novel.

What about as a reader of your own novels—do the picaresque elements strike you then?

Yes. Simply the fact that these women are always on the move—in order to escape. When they are stuck in one place, there's always an element of fear. First the silencing and second the lack of mobility, the "settling down," those are the two great fears. And they are very personal to me, as I have tried to escape through writing but also through leading a nomadic lifestyle. In this respect I am always portraying myself through these women-on-the-move. That's where the picaresque element comes from.

Another characteristic of that genre is a satirical perspective, for example, the naïve viewpoint of a protagonist is frequently employed to highlight the corruption in society.

Exactly! My novels have various levels, including a socially critical one, which is not targeted only at Austria but at any society encountered by the protagonists on their travels. They always see things from an outsider's perspective, from a distance, as is typical for the picaresque, and this distance sharpens their focus. It is no coincidence that the motto at the beginning of *Vienna Passion* is taken from *Moll Flanders,* a picaresque novel that—for a change—focuses on a woman.

In the twentieth century it's a different story, though. Many women have written in a picaresque style, and usually with a female protagonist.

Yes—a female protagonist who is always on the move! For women, that's a first step toward a kind of liberation, an inner liberation. Often, women are tied to one place or to a particular lifestyle by family and children. And at least in the imagination—in writing, for example—such boundaries can be crossed. In writing one creates a free, unfettered existence. Take my novel *Die Neue Scheherazade* (The New Scheherazade), for example, where the protagonist Scheherazade Hedwig Moser categorically rejects the roles available to her, sits on her sofa, and creates in her imagination a different life for herself. In that respect this novel

is picaresque, too, even though her travels all take place in her mind's eye. In reality she's sitting on the sofa, but even that constitutes a rejection of traditional female roles.

Fear of being static, and of the madness that must inevitably result, leads Magdalena to burst the suffocating bonds of family love and flee. In a dramatic escape scene, Austrian cuisine functions as an instrument of oppression, in that the mother wields her hearty home-cooking as a weapon in an—almost successful—attempt to render Magdalena immobile. At the start of her confession, Magdalena claims that the delicious pastries lured her back to Austria. Did Austrian food play a role in your own decision to return?

Not really. That over-feeding is a metaphor, obviously. The mother's over-feeding of her child is perhaps a sign of love, of a love that cannot otherwise find expression in a society where women are supposed to be seen and not heard. And it's a stylistic thing too, of course, the scene is described in a hyperbolic way.

Indeed, your female protagonists are often condemned to silence. And when they finally do break the silence, they are unable to stop talking! Should one consider this over-feeding on the part of Magdalena's mother as yet another over-compensation for speechlessness?

Yes, it's something very similar! But in another area.

Your novels contain long passages in indirect speech, especially when one character is prescribing the thoughts and feelings of another. In Vienna Passion *whole conversations, including the words of the respective narrators, are given in the subjunctive. Do you believe communication is possible—either in literature or in life?*

Yes, I do believe that communication is possible in life. Literature is always artificial, of course. In *Vienna Passion* I employed an excess of indirect speech in order to create an alienation effect. By this means the infamy of society—or of particular individuals who exploit Rosa—comes even more starkly to the fore. It becomes almost nightmarish, this world in which Rosa lives, in which she is always the tool of others' self-interest.

Music, a structural principle of Vienna Passion, *constitutes an ever-present leitmotiv in your work. And like everything else, music is an ambivalent sign because it, too, can function as an instrument of female*

oppression. Frequently in your novels, attempts to change a mezzo-soprano voice to a high soprano are linked with images of femininity.

Right! The motif of the high voice is definitely to be viewed negatively, because the voice of a truly mature woman is really not so high. The pitch of the voice goes hand in hand here with the development of a mature sexuality—certain forces are trying to prevent the woman in question from reaching her maturity. In *Vienna Passion,* for example, the nuns in Prague want to change Rosa from a mezzo to a high soprano: "Rosa, you look like an angel, you should sing like one, too." An angel is something ethereal, it has nothing to do with the sensually experienced reality of a woman. That is certainly a form of oppression. And Magnolia and Magdalena are expected to develop high soprano voices too. It's always other people who demand that of them.

Nevertheless, music can play a liberating role, for example in the episode where Rosa learns to play the zither in the subterranean sewers of Vienna....

Yes, music can be a source of comfort, especially for the oppressed and marginalized. For a long time now, I've had in mind a novel-project about a street musician, a harpist, an older woman who travels with a young girl. So there are two voices again, and the old woman tells stories from her own rich store of experience. The harp, the instrument of angels *par excellence,* has already made a few appearances in my works, for example in *Magdalena the Sinner,* where again it appears in the context of the underworld, the London Underground transit system. It's connected with buried feelings, buried creative possibilities, which should be brought to the surface....

I see the scene with the harp in a more negative light because the instrument is put into her hands by a man who wants to paint her, to make a graven image of her.

My female protagonists are always subject to determination by others.

Male characters, most especially husbands and lovers, insist on forcing your protagonists into stereotypical female roles—to such an extent that these women come to view murder of the husband/lover in question as their only escape. However, Vienna Passion *seems to offer a happy ending, for Magnolia, if not for Rosa. I have to ask, in the face of the seemingly inevitable spousal murder, the sadism that characterizes family relationships in your novels, and the racism that the Afro-American*

Magnolia encounters on a daily basis in Vienna, what are the prospects for the happy couple Josef and Magnolia?

[*Laughing*] The prospects are relatively poor! I think you have to take that happy ending with a pinch of salt because [Josef] is basically quite incapable of coping with life, plus he's already beginning to act in a domineering way. He tells her, you're to move in with me now, you'll practice your music in the laundry room, and so on.... The prospects are ultimately no better than those in *Magdalena the Sinner*, should Magdalena have chosen to stay with the Austrian Clemens, who offered her a stifling small-town existence. The situation is not quite so bad in *Vienna Passion,* but the tongue is firmly in the cheek where that happy ending is concerned.

Playfulness is an important element for you in writing, isn't it?

Yes, very much so! Working with allusion, dropping threads and picking them up again later—these are all things that make writing fun! I wouldn't write if it didn't bring me pleasure, because how else would it bring pleasure to readers? One invests a certain amount of energy, which the reader then recovers from the text.

The psychoanalytical profession generally appears in an unflattering light in your novels. Like Virginia Woolf, you equate psychiatry with patriarchy. I was wondering, can one compare your protagonist Rosa with Freud's Dora?

Freud is an important motif in *Vienna Passion,* particularly as someone who embodies the patriarchy and who tries, metaphorically, to force women into an ill-fitting costume. He treats them like failed men. He is situated at the beginning of modern psychology, at a time when all so-called female characteristics, such as intuition, were interpreted negatively for women. Thank heavens, that situation has improved! But a few decades ago psychiatry was really a male domain and also an instrument of oppression for women, who were considered particularly susceptible to hysteria, manic depression—what nonsense!

And your chosen form of therapy is writing.

Yes, I'm rather distrustful of conventional forms of therapy because I see them as a continuation of the priesthood. We used to go to confession, and now we go to see our analyst. Back then, the priest sat in the confessional and listened to what the penitent had to say, today the psychiatrist or psychologist sits there like a priest and his or her most

important job is really to listen. For me, that's still a form of determination by others. It's difficult to say, though. I've often considered therapy because sometimes one has the feeling that, if one finds a really good therapist, one can make progress more quickly that way than through writing. But I don't really trust that profession. In any case, why shouldn't one have confidence in one's own stock of capabilities—intelligence, intuition, inspiration? Why should one always let others tell one how to behave? Basically, it's all directed at social regulation.

Your novels represent attempts at self-expression and self-determination on the part of female protagonist-narrators who find themselves faced with a limited and unattractive range of patriarchally determined identity options. As narrated characters they all allow the male gaze to determine their respective identities, but as narrators they do not. At the conclusion of Magdalena the Sinner, *one could even say that Magdalena, having convinced the priest of her own self-portrayal, and having seduced him to boot, has thus achieved her goal of self-assertion. Then she moves on again, evading the police and roaring off into the distance on her motorcycle. What do you imagine she might be doing now? Will this extraordinary "confession" have a lasting positive effect on her, or will the cycle of love and murder that characterized her life-story to this point simply continue?*

I don't know! Actually quite a few people have asked me to write a sequel! Some readers sent me their own suggestions: she could go to Spain, for example, and have an affair with a toreador, or she could even go to America—she's made things well nigh impossible for herself in Europe! As for me, I really don't know what she's doing now. In the novel she does get a lot off her chest, which leads to a certain catharsis, a kind of healing process, but what happens next is unclear. She moves on again, alone, so the nomadic existence and the solitariness continue. Basically, nothing has changed. And she's still wearing the false nun's habit as she drives away. It's difficult to judge. She has escaped for now, but perhaps not forever.

The theme of writing as survival plays an important role in your work. You have also previously spoken of the wish to "rescue" other women through your writing.[2] In Vienna Passion, *Rosa achieves this aim in that her personal narrative helps her great-granddaughter to discover her own inner strength. By the same token, Rosa is in a sense "redeemed" through Magnolia's reading of—and positive reaction to—her life-story.*

One could perhaps say that your primary goal is to reclaim women's voices for themselves. Do you believe that your writing has helped some of your readers to find their own voices?

I truly hope so! Otherwise I wouldn't be writing! I'd like to arouse a kind of life-energy in women, a confidence in their own abilities. This is a theme in everything I write. It begins with *Die neue Scheherazade* and my personal interpretation of the old myth: Scheherazade keeps the king in thrall with her storytelling and thus prevents him from killing any more women. That means that certain women, owing to education that they were lucky enough to enjoy or to a particular talent, can help other women who did not have the same privileges and who are much more helpless and trapped. Indeed, I would like to awaken a power of resistance in women so that they don't just accept things the way I did as a younger woman.

How do men react to your work?

It varies. Some men are afraid of it. The weaker, more conventional types are uncomfortable with it, and they tend to criticize it. But there are also men who genuinely like women. This type is not afraid and really understands the humor. So they fall into two camps, but I have come to see that my writing can feel intimidating to men. I never suspected so much fear of woman in them! I really enjoy writing, and it doesn't occur to me until afterwards that what I've written can be intimidating to men.

What are you working on at present?

I'm working on a cycle of stories now. It goes in phases: I have the energy to write a novel—and it really does take a lot of energy—and then comes a kind of rest period when one withdraws, perhaps into depths as yet unplumbed. There will be ten stories again, as in *Woman with Three Aeroplanes*. This time the stories will all be connected through a unity of time, place, and action. The setting is Paris, strongly influenced by my own images of Paris and by my love for the city where I lived for quite a long time—this metropolis where so many people try to lead their lives and sometimes briefly encounter or touch one another, often by chance and only slightly. The story-cycle is structured on the principle of a circle. One character from each tale goes into the next story until the whole thing has gone full-circle. The action takes place at the time of the soccer World Cup in Paris: June and July 1999.[3] I see it as a big picture of Paris. I'm writing it in Vienna, as a memento

of my time in Paris. It seems that I always have to remove myself from the place I'm describing. That's always helpful. In Paris I wrote about Austrian issues and now, in Vienna, I'm writing about Paris.

You once said, "little epiphanies often happen while I'm traveling."[4] Can you reveal any epiphanies that have occurred during this, your first Canadian tour, which we might encounter later in your writings?

Oh, that's a secret! There have been a couple. One sees one's own very personal signs and connections—perhaps that's a female thing—and sometimes I do write these things down for later. One is much more open to that kind of insight when traveling. At home, one is too closed, too stuck in a rut, but when traveling, I find, one can more easily experience these epiphanies—that's perhaps too big a word, maybe insights into life. And I do think that every woman establishes her own very subjective, secret system of connections.

And you will always keep on writing....

One is continually developing, and the characters one describes reflect one's stage of development at the time of writing. And that situation will continue, one hopes, for the rest of one's life!

Notes

[1] Brenda L. Bethman, "My characters live only insofar as they speak: Interview with Elfriede Jelinek," *Women in German Yearbook 16*. Ed. Patricia Herminghouse and Susanne Zantop. Lincoln: U of Nebraska P, 2000. 61.

[2] "Lilian Faschinger im Gespräch mit Gisela Roethke." *Script* 19 (2001). 42–59: 43.

[3] As of February 2002, the number of stories planned had changed to eight, and the unifying factor in them is no longer the soccer World Cup but the fireworks of July 14 (Bastille Day).

[4] "Im Gespräch mit Gisela Roethke": 53.

Appendix
Selected Bibliography of Publications by Lilian Faschinger

Novels

Die neue Scheherazade. München: List, 1986; paperback München: dtv, 1989.
Lustspiel. München: List, 1989.
Magdalena Sünderin. Köln: Kiepenheuer & Witsch, 1995; paperback München: dtv, 1997; English (British) *Magdalena the Sinner.* London: Headline Review, 1996; paperback 1997; English (American) *Magdalena the Sinner.* HarperCollins, 1997; also available in fifteen other languages.
Wiener Passion. Köln: Kiepenheuer & Witsch, 1999; paperback, München: dtv, 2001. English *Vienna Passion.* London: Headline Review, 2000; paperback 2001.

Other Fiction

Selbstauslöser. Poems and short stories. Graz: Leykam, 1983.
Frau mit drei Flugzeugen. Short stories. Köln: Kiepenheuer & Witsch, 1993; paperback München: dtv, 1993; English: *Woman With Three Aeroplanes.* London: Headline Review, 1998; paperback 1998.
Ortsfremd. Poems. City of Baden-Baden, 1994.
Sprünge. Short Stories. Graz: Leykam, 1994.
Several radio plays and plays for the theater

Selection of Literary Translations from English into German

(with Thomas Priebsch) Gertrude Stein. *The Making of Americans.* Klagenfurt: Ritter, 1989. (Received the Austrian National Award for Literary Translators.)
(with Thomas Priebsch) Paul Bowles. *Tangier Journal.* Graz: Droschl, 1991.
Elizabeth Smart. *By Grand Central Station I Sat Down and Wept.* Salzburg: Residenz, 1993.
Janet Frame. *An Angel at My Table.* München: Piper, 1993/94.
John Banville. *Athena.* Köln: Kiepenheuer & Witsch, 1996.

Everything Will Be Fine: An Interview with Fatima El-Tayeb

Barbara Kosta

Introduction

Fatima El-Tayeb collaborated with director Angelina Maccarone in writing the script for the feature film *Everything Will Be Fine* (*Alles wird gut,* 1997), for which they received a grant from the state of Schleswig-Holstein in 1996. The film has won awards at the New Festival in New York, at Toronto's Inside Out, and at the Gay and Lesbian Film Festival in Los Angeles. *Alles wird gut* was published in book form by the Orlanda Frauenverlag in 1999.

El-Tayeb is an Afro-German scholar who earned her doctorate in History from the University of Hamburg, where she wrote her dissertation entitled "Black Germans and German Racism: Oxymoron or Repressed History: African Germans and the Discourse on 'Race,' 1900–1933." A revised version of this study, *Schwarze Deutsche: Der Diskurs um "Rasse" und nationale Identität 1890–1933,* has been published by Campus Verlag. El-Tayeb was the special guest at the 2001 Women in German conference in Rio Rico, Arizona. The interview was inspired by the discussion that followed the film screening there and took place via e-mail.

Interview

Barbara Kosta: *You and Angelina Maccarone worked together to produce the script for* Alles wird gut. *Could you please talk about your collaboration? How did the idea for the film develop?*

Fatima El-Tayeb: Angelina and I have been friends for a long time. While she was in the process of writing the script for her first movie *Kommt Mausi raus?* [dir. Alexander Scherer, 1994; Is Mausi Coming Out?!], we talked a lot about it and realized that we would probably work very well together. The experience she had co-directing that first

movie was not very pleasant. Angelina was a newcomer and she was confronted full force with the power games in the film industry. The director and producer of *Kommt Mausi raus?* (for those who have seen *Everything Will Be Fine,* the character of the fish, Frau Müller, is based on the producer) went out of their way to put Angelina in "her place." A particularly annoying aspect was that they refused to have one of the protagonists played by a black actress. They insisted that the casting of a black actress should have been made explicit in the script (of course, the script did not say anything about the character being white either).

Angelina and I had talked before about writing a script together, but I think our idea to make a film with two black women in leading roles basically started then. The presence of black women on the screen is still extremely rare in mainstream films as well as in feminist/lesbian films, both in Germany and in the United States. The debates around racism in the lesbian community often resulted in the introduction of "the black character." In these cases, the protagonist is either reduced to being black, which means that blackness is used to initiate a discussion on racism, or a black person is totally "whitened," which means that she/he appears isolated in an otherwise white world with no connection to a community of color.

We wanted our script to reflect the world that we actually were living in, an urban German scene that is not nearly as white as the media make it out to be. Our decision to cast two black women in leading roles had a lot to do with wanting to overcome this representation of blackness as a single and self-sufficient marker. Our initial idea was to create a situation in which two extremely different people are thrown together and these two characters would be both black and female. Originally we intended to make a road movie, because that genre provides such a good opportunity to present a relationship that evolves between people who initially do not seem to have anything in common. But then *Thelma and Louise* came out, and we did not want it to look like we were copying it. So instead, we decided to move in the direction of screwball comedy, which is a form of comedy I have loved since I was a teenager. Screwball comedies play with language, with gender stereotypes, and generally they reject the notion that being "normal" is an admirable aspiration. So that came very close to what we wanted to show.

How long did it take to write the script?

I do not remember exactly how long it took from our first idea to the final script. Being friends, we met frequently anyway and talked more

and more about the film: how we envisioned the characters, how the plot should progress, etc. Of course, we also watched a lot of screwball comedies. Toward the end, we met every day for about a month and sat in front of a computer all day until the story was written. We really developed everything together, which is quite amazing in retrospect. (We later published a book based on the script, but then we divided up the story and each of us wrote her part). It is a great way to work. First of all, it's a lot of fun, and second, it really makes you do your best. If I had an idea that I considered incredibly funny, and Angelina did not, each of us tried her best to convince the other of the idea. It forced us to be clearer about what we wanted to achieve and how to get there. Most of our best ideas evolved while we were talking about them.

How was the project funded?

We had envisioned a low-budget film, since we did not expect to get funding easily. We had a number of friends who were marginally involved in the film industry, and we thought we basically would work with them. We sent a treatment to German public television anyway, since they had funded Angelina's first film, even though we did not expect much support because we insisted on directing the film ourselves. The NDR [Norddeutscher Rundfunk], however, actually agreed to the project, and only demanded, quite reasonably, that we get more experience directing. So it very quickly came down to Angelina becoming the director, since she already had some experience and was willing to work full-time on several productions in order to gather more. And most important, she has a lot more talent for directing than I do. The film's budget was about $750,000, which is not much, even by German standards, but it was enough to ensure a professional production. We did, however, have to put up some fights. The film is very fast-paced with lots of short scenes. That is expensive, of course, so there was some pressure from the producers to cut out scenes and slow down the film to the usual speed of German movies (pre-*Run, Lola, Run,* that is). Fortunately, we got to do it our way. The film became what it is today because of the professional team that we worked with (about two-thirds, by the way, were women). We had an excellent camerawoman, whose work added a whole new dimension to the film, a very experienced editor, a woman who worked wonders with the set design, and, of course, professional actors.

How was the film received in Germany?

The film was produced by and for public television, so the response is more difficult to discern than with productions that are screened in movie theaters. Reviews were overwhelmingly positive, even in the mainstream press. It could mean that our attempt to use the subversive potential of comedy worked. We wanted to represent a group of people, who all belonged to minorities—women, lesbians, and/or blacks—and show them interacting with each other, not in relation to the majority. We believed that their experiences were as universal as anyone else's. The trick was to present various minorities to a German primetime TV audience (definitely neither predominantly black nor gay) without having "to explain" the characters to them, but rather to make viewers identify with the characters, to share their point of view, and to want what they want. Comedy seemed the perfect way to do that. It works against a distanced, detached, "ethnological" viewpoint or one that is supposed to arouse pity—a view that a white and/or straight audience might easily have toward a film about black lesbians.

It was also clear from the beginning that we would deal with racism. Any convincing portrayal of black life has to include the issue, since, unfortunately, it is such a daily part of black experience. But at the same time, black life is so much more than just being subjected to racism. So we wanted to avoid presenting black characters as victims or singling out racism and separating it from the rest of the characters' lives. We wanted to avoid having a "racist confrontation scene" that allows the white audience to feel like they have had an educational experience, while a black audience gains nothing from the simplification of its experience. So again, even though our story had a different topic, comedy offered us the opportunity to show the influence of racism in a way that was convincing (and empowering) for people of color, while it forced a white public to confront the issue without guilt-tripping them. The film reviews indicate that this worked for the white audience, and judging from the conversations I have had, it also worked for the black community in Germany, including those who usually are quite homophobic but could totally identify with the heroines' experiences in (and resistance to) a racist society. And of course, it gained quite a status in the lesbian community, especially since Angelina is one of the very few queer directors in Germany who is out.

The TV ratings were not too good, though. I do not remember the exact number of viewers; it may have been a few million. That is not so bad, considering that there was a soccer match on at the same time and

an Uschi Glas movie on another channel. But the TV station clearly saw our film as a commercial failure.

The film appeared on German public television (NDR) in a series entitled Wilde Herzen *(Wild Hearts). How do you see your film in the context of the series?*

Public television in Germany is still larger than its commercial rivals. But they are getting closer, so public TV tries a lot of different things to keep its audience. One approach is exemplified in the series "Wilde Herzen," which provided young directors with a forum. It signaled that public TV is ready to experiment and that it is willing to make room for diversity, unlike the private stations. We were very lucky that we offered them our story during this period. "Wilde Herzen" ran for two seasons and featured three of Angelina's movies. They then took the opposite approach and enforced a strict policy of "give the audience what it expects and nothing else." When this internal order became public, the stations were showered with criticism, but it did not stop the trend of public TV becoming more like commercial TV.

Nabou, played by Kati Stüdemann, seems to negotiate her urban environment with tremendous ease. Just the way in which she rides her bike through traffic suggests her command of her environment. She knows what she wants and how to get it. She also belongs to a marginalized subculture. Kim, played by Chantal de Freitas, seems to have more difficulty coming to terms with questions of identity. Could you discuss these two characters and what they represent?

Well, actually, I would not entirely agree with this characterization. In many ways, Kim knows much better what she wants. She approaches her life in a very rational manner, determining her goals and then taking the appropriate steps to achieve them. But of course a premise of screwball comedies is that you have to throw rationality overboard to achieve happiness. Nabou is much more of a drifter. In the beginning, she apparently knows that she wants Katja, but needs her friend Giuseppa's none-too-subtle prompting to do anything about it. Later, of course, she realizes that what she initially thought she wanted is not what she wants at all.

We created detailed biographies of all of the main characters. Many of the details never show up in the film itself, but they are central to making the protagonists' actions plausible. Kim, Nabou, and Kofi are intended to represent different generations of African Germans. Kim stands for those born in the 1950s and 1960s; she's an "occupation

child." Her father was a GI whom she never met. She grew up alone among whites in a village in southern Germany. There was no place for people like her, so she basically had to reinvent herself. She moved to the city, broke off all contacts with her family, and renamed herself. She dropped her old-fashioned German name "Erika" and took on the more cosmopolitan name "Kim." Since she always had to fend for herself, she prefers to keep people (and her emotions) at a distance. Rather than risk losing control, she chooses a "sensible" relationship and focuses on professional success as the means of self-fulfillment. That, however, does not mean that she is unaware. She has dealt consciously with her black identity. There are some references to that: she talks about "Toxi," a picture of Angela Davis hangs on her wall, and she and Kofi apparently met in a student activist group. A black community was not something she grew up with; she had to look for it.

Friendship is a central issue in our movie; we wanted to show that friends are as important as lovers. Since you can't introduce too many characters in a movie like this, the circle of friends that each protagonist has is represented through one person. That Kim's friend is a black man is no coincidence. He is the one person she trusts completely and, of course, that is a reference to the sense of community that exists between black Germans, men and women, straight and queer. (Well, of course, that is an idealization. There are many conflicts within the community, but I would still like to believe that there is enough common ground to overcome them, at least temporarily).

And Nabou?

Nabou is in many ways more privileged than Kim. She is younger; she grew up in an urban, "multicultural" environment with her German mother and her Senegalese father. Contrary to Kim, we envisioned her as belonging to the middle class, which allows her the luxury of figuring out what she wants to do with her life. But she also made a conscious decision not to try to "make it" in the dominant culture, the way that Kim does, since her values are very different. Nabou lives in an urban alternative/queer subculture that tries to carve out a space for itself. And actually, the yuppie world Kim moves in is attracted to this subculture, so that the two groups often live in close proximity (a very one-sided attraction). Nabou's best friend is Guiseppa, an Italian German dyke, which not only gave Angelina a chance to work out some identity issues too, but also draws attention to the fact that the urban queer culture in Germany is multicultural and multiethnic.

Kofi stands for those black Germans who actually spent part of their childhood in their black parent's home country. People often seem to think that he's African, since he talks about going "back" to Ghana, but actually, he's Afro-German as well.

The film flirts with the format of the screwball comedy (traditionally a comedy that focuses on the "battle of the sexes"). In screwball comedies, gender distinctions often become messy and are not necessarily recuperated at the end of the film. As the title suggests in Alles wird gut, *the narrative aims to bring the "right" people together. In this case, it is two Afro-German women. What makes the two women "right" for each other? Does a subversion of cultural norms take place?*

Well, within the logic of screwball comedies, whenever you have two characters who hate each other's guts, it's a clear indication that they are meant for each other. There is constant fighting, usually one of the characters is in a sensible but boring relationship, and the other character tries to break it up. Everything and everyone is constantly over the top, creating a permanent madcap atmosphere. So, you could say, what makes two characters "right" for each other is that they make each other go to extremes that they never would have thought possible. They make each other feel alive and challenge each other to develop their full human potential.

But the genre did not only appeal to us because of its interesting concept of love. It reached its height in Hollywood films of the 1930s and 1940s, but its narrative and formal structure was very fitting for the modern story we had in mind. It is fast-paced; it has many cuts and short scenes (something a 1990s audience was used to because of MTV). There is a sharp sense of humor that is not slapstick but verbal and a constant play with absurdity that finally leads to a perception of the accepted norms as much more absurd than the consistent madness of the protagonists' behavior. And even though the traditional screwball comedy is set among upper-class whites, its structure allows for the presentation of "unconventional" people and plots. While the screwball comedies of the 1930s were otherwise apolitical, they did that already in their presentation of women: females in these movies were independent (either rich or working), strong, self-confident, less interested in marriage than in pursuing their own goals. In short, women were represented as more than equal to men. This explains why marriage as the prescriptive happy ending actually seems disappointing in these comedies because it returns women to their traditional role and reestablishes the gender hierarchy. Throughout the movie, the world has been turned

upside down and at the end there is a final reconciliation with convention. This is a problem that can be avoided in a lesbian screwball comedy: "marriage" as a happy ending defies conventions, especially the conventions of classical narratives.

Screwballs are also very stylish; they convey a certain hipness. The characters are either rich or they have "cool" jobs (often at newspapers); a "smart" urban setting is very important (or humor develops from urbanites being transplanted to the countryside). The importance of style is reflected in the attention paid to visual aspects: decor, clothes, and furniture.

At first glance, it seems totally different from our story. It is not about the happy few, but rather about people who are usually marginalized. We attempted realism, certainly not in the storyline, but in the presentation of the characters and their living conditions. We deal with racism, which definitely was not addressed in traditional screwball comedies. They typically challenged notions of gender, but not of race. We also include more banal examples of everyday life; while the independence of women in 1930s screwball comedies meant that there were no children and no housework, housework is quite central in our film. But there are also important features that we kept: we wanted a certain urban "hipness," the content of which, of course, has changed drastically since the 1930s. Subcultures are exploited by popular culture today in such a manner that they are the epitome of hipness (subcultures as symbols, of course, not the real people). And this hipness is conveyed on non-narrative levels in the movie through the light, which has a slightly blue tint, the fast-moving hand-held camera, and the music. Moreover, we wanted the characters of the heroines to be reflected in their clothing and the interior of their homes. We had worked that out in detail in the script already, down to Nabou's orange boots (other things were added during the shooting, like Kim's gigantic hair curlers, which Chantal, the actress who played her, wore in between takes).

The screwball approach to love was probably most important. Attraction reveals itself in aggression; a couple that is happy at the beginning of the film is certainly doomed. The audience invariably sympathizes with the weirdo who tries to destroy the idyll everyone is supposed to long for (now as in the 1930s, I assume). The play on the opposition between male and female characters, which often is staged in a gender role reversal—an aggressive woman and a passive man—was something we could not repeat with two female leads (unless we would have chosen a very un-Butlerian butch-femme couple). Rather, the tension derives from two women's opposite outlooks on life. Kim is a cool career woman, self-controlled, bitchy, sensible, straight, and in a

relationship. Nabou's quite a bit younger, a slacker, chaotic, emotional, and a lesbian. This seemed like a constellation with enough potential for conflict.

Another important difference in the presentation of the love story lies in the fact that screwball comedies were a product of the Hayes code: any open allusion to sexuality was forbidden. So the script had to be very subtle in that regard, there had to be a lot of sublimating, which lent the films their special kind of humor. We, on the other hand, had a very different approach. We did not problematize "lesbianism," but rather it was taken for granted, including the explicit representation of lesbian sexuality. But sexual repression is a, if not *the* motor of screwball comedies, so it has to be there. In our case, the repression was not imposed on the script due to external circumstances, i.e., censorship, but it was an essential part of the storyline. We included the issue of repression by making half of the potential lesbian couple straight.

Nabou and Kim's first sexual encounter is accompanied by African music. During the discussion following the film at the Women in German conference, concern was expressed about the essentializing effect of the music in this scene—two women of African origin come together. Why was this music chosen?

Well, the film music was entirely Angelina's doing, and I think she did an absolutely terrific job with it. She is a musician herself, so her choices are based on far more complex ideas than I can convey. Thus my answer will be second-hand and inevitably limited. The whole sex scene was rather tricky. We really wanted one, since the representation of lesbian sexuality is often so totally dominated by the male gaze. But that was one scene we had not worked out in the script. The actresses did not offer much input either, so it was all up to Angelina. She tried to avoid a voyeuristic presentation by focusing on the characters' inner perspective. She wanted to show what it feels like for them to make love. She did that through close-ups, repetitions, and through music. The song is *a capella,* sung entirely by female voices, which conveys an intimacy and sexiness that was just right for the scene (the lyrics were quite fitting too, but I forgot them). The music is not exactly African. It is by an Afro-Belgian band called "Zap Mama" that we both had been fans of for quite a while. What they try to do in their songs is pretty much what we tried to do in the movie: find their own voice in between essentialist concepts of "Africanness" and "Europeanness," "foreignness" and "belonging." So while African music is at the root of about 95% of all the songs you hear on the radio these days, it is no

coincidence that the music of this group of eccentric black, brown, white, straight, and queer Belgian women is heard when the protagonists have sex for the first time. Just as it is no coincidence that Nabou's "theme song," "Hedonism," is sung by a black European dyke, Skunk Anansi's Skin.

How does the film deal with issues of class? After all, Nabou cleans Kim's apartment.

As I said before, there is a class difference. But it is Nabou who has a middle-class background, even though she is always short on money. Taking on a cleaning job is only a means to an end, not something she really has to do or takes very seriously. Kim, in contrast, had to work very hard to get to where she is financially, and consequently, it's quite a step for her to give that up. I felt a bit uneasy about Nabou playing the cleaning woman because of all of the clichés about black maids in movies. But we just could not think of another way that would work on a cinematic level for these two women to be forced to spend a lot of time together. Interestingly enough, no one has ever pointed it out, except at one screening in Green Bay, where a lot of retirees come to the university film club showings. One of them said that she found this black maid thing a bit problematic. I do not know if that is because younger people really do not make this connection anymore, but I found it remarkable.

I look at it a bit differently. Cleaning also could suggest that Nabou metaphorically helps Kim organize her life and find her identity. What is the relationship then between the subculture and the dominant culture? You mentioned a fascination that the dominant culture has with the subculture.

Obviously, our sympathies lay entirely with the subculture. It does not necessarily mean that we had more sympathy for Nabou. I think they both helped each other in finding their identities. After all, Nabou's life needed quite a lot of organizing, too. She used to depend very much on Guiseppa to provide guidance and was totally obsessed with a woman who is as much a parody of the "hip dyke" as Dieter is of the cool guy who dominates the world of advertising.

In the final scene the two women jump ship. A small buoy keeps them afloat. Is this a "sink or swim" situation, or does the ending suggest a transition into a new and undefined space?

Well, both. They needed to make a definite decision and they did. They are there together and safe. But then the camera moves away, and you see them get smaller and smaller in a vast, dirty river surrounded by a rather desolate industrial landscape. We absolutely wanted a happy ending. When we started the script, in the mid-nineties, there hardly were any movies about lesbians that had a positive ending. And we had both grown up with all these stories about suicide, madness, and alcoholism in both Hollywood and independent cinema. We felt that it was important to represent a lesbian story with a big happy ending. But it also needed to have an ironic twist, and the buoy seemed to nicely represent both.

Could you describe what you mean by an "ironic twist"?

Well, basically, it is what I just described. The ending is tongue-in-cheek, right? It *is* a happy ending, but the buoy is obviously a totally over-determined signifier, so using it instead of a more "serious" symbol is ironic and the camera moving away reminds you that what you see is rarely what you get.

Which films do you think influenced the making of Alles wird gut? *Do you see a relationship between your film and other lesbian films?*

Definitely. As I said, the representations of lesbians in film were for the most part very frustrating. Moreover, the representation of women of color is close to zero. The few exceptions are often so clichéd and one-dimensional that it is almost impossible to get something positive out of them even though both lesbians and people of color are experts, out of necessity, in getting something positive out of negative, stereotyped images. Independent films are not much better; straight and/or male filmmakers took over the image of the depressed, crazy dyke, see Fassbinder. Early feminist films approached lesbianism very psycho-analytically. Films made by lesbians were often experimental, both because they reject mainstream narrative conventions and because of financial restrictions. But we wanted to use mainstream forms to tell our story. On the one hand, because we love a lot about the Hollywood tradition, like the screwball comedies, but on the other, because our taste in films other than Hollywood is quite different (about as different as Lars von Trier and Luis Buñuel). However, things have changed quite a bit over the last few years. There are a lot more feature films made by lesbians, even some by lesbians of color. I think we would not feel the need anymore to prove that a black lesbian mainstream comedy is not an oxymoron (and everybody is tired of German comedies,

anyway). But at the time we made *Alles wird gut,* things were different. And so our role model in using mainstream comedy to transport and not to exploit a "minority" subject was not a lesbian filmmaker (even though Patricia Rozema's *I've Heard the Mermaids Singing* and Cheryl Dunne's shorts certainly impressed us), but a straight, black man: Spike Lee. At least in his early work made in cooperation with Ernest Dickerson as cameraman, Spike Lee was a pioneer in using traditional Hollywood—i.e., anti-black—narrative and visual features and to expand them, play with them, and create a quite different story. While formally never leaving the realm of mainstream (and that means never leaving the possibility of reaching a "mainstream" audience), he achieved something unprecedented: a complex, realistic portrayal of black life—or rather, of black male life. His female characters, though he tried, remained one-dimensional and were defined exclusively by their relation to men. In my eyes, there are few people who have used the subversive potential of comedy better than he did and we surely owe a lot to him.

In writing the script for Alles wird gut *did you feel restricted by demands placed on you by the producer? If so, what would you have done differently if those constraints were lifted? In other words, what would you have liked to do differently?*

Both the executive producer and the producer from the public TV station (both women) were very supportive. Of course, it is basically their job to be annoying, but we still had a lot of freedom. I don't know what I would have liked to do differently, which doesn't mean at all that I think the film is perfect. But *Alles wird gut* is a story we really wanted to tell then, and we did it as best as we could. We have moved on since and are interested in other stories.

Are you working on another script?

Nope.

The film won a number of prizes at gay and lesbian film festivals and now has quite a following. Will it be available on video?

No. We made a stupid beginner's mistake. If you do something for TV, you can use every single song in the world without having to pay for it. If you want distribution rights for movie theater showings or video, you have to pay for each song and get permission to use it in advance. We did not know this and used a number of popular songs, which got us into real trouble when a couple of distributors expressed interest.

Angelina actually tracked down all the people who held the rights to the songs. They not only wanted too much money, a number of them flatly refused to grant us permission. So, that was that. I believe that it would be possible to sell the film legally to a non-commercial distributor. We tried our luck with InterNationes, but unfortunately they have not been very responsive.

Has your work as a historian influenced the ways in which you tell stories?

I think it is more the other way around. There are certain stories I want to tell by any means necessary. A historical study often seems the best way to do it, but sometimes a very different approach works much better.

Appendix

Bibliography of Works by Fatima El-Tayeb

Film

Alles wird gut, 90 min, Germany 1997 (with Angelina Maccarone).

Books

Alles Wird Gut: Das Film-Buch. Berlin: Orlanda, 1999 (with Angelina Maccarone).
Schwarze Deutsche: "Rasse und nationale Identität (1890–1933). Frankfurt a.M.: Campus, 2001.

Articles

"Begrenzte Horizonte: 'Queer Identity' in der Festung Europa." *Postkolonialer deutscher Feminismus: Ein Reader.* Ed. Nina Zimnik and Mechthild Nagel. Berlin: Orlanda, forthcoming.
"'Blood Is a Very Special Juice': Racialized Bodies and Citizenship in 20th Century Germany." *Complicating Categories: Gender, Class, Race and Ethnicity.* Ed. Eileen Boris and Angélique Janssens. *International Review of Social History* 44 (1999), Supplement 7.
"Dangerous Liaisons: Race, Nation, and German Identity." *Not So Plain As Black and White: Afro-German History and Culture 1890–Present.* Ed. Patricia Mazón and Reinhild Steingröver. Albany: SUNY Press, forthcoming.

"Germans, Foreigners, and German Foreigners: Constructions of National Identity in Early 20th Century Germany." *Unpacking Europe.* Ed. Salah Hassan and Iftikhar Dadi. Rotterdam: NAI, 2001.

Illustrations. Olumide Popoola and Beldan Sezen, eds. *Talking Home: Heimat aus unserer eigenen Feder. Frauen of Color in Deutschland.* Amsterdam: Blue Moon Press, 1999.

"Verbotene Begegnungen, Unmögliche Existenzen: Afrikanisch-Deutsche Beziehungen und Afro-Deutsche im Spannungsfeld von *race* und *gender.*" *Die (koloniale) Begegnung: AfrikanerInnen in Deutschland (1880–1945). Deutsche in Afrika (1880–1918).* Ed. Marianne Bechhaus-Gerst and Reinhard Klein-Arendt. Frankfurt a.M.: Lang, forthcoming.

"'We Are Germans, We Are Whites, and We Want to Stay White!': Whiteness and German National Identity 1900." *Colors 1800/1900/2000.* Ed. Birgit Tautz. Amsterdam: Rodopi, forthcoming.

Local Funding and Global Movement: Minority Women's Filmmaking and the German Film Landscape of the Late 1990s

Barbara Mennel

The German cinema landscape of the 1990s was characterized by two major trends: one featured international mainstream successes with post-feminist representations of strong female heroines, and the other consisted of a new independent minority cinema, identified by the German feuilleton primarily as male. For minority cinema directed by women, these trends create expectations and pressures, which are often expressed through the identity politics of funding decisions. Two films from the period, Seyhan Derin's *I Am My Mother's Daughter* (1996) and Fatima El-Tayeb and Angelina Maccarone's film *Everything Will Be Fine* (1997), subvert the implicit and explicit expectations of their funding by reworking traditional genres and employing narratives of movement that reconfigure notions of identity. (BM)

"Chick Flicks": Cinefeminism Revisited

In her book-length study of the feminist film movement, *Chick Flicks: Theories and Memories of the Feminist Film Movement* (1998), B. Ruby Rich claims that the women's film movement has abandoned the diversity of concerns—including production, distribution, and reception—that characterized its beginnings in the 1970s. She argues that in a process of academization, its concerns were increasingly limited to the theoretical question of female spectatorship. In this essay, I take up Rich's challenge to address the conditions of production, distribution, and reception, on the one hand, and cinematic representation, on the other. How do the political dynamics of production, distribution, and reception shape the possibilities for minority women filmmakers in contemporary Germany to make and show films? How do their films, in turn, reflect and subvert these political dynamics?

Funding and distribution for women's films were central to cinefeminism, the feminist film movement of the 1970s in the United States, argues Rich. The activism rooted in these concerns led to the creation of women's film festivals, distribution companies such as Women Make Movies, and archives and journals devoted to women's film. In Rich's account, German films and directors feature centrally, both in regard to the discovery of forgotten women directors as well as to an emerging feminist cinema: "New German Cinema was the riveting center of attention in seventies film circles, propelled by the new generation of German auteurs as well as by the pioneering academic work of journals like the *New German Critique*" (175). Similar to cinefeminism in the United States, the West German feminist film movement was also concerned with production and distribution, exemplified in Helke Sander's film *The All-Round Reduced Personality* (*Die allseits reduzierte Persönlichkeit,* 1978). The film documents the fictional struggles of a collective of feminist photographers discussing the means of production for their photo series about women in Berlin as well as access to potential exhibition spaces, ranging from an art gallery to billboards in the city. The film's emphasis on production and exhibition parallels the concerns of the feminist film movement in West Germany. By organizing women's film festivals and feminist film journals, such as *Frauen und Film,* the feminist film movement created alternative venues and ultimately a public sphere for distribution of a feminist cinema, and, in turn, a feminist audience and reception.

Rich argues that the academization of feminist film studies in the United States during the 1980s and 1990s increasingly limited concerns to the question of female spectatorship, first developed by Laura Mulvey in her path-breaking article "Visual Pleasure and Narrative Cinema." In this 1977 classic essay, Mulvey suggests that both cinematic apparatus and spectatorship are organized by the male gaze, while the narratives of Hollywood films are arrested by "woman as image" (62). Rich does not criticize the concept of cinematic spectatorship, but rather the singular attention it has received in Anglo-American feminist film scholarship of the last two decades. In German feminist film studies in the United States, spectatorship has been the focus of several studies but with a socio-historical approach that expands the sole emphasis on psychoanalysis that characterizes Anglo-American feminist film studies.[1] Rich claims that the single focus in feminist film studies created "a tendency towards stasis and atrophy" (380).

Rich's historical narrative of cinefeminism delineates a division between a socio-economic approach, which addresses funding and distribution, and a psychoanalytic approach, which focuses on the gendering of

representation and spectatorship; the first approach is mapped onto feminist film activism, while the second shapes academic feminist film studies. In German Studies this methodological bifurcation mirrors the methodological split between the study of DEFA film, dominated by a sociological approach, and the study of West German film, dominated by a semantic and psychoanalytic approach. Rich calls for reviving the diversity of methodological and topical approaches that characterized the beginning of cinefeminism, yet her account leaves the boundaries between different methodologies intact. I suggest, however, that these methodological boundaries need to be revisited in order to account for the interdependence of socio-economic conditions of cultural production, on the one hand, and the psycho-social structures that shape our cultural imaginary, on the other.

Taking Up the Challenge

I take up Rich's challenge to address the conditions of production, distribution, and reception by investigating two examples of films directed by minority women in contemporary Germany, emphasizing the tenuous link between funding and distribution, on the one hand, and cinematic representation, on the other. This link often serves as a linchpin for women filmmakers, specifically for minority women filmmakers, because funding and distribution are tied in implicit and explicit ways to identity politics, and thus to cinematic representation. Do films reflect and negotiate the implications of their funding? To answer this question, I probe the relationship of the funding parameters to the narrative and structural emphasis on movement in Seyhan Derin's *I Am My Mother's Daughter (Ben annemin kiziyim—Ich bin die Tochter meiner Mutter,* 1996) and Angelina Maccarone and Fatima El-Tayeb's *Everything Will Be Fine (Alles wird gut,* 1997). While El-Tayeb and Maccarone's *Everything Will Be Fine* is characterized by movement within the city of Hamburg, *I Am My Mother's Daughter* narratively and structurally moves between Turkey and Germany. *I Am My Mother's Daughter* meditates on the aftereffects of Turkish migration to Germany for a collective Turkish diaspora and for Derin's family. *Everything Will Be Fine* is an Afro-German screwball comedy that insists on the locally specific identities of its minority characters, while negotiating belonging to the transnational African diaspora.

In the late 1990s, a new ethnic cinema emerged in Germany, similar to the emergence of a new feminist cinema that had been marked by *The All-Round Reduced Personality*. My analysis offers a symptomatic reading of the interplay of the politics of funding, distribution, and

cinematic representation, which is especially pronounced when a new cinema emerges. This analysis does not suggest reading the films' narratives as allegories of funding, nor does it ignore the heterogeneity of the last decade of filmmaking in Germany by claiming representative status for *I Am My Mother's Daughter* and *Everything Will Be Fine*. But when filmmakers intend to address discriminatory practices, which, however, also shape the conditions of their work, that paradox can leave traces in the cinematic text itself.

While securing funding might not be harder for minorities in quantifiable and absolute terms, nevertheless for minority women filmmakers it comes with the added complications of identity politics. A panel discussion at the film festival "Women Behind the Camera: Contemporary Filmmakers in Multicultural Germany" illustrates the complex relationship between funding and minority cinematic representation.[2] One filmmaker explained that in order to secure funding from German production companies, she includes minor stereotypical characters and action in her script, such as a Turkish wife who is beaten by her husband. Once she receives funding, she deletes the scenes. This example illustrates one filmmaker's approach to the unacknowledged ways that funding is tied to expectations about minority representation, the individual filmmaker's awareness of these processes, and her strategies for reappropriating and subverting these expectations. Her statement, however, led to a heated and controversial debate among the filmmakers, in which a second filmmaker argued that this reproduces stereotypes, while a third filmmaker acknowledged that her own internalized stereotypes shaped her script writing, which she had to revise continuously. These different and contradictory positions illustrate the diversity of approaches that minority women filmmakers have taken in the face of the politics of funding.

I Am My Mother's Daughter and *Everything Will Be Fine* serve as examples for the relationship between complex but symptomatic funding parameters and the films' narratives, since they reflect and move beyond these parameters. To account for the situatedness of minority women filmmakers in Germany as well as the implications for scholarship in the United States, I sketch out the contemporary film landscape in Germany, taking into account broader cultural and political forces that shape the production and the circulation of cinematic images.

Funding and Minority Cinema: *I Am My Mother's Daughter* and *Everything Will Be Fine*

Derin's *I Am My Mother's Daughter* was her final project for the Munich Film and Television School (Hochschule für Film und Fernsehen). She had been offered a special fellowship by the school for a project that involved three generations of Turkish women. In an interview with Henriette Löwisch, Derin describes how the funding prescribed the film's content:

> It came about quite by coincidence; my film school [HFF, Hochschule für Film und Fernsehen, H.L.] cooperates with a school in Turkey; exchange projects exist on the theme "three generations of women." A daughter born in Turkey and growing up in Germany, a mother who came to Germany as a guest-worker, a grandmother who never left Turkey—those were the conditions, and I fulfilled them (Löwisch 130).

The funding conditions determined the parameters of the film's narrative and imposed a biographical framework. The grant takes on a paradoxical function: on the one hand, it enables a productive engagement with the female history of migration from Turkey to Germany, while on the other hand, it ties the identity of the filmmaker to the film's prescribed content, making the grant a site where different forms of discrimination intersect. There are few women and even fewer minority women who attend film school; in Derin's year, four out of thirteen students were women (Löwisch 131). The specific parameters of the funding reduce the artistic choice of the filmmaker, and consequently those of the other students as well. The important topics of female migration and Turkishness are reduced by the essentializing funding parameters to one autobiographical account.

Everything Will Be Fine, co-written by El-Tayeb and Maccarone, is directed by Maccarone. Maccarone's writing credits also include *An Angel's Revenge* (*Ein Engel schlägt zurück,* 1997), *Alles wegen Robert de Niro* (It's All Robert De Niro's Fault, 1996) and *Kommt Mausi raus?!* (Is Mausi Coming Out?!, 1994), for which she was also assistant director. In the early 1990s, Maccarone won a competition entitled "Step by Step towards a Script" (*Schritt für Schritt zum Script*) with a treatment of her first film *Kommt Mausi raus?!,* a story of a young woman who moves from the countryside to Hamburg and decides to return home to come out as a lesbian. Part of the competition's first prize was the participation in a scriptwriting seminar of the television and radio station of Northern Germany NDR (Norddeutscher Rundfunk). The resulting script, *Kommt Mausi raus?!,* was subsequently screened in the

public station's ARD series *Wilde Herzen* (Wild Hearts), a series created to lure viewers away from the competition of the private television stations. Following the success of *Kommt Mausi raus?!, Everything Will Be Fine* was also produced through NDR for *Wilde Herzen*. El-Tayeb and Maccarone received funding for the script (*Drehbuchförderung*) from the state of Schleswig-Holstein before the film went into production. While producing for television provided them with access to funding, legal arrangements between the television stations and music production companies left them without distribution rights for their film, which has effectively disabled national and international distribution of the film.[3] The city of Hamburg is predetermined as location by the funding from the NDR, while the partial funding for the script from Schleswig-Holstein necessitates that at least one character is from Schleswig-Holstein.[4]

Both films have been shown at film festivals in Germany and abroad. *I Am My Mother's Daughter* premiered at the Berlin Film Festival in 1996 and won second prize at the Munich documentary film festival the same year. It was also shown abroad, in the United States and in Turkey. *Everything Will Be Fine* screened at gay and lesbian film festivals in Europe, South Africa, the United States, and Canada. The diminishing numbers of art house movie theaters (*Programmkinos*) in Germany and the decrease in distribution for independent films have increased the significance of film festivals nationally and internationally, which, however, address specialized audiences such as professional critics and members of the film industry. Film festivals organized around themes of identity, such as gay and lesbian film festivals or Jewish film festivals, address specific interest groups. Thus, the existence of several international gay and lesbian film festivals provided *Everything Will Be Fine* with an international exposure that other German films by minority women generally do not receive.[5]

The very fact that Derin's *I Am My Mother's Daughter* and El-Tayeb and Maccarone's *Everything Will Be Fine* were produced in the late 1990s and have not found professional distributors beyond the Munich Film and Television School and German television poses theoretical and practical challenges for scholarship, especially scholarship abroad.[6] With the increasing lack of distribution, more and more academics in the United States work on fewer and fewer films, and canonization of films easily available abroad reflects market forces. Academics thus become implicated in the political economy that shapes the production, distribution, and circulation of films.

From a State-Funded to a Market-Driven Cinema

The specific context for funding and the lack of distribution for *I Am My Mother's Daughter* and *Everything Will Be Fine* illustrate how identity politics intersect with traditional forms of gender, racial, ethnic, and sexual discrimination. The reliance on funding by television stations and specified fellowships is also a result of larger changes from federal funding in West and East Germany to market-driven production investments in unified Germany.[7] As Julia Knight explains in her book *Women and the New German Cinema,* significant federal funding allowed New German Cinema to flourish in the 1970s and early 1980s, which also created a generation of feminist filmmakers. Claudia von Alemann, Jutta Brückner, Valie Export, Jeanine Meerapfel, Elfie Mikesch, Ulrike Ottinger, Helga Reidemeister, Marianne Rosenbaum, Helke Sander, Helma Sanders-Brahms, Ula Stöckl, and Margarethe von Trotta were born between 1937 and 1944 and emerged as directors between the late 1960s and the early 1980s. Yet, when the Free Democratic Party (FDP) switched from their coalition with the Social-Democratic Party (SPD) to a coalition with the conservative Christian Democratic Union (CDU/CSU) in 1982, a conservative government restructured and ultimately limited public funding for film production. As a result, West German feminist film culture developed into two broad tendencies defined by Knight as "totally devoid of feminist polemic" and as "post-feminist" (154).

Based on the changed funding system and motivated by the box-office success of Doris Dörrie's comedy *Men* (*Männer*) in 1985, German filmmakers of the 1980s and 1990s began increasingly to rely on market forces. The women filmmakers who had been part of the generation of New German Cinema moved into academic positions, became engaged in multi-year attempts to secure funding for larger projects, or continued making films. This generation of feminist filmmakers has not been replaced by a new "generation" of women filmmakers defined by equally cohesive concerns, aesthetics, politics, and age. The contemporary German film landscape is diversified and heterogeneous. While Dörrie is often cast as the token woman of post-New German Cinema, post-feminist filmmakers such as Caroline Link and Katja von Garnier have garnered international commercial success.[8] More recently, the following queer avantgarde and experimental filmmakers have produced shorts and animation: Claudia Schillinger, Ursula Pürrer, Nathalie Percillier and Lily Besilly, Heidi Kull, Ulrike Zimmerman, Stefanie Jordan, Claudia Zoller, and Bärbel Neubauer. These women filmmakers share many of the same obstacles faced by male avantgarde and

experimental filmmakers; their works are shown only at film festivals and have little or no distribution, as Alice Kuzniar has documented in her recent study *The Queer German Cinema*. The funding and distribution of these films stands in sharp contrast to the international successes of *Run Lola Run* and *Aimee and Jaguar* in the late 1990s.

Post-Feminist Heroines

Images of strong and independent women proliferate in post-feminist culture, successfully appropriated by male mainstream directors.[9] With the proliferation of strong female figures in popular culture, feminists have lost the sole claim to these images and consequently the claim to the production of these images. The two nationally and internationally most successful German films of the late 1990s center on strong female characters: Tom Tykwer's *Run Lola Run* (*Lola rennt,* 1998) and Max Fäberböck's *Aimee and Jaguar* (*Aimee und Jaguar,* 1998). An international success, Tykwer's *Run Lola Run* shows its female heroine Lola in control of her own body, beyond traditional beauty aesthetics, inhabiting the city, and more capable than her male counterpart, Manni, of resolving dangerous situations. Ingeborg Majer O'Sickey, in a forthcoming essay, argues, however, that the film's final sequence subordinates Lola to Manni. This might not be the only indicator of the appropriation that organizes the film: Lola's striking red hair, her clothes, the way she moves through the city, and her apartment are reminiscent of punk at a time when punk is dead. The film's main musical reference, however, is techno, in which control is exercised by the DJ instead of the musician. Techno relies on a practice of borrowing and recycling of traditions and conventions; however, the style that emerges is also characterized by a newness of the recycled materials, not only in regard to music but also in regard to clothing, which differentiates punk from techno. In *Run Lola Run,* the remnants of punk in Lola's clothes and apartment are not marked as new but as old and run-down, providing signifiers of punk as an anti-establishment practice without its anti-establishment politics. Tykwer received his funding of three million German marks for *Run Lola Run* from the production firm X-Filme Creative Pool, which was founded in 1994. A group of three young German filmmakers—Wolfgang Becker, Dani Levy, and Tom Tykwer—and film economist Stefan Arndt successfully created a new form of integrating funding and film production. The fact that the group consists only of men is indicative of the ways in which networks are established that benefit men without explicitly discriminating against women.

Max Fäberböck's *Aimee and Jaguar* tells the real-life love story of a lesbian member of the Jewish underground, Felice Schragenheim, and a German Hausfrau, Lilly Wust, during the last years of World War II. It received the Silver Bear at the 1999 Berlin Film Festival for its main actresses Juliane Köhler and Maria Schrader, had a short run in United States movie houses, and is now distributed internationally on video. Fäberböck's melodrama is based on Erica Fischer's book account *Aimee & Jaguar: A Love Story, Berlin 1943* (*Aimee & Jaguar: Eine Liebesgeschichte, Berlin 1943*, 1994); a lesser-known documentary, Catrine Clay's *Love Story* (1997), also exists. Both portray the historical events with an emphasis on lesbian desire and Jewish survival. Fäberböck's melodrama recreates the story of lesbian love and Jewish underground but frames it with references to the new German nation and the relationship of German guilt to the memory of the Holocaust.

The international success of these films indicates that the late 1990s saw an important shift in the treatment of feminism, lesbianism, and urban subculture, from being solely defined by alternative and feminist discourse of independent cinema to mainstream, big-budget productions, directed and produced by men. The appropriation and commodification of feminist topics in films represent one important factor for the context of a discussion of minority women's films of the late 1990s. The other important factor can be found in the redefinition of German national cinema by a new generation of migrants.

The New German Cinema Is Turkish? All Minorities Are Turks, and All the Turks Are Male?[10]

Tunçay Kulaoglu's question "The New German Cinema is Turkish?" (Das neue deutsche Kino ist Türkisch?) indicates the significance of the wave of Turkish-German cinema in the late 1990s (8). The new generation of minority filmmakers and their use of popular genres created a critical change for representations of minorities in Germany, identified by Deniz Göktürk as a move away from the "cinema of duty," the description of silent and suffering guestworkers, to "the pleasures of hybridity," denoting playful and self-confident representation by minority filmmakers themselves (1). While her seminal essay explicates an undeniable and significant shift in the representation of minorities in Germany, my analysis also complicates Göktürk's account of a linear development, since performing the pleasures of hybridity might just have become the new duty.

The success of filmmakers Thomas Arslan, Yüksel Yavez, Fatih Akin, and Kutlug Ataman has contributed to defining contemporary

minority cinema in Germany as Turkish and male. The directors, in turn, are typecast for "Turkish-German" topics.[11] Arslan's *Brothers and Sisters* (*Geschwister-Kardesler,* 1995) and *Dealer* (1998), Fatih Akin's *Short Sharp Shock* (*Kurz und Schmerzlos,* 1998), Yüksel Yavus's *April Children* (*Aprilkinder,* 1998), and Kutlug Ataman's *Lola and Billy the Kid* (*Lola und Bilidikid,* 1999) center on male characters, the majority of whom live a life of illegality in "the ghetto" where there are few roles for women, who are typically cast as sisters, wives, and prostitutes.[14] The feuilleton reception of this cinematic trend limits the understanding of minority film in Germany to Turkish-German, and Turkish-German, in turn, to male. The fact that Derin was the assistant director for Akin's *Short Sharp Shock* before she could secure funding for her own second feature illustrates how quickly male directors are awarded public success and subsequent funding in contrast to women filmmakers.

Dreaming beyond Funding: *I Am My Mother's Daughter*

I Am My Mother's Daughter reflects the autobiographical charge of the funding; Derin is filmmaker, narrator, and main character. The film therefore fulfills the grant's requirements, but, as will be seen in the following, also exceeds them. The narrative of the film is a self-reflexive meditation about Derin and her family. Through interviews, voice-over narrative, and the use of photos and letters, the film shows Derin and her family in Germany and Derin and her mother on a trip to Turkey, where Derin interviews her mother, grandmother, aunt, and friends.[13]

The film opens with a shot of ocean waves, framing the film's narrative in a poetic realm that exceeds realist representation. The opening scene subverts the geographically specific parameters prescribed by the funding and the notion of borders delineating national identity that underlie the grant. Ocean connotes movement and migration, the overcoming of geographical borders. Thus, the very opening shot points beyond the realist sociological and (auto)-biographical representation of traditional documentary conventions. The shots of the ocean are intercut with close-ups of a page of Derin's mother's passport, which includes a photo of her and her small children. A brief close-up of the photo itself shows Derin's mother with her four small daughters, each of their faces crossed out, presumably by border officials. The passport and the photo show several stamps by immigration officers, emphasizing the role of visuality in the administration and surveillance of national borders and of the bodies crossing them. The opening montage juxtaposes the ocean, a natural state that exceeds signification, with the passport, an

overdetermined signifier. The third shot dialectically resolves the established opposition: Derin's young niece looks at family photos, trying to decipher them, talking to Derin about them, and being frustrated at her inability to read a letter in Turkish addressed to Derin's father, which Derin then begins to read in a voice-over.

The dialectical conclusion suggests that images are a site where a struggle to decipher meaning takes place but that images are neither indeterminable and radically open to reading, nor overdetermined in their meaning. The film opens with the process of reading the traces of individual history by Derin and her young niece, thus exceeding the requirement to portray three generations. This undermines the symmetry that is implied in the suggestion of three female generations, which relies on the assumption that the process of migration is complete once individuals settle in a different country. The film expands notions of social reality by emphasizing the sociological and psychic dimensions of migration.

I Am My Mother's Daughter includes traditional ethnographic shots of Turkish landscapes, talking-head interviews with Derin's mother and siblings, friends and female relatives, and cinema verite footage of Derin and her mother on a trip to Turkey. After the opening sequence, Derin's voice-over begins to read a letter in German to her father. The letter includes some pertinent information about the family story: the father came to Germany first, the mother followed with the children, Derin's father broke his back at work, Derin and her sisters ran away during adolescence, and one of Derin's sisters married a German Christian. All the letters, which are written in Turkish and German from Seyhan to her father, mother, and grandmother, and from her father to Seyhan and her sister Bilhan, are read in voice-over by Derin and her father, respectively. The two letters from her father allow another voice to be heard. The multiple voice-overs contrast with the conventions of traditional documentaries, which employ ethnographic images and the commentary of one omniscient voice-over. *I Am My Mother's Daughter* is characterized by a dialogic structure between the several members of Derin's extended family. Meaning emerges from multiple positions instead of being imposed by one voice, as in traditional documentaries.

Dream sequences in which a young girl is trapped alone in an old-fashioned train compartment are repeatedly interjected into the narrative. We are to assume that this character re-enacts the alter ego of the filmmaker as a young girl. In the last sequence, the girl sees another little girl standing in a field and waves at her, which provides closure for the film. The film is marked by the repetition of this dream episode, which provides visual consistency and familiarity but no narrative logic. The

dream sequences are interspersed in the opening sequence, in the later account of the teenaged daughters running away from their parents, in an interview Seyhan conducts with her mother about being a filmmaker, in the mother's account of her own love and life story, and in the final scene.

These dream scenes in black and white possess a grainy quality, which creates images with soft contours, reflecting the indeterminacy and vagueness of memory. The first of these repeated dream scenes is intercut with documentary footage of Turkish men being examined by the German Department of Labor in Turkey, illustrating the evaluation and quantification of a labor force and providing an integral part of the history of Turkish migration to Germany. Later Turkish guestworkers are shown arriving in Germany and being greeted by a welcome committee with a television as a prize for their arrival. Thus, the film's montage technique creates an intertext between images that represent the German public's understanding of an official and generous welcome of guestworkers and the aesthetic and phantasmatic dimension of social reality through the dream sequence. Both the dream scene and the documentary footage consist of movement from Turkey to Germany, contrasting male with female, adult with child, and realism with fantasy. This movement from Turkey to Germany contrasts with the narrative movement of Derin's and her mother's journey from Germany to Turkey.

During the film's final sequence, which again shows the dream sequence, we see the filmmaker Derin setting up the equipment to film the young actress and discussing the scene with her. Derin says to the little girl "dream image"; the little girl repeats her words, "dream image," and then giggles. The acting of the role of the little girl is foregrounded, which undermines assumptions that documentary film relies on authentic subjects and points to the constructedness of this scene and, by extension, of the whole film. While the subject of the film, Derin, is doubled by the representation of her alter ego as a little girl, she is also doubled as the subject and the director of the film. This last scene in particular exposes the double function of Derin in front of and behind the camera.

The film tells the story of the Turkish migration to Germany from a female, multi-generational perspective as it was specified in the production grant. It also reflects, however, on the nature of documentary as a vehicle of supposed truth-telling by using the dream sequence to address the fictional, phantasmatic, and psychological dimension of the story of migration that cannot be contained in the traditional documentary genre. The little girl's difficulty in distinguishing and determining

her fate, as well as our—the spectators'—difficulty in positioning the scenes in a temporal and geographical certainty bespeak the ambiguity of memory that is evoked by this narrative of migration. The incorporation of the dream sequence allows the film to move beyond the limitation imposed by the film's funding. Paradoxically, the emphasis on movement both fulfills and moves beyond the parameters of the grant.

Sex in the City: Urban Movement in *Everything Will Be Fine*

Everything Will Be Fine, a screwball comedy, employs a distinctly different genre than *I Am My Mother's Daughter* but shares the productive interplay between funding and an emphasis on movement. In keeping with the genre conventions, the movement of *Everything Will Be Fine* is not between nations but within a city. Fast narratives situated in urban environments characterize the conventions of screwball comedies, in which two main characters, traditionally a heterosexual couple, face several hindrances before they come together in a happy ending. The genre often shows comedic, self-confident, and independent female characters. *Everything Will Be Fine* and *I Am My Mother's Daughter* rely on well-known genres but also rework traditional genre conventions. The two genres, documentary and screwball comedy, suggest a mapping onto Gökürk's categories of "cinema of duty" and "pleasures of hybridity," yet also complicate that history of ethnic representation in Germany, since both films were made in the late 1990s. *I Am My Mother's Daughter* fulfills the clearly circumscribed duty inscribed in the funding to investigate migration not only for Germany but also for Turkey. The question of duty versus pleasure is more complex and ambivalent in regard to *Everything Will Be Fine.* Since this was a film made for *Wild Hearts,* intended to lure audiences away from private television stations, the duties and functions of minority representation might also be shifting to include a performance of pleasure of hybridity for the mainstream.

In *Everything Will Be Fine,* the main character, the Afro-German Nabou, is dumped by her white German girlfriend Katja. In an attempt to win her back, Nabou takes a cleaning job in Katja's building. Nabou is employed by Kim, a successful Afro-German who works in an advertising agency but whose domestic life is chaotic. Romantically involved with her boss Dieter Lauer, Kim dreams of making partner in the advertising company, while he is considering marrying her. Several subplots concern Kim's African friend Kofi and his son Kwame, Kim's racist co-workers, and Nabou's roommate Guiseppa, "an agent in matters of love." After trials and tribulations, which include Nabou's

attempts to regain Katja's attention, Kim and Nabou fall in love in the happy end of the film, a comedic grand finale in the Hamburg harbor.

Everything Will Be Fine eroticizes movement from its very outset. The anonymity of the urban environment not only allows ethnic and sexual minorities to express their identity, it also enables sexual and chance encounters. When Nabou finds Kim's passport, she can see that Kim's original name was Erika, and that she reinvented herself when she moved to the city from the country by taking on an Americanized, and therefore more hip name. The film maps relationships onto vertical and horizontal movements and geography. When Nabou takes the cleaning job with Kim one floor beneath Katja, this offers several comedic and satirical views of domesticity, traditionally associated with the woman's film. Female voyeurism is evoked when Nabou sneaks up the fire ladder or plays music via the bathroom pipes when Katja has found a new love. The staircase—the space of movement up and down—becomes a contact zone for accidental, intentional, attempted, and frustrated encounters. The staircase is also doubled, since the house has one internal and one external staircase.

The film engages with the public sphere through its emphasis on the representation of the public space of the city. In pursuit of Katja, Nabou rides through the city on her bike, which she fetishizes and decorates with fake red fur. When Nabou on her bike crashes into a car and is yelled at—"We're not in Africa" ("Wir sind doch hier nicht in Afrika")—the right to inhabit the city's public space is turned into a question of national and racial identity. Thus the insistence of the film on showing Nabou in the public sphere reiterates its insistence on the presence of Afro-Germans in Germany. In his essay "Das Integrationspotential von Städten" (The Potential of Cities for Integration), Werner Schiffauer argues that young migrants and minorities identify with the city more than with the nation they live in (15). As do other European multicultural comedies of the 1990s, such as Mathieu Kassovitz's *Café au Lait* (1993) and the recent "ghetto films," such as Fatih Akin's *Short Sharp Shock*, *Everything Will Be Fine* negotiates the space of the city both as a stand-in for, as well as an alternative to the nation.

Everything Will Be Fine insists on the presence of different minorities in Germany, including Afro-Germans, Italo-Germans, and Africans, as well as different individual identities of Afro-Germans. The film insists on offering differentiated images of Black Germans while commenting on larger issues of the African diaspora, thus interweaving local and global concerns. Crucial to the negotiation of this encounter of the local and the global is the space of the harbor, which provides the backdrop for important scenes throughout the film and for the highpoint of the

film. The harbor characterizes Hamburg, but it also connects the city to the world beyond and links the characters to an African diaspora. Throughout the narrative, we see Kim and Kofi doing Tai Chi in the harbor and conversing about leaving or staying in Germany. In the film's final scene, all the different characters meet in the harbor at an office party on a boat, and all misunderstandings are finally resolved in a happy end. Kim expects her boss to offer her a partnership in the advertising film. When he instead proposes to her, Kim and Nabou jump off the boat and swim to a buoy. They kiss in the water, say to each other in Swahili *"hakuna matata"* ("everything will be fine"), and suddenly realize that they both know Swahili. Swahili is the language of choice for African diasporic people who grew up with no African language, since it is the only language proposed by Africans as a pan-African language, one that would replace any colonial language.[14] Throughout the film, Afro-Germans have been repeatedly confronted with a racist attitude of surprise by white Germans regarding the characters' mastery of the German language.[15] The ending shows the cultural productivity of African diaspora while insisting on the Germanness of Afro-Germans.

The ending thus explicitly exceeds the geographical limitation of the urban space of Hamburg and moves linguistically beyond German, invoking the African diaspora. Since the phrase, in translation, also provides the film's title, the film situates itself as claiming the specific German version of an African diaspora. Ironically, many viewers understand *"hakuna matata,"* because the term has proliferated since Walt Disney's animated 1994 film *The Lion King*. While *The Lion King* appropriates, commodifies, and simplifies the diversity of African cultures, it also succeeded in "owning" the rights to the Swahili phrase, since the screenwriters El-Tayeb and Maccarone gave up their originally intended title *Hakuna Matata* in favor of *Everything Will Be Fine* for fear of being sued by the Disney coorporation.[16] While a reading of the final scene as an African diasporic rewriting and reappropriation of the Disney-fied phrase might thus be historically inaccurate, it nevertheless is an unintended effect of intertextuality that points to the ongoing negotiation over cultural meaning.

Conclusion: Endings and Beginnings

The ending of *Everything Will Be Fine* connects to the beginning of *I Am My Mother's Daughter* through the images of the ocean, which expand the realist demarcations of identity and geo-political accounts of nationhood and evoke a larger diaspora in aesthetic utopian moments. Thus, both films reflect their funding structures, but more importantly,

also exceed them. They not only exceed the local funding through global movement, but also by complicating implicitly and explicitly predetermined demarcations of identity and genre. *I Am My Mother's Daughter* redefines the traditional genre of documentary about migration and *Everything Will Be Fine* reinvents the image of the German city. Both films map narratives of gendered German minority identities onto the spatial politics of urbanity and transnationality. Both offer shots of passports to emphasize national belonging and narratives of movement that emphasize and exceed the demarcated national borders. In that process, they are dependent on production funding, but they also integrate and rework the ambivalence of funding, which includes both possibilities and limitations.

Notes

I thank Fatima El-Tayeb for her engagement with the questions I raise in this essay, especially her reading of an earlier version of the paper, which I presented at the Women in German annual conference in the fall of 2000. I am also thankful for the continued generosity that Mine Eren extended to me by sharing her unpublished manuscript "Traveling Pictures from a Turkish Daughter: Seyhan Derin's *Ben annemin kiziyim—I Am My Mother's Daughter*," inviting me to moderate a panel on Turkish-German women filmmakers at her film festival "Women Behind the Camera: Contemporary Filmmakers in Multicultural Germany," and sharing resources and information about filmmakers and distributors. I also benefited from ongoing discussions with Amy Ongiri about minority cinema and Sandra Shattuck's helpful reading of the final version of this essay. Both Amy Ongiri and Sandra Shattuck shared their knowledge of Swahili with me. I also appreciate feedback from Birgit Tautz, who included the unpublished version of this essay in her German Women's Cinema Course.

[1] For examples of German film studies in the United States that analyze female spectatorship with a socio-historical approach, see Carter; Fehrenbach; Petro. For two important dissertations written in the late 1990s that focused on female spectatorship in postwar West Germany, see Baer and Caprio.

[2] The film festival "Women Behind the Camera: Contemporary Filmmakers in Multicultural Germany" was organized by Mine Eren for the Department of German at Wellesley College, 7–10 March 2002. I was moderating a panel and had asked the filmmakers on the panel whether they thought that the definition of German cinema in Germany had changed to

include films by minority women. In order to protect the identity of the filmmakers who provided the individual answers, I have not identified the different participants of the discussion to which I am referring here. The following filmmakers attended the film festival: Angeliki Antoniou, Wanjiru Kinyanjui, Branwen Okpako, Seyhan Derin, and Ayse Polat. In the context of this essay, it is of interest that the films screened by Wanjiru Kinyanjui and Branwen Okpako were funded by the Deutsche Film- und Fernsehakademie Berlin (dffb), while Angeliki Antoniou's films were also financed through television.

[3] Here a comparison between the contemporary funding of minority cinema through television in Germany and the United States and the function of the funding of Channel Four in Britain in the 1980s is in order. In the 1980s Channel Four's funding decisions virtually created the emergence of minority cinema in Britain. Films were produced for television and then distributed worldwide through international distribution companies, such as Third World News Reel and Women Make Movies. The careers of filmmakers such as Isaac Julien, Ngoze Onwurah, and Pratibha Pharmar were established through Channel Four. In the United States, contemporary independent filmmakers of color, such as Cheryl Dunye, are now being funded by HBO, since they have not been able to receive funding through film producers, but have thereby cut themselves off from distribution, which is comparable with the situation of *Everything Will Be Fine* by Maccarone and El-Tayeb. Ironically, *Everything Will Be Fine* has been seen by a wider audience in German Studies in the United States because El-Tayeb is an academic and can therefore afford to travel with the film individually, while Maccarone, a filmmaker, is not able to tour extensively with the film because of pressures to secure funding for her other projects.

[4] Hagener refers to the "genre of the subsidized road movie" ("das Genre des Förderungs-Roadmovies") when film narratives have to account for subsidies from different locations, specifically Hamburg or Berlin, because film subventions are part of the *Länder* (the individual states, and Hamburg and Berlin are city-states). His article claims that the films of Fatih Akin and Yüksel Yavuz shifted the cinematic image of Hamburg but that funding in general addresses different kinds of audiences and therefore creates a heterogeneous image of the city. Fricke advanced a similar argument about Berlin films at the Berlin film festival in 2000.

[5] One of the few exceptions is the film festival organized by Mine Eren, "Women Behind the Camera," Wellesley College, March 2002.

[6] Television stations and German film schools function in effect as distributors of films for educational settings without charging a fee. However, they lack the public relations material that leads to distribution of the films to a general public, for example, through video stores.

[7] As a result, several essays deal with questions about funding, production, and distribution in a recent representative collection on film from the 1990s. See X-Filme Creative Pool; Hofer; Hofmann; Weber and Schaumann.

[8] Caroline Link's films *Nowhere in Africa* (*Nirgendwo in Afrika*, 2001), *Annaluise & Anton* (*Pünktchen und Anton*, 1999), and *Beyond Silence* (*Jenseits der Stille*, 1993) and Katja von Garnier's *Bandits* (*Bandits*, 1997) and *Making Up!* (*Abgeschminkt*, 1993) are distributed internationally.

[9] The term "post-feminism" accounts for the cultural, political, and theoretical discourse of members of the generation after feminism, whose work relies on the assumption that feminism fulfilled its political agenda. Often post-feminist work recycles feminist topics by resignifying it in non-feminist terms. The German press discusses post-feminism only in relationship to American and French culture and theory. See Niroumand; Stolz; Westphal.

[10] The implied reference here is to the foundational text of Black feminism in the United States: *All the Women Are White, All the Blacks Are Men, But Some of Us Are Brave: Black Women's Studies*. This structure defines femininity as white and men as representative for minority groups, which obscures the existence of women of color. This structure is reproduced in different national, cultural, and historical contexts. For a discussion of the representation of silent men as stand-ins for an assumed backward Turkishness and the emphasis of German Studies on Turkish female writers as Westernized and liberated, see Adelson.

[11] For a discussion of this phenomenon and his strategies to undermine this typecasting by radically changing the aesthetics and genre of his second feature-length film, see the interview with Fatih Akin in Hatice Ayten's documentary *Wie Zucker im Tee* (Germany, 2001).

[12] I offer a more extensive discussion of this in my unpublished essay "Bruce Lee in Kreuzberg and Scarface in Altona: Transnational *Auteurism* and Ghettocentrism in Thomas Arslan's *Brothers and Sisters* and Fatih Akin's *Short Sharp Shock*," a companion piece to this essay. Jacquie Jones coined the term "ghetto aesthetics," referring to the emergence of young, urban, Black cinema in the United States. Ed Guerrero offers a socio-economic explanation of the emergence of what he labels the "ghettocentric film." For references in the German feuilleton to both ghettocentric ghetto aesthetics and international *auteurs* in Akin's films, see feuilleton essays by Buß and Distelmeyer.

[13] No published critical work is available on the film. Mine Eren kindly shared her forthcoming manuscript with me.

[14] Swahili originated on the east coast of Africa. It was taken up as a pan-African language at the end of the colonial period. I thank Amy Ongiri

and Sandra Shattuck for pointing out the symbolic significance of Swahili for the African diaspora.

[15] Essays in the first collection of Afro-German women, *Showing Our Colors,* provide repeated references to white Germans expressing disbelief that Afro-Germans are actually German and can speak German. See Emde; Baum; Wiedenroth; Berger.

[16] Phone conversation with Fatima El-Tayeb, 4 May 2002.

Works Cited

Adelson, Leslie. "The Price of Feminism: Of Women and Turks," *Gender and Germanness: Cultural Productions of Nation.* Ed. Patricia Herminghouse and Magda Mueller. Providence: Berghahn Books, 1997. 305–19.

All the Women Are White, All the Blacks Are Men, But Some of Us Are Brave: Black Women's Studies. Ed. Gloria T. Hull, Patricia Bell Scott, and Barbara Smith. Old Westbury, NY: The Feminist Press, 1981.

Baer, Hester Delacey. "Gender, Spectatorship, and Visual Culture in West Germany, 1946–1962." Diss. Washington U, 2000.

Baum, Laura, Katharina Oguntoye, and May Opitz. "Three Afro-German Women in Conversation with Dagmar Schultz: The First Exchange for This Book." *Showing Our Colors.* 145–64.

Berger, Julia. "I Do the Same Things That Others Do." *Showing Our Colors.* 196–98.

Buß, Christian. "Kulturtransfer in der Hood." *die tageszeitung* 15 Oct. 1998: 15.

———. "Monstren mit Gefühl: Ursache und Wirkung: Im Abaton läuft *Kurz und schmerzlos* mit Fatih Akin's Lieblingsfilm *Scarface.*" *die tageszeitung* 18 Feb. 1999: II.

Caprio, Temby Mary. "Women's Film Culture in the Federal Republic of Germany: Female Spectators, Politics and Pleasure from the Fifties to the Nineties." Diss. U of Chicago, 1999.

———. "Scorsese aus Altona." *die tageszeitung* 10 Feb. 1998: 19.

Carter, Erica. *How German Is She? Postwar West German Reconstruction and the Consuming Woman.* Ann Arbor: U of Michigan P, 1997.

Claussen, Jakob, and Thomas Wöbke. "Wovon träumt ein Produzent?" *Szenenwechsel.* 58–69.

Distelmeyer, Jan. "Mit dröhnendem Unkraut auf zur Mannwerdung: Vom amerikanischen Kino sozialisiert zieht Fatih Akin aus zum großen Publikum: 'Getürkt.'" *die tageszeitung-Hamburg* 6 Aug. 1997: 23.

El-Tayeb, Fatima, and Angelina Maccarone. *Alles wird gut: Das Film-Buch.* Berlin: Orlanda Frauenverlag, 1999.

Emde, Helga. "An 'Occupation Baby' in Postwar Germany." *Showing Our Colors*. 101-12.

Eren, Mine. "Traveling Pictures from a Turkish Daughter: Seyhan Derin's *Ben annemin kiziyim—I Am My Mother's Daughter*." Forthcoming in *Moving Images/Migrating Identities*. Ed. Eva Rueschmann. Jackson: U of Mississipi P, 2003.

Fehrenbach, Heide. *Cinema in Democratizing Germany: Reconstructing National Identity after Hitler*. Chapel Hill: U of North Carolina P, 1995.

Fenner, Angelica. "Turkish Cinema in the New Europe: Visualizing Ethnic Conflict in Sinan Cetin's *Berlin in Berlin*." Special Issue: Marginality and Alterity in New European Cinemas, Part 1. Ed. Randall Halle and Sharon Willis. *Camera Obscura* 15.2 (2000): 105-48.

Fischer, Erica. *Aimee & Jaguar: Eine Liebesgeschichte, Berlin 1943*. Köln: Kiepenheuer & Witsch. 1994.

Fricke, Harald. "Rotester Teppich aller Zeiten." *die tageszeitung-Berlin* 18 Feb. 1999: 29.

Göktürk, Deniz. "Turkish Delight—German Fright: Migrant Identities in Transnational Cinema." *Transnational Communities: Working Paper Series* 99-01. University of Oxford: 1-14.

Guerrero, Ed. *Framing Blackness: The African-American Image in Film*. Philadelphia: Temple UP, 1993.

Hagener, Malte. "Schönwetter und Strassendreck." *die tageszeitung-Hamburg* 31 Dec. 1998: 27.

Hofer, Arthur. "Geld ist da: Babelsberg Independents." *Szenenwechsel*. 81-87.

Hofmann, Nico. "Ein Regisseur wird Produzent." *Szenenwechsel*. 125-312.

Jones, Jacquie. "The New Ghetto Aesthetic." *Wide Angle* 13.3-4. (July-Oct. 1991): 32-43.

Knight, Julia. *Women and the New German Cinema*. London: Verso, 1992.

Kulaoglu, Tunçay. "Der neue 'deutsche' Film ist 'türkisch'? Eine neue Generation bringt Leben in die Filmlandschaft." *Filmforum* 16 (Feb.-Mar. 1999): 8-11.

Kuzniar, Alice A. *The Queer German Cinema*. Stanford: Stanford UP, 2000.

Löwisch, Henriette. "Interview with Seyhan Derin: *ben annemin kiziyim* (I Am My Mother's Daughter)." *Triangulated Visions: Women in Recent German Cinema*. Ed. Ingeborg Majer O'Sickey and Ingeborg von Zadow. Albany: State U of New York P, 1998. 129-35.

Mennel, Barbara. "Bruce Lee in Kreuzberg and Scarface in Altona: Transnational *Auteurism* and Ghettocentrism in Thomas Arslan's *Brothers and Sisters* and Fatih Akin's *Short Sharp Shock*." Unpublished Essay.

Mulvey, Laura. "Visual Pleasure and Narrative Cinema." *Feminism and Film Theory.* Ed. Constance Penley. New York: Routledge, 1988. 57–69.
Niroumand, Mariam. "Adieu meine Konkubine." *die tageszeitung* 15 Feb. 1994: 21.
O'Sickey, Ingeborg Majer. "Whatever Lola Wants, Lola Gets (Or Does She)? Time and Desire in Tom Tykwer's *Run Lola Run.*" Forthcoming in *Quarterly Review of Film and Television* 19.2 (2002).
Petro, Patrice. *Joyless Streets: Women and Melodramatic Representation in Weimar Germany.* Princeton: Princeton UP, 1989.
Rich, Ruby B. *Chick Flicks: Theories and Memories of the Feminist Film Movement.* Durham: Duke UP, 1998.
Schiffauer, Werner. "Das Integrationspotential von Städten." *Heimatkunst: Kulturelle Vielfalt in Deutschland.* Ed. Haus der Kulturen der Welt. Berlin: Promotion + Service, 2000. 15.
Showing Our Colors: Afro-German Women Speak Out. Ed. May Opitz (Ayim), Katharina Oguntoye, and Dagmar Schultz. Trans. Anne V. Adams. Amherst: U of Massachusetts P, 1992.
Stolz, Markus. "Abschied vom alten Feminismus." *Werben und Verkaufen* 18 Nov. 1994: 64.
Szenwechsel: Momentaufnahmen des jungen deutschen Films. Ed. Michael Töteberg. Reinbek bei Hamburg: Rowohlt, 1999.
Weber, Michael, and Thorsten Schaumann. "A New Chapter in German Film Making: Der Weltvertrieb 'German Independents.'" *Szenenwechsel.* 230–38.
Westphal, Anke. "Feminismus mit Nährwert." *die tageszeitung* 19 Sept. 1998: 10.
Wiedenroth, Ellen. "What Makes Me So Different in the Eyes of Others?" *Showing Our Colors.* 165–77.
X-Filme Creative Pool. "Eins, zwei, drei...x Filme." *Szenenwechsel.* 40–45.

Appendix

Filmography

Akin, Fatih. *Kurz und Schmerzlos.* (*Short Sharp Shock,* 1998).
Allers, Roger and Rob Minkoff. *The Lion King.* 1994.
Arslan, Thomas. *Geschwister—Kardesler.* (*Brothers and Sisters,* 1995).
Ataman, Kutlug. *Lola und Bilidikid.* (*Lola and Billy the Kid,* 1999).
———. *Dealer.* 1998.
Ayten, Hatice. *Wie Zucker im Tee.* 2001.

Becker, Wolfgang. *Das Leben ist eine Baustelle.* (*Life Is All You Get,* 1996).
Clay, Catherine. *Love Story.* 1997.
Derin, Seyhan. *Ben annemin kiziyim—Ich bin die Tochter meiner Mutter.* (*I Am My Mother's Daughter,* 1996).
Dörrie, Doris. *Männer.* (*Men,* 1985).
El-Tayeb, Fatima and Angelina Maccarone. *Alles wird gut.* (*Everything Will Be Fine,* 1997).
Fäberböck, Max. *Aimee und Jaguar.* (*Aimee and Jaguar,* 1999).
Kassovitz, Mathieu. *Café au Lait.* 1993.
Link, Caroline. *Nirgendwo in Afrika.* (*Nowhere in Africa,* 2001).
———. *Pünktchen und Anton.* (*Annaluise & Anton,* 1999).
———. *Jenseits der Stille.* (*Beyond Silence,* 1993).
Maccarone, Angelina. *Ein Engel schlägt zurück.* (*An Angel's Revenge,* 1997).
Scherer, Alexander. *Kommt Mausi raus?!.* 1994.
Tykwer, Tom. *Lola rennt.* (*Run Lola Run,* 1998).
———. *Winterschläfer.* (*Winter Sleepers,* 1997).
Von Garnier, Katja. *Bandits.* (*Bandits,* 1997).
———. *Abgeschminkt.* (*Makin Up!,* 1993).
Yavus, Yüksel. *Aprilkinder.* (*April Children,* 1998).

Eighteenth-Century Libertinism in a Time of Change: Representations of Catherine the Great

Ruth Dawson

During and soon after Catherine II's long reign in Russia, accounts of her in her native Germany often included gendered representations of her sexual behavior. Assessments in prayers, biographies, caricatures, and histories shifted from chaste and virtuous to adulterous and libertine. Meanwhile, interpretations of sexuality also changed. Extramarital sexuality among aristocrats and royals that long elicited no shock became a target of middle-class criticism, boosted by anti-royalist sentiments of the French Revolution and new middle-class notions of faithful womanhood. Two novels about Catherine written soon after her death, *Miranda* (1798) by Johann Friedrich Ernst Albrecht and *Der Günstling* (1808) by Caroline Auguste Fischer, navigate these shoals. (RD)

Representations of the sexual behavior of public figures draw on a richly textured assemblage of duties, pleasures, distastes, taboos, allusions, and metaphors, all variously inflected by powerful social factors such as gender, age, and class. In the eighteenth century the famous people whose sexuality was dissected in government documents, such as trial records or diplomatic accounts, in journalism, correspondence, and just plain gossip, were mostly at court,[1] and their inconstant, hedonistic, unsentimental, and even predatory sensuality was often classed as libertine. Much as that term was associated with men, and complex though it was for a woman to live the libertine life, some (allegedly) did, none perhaps more famously than the German princess who had taken the throne of Russia: Catherine the Great.

For geographical, political, and protonationalistic reasons (both Catherine and her royal husband Peter III, grandson of Peter the Great, grew up in Germany), Catherine's German contemporaries were fascinated with the tsarina. The German book and print markets circulated numerous graphic and textual images of her, including speedy

translations of accounts from other European languages. In such public representations, and augmented by more private ones, accounts of Catherine's marital and extramarital sexual behavior came into circulation in Germany. Within a few years of her death (1796) the stories were even recycled into two German novels: *Miranda, Königinn im Norden, Geliebte Pansalvins* (Miranda, Queen of the North, Beloved of Pansalvin, 1798) by Johann Friedrich Ernst Albrecht and *Der Günstling* (The Favorite, 1808) by Caroline Auguste Fischer. Because procreative (hetero)sexuality was an urgently advocated arena of action for rulers, discourse on the sexuality of rulers was legitimized. Furthermore, libertinism was considered and represented to be a widespread practice in the highest levels of society. At the same time, the emerging middle class was sharpening its critique of the all-powerful upper levels of society by attacking aristocratic immorality, especially sexual immorality. So although extramarital sexuality among aristocrats and royals elicited no shock or surprise (and *Miranda* is an instance of this accepting attitude), it was a frequent target of criticism, often with representations of predatory aristocratic men exploiting vulnerable and good middle-class young women. The French Revolution and its critique of royalty gave a powerful boost to these familiar moralistic attacks, while new middle-class notions of family intimacy and tender, faithful womanhood reinforced the condemnation of libertine aristocrats, including Catherine (evident, for example, in *Der Günstling*). Both positions, the accepting and the critical, ignited the public imagination surrounding Catherine II's sexuality during her lifetime, after her death, and until today.

Much as Catherine has served as a sexual Rohrschach blot, she is also a historical figure who ruled Russia for thirty-four years (1762–96). She conducted experiments in enlightened governing, including calling together an assembly of delegates to draw up a law code for Russia, establishing a system of schools, reforming the administration of the country, and alternately tolerating, encouraging, and censoring the expansion of publishing and the development of Russian intellectual life. Like most other rulers of her era, she failed to end serfdom. She significantly enlarged the boundaries of Russia at the expense of Poland, the Ottoman Empire, and the less organized central Asian region, and settled vast areas with new populations. Under her rule, Odessa and Sebastopol were founded and Russia became a power on the Black Sea. Her art collecting and book purchasing laid the foundation for several of Russia's impressive cultural institutions. And her lovers included several distinguished men.

In *Love as Passion,* Niklas Luhmann attempts an analysis of passionate love not as a human emotion, thus not in anthropological terms,

but as a codified medium of communication that developed among members of the seventeenth-century aristocracy, especially in France. Luhmann's claim is that this code was needed to distinguish the kind of relationship that occurred in extramarital affairs from the kind that occurred within marriage. In the seventeenth century, he believes, high-ranking women had obtained greater freedom and more rights than before and this development made it easier for an aristocratic man—married or not—to seek a sexual relationship with a married aristocratic woman. But to persuade her to participate, the lover needed a new discourse (created from a set of pre-existing elements that had developed in the Middle Ages and Renaissance) and, since the woman was already married to someone else, it had to be a discourse that sounded persuasive but did not promise marriage. This was the discourse of passion and intimacy. In the eighteenth century, matters changed somewhat when friendship developed as an alternative form of close personal relationship. As the logic of marriage choice changed during the century and as cultural hegemony shifted away from the aristocracy at the end of the century, there was a choice between grounding marriages in friendship or in passionate love. When passionate love won out, it had in turn to be significantly reinterpreted and redirected to accommodate its institutionalization in marriage. Passionate love shifted from being fleeting, extramarital, and aristocratic, to being eternal, marital, and bourgeois. The enormous change in valence of passionate love for the educated middle class, from an expected but disapproved option of the aristocracy to the foundation of marriage, is an important element in the shift in representations of Catherine from predominantly tolerant representations in the eighteenth century to numerous vilifications of her early in the nineteenth. (Two less ideological reasons for the shift were the simple facts of Catherine's death, bringing the end of her occasional but well-publicized gifts to authors and artists who pleased her, and the arrival on the Russian throne of Paul I, who bore no love for his mother and did nothing to protect her reputation.)

How was the unstable set of values and coded behaviors called "passionate love" invoked in representations of the most powerful woman in the eighteenth century? The sexuality of queens and crown princesses was politically always of public interest: without heterosexual activity on their part, dynasties changed branches or died off completely. With the Romanov dynasty at stake and given the German background of the Grand Duchess Catherine (and of Peter), it was logical that ritualized representations of her sexuality would receive widespread attention in the German-speaking world. Newspaper accounts, poems, and festivities celebrated Catherine performing the parts of virginal bride and faithful

wife, followed nine years later by more newspaper coverage and poetry honoring her at long last as mother of the heir. Accompanying this well-publicized and still preserved record of expectations fulfilled are traces of rumors about the years without progeny during which the Grand Duchess slowly slid into the dangerous position of barren woman. Once she finally did give birth to a son, rumors spread that Peter was not the father. Yet at the same time that Catherine was being depicted as an adulteress, she was also playing the wronged but patient legitimate wife with a semi-legitimate rival in the form of Peter's widely acknowledged mistress. In short, before she acted the role of libertine, the former minor German princess from insignificant Anhalt-Zerbst played through all the other key permutations of the sexual roles of eighteenth-century female royalty. Several texts illustrate the official and unofficial accounts, some showing the proper, conventional, discreet version of Catherine, but others showing traces of the improper, illicit, and indiscreet.

Wedding poetry of course tells the official story about the dynastic marriage. When Sophie Auguste of Anhalt-Zerbst changed religions, took a new name (Catherine Alexievna), and in 1745 at age fifteen married her sixteen-year-old cousin, the celebration in St. Petersburg was enormous. It was repeated on a tiny scale in Zerbst, where a local employee of the court wrote and published a short musical masque as part of the festivities. In this text, love and virtue speak about the fortunate couple. Love proclaims the following wish for the bride:

> May the chaste desire that enchants her breast,
> Enlarge itself from day to day,
> That she may bear many fruits of love! (Röllig 7).

Interest in reproductively successful marital sexuality did not exclude desire ("Brunst") but, for the woman, was limited by chastity ("keusche Brunst"). Even so, it is unmistakably Catherine's sexuality that is being publicly discussed in a text such as this.

Other kinds of celebratory texts continue the official account. In 1762, seven years after Catherine had given birth to Paul (whose birth was also celebrated in Germany with various publications, such as Appelgreen and Appelgreen or Richter), Peter at last came to the throne; one of the German prayers printed for the new tsar contained the hope that God would give Catherine more children (Bilbassoff 1: 14–15). This wish fits the official account of a functioning marital relationship between Peter and Catherine.

Six months into his reign, Catherine overthrew Peter. With that, the pleasant official image of a contented royal couple was irretrievably

overthrown as well. The manifesto explaining the causes of the coup included a new official account of the marriage, specifically mentioning Peter's failure to acknowledge Paul as legitimate heir, in addition to his dismaying conduct of military affairs and his moves against the Orthodox Church. In Germany, all of the early separate accounts of the coup printed in pamphlets and broadsheets and many, but not all, of the accounts in newspapers mention the allegations of Paul's illegitimacy and hence imply the accusation that Catherine had engaged in extramarital sexual behavior. Peter's repudiation of Catherine, disinheritance of Paul, and planned marriage with his mistress Vorontsova become lines in the mantra of justification for Catherine's coup. A German biography of Peter that was published immediately after his short reign and reprinted twice more the same year elaborated slightly:

> The main circumstance was probably that the emperor wanted to declare his prince to be illegitimate, divorce his consort, with whom he had never lived in perfect harmony, banish her with the prince to a convent or even have them killed, and marry the young Countess Vorontsova, a niece of the chancellor and daughter of the Senator Vorontsov (Will 38–39).

Peter III is seen here to have his own personal and political reasons for discrediting Catherine. He could use sexual allegations against her to divest himself of both her and her son, leaving him to acquire a new consort of his own choosing and theoretically also to have a new heir of his own fathering. But Peter may not have waited until he came to the throne to start attacking Catherine with the accusation of infidelity and the assertion that Paul was not his son.[2] A few months after the coup, a local print entrepreneur in a village not far from Erfurt published a history of Russia in which he commented that the infidelity accusation had circulated for years: "The false and bitter charges that Peter raised against his faithful spouse when she gave birth to the now still underage Grand Duke Paul Petrowitz are well known" (Hörschelmann 153).[3] Despite the fact that Friedrich Ludwig Anton Hörschelmann wrote this assertion from the provincial village of Grossrudestedt, in the Duchy of Saxe-Weimar, and not from a major city or even from a town with a princely residence, the rumors seem to have achieved wide dissemination.[4] Anna Luise Karsch's response to news of Catherine's coup against Peter may corroborate the long-standing circulation in Germany of sexual allegations against Catherine, for Karsch instantly described the new empress with allusions to Livia and Maria Stuart, two women emblematic of the imbrication of sexual voraciousness with women holding power (1: 138). Even if the rumor had not spread widely outside Russia

in 1754 when Paul was born, alert eighteenth-century readers could have detected it between the lines when Peter III became tsar in January 1762. The failure of Peter's accession manifesto to mention Paul as crown prince signaled the danger to both Paul and herself that Catherine successfully forestalled with her coup.

The rhetoric of illegitimacy and infidelity, however, did not conveniently disappear when Catherine no longer had the immediate problem of justifying her seizure of power. Two years later, for example, a work of classic eighteenth-century hybridity appeared; *Anecdotes russes, ou lettres d'un officier allemand à un gentilhomme livonien, écrites de Pétersbourg,* despite the claims in its title, was an epistolary work written by a German who had never been to Russia; it was published in French by a press in London; two German translations followed immediately (Bilbassoff 1: 36–37, 46–47). In this work, Catherine's marital behavior was still being discussed under the guise of criticizing Peter III for raising distasteful questions:

> It is not fitting for me to judge whether the emperor had reason to cast doubt on the faithfulness of his consort. I cannot hide from you in the slightest that there is no one in Russia who approves of the prince speaking about that so boldly and often using expressions that are no honor to him. No one would ever have thought of such detestable things, if he had not himself offered the occasion; and no one has ever believed that the empress could be capable of such debauchery. Is it not painful for this princess and for the whole nation that the only heir to the throne, who is beloved and valued by all his subjects, was declared a bastard by his own father? (Marche-Schwann 29–30).

The author keeps the salacious rumors in circulation, using such words as "detestable" (*verhasst*) and "debauchery" (*Ausschweifungen*) even while claiming not to believe the charges.

In the first phase of the French Revolution, Louise de Keralio, in her 1791 denunciation of French female rulers entitled *Les Crimes des reines de France,* wrote: "A woman for whom all is possible is capable of anything; when a woman becomes queen, she changes her sex" (qtd. in Maza 82). Catherine's seizure of the throne completely transformed her sexual options. Married aristocratic women were expected to produce legitimate heirs and were thus generally excluded from libertinism until they had borne at least one son; married queens and crown princesses were expected to maintain the semblance of fidelity permanently (example: Maria Theresia). But once Catherine came to the throne, and after Peter's convenient death (while under house arrest a

few days after the coup), she was a queen who was both unmarried and ruling. The difference between the chaste consort (as first routinely and then anxiously proclaimed in the pre-coup years) and the later libertine queen, arrogating to herself the same right to take lovers as most male monarchs used, seems to fit Keralio's description: it is as if Catherine underwent a public sex change halfway through her life. It is not surprising, then, that immediately after the coup the new empress allowed Grigorii Orlov to demonstrate his status as favorite. In that light, many readers of the hybrid *Russische Anekdoten* in 1764 probably noted that although the narrator claimed to believe always in Catherine's virtue and to regret the rumors, he did not actually refute them. In short, Catherine II not only took lovers but did so openly after she came to the throne.

For this openness eighteenth-century commentators gave various explanations. One was straightforwardly tactical. The Frenchman Claude Carloman de Rulhière depicted the English ambassador to St. Petersburg as advising Catherine that "when you dispose of restraint, when you name aloud the person whom you honor with your goodness, when you make it understood that you will consider any mortification to that person as a personal insult against you, then it will be easy for you to live in accordance with your own desire" (30). The cultural setting that tolerated libertinism made this kind of advice possible. At the same time, the openness exposed rich lodes for the textual and graphical deployment of Catherine's sexuality.

This abounding material was not dependent on a continuous flow of factual information. Indeed, the openness of the favorites at court did not mean that Catherine's affairs were explicitly mentioned outside of court or that public discussion of them was tolerated, especially in print. Thus, the tsarina's backers in France worked vigorously to prevent publication of the little book in which Rulhière recounted Catherine's sexual experience up to the time of the coup. (In fact, much of it was corroborated by Catherine's own memoirs published in the mid-nineteenth century.) But, beside publication, there were other effective forms of communication, most notably conversations, the circulation of manuscripts, and private letters. During the early years of Catherine's reign, Rulhière's manuscript was read aloud in salons (it was finally published immediately after her death). As her reign continued, completely new stories of sexual experimentation circulated, some of them leaving faint traces visible today. One example is in a note that Lichtenberg wrote to one of his correspondents: "Do write me the anecdote about the empress and the trumpeter. Call her Cousin Meichel and the other one.... Mouthpiece; then no one will understand it but you and I, but in any

case also use a separate large sheet of paper and I will burn it up. Please, please" (3: 35). The passage reinforces also the necessity of taking precautions in writing such material in Germany during Catherine's lifetime. Heads of state could of course be less careful. Friedrich II sneered of Catherine and her first lover after the coup: "It is a terrible business when the prick and the cunt decide the interests of Europe" (qtd. in Alexander 137).

A similar need for caution may explain the uneven distribution of visual satires on Catherine, particularly satirical cartoons that allude to her sexuality. During the course of her rule Catherine was involved in controversial activities, such as dividing Poland and conducting bloody wars against the Ottoman Empire. In images satirizing such events, sexuality was frequently part of the visual code of the critique.[5] The preserved examples from Germany, however, all treat both sex and satire very cautiously. One example originated in France, where it was called "The twelfth cake, le gâteau des rois," but also appeared in numerous titled and untitled copies (Figure 1). It contains in its depiction of the division of Poland a subtle sexual reference: Catherine is in conversation with her former lover Poniatowski, now the king of Poland; his undone hair flows loosely down his back, a transference of conventional sexual imagery from the sexually undone woman to the sexually and politically undone man. Such details were probably only understandable to those who already knew the reports of Catherine's pre-coup affair with Poniatowski—information that Rulhière's salon readings of his manuscript had put into at least limited circulation and which had apparently reached the engraving artist Noël LeMire (who signed the work with an anagram of his name, Erimeln [Geisbauer 192]). Poniatowski holds on to his slipping crown, which he had received when Catherine forced him on the Poles as their king; on the right side, Friedrich II and Joseph II converse together, Friedrich with his phallic sword drawn.

There are several much less pointed German versions of the caricature, this time with their titles in only one language. Engravers who copied designs from one another often allowed minor deviations to creep into the marginal areas of the print, as in this case, but the single-language German (and other) copies also rob the image of all critical effect. Now allusions to Poniatowski's sexual relations with Catherine are erased: he looks at the map instead of toward her, and a wig replaces his loose hair in the other version; furthermore, he points heavenward instead of grasping his crown, as though the excision of large slices of his territory were the will of God rather than an assault on his country and throne. Friedrich's sword is back in its scabbard (Figure 2).

Figure 1. One of several copies by various anonymous engravers of a fictional scene depicting the first division of Poland; the original was the work of the French engraver Noël LeMire. Catherine II looks up at her former lover, Stanislas Poniatowski, who tries angrily to hold onto his slipping crown as his hair flows freely down his back. To the right of Poniatowski, Joseph II, then co-ruler of Austria, confronts Friedrich II of Prussia, who points with his sword toward Danzig on the unlabeled map. While this copy, made in London, has no title, the probable original was called "The twelfth cake, le gâteau des rois," corrupted in later prints to "The troelfth cake, le gateau des rois" (Rovinskii, 878–79). Courtesy of the Germanisches Nationalmuseum (Nürnberg, Graphische Sammlung, Inventar-Nr. HB 5301, Kapsel-Nr. 1314a).

Figure 2. Under the innocuous title, "Die Lage des Königreichs Pohlen im Jahr 1773," this engraving unbarbs the LeMire (see Figure 1). Probably from 1773 and perhaps made in Augsburg, it is the work of an unnamed engraver. Here Friedrich II no longer holds a sword, and a primly bewigged, almost anonymous Poniatowski, gesturing vaguely, gazes at the neatly labeled map instead of at Catherine II. Beneath Fame's trumpets are banners suggesting the manifestos of the three appropriating powers. Courtesy of the Germanisches Nationalmuseum (Nürnberg, Graphische Sammlung, Inventar-Nr. HB 5301, Kapsel-Nr. 1314a).

As the years went by, satirical images of Catherine did not remain so tame or so highly coded. Once the French Revolution erupted, a barrage of caricatures of her that suddenly edged much closer to the lewd began to appear, mostly in England (where, with artists such as Gillray and the Cruikshanks at work, a "golden age" of caricature was underway),[6] and secondarily in France. The possibility that the closer one got to Russia the more effectively indecent and satirical materials could be suppressed, and the fact that during the Revolution it was of course far more dangerous in Germany to satirize monarchs of any country than it was in France are perhaps two reasons for the present untraceability of German political cartoons attacking Catherine after 1788. Yet the existence of pornographic political cartoons against her outside of France and Britain is documented in an eyewitness account of Catherine's reign by the Swiss Charles François Philibert Masson. In his book,

which first appeared in France in 1800 and was translated into German that same year, Masson wrote about Polish caricatures he had seen, especially one that was extremely vicious:

> Among the satirical engravings that were made in Poland about the empress of Russia, one is especially remarkable, entitled "Catherine's Mealtime." The empress sits alone at the table. From one side some Cossacks offer her the still bloody limbs of Swedes, Poles, and Turks, whom they have just murdered. On the other side lies a row of young, naked men side by side, like barrels in a wine cellar, and by means of a specific manual operation an old woman draws from these living kegs a juice that she catches in a goblet and hands to the empress for her to drink. Below this despicable caricature are some verses worthy of it. One can with a little decency translate them thus: Since you love men so much, eat their flesh and drink their purest blood! (161–62).

This is a blasphemous image of extreme debauchery and depravity, with multiple young men being objectified for the satisfaction of an empress with a reputation for sexual voracity, as made clear in the verse Masson paraphrases. The pornographic image of a powerful woman being sexually "serviced" by troops of men, especially guards or soldiers, is both a legacy of classical images (Messalina) and a bizarre reversal of the far more common reality of wartime rapes of women.

Recent work on eighteenth-century pornography has stressed the philosophical and political elements of such images and texts during the ancien régime, arguing that they make vivid "the irrationalities of the ancien régime moral system" and suggest "the feminization of both the aristocracy and monarchy" (Hunt 330, 329). Bawdy representations of, for example, Marie Antoinette bring the targeted woman down to the level of a common prostitute. The coded and uncoded semi-pornographic depictions of Catherine that began to appear in 1789 and continued for years after her death consistently invoke anxieties about a woman in power and the power of women, represented by sexuality and female sexual appetite. Depictions of Catherine as a powerful woman tended to slide into those of her as a lascivious woman. Even so decorous a posthumous account as the biography written by Johann Gottfried Seume (but published anonymously in 1797) said it was no secret that the empress was "somewhat passionate in the physics of love" ("in der Physik der Liebe"), but claimed she never infringed on "feminine modesty": "All who have been much in the company of the empress insist that they have never seen a woman more modest in her conversation and conduct" (141–42). Passionate and extravagant but in other respects well behaved is the pattern Seume tried to describe; he could not deny the

passion since it was "no secret." He tried to resist strict (bourgeois) sexual morality not by endorsing aristocratic libertinism but by arguing that Catherine's lovers may have been expensive (due to her generous gifts to them) but were not a harmful weakness. And since Catherine had practiced leniency, the critic should as well. Seume attempts to package Catherine's active sexuality as regrettable but not of profound importance.

Within twelve years of Catherine's death two novels about her appeared, both German. In one she is called Miranda, Queen of the North, and in the other, although initially referred to only as "she," the Catherine character is named Iwanova. Written in 1798, less than two years after Catherine died, the Miranda novel is by a man, Johann Friedrich Ernst Albrecht; ten years later, in 1808, the Iwanova novel, *Der Günstling* (The Favorite), is by a woman, Caroline Auguste Fischer.[7] Albrecht had already published a novel, *Pansalvin, Fürst der Finsterniss, und seine Geliebte* (Pansalvin, Prince of Darkness and His Beloved), about Potemkin, in which Catherine also figures, and later he wrote several more centering on other men in Catherine's life. An important difference between the Albrecht and Fischer texts is their contrasting interpretation of passionate love, Albrecht still accepting aristocratic libertinism and Fischer seeming to refuse any version of love that was not exclusive, eternal, and aimed toward marriage. As a woman writer, Fischer's unstable public status probably would have made directly questioning the emerging code of sexual morality especially difficult.

Miranda depends for its depiction of Catherine overwhelmingly on Rulhière's just-published account of the coup and his stories of the Grand Duchess's lovers in the years before Peter III came to the throne; after the Rulhière materials, which take up more than three quarters of Albrecht's novel, the years of Catherine's reign are treated swiftly so that the book ends with the empress's (natural) death. What makes *Miranda* interesting is both its indebtedness to Rulhière and its invention of discourses that Rulhière alluded to but left undeveloped. These include dialog between palace guards about their class-based relation to the Grand Duchess, conversations between bourgeois members of the crowd cheering the self-proclaimed new empress, and a stranger's interrogation of a Russian Orthodox priest about the ethics of Catherine's ascent to power and her reign. Furthermore, in an invented secondary plot a young German officer, who is tricked into believing Catherine loves him and has married him, is exiled to Siberia, where he conducts long discussions with a Russian statesman also banished there. The result is a novel with many crosscurrents, some critical of Catherine, some admiring.

Albrecht depicts men at court—with Orlov coded as "Zadro"—as sexually attracted to Miranda, who is witty, confident, ambitious, and lustful:

> Queen Miranda had always been receptive to love and this seemed to increase with her greatness.... Zadro was no longer the only one who was allowed to carouse in the blissful pleasure of the oversized royal charms. Miranda was a friend of society; she especially loved certain games associated with tender jests and caresses. To satisfy this inclination, she had founded a circle, which actually consisted of intimate friends of both sexes, to which, however, others occasionally obtained entry through the introduction of one of the initiates. Among the male intimates some occasionally acceded to a secret rendezvous with the queen, at which others enjoyed that which Zadro had until then considered only himself to have a right to. Since it was not so easy for any stranger who was not distinguished both by the bloom of youth and an advantageous education to obtain entry to that intimate social circle, Miranda found opportunity in this way also to heighten the pleasure of loving embraces by means of delightful change and to increase it with new charms (306-07).

The lubricious story of Catherine's intimate circle, often repeated in early posthumous accounts of her, is laden with semi-pornographic hints.

This sexualized but not censorious view of the empress from within her circle is combined with a distinctly critical but not particularly sexualized political view. For example:

> She knew how to obtain for her throne a splendor that blinded thousands and transported them to astonished admiration of a greatness that to a clearer eye consisted more in a deceptive shimmer than in reality. Along with all the appearance of a wise, active self-government, working tirelessly for the increasing perfection of the state constitution and the prosperity of the subjects, there nonetheless very quickly arose at Miranda's court the most sumptuous Asiatic luxury, and the queen who appeared so active spent by far the greatest part of her time at her toilette, at the dinner table, and at amusements (305-06).

Although Albrecht is sometimes labeled a Jacobin and some of the criticisms of Catherine in the novel seem to support that designation, none of his overt criticisms attacks her sexual behavior, except as a distraction from the task of ruling. Many scenes are far more obviously written for their titillating effect on the reader.

In a scene set early in Miranda's marriage, while she still goes by the name Auguste (reminiscent of Catherine's original German name, Sophie Auguste) and before a fertile lover had been found for her, Miranda/Auguste and another woman watch the guards practicing their formations in the palace square. When Auguste asks the Countess which of the guards she would choose, the Countess ponders before deciding that the best solution would be to love the whole regiment, at which Auguste laughs, embraces her, and agrees that nothing could be better (82–83).

In *Miranda,* Albrecht depicts a frankly sexual woman and intermittently uses a female first-person narrator typical of many eighteenth-century pornographic novels. Caroline Auguste Fischer, in contrast, writes *Der Günstling* almost entirely from the perspective of a man. Fischer's narrator appears for most of the novel to be a male paragon of virtue, a man who from the start is fearful of Iwanova's attention. Indeed the first sixth of the book reads like a novel of workplace sexual harassment: Alexander is trying to do his important work, but his boss keeps making passes at him. Finally he has to tell the boss he is not interested, because he does not love her and cannot be forced to love her. She is furious. Immediately thereafter, Alexander becomes the guardian of an innocent and beautiful fifteen-year-old girl and promptly begins to fall in love. Everything about his love for Maria is validated as reasonable, positive, and virtuous. (Contrasting with Maria's classically virginal name is Iwanova, Eva nova, new Eve. The name is laden with connotations of danger and evil and sounds vaguely Russian—one of Russia's other eighteenth-century women rulers was named Anna Iwanovna. That this novel set "in the north" is a reading of Catherine is further reinforced by Iwanova being called "the Great" [110–11] as Catherine was during her lifetime.)

At exactly the same time that Maria appears in Alexander's life, Iwanova takes as her lover a handsome and innocent young man, R. Everything about this relationship is invalid: R. is dumb, revels stupidly in his pathetic status, and is the pawn of courtiers; for Iwanova he is only a stand-in for Alexander, and at the same time she uses him in an effort to make Alexander jealous. Before long, however, her majesty (her position is not explicitly labeled) gets bored with the young man. This boredom is sure proof that—by Alexander's standards of love, which correspond to the increasingly dominant bourgeois notion—Iwanova's feelings for R. were not love: "love" includes sexual passion, but it belongs with marriage, and it lasts for a lifetime, indeed, for eternity (156). Likewise, Iwanova's feelings for Alexander in their excessiveness and immoderateness, qualities that, Luhmann argues, in an earlier time had been indexical for passionate love, are now reinterpreted as

not-love. Alexander comments as though to Iwanova: "Unhappy one! on your lonely throne, you were begging for love, and it was denied you. The terrible pain threatened to destroy you, and you fled into the arms of lust. Ach! you saved the appearance of life and sacrificed true living. Your example is a warning to me!" (50). Iwanova's willingness to substitute lust for love demonstrates that her emotions do not meet the new standard.

While the needy, calculating, promiscuous, and carnal Iwanova is presented as less admirable than the restrained, chaste, and rational Alexander, this simple contrast omits emotional privileges of the statesman over the female monarch: first, the statesman has been raised since his childhood to control his emotions, and, second, at the end of the day he is able to escape from court and restore himself emotionally at home. But his emotional self-control is not uniformly admired. When confronted with one of the instances of Alexander suppressing his emotions in favor of his reason, Iwanova exclaims, "You clumps of ice, who will ever understand you! But it is the compulsion under which you have been groaning ever since your youth. So, then, you believe that groaning and being in want are the human lot" (98). The change from the familiar singular form of address a few lines earlier to the plural familiar here ("Ihr Eismassen!") makes it clear that Iwanova is describing not just Alexander, but the collectivity of excessively rational people and probably more specifically the group of educated men. And although she is repeatedly shown overcoming her emotions in the novel, she suggests here that such behavior is constricting and undesirable. Yet Alexander's case shows that even the man who has so fully internalized emotional inhibitions and courtly etiquette requires regular periods of respite, available to Alexander by being with Maria (43, 65–66) and symbolized by replacing his ornate court coat with a plain one (65, 129). This relief and sustenance, of exactly the type the nineteenth-century bourgeoisie were beginning to expect from the family, is the opposite of Iwanova's situation on her "lonely throne."

Before meeting Maria, Alexander had thought that work offered sufficient emotional satisfaction, but afterward he decides it does not (50). Yet he fails to recognize the implication of this for Iwanova, as evident in one of the best realized episodes in the novel, describing her emotional collapse after she has dismissed R. Coming to her apartments for a signature, Alexander finds the monarch lying on the floor. When he asks if he should call for help, her answer is an existential question, "Where is help?" Alexander tries glibly to say help is in Iwanova's heart and spirit, and she retorts: "My heart is without hope, so you switched quickly to spirit" (95). Silenced, Alexander tries to move her

to a chair, the only one available being, significantly, her throne, "the place where Iwanova belongs." When Iwanova, not wanting to return uncomforted to duty, complains that he is still uninterested in her, he utters a cry about his own happiness that puts her on alert. "How are things with Maria?" she asks (96). The thought of her girl-rival is not comforting but it does rouse Iwanova so that she gets up and goes back to the work of ruling.

Alexander answers Iwanova's question by saying that Maria is living the life of innocence. This innocence is edged, however, with incest. Because Maria does not know the code of intimacy, as Luhmann calls it, she thinks her hugs for her guardian are because he is her "father"; she has no other word for her feelings and no awareness of his more than fatherly love for her. Alexander too invokes fatherliness, noting that he is almost old enough to be her father and that emotionally he fulfills the role (33).[8] Allwina, Maria's governess and companion, warns Alexander that outside observers might think he and Maria are engaged, and she reminds him that he was recently fearful about "the appearance of any sort of guilt" (42). They avoid naming the taboo directly ("any sort"), and Alexander tries to suppress it by shifting the parental position to Allwina, calling her "Mother of my Maria," and shifting the paternal role away from himself, asserting that his only plan is to be a man (43). Yet he continues to elicit and accept Maria's daughterly embraces and familiarities. Later he tells her: "I wanted to be your father and wanted to remain that and did not want to make room for any other feeling. I wasn't able [to abide by this plan]" (130). Alexander's inability to resist his love for Maria is treated as a sign not of incest, nor of insufficient emotional control, but of an irresistible love. Her persistence in calling him father is similar. When Maria at last recognizes her feelings as love, she continues to articulate them partly in fatherly terms, even when Alexander's behavior is far from paternal. When she rejects his offer to send her to England, he kisses her: "I pulled her quickly into my arms and covered her face with burning kisses. 'Oh my father, my beloved' she cried, 'now we are alive!'" (135). The many evocations of incest are deployed not to indicate a problematic relationship (although Allwina hints at that) but to articulate the new kind of love different from libertine passion.

A critical mark of this new love is its immediate progress toward marriage (something that Iwanova never mentions), and precisely this, the urge of the new kind of love toward its denouement in marriage, precipitates the final crisis of the novel, for the courtier must have the monarch's permission to marry. Using his popularity among Iwanova's subjects and her dependence on his work as leverage, Alexander insists

that he will no longer help her rule the empire if she does not allow him to marry Maria. She appears to acquiesce but then poisons their wedding bed. Maria and Alexander die.

The libertine woman, the ruling woman unsexed by the manly virtues that her position entails (46), is the target of demonization, and the pure maiden, whose sexual potential has only been evidenced symbolically through her passion for arts and learning, is her idealized counterpart. Maria's spontaneous and unwitting love for Alexander and her uncomplicated immunity to other aspiring lovers (whose intentions she also does not recognize), underscored by her youth, beauty, and conventional femininity, contrast with Iwanova's carnal and tactical exploitation of R., her repeated efforts to force herself physically on Alexander, her inability to accept the love of Alexander and Maria, and her treacherous response to Alexander's plan to marry. Although Fischer's novel is seemingly ready to concede to Iwanova a male role as ruler, Iwanova's obsession with Alexander has turned her into a murderous monster. And yet of the three main characters in Fischer's novel it is Iwanova who survives. Fischer does not kill her.

Iwanova's survival is knowable because of the laconic final pages of the novel by an unidentified narrator who invites a radically different reading of the novel. Here, as Anita Runge points out, Alexander's adamancy in rejecting Iwanova and demanding the right to marry Maria is identified as excessive and as driving Iwanova to extremes (172; Runge 200–01). Here it is reported that Iwanova is assisted in organizing the murders by two other people whom Alexander had judged harshly (including Allwina, whom he had dismissed for advising Maria to make a conventional courtly excuse rather than always saying only the truth; 105–07). Rereading Alexander's behavior as arrogant rather than high-minded also fits with the title of the novel. Favorites at court had power and influence, but only as long as the approval of the ruler continued; that approval also often connoted a sexual relationship. Alexander forgets his role, forgets that he derives his power not from his popularity but only from the empress whom he spurned. He also forgets what he knew about Maria, who is shown from the start as dangerous to men, specifically to fatherly ones, and who repeatedly associates love with death. Orphaned since she was five, Maria had been raised by an aunt whose recent death is reported at the start of the novel. A few months later her uncle, Count G., returns from nine years' absence: "As a five-year-old child, Maria had been torn from his arms. Now he saw the most beautiful maiden embracing his knees, and heard her call him father. It was too much." He smiles and dies (33). Her

maidenly beauty and the suggestion of intimacy contained in the word father and in the daughterly gesture of embrace suffice to kill the count.

The text's version of love and especially of love's culmination in marriage also invites a more problematized rereading. Maria's notion of love and marriage as union with the beloved, knowing his thoughts and feelings, and excluding all else, matches closely with Luhmann's account of passionate love—except for the expectation of marriage. Alexander himself calls Maria's notion of marriage an unreachable ideal, for men's serious public duties distract them and teach them to devalue women and women's work (139–41). Even though Maria claims that, forewarned, she will not be disappointed, the novel makes the insightful argument that the gender characteristics and gender roles being promoted at the time and embodied in Maria and Alexander will lead to an unhappy, unsatisfying marriage for the woman, as it did for Alexander's mother (141). *Der Günstling* criticizes libertinism but also questions the realizability of the nineteenth-century bourgeois alternative.

* * *

It has been suggested that one of the consequences of the Clinton-Lewinski scandal of 1998–99 was "the necessary admission that the American President has a body" (Leonardo 9). In the eighteenth century it was not a surprise to discover that kings and queens had bodies: their sexuality was part of their jobs. American presidents come into office as the result of a kind of birth-without-a-woman, by election. Most kings come into office specifically because of who their mother and (ostensible) father are, and their own duty in turn is to procreate, especially to have sons. When Catherine underwent what Keralio had called a female ruler's sex change (see Maza 82) and began to indulge in kingly sexual behavior she initially had the permission of rank, though not of gender. As long as Catherine reigned, she could appropriate to herself the body of the king with all its privileges, including suppressing most criticism of her sexual behavior without needing to hide her dalliances. Then times changed. Criticism no longer came mainly from male monarchs and their factions, angry at having to share their exalted rank with women and in some cases incensed that the queens and empresses who came before them had delayed their arrival on the throne. Criticism also came from the self-righteous bourgeoisie, eager to assert their moral superiority to the aristocracy by assailing the licentiousness of the upper classes. After Catherine's death the powerful woman could be sexually demonized, and the unmotherly, unchaste aristocratic woman could be vilified. What better punishment of an overtly sexually active,

self-directed woman than to invent the story of the horse?[9] This story even today continues to circulate as oral tradition, despite the fact that the societies where it exists are all societies of the written word. The assertion that Catherine's excessive sexuality, carried to the extreme of bestiality, had killed her, demonstrates the neatness and economy of a fable and uses the readily available stuff of eighteenth-century pornographic prints. Catherine the "Great" could be transformed from the most powerful woman of her century into the most ignominious. Under the guise of a "joke," the libertine woman would be crushed to death again and again for centuries.

Notes

All translations are mine, unless otherwise noted, and are from the German, in cases when texts exist in both German and French. I wish to thank Kathy Phillips and the *Yearbook* reviewers for their helpful comments on earlier drafts of this paper.

[1] German examples can be found in Meise and Osswald-Bargende.

[2] I have so far found no text printed before the coup that contains this allegation, but it may have spread through less formal circuits.

[3] This claim is repeated almost exactly in one of the first biographies of Peter III (*Denkwürdigkeiten*, 70). Of course if Catherine's coup against Peter had not been successful, Hörschelmann's value judgments against Peter would probably have been reversed.

[4] Exactly how illicit news of this kind may have reached the populace of Germany is hard to trace. Grand Duke Peter had many retainers from Holstein (where he was the Duke), with whom he drank and talked; they may have repeated some of his comments within informal communication networks that reached back to Germany. Peter also treated the Prussian ambassador as a friend and thus gave Friedrich II extensive information about his activities and his thoughts; in fact, he corresponded directly with Friedrich even before becoming tsar. Some of the many other foreigners—German, French, Dutch, English, and others—working in St. Petersburg may have spread rumors that Peter was disclaiming Paul. Or some of the German courts that had representatives in St. Petersburg perhaps heard this rumor from their diplomats, and it then spread from the courts to a broader public.

[5] It is possible that Western Europeans kept track of Catherine's lovers by means of newspapers and magazines. There may have been ways of

referring to Orlov, Vasil'chikov, Potemkin, and their successors that signaled their status to readers of the time.

[6] For a rich and well-illustrated analysis of British satirical images of Catherine, see Carretta.

[7] Confronting varied listings for the year when *Der Günstling* was published, Runge explains: "The novel appeared in 1808; in the following year a copper engraving was supplied, and the titles decorated with this engraving bear the date 1809" ("Nachwort" 202). *Der Günstling* has received the least critical attention of Fischer's three novels. See Purver; Runge; Zantop.

[8] One of the criticisms frequently leveled at Catherine II is connected in the novel with Alexander, not Iwanova: the issue of falling in love with a much younger person. This matter is sufficiently disturbing to Alexander that he mentions it frequently (e.g., 138), and when Maria dreams about their transformed relationship, she imagines him "not much older" than she is (121).

[9] The story and some speculation about its origins are in Alexander (332–35).

Works Cited

[Albrecht, Johann Friedrich Ernst.] *Miranda, Königinn im Norden, Geliebte Pansalvins*. Germanien [Erfurt: Hennings], 1798.

_____. *Pansalvin, Fürst der Finsterniss, und seine Geliebte. So gut wie geschehen*. Germanien [Gera: Heinsius], 1794.

Alexander, John T. *Catherine the Great: Life and Legend*. New York: Oxford UP, 1989.

Appelgreen, Gottfried Ludolf, and Friedrich Wilhelm Appelgreen. *Augustissimi principis Pauli, Petri f., magni ducis Russiae reliqua cunas ea qua par est pietate venerantur....* Göttingen: n.p. 1754.

Bilbassoff, B. von. *Katharina II., Kaiserin von Russland, im Urtheile der Weltliteratur*. 2 vols. Berlin: Räde, 1897.

Carretta, Vincent. "'Petticoats in Power': Catherine the Great in British Political Cartoons." *1650–1850* 1 (1994), 23–81.

Catherine: Memoirs of the Empress Catharine II, written by herself. Ed. A. Herzen. London: Trübner, 1859.

Fischer, Caroline Auguste. *Der Günstling*. 1808. Ed. Anita Runge. Hildesheim: Georg Olms, 1988, rpt.

Gaisbauer, Herbert, ed. *Maria Theresia und ihre Zeit*. Wien: Bundesministerium für Wissenschaft und Forschung, 1980.

Hörschelmann, Friedrich Ludewig Anton. *Friedrich Ludew. Ant. Hörschelmanns pragmatische Geschichte der merkwürdigen Staatsveränderungen*

im rußischen Reiche von dem Ableben Peters des Grossen an bis auf den Regierungs-Antrit der ietzregierenden Kaiserin Catharina II: Aus sichern Quellen und authentischen Nachrichten mit unparteiischer Feder vorgetragen auch mit nötigen Beweisen bestätigt. Erfurt: J.J.F. Straube, 1763.

Hunt, Lynn. "Pornography and the French Revolution." *The Invention of Pornography: Obscenity and the Origins of Modernity, 1500–1800.* Ed. Lynn Hunt. New York: Zone Books, 1993.

Karsch, Anna Luisa, and Johann Wilhelm Ludwig Gleim. *"Mein Bruder in Apoll": Briefwechsel zwischen Anna Louise Karsch und Johann Wilhelm Ludwig Gleim.* Ed. Regina Nörtemann. Göttingen: Wallstein, 1996.

Leonardo, Micaela di. "An Affair to Remember." *Women's Review of Books* 18.12 (Sept. 2001): 8–9.

Lichtenberg, Georg Christoph. *Briefwechsel: 1785–1792.* Vol. 3. Ed. Ulrich Joost and Albrecht Schöne. München: C.H. Beck, 1990.

Luhmann, Niklas. *Love as Passion: The Codification of Intimacy.* Stanford: Stanford UP, 1998.

Marche-Schwann, C.F.S. de la. *Russische Anekdoten von der Regierung und Tod Peters des Dritten; imgleichen von der Erhebung und Regierung Catherinen der Andern. Ferner von dem Tode des Kaisers Iwan, welchem zum Anhange beygefügt die Lebens-Geschichte Catherinen der Ersten.* Petersburg: n.p., 1764.

Masson, Charles François Philibert. *Geheime Nachrichten über Russland unter der Regierung Catharinens II. und Pauls I.: Ein Gemälde der Sitten des Petersburger Hofes gegen das Ende des achtzehnten Jahrhunderts.* Paris: in Commission bei den vorzüglichsten Buchhändlern Deutschlands, 1800.

Maza, Sarah. "The Diamond Necklace Affair Revisited (1785–1786): The Case of the Missing Queen." *Eroticism and the Body Politic.* Ed. Lynn Hunt. Baltimore: Johns Hopkins UP, 1991. 63–89.

Meise, Helga. "'obwohl sie eigentlich nur Ihm allein gehörte...'—Ehebruch, Majestätsverbrechen und weibliche Ehre im ausgehenden 18. Jahrhundert." *Ordnung, Politik und Geselligkeit der Geschlechter im 18. Jahrhundert.* Ed. Ulrike Weckel, et al. Göttingen: Wallstein, 1998. 89–117.

Osswald-Bargende, Sybille. "Eine fürstliche Hausaffäre: Einblicke in das Geschlechterverhältnis der höfischen Gesellschaft am Beispiel des Ehezerwürfnisses zwischen Johanna Elisabetha und Eberhard Ludwig von Württemberg." *Ordnung, Politik und Geselligkeit der Geschlechter im 18. Jahrhundert.* Ed. Ulrike Weckel, et al. Göttingen: Wallstein, 1998. 65–88.

Purver, Judith. "Passion, Possession, Patriarchy: Images of Men in the Novels and Short Stories of Caroline Auguste Fischer (1764–1842)." *Neophilologus* 79 (1995): 615–28.

Richter, C. E. *Das Lob und Danck-Fest vor die Höchstbeglückte Entbindung I. K. Hoheit der Gross-Fürstin aller Reussen Catharina Alexiewna mit einem Gross-Fürsten.* Petersburg: n.p. 1754.

Röllig, J. G. *Als die erfreuliche Botschaft von der Vermählung des Herrn Peters Feodorowiz wie auch der Frau Catharina Alexiewna bekannt und Derselben hohe Feyer an dem Hochfürstlichen Anhalt-Zerbstischen Hofe begangen wurde, wolte seine Pflicht in Drama und Musica an den Tag legen J.G. Röllig.* Zerbst: n.p., 1746.

Rovinskii, D.A. *Podrobnyi slovar' russkikh gravirovannykh portretov.* Vol. 2. St. Petersburg: Tip. Imp. Akademii nauk, 1887.

Rulhière, Claude Carloman de. *Geschichte der russischen Revolution im Jahr 1762.* Germanien [Strassburg: König], 1797.

Runge, Anita. "Die Dramatik weiblicher Selbstverständigung in den Briefromanen Caroline Auguste Fischers." *Die Frau im Dialog: Studien zu Theorie und Geschichte des Briefes.* Ed. Anita Runge and Lieselotte Steinbrügge. Stuttgart: Metzler, 1991. 93–114.

———. "Nachwort." *Der Günstling,* by Caroline Auguste Fischer. Ed. Anita Runge. Hildesheim: Olms, 1988. 175–209.

———. "Wenn Schillers Geist weibliche Körper belebt: Emanzipation und künstlerisches Selbstverständnis in den Romanen und Erzählungen Caroline Auguste Fischers." *Untersuchungen zum Roman von Frauen um 1800.* Ed. Helga Gallas and Magdalene Heuser. Tübingen: Niemeyer, 1990. 184–202.

Seume, Johann Gottfried. *Ueber das Leben und den Charakter der Kaiserin von Rusland Katharina II. Mit Freymüthigkeit und Unpartheylichkeit.* Altona [Leipzig: Göschen], 1797.

[Will, Georg Andreas]. *Merkwürdige Lebensgeschichte Peter des Dritten, Kaisers und Selbsthalters aller Russen, nebst einer Erläuterung zweyer, bereits seltener Münzen welche dieser Herr hat prägen lassen.* Frankfurth und Leipzig: n.p. 1762.

Zantop, Susanne. "Karoline Auguste Fernandine Fischer." *German Writers in the Age of Goethe: Sturm und Drang to Classicism.* Ed. James Hardin and Christoph E. Schweitzer. Dictionary of Literary Biography. Vol. 94. Detroit: Bruccoli Clark Layman/Gale Research, 1990.

Suffering, Silence, and the Female Voice in German Fiction around 1800

Anna Richards

I investigate the link between the silence, self-expression, and illness of female characters in five German novels in the context of medical writing. Is the frequent reticence of sickly heroines a rejection of language in favor of a more authentic, physical means of expression, or should it be read as a patriarchal silencing of the female voice? And what of the verbal and written outpourings of emotion to which the wasting heroine is also given? I conclude that while the majority of the novels reinforce a traditional understanding of women's relationship to language, in her novel *Luise* (1796) Therese Huber puts forward an unconventional view. (AR)

To be silent, modern feminist criticism has taught us, is not necessarily to withhold communication. If, in the past, women have had their voices suppressed, ignored, or belittled, they have also chosen to say nothing as a means of expression or a strategy for resistance. Feminist literary critics have read the gaps and absences in texts by women or the reticence of their female characters as a protest against patriarchal language, as a sign of integrity, or as the expression of an "alternative" truth.[1] Such recognition of the potentially positive value of silence has been tempered, however, by timely reminders from critics such as Elaine Showalter and Susan Bordo of the patriarchal origin of its association with the female sex. Bordo asks us not to forget that, although it may express a protest, "*at the same time...*, muteness is the condition of the silent, uncomplaining woman—an ideal of patriarchal culture" (99). Showalter insists that, in the past, women "have been forced into silence" rather than choosing it freely, and that the blanks and holes in texts are therefore "not the spaces where female consciousness reveals itself, but the blinds of a 'prison-house of language'" (255-56).

Both collusion and resistance, a symptom of gender stereotyping and the expression of a female point of view in a patriarchal world: feminist theorists' evaluation of women's silence has much in common with recent debates about that other historical phenomenon often associated with the female sex, illness. The work of medical historians such as Esther Fischer-Homberger, Claudia Honegger, and Lorna Duffin has illuminated the ways in which patriarchal society, particularly from the late eighteenth century onwards, has "pathologized" the female sex. First, they argue, "healthy" female physiological processes and states, because different from male, have been judged deviant. Second, the restrictive conditions, both physical and psychological, imposed on women have promoted a higher incidence of actual illness among them. Just as they have reclaimed the silence imposed on women as an expression of protest, however, feminist critics have suggested that women's illness could also be a way to *resist* a traditionally female role, by allowing women to escape duties such as housework and childbirth, for example. Literary critics such as Birgit Wägenbaur and Lilo Weber have interpreted the representation of women's illness in the fiction of German authors, including Fanny Tarnow (1779–1862) and Theodor Fontane (1819–1898), in this way.

Female silence and female sickness are often found together in literary and medical texts. Ill women, that is, often stop speaking, and reticent women often become ill. Critical opinion on the link between the two, as on each separately, has been divided. On the one hand, Bordo suggests that the loss of voice that has often accompanied women's nervous diseases testifies to the female body's inscription with patriarchy's "ideological construction of femininity" (93). In *The Gendering of Melancholia* (1992), a psychoanalytical feminist study of literary representations of grief in the Renaissance period, Juliana Scheisari similarly interprets the fact that sickness lends eloquence to male characters, but typically silences female characters (15) as a symptomatic of patriarchy's privileging of male creativity and suppression of the female voice (7–8). Other feminist critics view the link more positively, however, arguing that silence and illness are often found together because women use physical symptoms to express that which lies outside the symbolic linguistic order. They have argued that Freud's often mute hysterical patients, for example, reject language in favor of a more authentic, corporeal means of communication.[2]

In this essay, I want to investigate the nature of the link between the silence, the self-expression, and the illness of female literary characters in five German novels from around 1800, by both male and female authors. What effect does illness have on the female voice, and vice

versa? The feminist theories discussed above will be important in my analysis, but it will become clear that an examination of the literary texts in the light of medical and popular thinking on women of the time offers the most insight into the significance of the heroines' speaking or their silence. I therefore draw extensively on medical history, on medical works, and on popular writing on women from the period. In the main part of my essay, I deal with four texts that, although very different, all put forward a largely conventional view of women: Johann Martin Miller's *Siegwart: Eine Klostergeschichte* (*Siegwart: A Monastic Tale*, 1776), Friedrich Hölderlin's *Hyperion, oder der Eremit in Griechenland* (*Hyperion, or the Hermit in Greece*, 1797–1799), and Johanna Schopenhauer's two novels *Gabriele* (1819–1820) and *Die Tante* (The Aunt, 1823). In conclusion, I analyze in greater depth a novel by an author whose portrayal of the relationship between female suffering and the female voice is more unusual: Therese Huber's *Luise: Ein Beitrag zur Geschichte der Konvenienz* (Luise: A Contribution to the History of the Marriage of Convenience, 1796).

These five novels were published during a period when gender roles were both the subject of intense discussion and more immutable than they had ever been. Between 1770 and 1830, hundreds of medical, philosophical, literary, anthropological, and "moral" works redefined the female sex as the direct opposite of, rather than the complement to, the male.[3] Women's physical role in reproduction was interpreted as purely receptive and taken as a model, not only for female physiology, but for female "nature" in general. It was widely accepted that, while men were active and rational, women were passive and guided by their emotions; that, while it was for men to act upon the world, women should remain in the domestic sphere. They were naturally imbued with the modesty, propriety, and selflessness that were essential to the well-being of the family and the nation in general, and their weaker bodies and minds and tendency to ill-health were the necessary concomitants of these qualities.

The vulnerable female body was considered particularly susceptible to nervous illnesses such as chlorosis (*Chlorose*), also known in German as *Bleichsucht*. This condition, which typically affected women around puberty, involved the extreme manifestation of characteristics that at this period were considered desirably feminine. If the ideal woman, for example, was fair-skinned and slim, the chlorotic was typically deathly pale and thin. In non-medical circles, it was often attributed to unhappiness in love and referred to as "love-fever" (*Liebesfieber*) or "virgin's disease" (*Jungfernsucht*); physicians and laypeople alike agreed that sufferers were possessed of an unusual degree of "womanly" sensitivity

and emotionality. In her speaking habits, too, the chlorotic exaggerated the qualities valued in her sex: if women in general were encouraged to be reserved and modest, the chlorotic was frequently disinclined to express herself at all or was at least silent on the subject of her love. Medical writers of the period frequently remark on this symptom. Carl Gustav Carus (1789–1869), the famous scientist and physician from Dresden, writes in his *Lehrbuch der Gynäkologie* (Textbook of Gynecology, 1820) that chlorotics speak very little (1: 161), while the American physician William P. Dewees (1768–1841), whose work was translated into German, observes that they withdraw from social intercourse and are taciturn (361). In the discussion of chlorosis to be found in his popular moral-anthropological work *Betrachtungen über das weibliche Geschlecht und dessen Ausbildung in dem geselligen Leben* (Observations on the Female Sex and its Education in Society, 1802), Ernst Brandes (1758–1810) cites the lines from Shakespeare's *Twelfth Night* (1601)[4] in which Viola describes the fate of an imaginary lovelorn sister who, rather than speaking of her feelings, "lets concealment, like the worm in the bud / Feed on her damask cheek" and falls as a result into "a green and yellow melancholy" (Act 2, Scene 4). As does Viola, Brandes explains, those who suffer from chlorosis usually harbor a passion that they do not express (112).

Brandes need not have delved 200 years into the past nor into the literature of another country in order to find literary evidence for the reticence of the lovesick, wasting woman. German fiction around 1800 is littered with women suffering from a literary version of chlorosis, who either are untalkative in general, or, more commonly, refuse to speak of their love. In Hölderin's famous novel *Hyperion,* the hero comments on the disinclination to speak of his beloved, the angelic Diotima: she is "the sweet, silent one who was so reluctant to speak" (65). Diotima fades away when he leaves her to go to battle. *Siegwart: Eine Klostergeschichte* by Johann Martin Miller (1750–1814) is a highly sentimental novel that is much less well-known than *Hyperion* today but was enormously popular in its time. It is the story of a sensitive young man who enters a monastery in the mistaken belief that Marianne, the object of his affections, is dead. Only some time later, when called upon to attend her on her deathbed, does he realize his error. He soon follows her into the grave. These two are not the only sentimental deaths in *Siegwart.* Earlier in the novel, the reader learns the fate of Sophie, a young friend of Siegwart's family, who is deeply in love with him. Aware that her affection is not returned, she determines to speak of it to no-one, enters a convent, loses her voice, becomes pale and thin, and poignantly wastes away.

The three-volume novel *Gabriele* by Johanna Schopenhauer (1766–1838) is often described by critics as an *Entsagungsroman* (novel of renunciation), because it portrays in idealized fashion the life of a beautiful, reserved young woman who repeatedly sacrifices her own desires to those of others. Gabriele marries against her will to please her father. She subsequently meets and falls in love with the young nobleman Hippolit, but conceals her feelings from him until she is on her death-bed. Schopenhauer's later novel *Die Tante* (The Aunt) has a happier ending: the father of the young heroine Viktorine finally permits his daughter to marry her beloved Raimund, even though Raimund is a member of a class he despises. But he only does so because Viktorine falls seriously ill after concealing her feelings for Raimund from those around her.

As Schiesari argues is typically the case in Renaissance literature, the association between illness and silence in German fiction around 1800 is not gender-neutral. Male characters are far less likely than female ones either to grow ill as a result of unhappiness or to be silenced by their suffering. Siegwart, the hero of Miller's novel, does, it is true, grow pale and thin and eventually even waste away when disappointed in love, but not before he has given full voice to his feelings and even found success as a travelling preacher. Schiesari concludes that the silence of the sickly heroine is an example of society's gender bias written into the text, an extreme manifestation of the voicelessness from which all women suffer under patriarchy. Can the same diagnosis be applied to the sickness and the silence of Diotima, Sophie, Gabriele, and Viktorine?

In *Hyperion,* Diotima's reticence is not directly related to her illness: it is neither a precipitating factor in, nor a result of, her decline. Diotima is from the first a "quiet being" (66); it is not until later, when Hyperion departs for battle, that she begins to waste away. Her disinclination to speak is not portrayed as the result of external pressure; rather, it is valued positively as a mark of integrity. As critics such as Thomas E. Ryan have argued, Hölderlin was skeptical of language's representational ability.[5] In this novel, he suggests that the most powerful emotions are inexpressible, and that silence is therefore the most authentic response to them. When Hyperion and Diotima first meet, for example, their connection with one another is so profound that it takes place on an extra-linguistic level, and they speak very little (63). Similarly, Hölderlin suggests that the power and beauty of Nature exceed words. Hyperion criticizes himself for attempting to convey through language his delight at the beauty of Diotima's island Kalaurea

(60), and Diotima communes with her natural surroundings with sight and touch, "with eye and hand" (66) more than with words.

Diotima's reticence would seem to lend itself, then, to interpretation by the feminist critic as the active rejection of a language insufficient to express her view of the world and a superior means of communication, rather than the condition of the oppressed. But, in fact, her reticence and her physical wasting, although not in a causal relationship to one another, are both aspects of a conventional, restrictive image of femininity. Both are, first, symptoms of her extreme emotionality: she wastes away for love and cannot speak because she feels too deeply. Second, her silence is a sign that she is at one with Nature and her death is a complete return to the natural sphere. In this period, both these qualities were idealized and attributed to the female sex, and both worked against women's emancipation. While men, it was argued, were perfectible, women were complete in themselves and therefore had little need of education, which would merely disturb their natural "unity" and be incompatible with their "emotional" wisdom. Impressed by Diotima's wordlessness, Hyperion himself contrasts the wisdom that comes from learning with that which is natural and feminine, and associates the latter with silence: "What is the wisdom of a book compared with the wisdom of an angel?" he asks, adding immediately afterwards, "She always seemed to say so little, and said so much" (66). But although he admires and even tries to imitate Diotima's silence and her depth of feeling (e.g., 72), unlike her, he carries neither to a fatal conclusion. The silent, sensitive Diotima, who is described as "miraculously omniscient" (71), may represent Hölderlin's ideal for humanity in general, but she at the same time reinforces the period's ideal of passive femininity.

In *Gabriele,* Schopenhauer often uses adjectives such as "indescribable" (*unbeschreiblich*) and "inexpressible" (*unaussprechlich*). But, unlike Hölderlin, she is not thereby making a point about language's inability fully to express reality and thus motivating her heroine's refusal to speak. These adjectives, employed to excess and almost always in reference to her characters' emotional states—as for example in "an inexpressible longing" (7: 21), "an indescribable sadness" (7: 347), or the superlative "the most inexpressible sympathy" (8: 16)—function in this novel simply as conventional sentimental signifiers. When the heroine Gabriele refuses to speak about her feelings, this is, likewise, not a philosophical response to the inadequacy of language: she conceals her love for Hippolit because she is married to Moritz von Aarheim. In *Die Tante* and *Siegwart,* it is also made clear that the heroine declines to speak of a particular matter as a concession to external pressure or social convention. Viktorine has to endure "the heavy burden of enforced

silence" (13: 120) because her father will not sanction her union with Raimund; Sophie does not speak of her feelings for Siegwart because they are not returned and it was unseemly for a woman to entertain unrequited love. Their silences, far from constituting a rejection of or a resistance to patriarchal influence, must be interpreted as a surrender to it.

It does not follow, however, that the portrayal of their silence must therefore serve an unemancipatory end. On the contrary, by portraying its link with their heroines' illnesses, Schopenhauer and Miller display an insight into the workings of repression that could problematize the equation of femininity and voicelessness Scheisari suggests is present in texts she examines. A closer look at medical thinking of the period will help to illustrate this point.

Brandes, who was not a physician, uses a literary source—Shakespeare—to illustrate a point about women's illness. But the medical writers of the early nineteenth century were becoming increasingly "scientific" in their approach, which meant that where, in the past, emotional and psychological explanations for disorders had been given, they were eager to find physiological ones. The spheres of medicine and literature, then, were growing further apart. As its popular name suggests, chlorosis or "lovesickness" had traditionally been understood by physicians to be the result of unrequited affection or some other overwhelming sadness, in particular one that remained unexpressed, since feelings that were not given voice were liable to "turn in" on the sufferer and "consume" (*verzehren*) the inner self. But by 1800, this explanation was losing ground. The German physician Johann Jörg (1779-1856) does suggest in his *Handbuch der Krankheiten des Weibes* (Handbook of Woman's Diseases, 1809) that "silent and suppressed troubles" (217) may be a factor in the onset of chlorosis, while others, such as Carus, allow that unhappy love or grief may sometimes play a role (162). In general, however, physicians around 1800 were focusing more on organic disturbances in the blood system or a build-up of energies in the reproductive organs as causative factors, and mentioning silence and grief merely as symptoms. Even Brandes, although he cites lines from Shakespeare that, in keeping with the old-fashioned understanding of lovesickness, seem to ascribe an instrumental role in its development to silence, himself suggests no such causal link. Instead, he sees a lack of sexual activity as the provoking factor (111-12).

Literary authors, on the other hand, tended to stick to conventional ideas about the origins of female wasting and thus, paradoxically, to approach more closely the "new" understanding of nervous illness propounded by Freud in the late nineteenth and early twentieth centuries. Early in his career, Freud, together with his colleague Josef Breuer,

developed the theory that emotions, drives, or traumatic memories that were "repressed" sought expression in physical symptoms (see *Studies on Hysteria,* 1895). Later, in the essay entitled "Mourning and Melancholia" ("Trauer und Melancholie," 1917), he argued that the unsuccessful mourning of a lost object entailed the internalization of that object, which would then "consume" the ego of the mourner, a theory that clearly resembles the traditional notion of unhappy grieving explained above. Although there is no intimation in their fiction of an unconscious region to which feelings, memories, and losses are banned, as there is in Freud's work, Miller and Schopenhauer do suggest that the repression of an emotion through a failure to verbalize it, and the "turning in" of feelings of grief that should be directed outward, are not just the symptoms, but part of the etiology of chlorosis.

In *Siegwart,* the link between reticence and the onset of wasting is implied, rather than stated directly. Sophie's repeated, almost obsessive reference in her diary to her inability to speak of her feelings for the hero can leave the reader in little doubt that this silence has been at least a precipitating factor in her decline, although the connection is never named. "I cannot speak!" she insists twice; "I may not speak" (463-64); "I have long suffered and struggled, and not opened my mouth" (459). Schopenhauer makes the causative role of silence rather than, or in addition to, suffering in her heroines' illnesses more explicit. When Gabriele falls in love with Hippolit, she determines "completely to conceal her inner being" (9: 220). This, Schopenhauer writes, is no easy task. Gabriele's attempts to conceal "that which often filled her impassioned heart to bursting" (9: 222) have a direct negative impact on her health: "her physical strength succumbed to the immense strain" (9: 222). Most of Gabriele's friends lack insight into the cause of her decline, but when she is near death, her fatherly friend Ernesto "saw clearly in Gabriele's heart all the unexpressed pain, the burden of which had defeated it" (8: 240). In *Die Tante,* likewise, Schopenhauer attributes her heroine's illness in unequivocal terms to the pressure of keeping her feelings to herself: "Thus the violent forcing back of the feelings of sorrow and anxiety about her loved one, which dominated her completely, had alone brought her to the brink of the grave" (13: 120). Viktorine's governess, like the novel's narrator, demonstrates an awareness of the role of self-expression in the maintenance of good health: "If only she had confided in me," she sighs, "but instead she said nothing and wept, and wept and said nothing, and now she's lying there" (13: 17).

In light of the fact that the failure of these heroines to express themselves makes them ill and that silence is imposed on rather than freely chosen by them, it could be argued that Miller and Schopenhauer

avoid the essentialist association of the female sex with silence. But their agenda in depicting the workings of repression is not, ultimately, an emancipatory one. The heroines' voicelessness may be the result of social convention or imposed by their parents, and may be unhealthy, but it is nevertheless not called into question. It is portrayed, rather, as part of their "natural" destiny as women, or as Frau von Willangen, Gabriele's trusted friend and a reliable moral authority, puts it, quoting from the same speech by Shakespeare's Viola to which Brandes refers: "Shakespeare's 'Smiling at grief' is more or less the lot and the virtue of the best of all our sex; we are born for it" (8: 22–23).

The illnesses that result from such "feminine" behavior are not a device to illustrate critically the detrimental nature of contingent dictates of femininity: on the contrary, they are aestheticized and, in the case of *Gabriele* at least, presented as inevitable. Schopenhauer may suggest that repression contributed to Gabriele's early decline, but she also indicates that it was fated to happen: her heroine was born with only a "weak spark of life" and always had "something ethereal" about her (7: 40). Both Gabriele and Miller's Sophie are reconciled to, even look forward to death; neither suffers much pain; and Gabriele even grows more beautiful the more ill she becomes. When, in the later stages of their decline, both heroines lose their voices, the pathos of their decline is heightened. Like Schopenhauer's frequent use of adjectives such as "inexpressible," their loss of voice may also suggest that words are insufficient to express intense emotional states, but this, once again, is more a conventional sentimental trope used to point up the heroines' exemplary sensitivity than part of a sustained critique of the language system.

If neither Miller's, Schopenhauer's, nor Hölderlin's portrayal of female silence can be read as emancipatory, what are we to make of their representation of women's self-expression? Although Sophie, Gabriele, Viktorine, and Diotima all refuse to speak on certain occasions or of certain subjects, the argument that their authors do not intend this to represent a radical rejection of language is reinforced by the fact that each heroine, at other times, uses words to communicate at length and with conviction. Diotima expresses herself through song, while Sophie, Gabriele, and Viktorine all hold forth at some length to the loved ones attending them in their sickness. Viktorine also writes a lot in her grief (13: 31), although the reader does not learn what, or to whom, her text is addressed. Sophie writes fervently in her diary, while Diotima is a prolific letter-writer; in both cases, their words are addressed to and grieved over by their beloved ones.[6] Their illnesses, then, although generally caused by silence and/or causing a further loss of voice, at the same time provide them with an impetus for communication and an

attentive audience for their words. Could the link between illness and the female voice in fiction around 1800, then, in fact be interpreted in a more positive light than has hitherto been suggested? Could the heroine's illness, for example, be read as conducive to linguistic creativity, as Schiesari argues regarding the melancholia of *male* characters in Renaissance literature? Once again, an examination of the medical context will shed light on the significance of the sickly heroines' behavior.

When, in Schopenhauer's *Die Tante,* Viktorine becomes ill because she is forbidden to voice her anxieties, her doctor recommends quiet and repose to conserve her energies in an early version of Weir S. Mitchell's infamous "rest cure," commonly prescribed for nervous women in Europe and North America in the second half of the nineteenth century. But Viktorine persuades Anna, the aunt of the novel's title, to listen to her confession of her love and her fears, and speedily recovers. This, the narrator explains, is not only because Anna is able to assure Viktorine that Raimund, her loved one, is not going to leave, as Viktorine has feared he would, but also because speaking allows her "to pour out all the feelings in her heart, which was overflowing with fear and love" (13: 120). In direct opposition to the course of action suggested by the physician, then, Anna effects an early talking cure, albeit of a much less sophisticated nature than that of Freud, whose hysterical patients brought a repressed emotion into consciousness as they brought it into words and thereby relieved symbolically related symptoms.

The fact that Viktorine recovers as a result of self-expression makes this novel an exception in its period, however. Certainly, in analogy with the traditional medical notion that fluids that have built up inappropriately inside the body can be relieved by a process such as bloodletting, the majority of wasting heroines around 1800 experience self-expression through speech and writing as a welcome relief. Gabriele, for example, is "delighted, gladdened" (9: 266) when she tells Hippolit she loves him, and Diotima, who is "full of sighs" when she begins a letter to Hyperion, is "pure joy" (123) by the time she has completed it. But in these and in most cases, the heroine's speaking or writing does not lead to her recovery; it does not, therefore, prevent her ultimate silencing through death. On the contrary, what she delivers is a "swansong"—an image employed both in *Gabriele* (9: 250) and *Hyperion* (158) [7]—only able to speak freely because her death is certain and the desires she expresses pose no threat. "Let me speak to you after death!" (459), insists Sophie in the diary that she addresses to Siegwart; and "My life was silent; my death is loquacious" (161), Diotima tells Hyperion. It is Gabriele, however, who formulates most clearly the relationship between the heroine's approaching death and her license to

express herself, telling Hippolit, "She who is dying may confess that which it was her stern duty, while she lived, to bury deep in her heart in unutterable pain" (9: 265-66).

In fact, far from inducing recovery, the loquacity and/or prolificity that follows or accompanies the taciturnity of the late eighteenth- and early nineteenth-century wasting heroine is in most cases the literary manifestation of a pathological trait. Freud's hysterics may sometimes have suffered from a *loss* of voice, but in the medical textbooks of around 1800, hysteria was more commonly associated with verbosity. Like chlorosis, hysteria—a nervous condition to which medical historians and literary critics alike have devoted much attention in recent years[8]—was particularly prevalent among young, single women and was often attributed by the medical profession to sexual frustration. But if the chlorotic was characterized by introversion, withdrawal, and a disinclination to speak, the hysteric was typically extremely extroverted and eager to talk. Carus writes that she is given to excessive singing, speaking in verses, telling her doctor at length about her pains, and "exceptional talkativeness" in general (235). Jörg agrees that hysterics frequently become "very talkative," particularly when it comes to speaking of their suffering (265), and the French medical writer Pierre-Jean-Georges Cabanis (1757-1808), whose *Rapports du physique et du moral de l'homme* (Relations between the Physical and the Moral in Man, 1802) was published in German in 1804, notes that when suffering from attacks of "vapors," women often acquire great eloquence (French edition 1: 322). It was not until Freud, however, that it occurred to the medical profession that the hysteric's words might be worth listening to. Carus argues that her complaints are simply an attempt to elicit admiration, and Jörg dismisses half of them as "imaginary" (265). Dewees entreats the physician to be patient when the hysteric speaks, but only because he will otherwise lose her confidence, not because she has anything important to say:

> One should never appear impatient when the patient tells us at great length the history of her pains and her torments, because there is nothing to be gained from attempting to induce her to brevity, but much to be lost if she believes that we are ignoring her complaints (171-72).

If, as has been argued, the pathological and the "normal" feminine at this period existed next to one another on the same continuum, and if the chlorotic's aphasia stood in exaggerated fashion for women's voicelessness in society, then the excessive talking of the hysteric can be seen as a parody of the ordinary woman's supposed relationship to

language. The ideal woman may have been modest and reserved, but it was widely accepted in medical and lay circles that women were naturally loquacious, because they lacked the self-control to select and restrict their words. Kant (1724–1804) speaks in his *Beobachtungen über das Gefühl des Schönen und Erhabenen* (*Observations on the Feeling of the Sublime and the Beautiful,* 1764) of their "cheerful talkativeness" and warns against telling them any secrets, since they do not have the power to keep them (855). The French physician Pierre Roussel (1742–1802), whose medico-philosophical work on the female sex of 1775 was translated into German as *Physiologie des weiblichen Geschlechts* (Physiology of the Female Sex) in 1786, argues that women naturally have "a greater facility of speech than men" (19). Jörg writes that women tend to "chattiness" and are often guilty of the "fault of gossiping," and provides a wholly unconvincing "scientific" explanation: their smaller lungs and narrower thoracic cavity mean that they cannot hold their breath for long periods of time, and they are thus also unable to "hold back" their words. The things said by "healthy" women, like those said by the hysteric, were considered unlikely to be of any value or to be structured properly. Jörg remarks that their lack of verbal control means that they will never be good orators (75–76).

Women's written use of language was viewed in the same light as their speech. It was maintained that they were incapable of producing great literary works, because they could exercise no shaping power over their writing, but only "pour out" their feelings directly onto paper. As Brandes puts it, "they have to pour out their sentiments at the moment they are actually experiencing them" (3: 8).[9] Men, it was generally accepted, could write in order to change the world or create an aesthetic object, but when women wrote, their motives were personal, emotional, and "unartistic." The majority of women writing around 1800 themselves accepted this view, at least outwardly. As Magdalene Heuser writes, prefaces to novels by women typically included disclaimers of any aesthetic value (56–57). Women writers also frequently insisted on the predominant role played by feeling rather than reason in the composition of their novels. Fanny Tarnow, for example, insists in a dedication entitled "Den mir Wohlwollenden" (To those who wish me well, 1830) that in her works she lays "no claim to literary talent," and asserts, "My feelings were my muse" (quoted in Wägenbaur 97). If, as Schiesari argues, the silencing of women in grief was a consequence of patriarchy's devaluation of woman as artist, so, in the late eighteenth and early nineteenth centuries, was the ascription to the female sex of particular volubility in speech and in writing.

But Schiesari's argument that, on the rare occasions when the female literary melancholic of the Renaissance does speak, her laments "typically come across as mere chatter and thus as less dignified than the ranting of a Hamletian nobleman" (55) does not apply to the novels discussed here. Unlike those female patients treated by physicians such as Carus and Dewees, the heroine of the late eighteenth- and early nineteenth-century German novel, whose chlorotic silences alternate with hysterical (or, in other words, typically womanly) periods of loquacity or prolific writing, is listened to. Indeed, the message of abiding, self-sacrificing love she proclaims, far from being mere "chatter," is held up as an ideal in the text, and her gradual wasting death is one of its most "dignified" aspects. Not even the hero, typically, can emulate her.[10]

But this is precisely the point: the heroine expresses herself in an overwhelmingly "feminine" manner, speaking at some length, and in sentimental, often extreme, terms of feelings that prove to be the death of her. Her words are presented as the spontaneous "outpourings" of her soul. The reader does not hear Viktorine's words to her aunt in Schopenhauer's *Die Tante,* but he/she knows that she speaks exclusively of her feelings for Raimund, and the verb *ausschütten* (to spill/pour out) is used to describe the manner in which they are delivered. Diotima's favorite medium is the "feminine" medium of song; when she writes to Hyperion, she does so in poetic style, telling of her feelings for him and for Nature, of her decline and approaching death. Like Diotima and like those hysterical women observed by Carus, Gabriele, as she approaches death, takes to singing, delivering "an irregular song, inspired by the enthusiasm of the moment" (9: 250), in which she communicates her hopes, longings, and expectations to her loved ones. Sophie's diary is a repetitive, seemingly unstructured piece of writing, littered with dashes, exclamations, "Ach"s and "O"s, examples of apostrophe and images, often drawn from nature, which she uses to describe her emotions (2: 458–74).

It is clear that, although the wasting heroines of the novels from around 1800 examined here are neither completely silenced nor ignored, they nevertheless reinforce predominant, restrictive models of femininity. Their speaking and writing, like their silence, are more pathological female symptom than healthy self-expression. Certain feminist critics have interpreted the non-rational, fluid style of sentimental writing as a rejection of the constraints of patriarchal order, as an early example, even, of *écriture féminine,*[11] but in the speaking and writing of the characters Sophie, Diotima, Viktorine, and Gabriele, it is hard to see anything but faithful adherence to patriarchy's rules for female self-expression. While they are pouring out their souls in a passive,

unstructured manner and expiring their last, male characters are speaking in controlled ways conducive to their acting on the world.

One novel from this period offers a very different perspective on the role of self-expression in women's health, however. In *The Madwoman in the Attic* (1979), Sandra Gilbert and Susan Gubar argue that nineteenth-century British women novelists often express their discontent at their status in society through the depiction of minor, "mad" female characters such as Mr. Rochester's first wife in Charlotte Brontë's *Jane Eyre* (1847). In Therese Huber's (1764–1829) *Luise: Ein Beitrag zur Geschichte der Konvenienz* (1796), the "madwoman" is not relegated to an attic and a secondary role, as was the first Mrs. Rochester, but is given center stage and allowed to document in detail the wrongs that society has inflicted on her.[12] *Luise* tells the unhappy, at times brutal story of a young woman's engagement and disastrous marriage to a man chosen for her by her mother. The eponymous heroine develops hypochondria, a disease common in the eighteenth century, which was believed by many to be of nervous origin and which manifested itself in a variety of physical and psychological symptoms. Luise suffers most, however, not as a result of her illness, but because of the violent or sometimes even sadistic treatment she receives at the hands of her husband, her family, and their servants, often in the name of a cure. The novel relates how she is starved, force-fed, deprived of water, locked up in a succession of different rooms, beaten, and on one occasion, taken outside, stripped naked, tied up, whipped with a birch until her blood colors the bushes and briars around her, and taken for dead (108–10). This physical torment is accompanied by a wealth of emotional abuse. Luise tries continually, almost obsessively, to be a good wife, a good daughter, and, after she gives birth to a baby girl, a good mother, but her efforts are thwarted at every turn by her unfeeling family. As a married woman who is relatively poor, however, no other roles are open to her. From this summary, the novel would seem, as critic Lydia Schieth suggests, to be "explosive stuff" (190).

But the accusatory power of Luise's account is complicated by the novel's lengthy preface, in which a male editor gives an account of the genesis of the novel and advises the reader how to read it. Luise was lucky enough, he writes, to have "a physician very worthy of esteem" (iii), who was of the belief that the body cannot be cured unless the soul is as well. Like Viktorine's aunt in Schopenhauer's *Die Tante,* but unlike Viktorine's physician, Luise's physician appreciated the importance of giving verbal expression to emotion. He suggested that Luise write down the story of her suffering, in the hope that this would help her to come to terms with it:

Because it was impossible for her imagination to part with the black images of her past, he thought they could at least be kept within bounds if she could exert her reason at the same time to form a real and coherent whole from her fickle ideas (iv).

Unfortunately, the editor writes, the attempted cure was unsuccessful. Rather than helping Luise to gain control of her morbid imaginings, he explains, "this task on the contrary entrenched the thought and the expectation of death deeper in her heart" (v), for Luise lacked the "strength" to stop herself from dwelling on her pain (ix). Soon after composing her story, she died. He now offers it to the public to read, but recommends that they do so with a certain skepticism. Since Luise's reason was not sound when she wrote it, she was not the most competent judge of events (vii), and in any case, the most superficial understanding of psychology should be sufficient to encourage readers "to employ certain general cautionary rules when reading any biographies written by their own heroes" (xi). Had Luise's husband, for example, been in the habit of brooding over events, like his unhappy wife, then he would certainly have presented a different view of things. However, this is not, the editor insists, to suggest that the reader should withhold sympathy from the unfortunate protagonist. He writes that there can be no doubt that she has suffered greatly, even if her ascription of blame is misguided. The preface concludes with the suggestion—commonly found in prefaces to novels by women around 1800 (Heuser 57)—that the publication of the text is justified on didactic grounds. Luise's account may be biased and it may have failed in its therapeutic aim, but the editor hopes that it will encourage readers to evince more pity for those who suffer a similar fate and perhaps even prevent arranged marriages from taking place in the future (xxiv).

How are we to interpret this preface? At first, it seems to offer a more progressive understanding of women's self-expression than is present in those works examined thus far. Luise's physician not only believes that a patient's putting her suffering into words can contribute to psychological recovery, he also contradicts the popular view that women are incapable of imposing structure on their speech or their writing. Far from simply recording her thoughts and memories on paper as they occur to her, Luise, he suggests, should as she writes employ that unfeminine faculty, her reason, to construct "a coherent whole." In this, it could be argued, his conception of the talking cure—or, in this case, the writing cure—is more emancipatory even than Freud's, for Freud's female hysterics were expected to deliver up their emotions and recollections in stream-of-consciousness, fluid, typically "feminine"

style to an authority figure, the psychoanalyst, who himself undertook to fashion them into coherent narratives to be imposed on the patients (see Freud and Breuer, *Studies on Hysteria*). But in this preface the fictional editor of *Luise* also informs the reader that this enlightened cure is unsuccessful and that Luise proves unable to ward off her obsessional thoughts. Luise, he suggests, is too psychologically weak to compose the balanced account her physician proposes. Moreover, he undermines her point of view by insisting that her presentation of events is one-sided. Like the words of Rosalie, Gabriele, Sophie, and Diotima, Luise's story, he proposes, is a feminine, subjective account, for all her physician's insistence that she exercise artistic control over it.

According to Schieth, the preface was composed by Huber's editor in order to temper the novel's incendiary potential. But other critics, such as Heuser, are surely right to see Huber as its author. Are we to assume, then, that Huber herself wanted to weaken the impact of her heroine's words? Like the physician Dewees, she seems to be recommending that the madwoman's point of view, although it deserves to be heard, should be given little credence. Heuser writes that Huber often composed long, explanatory prefaces when the content of a novel was particularly unusual or daring (Heuser 61). Did she hope by means of this preface to render her novel more acceptable to a conservative reading public?

By adding the preface, Huber may have facilitated the publication of her novel. But it does not ultimately muffle the heroine's voice or obscure the controversial nature of the work. The fictional editor attempts to undermine the validity of Luise's narrative through his reference to her unstable mental state and to the precarious nature of truth in autobiography, but the reader does not necessarily persist in reading it as a biased account. The editor has, after all, encouraged the reader to approach the text with understanding if he/she is a true "philanthropist" (*Menschenfreund* xi). In the course of reading the novel, as the reader's striving to "understand" Luise's point of view becomes an acceptance of it, his/her allegiance is transferred from editor to supposed author.

There are several reasons for this. The reader may have been warned to exercise caution when reading life-stories composed by their protagonists, but Luise employs the third rather than the first person to narrate her story, which lessens the awareness of its autobiographical nature, and therefore its supposed lack of objectivity. As Schieth comments, what the reader is in fact presented with is not the immediate first-person narrative ("distanzlose Ich-Erzählung") for which he/she has been prepared, but an objective third-person narrative (191). Given that

it is nevertheless told from Luise's perspective, it is difficult to suspend belief in her version of events. She describes more than one occasion on which people around her insist that she is mentally unwell in order to discredit her words or her point of view and to advance their own interest. When, for example, her chambermaid hits her and Luise tells her husband, the chambermaid convinces him that Luise is suffering from delusions (92).[13] The reader is aware each time that Luise is in the right. The editor's bid to dictate the reader's response is mirrored, then, within the text, and its authority thereby called into question.

Furthermore, the novel, though free neither from stylistic inconsistencies,[14] nor from the occasional sentimental cliché,[15] differs from most of the fiction written by women around 1800 and from much of that written by men in its emphasis on the description of events rather than feelings, its attention to the more sordid aspects of life, and its relatively controlled, succinct style: in other words, in its "realism." Karl Gutzkow identified this aspect of Huber's writing when he commented in 1836, "Frau Huber by no means belongs amongst the gossiping tea-drinking crowd of our weak-nerved lady authoresses, with her you have something solid, something real" (228). Unlike the verbal or written outpourings of the heroines discussed above, the impression created by *Luise* is not one of subjective feminine fluidity. It is not surprising that as her career progressed, Huber, unlike most of her peers, increasingly laid claim to aesthetic value in her fiction instead of propagating the myth of spontaneous, unartistic female authorship (see Heuser 62, 64).

But the question remains: why, if Luise manages not only to express herself, but to do so in a masculine, "objective" manner, does her health deteriorate even further? Given that she ends up dead, can it still be claimed that the novel makes an emancipatory point in its depiction of female self-expression? Is Huber not thereby after all reinforcing the notion so dear to late eighteenth- and nineteenth-century physicians that intellectual activity in women, although not inconceivable, runs contrary to their physiological constitution?

Luise, as suggested above, portrays the practical aspects of and difficulties in women's lives. Luise is revealed in concrete ways to be the victim of patriarchal society. She receives little education, is denied autonomy over her own body and over her finances, and has her daughter taken from her by the courts. The ideology of this society is shown to determine not only external social structures but also the way individuals interact in their familial and personal relationships: her brothers and husband treat her as an inferior, while her mother consistently privileges her sons over her. The novel lays bare the disastrous effects of this kind of discrimination: Luise's husband spends all their

money and takes a mistress, their marriage disintegrates, and her health is destroyed. That she dies despite undergoing the progressive cure prescribed by her physician is not intended to imply that writing is unhealthy for women: rather, it serves to underline the fact that such suffering as Luise experiences cannot be relieved merely by giving it expression. Neither, the novel makes clear, is it the eternal, "poetic" lot of womanhood. Rather, it is portrayed as preventable through social and political change.

Huber's view of the role of self-expression is indeed more radical, then, not only than that of her contemporaries, but also than that of Freud. Freud's hysterical patients were typically highly intelligent women to whose talents society granted no outlet, but rather than suggesting a change to the material conditions of their lives, Freud saw the simple opportunity to voice their repressed feelings as an adequate solution. Putting one's suffering into words can, of course, serve a political end, but only when it goes beyond the level of personal therapeutic process and finds an audience in whom it inspires the urge for action. This, and not the portrayal of a writing cure in action, is the real intention behind Huber's novel. When the reader is told in the preface, then, that the aim of the publication is to encourage readers to act differently, this should not, in fact, be read as the conventional, formulaic gesture of a woman writer around 1800 justifying her writing by asserting its morally edifying effect, but as a genuine assertion of the potentially radical power of women's self-expression.

Notes

Unless otherwise indicated, all translations from original German texts are mine.

[1] See, for example, Stout; Fishkin and Hedges; Laurence.

[2] See Cixous and Clément (95); Ellman (72); Weber (39–40).

[3] See Honegger for a discussion of this development.

[4] Date of first performance. *Twelfth Night* was first published in 1623.

[5] In *Hölderlin's Silence,* Ryan writes of Hölderlin's "acute awareness of language's frequent inadequacy and superfluity" (148).

[6] The most famous example of a prolific wasting woman is, of course, Richardson's *Clarissa* (1747–48). See Ellman's *The Hunger Artists* (1993) for a discussion of the links between Clarissa's writing and her starving and for a fascinating analysis of the connections—literary, psychoanalytical, and historical—between food refusal and writing in general. The French model

for many nineteenth-century wasting heroines, Germaine de Staël's Corinne (*Corinne, ou l'Italie,* 1807), a poet whose voice fails her in her last hours, composes a moving poetic address as she is dying, which is recited by someone else.

[7] The address composed by de Staël's Corinne is also described as her "swansong" ("chant du cygne," 581).

[8] See, for example, Smith-Rosenberg; Showalter; Weber; Veith.

[9] On women's inability to write works of genius, see also Jörg (75); Campe (I: 89); Mauvillon (Chapter 2).

[10] As Walter Silz writes, "Diotima embodies the ideal toward which the whole book tends" (49).

[11] See, for example, Jirku (55–88).

[12] In an essay on Huber, Jeannine Blackwell entitles her section on *Luise* "The Madwoman in the Pantry" (1992).

[13] See also 83, 118, 194–97.

[14] For example, there are sometimes jarring switches from past to present tense (17, 19) and unnecessary repetition (14–15).

[15] For example, "The still of the night, the magical moonlight that painted the shadow of the black cross along the green grass, or silhouetted on the white gravestones the quivering leaves of tall lime trees, the blossoming branches of which filled the air with the sweetest scent, the peace of Nature united with the silence of death, all moved Luise's sensitive heart" (32).

Works Cited

Blackwell, Jeannine. "Marriage by the Book: Matrimony, Divorce, and Single Life in Therese Huber's Life and Works." *In the Shadow of Olympus: German Women Writers around 1800.* Ed. Katherine R. Goodman and Edith Waldstein. Albany: State U of New York P, 1992. 137–56.

Bordo, Susan. "The Body and the Reproduction of Femininity." *Writing on the Body: Female Embodiment and Feminist Theory.* Ed. Katie Conboy, Nadia Medina, and Sarah Stanbury. New York: Columbia UP, 1997. 90–110.

Brandes, Ernst. *Betrachtungen über das weibliche Geschlecht und dessen Ausbildung in dem geselligen Leben.* 3 vols. Rev. ed. of *Über die Weiber.* 1787. Hannover: Gebrüder Hahn, 1802.

Brontë, Charlotte. *Jane Eyre: An Autobiography.* London: Smith, Elder, and Co., 1847.

Cabanis, Pierre-Jean-Georges. *Rapports du physique et du moral de l'homme* (1802) [Published in German as *Über die Verbindung des*

Physischen und Moralischen in dem Menschen. Aus dem Französischen übersetzt und mit einer Abhandlung über die Grenzen der Physiologie und der Anthropologie versehen von Ludwig Heinrich Jakob. Halle, 1804], 2 vols. Paris: Béchet jeune, 1824.

Campe, Joachim Heinrich. *Väterlicher Rath für meine Tochter: Ein Gegenstück zum Theophron. Der erwachsenern [sic] weiblichen Jugend gewidmet*. 1789. Braunschweig: Schulbuchhandlung, 1809.

Carus, Carl Gustav. *Lehrbuch der Gynäkologie, oder systematische Darstellung der Lehren von Erkenntniß und Behandlung eigenthümlicher gesunder und krankhafter Zustände, sowohl der nicht schwangern, schwangern und gebärenden Frauen, als der Wöchnerinnen und neugebornen Kinder*. 2 vols. Leipzig: Fleischer, 1820.

Clément, Catherine, and Hélène Cixous. *The Newly Born Woman*. Trans. Betsy Wing. Minneapolis: U of Minnesota P, 1986.

Dewees, William P. *Die Krankheiten des Weibes*. First published in English as *A Treatise on the Diseases of Females*. 1824. Trans. Dr. A. Moser. Berlin: Rücker & Püchler, 1837.

Dixon, Laurinda S. *Perilous Chastity: Women and Illness in Pre-Enlightenment Art and Medicine*. Ithaca: Cornell UP, 1995.

Duden, Barbara. *The Woman Beneath the Skin: A Doctor's Patients in Eighteenth-Century Germany*. Trans. Thomas Dunlop. Cambridge: Harvard UP, 1991.

Duffin, Lorna. "The Conspicuous Consumptive: Woman as Invalid." *Nineteenth-Century Woman: Her Cultural and Physical World*. Ed. Sara Delamont and Lorna Duffin. London: Croom Helm, 1978. 26–56.

Ellman, Maud. *The Hunger Artists: Starving, Writing and Imprisonment*. London: Virago, 1993.

Fishkin, Shelley Fisher, and Elaine Hedges, eds. *Listening to Silences: New Essays in Feminist Criticism*. New York: Oxford UP, 1994.

Fischer-Homberger, Esther. *Krankheit Frau und andere Arbeiten zur Medizingeschichte der Frau*. Bern: Huber, 1979.

Freud, Sigmund, and Joseph Breuer. "Studies on Hysteria." *The Standard Edition of the Complete Psychological Works of Sigmund Freud*. Ed. James Strachey, in collaboration with Anna Freud. London: Vintage, 2001. Vol. 2.

Freud, Sigmund. "Mourning and Melancholia." 1917. Vol. 14: 237–58.

———. "Femininity." Vol. 22: 112–35.

Gilbert, Sandra M., and Susan Gubar. *The Madwoman in the Attic: The Woman Writer and the Nineteenth-Century Literary Imagination*. New Haven: Yale UP, 1979.

Gutzkow, Karl. *Beiträge zur Geschichte der neuesten Literatur*. 1836. Stuttgart: Balz, 1839.

Heuser, Magdalene. "'Ich wollte dieß und das von meinem Buche sagen, und gerieth in ein Vernünfteln': Poetologische Reflexionen in den Romanvorreden." *Untersuchungen zum Roman von Frauen um 1800.* Ed. Helga Gallas and Magdalene Heuser. Tübingen: Niemeyer, 1990. 52-65.

Hölderlin, Friedrich. *Hyperion, oder der Eremit in Griechenland.* 1797-1799. *Sämtliche Werke und Briefe in drei Bänden.* Ed. Jochen Schmidt. Frankfurt a.M.: Deutscher Klassiker Verlag, 1992-1994. Vol. 2.

Honegger, Claudia, *Die Ordnung der Geschlechter: Die Wissenschaften vom Menschen und das Weib 1750-1850.* Frankfurt a.M.: Campus, 1991.

Huber, Therese. *Luise: Ein Beitrag zur Geschichte der Konvenienz.* 1796. Hildesheim: Olms, 1991.

Jirku, Brigitte E. *"Wollen Sie mit Nichts...ihre Zeit versplittern?": Ich-Erzählerin und Erzählstruktur in von Frauen verfassten Romanen des achtzehnten Jahrhunderts.* Frankfurt a.M.: Peter Lang, 1994.

Jörg, Dr. Johann Christian Gottfried. *Handbuch der Krankheiten des Weibes, nebst eine Einleitung in die Physiologie und Psychologie des weiblichen Organismus.* 1809. 2nd. ed. Leipzig: Cnobloch, 1821.

Kant, Immanuel. "Beobachtungen über das Gefühl des Schönen und Erhabenen" (1764). *Werke in sechs Bänden.* Ed. Wilhelm Weischedel. Wiesbaden: Insel, 1960. 1: 821-84.

Laurence, Patricia. "Women's Silence as a Ritual of Truth: A Study of Literary Expressions in Austen, Brontë, and Woolf." Fishkin and Hedges. 156-67.

Mauvillon, Jakob. *Mann und Weib nach ihren gegenseitigen Verhältnissen geschildert: Ein Gegenstück zu der Schrift "Über die Weiber."* Leipzig: Dykische Buchhandlung, 1791.

Miller, Johann Martin. *Siegwart: Eine Klostergeschichte.* 1776. 3 vols. Leipzig: Weygandsche Buchhandlung, 1777.

Moreau de la Sarthe, Jacques-Louis. *Histoire Naturelle de la Femme, suivie d'un Traité d'hygiène appliqué à son régime physique et moral aux différents époques de sa vie.* 3 vols. [Published in German as *Naturgeschichte des Weibes.* Leipzig, 1810] Paris: L. Duprat, Letellier, et comp., 1803.

Richardson, Samuel. *Clarissa, or the History of a Young Lady.* 7 vols. London: Printed by S. Richardson, 1747-1748.

Roussel, Pierre. *Système Physique et Moral de la Femme ou Tableau Philosophique de la Constitution, de l'État organique du Tempérament, des Moeurs et des Fonctions propre au Sexe.* 1775 [Trans. into German as *Physiologie des weiblichen Geschlechts.* Berlin, 1786]. Paris: Crapart, Caille et Ravier, 1803.

Ryan, Thomas E. *Hölderlin's Silence.* New York: Peter Lang, 1988.

Schiesari, Juliana. *The Gendering of Melancholia: Feminism, Psychoanalysis, and the Symbolics of Loss in Renaissance Literature*. Ithaca: Cornell UP, 1992.
Schieth, Lydia. *Die Entwicklung des deutschen Frauenromans im ausgehenden achtzehnten Jahrhundert: Ein Beitrag zur Gattungsgeschichte*. Frankfurt a.M.: Peter Lang, 1987.
Schopenhauer, Johanna. *Gabriele*. 1819/1820. *Sämmtliche Schriften*. 24 vols in 12. Leipzig: Brockhaus, 1834. Vols. 7, 8, 9.
―――. *Die Tante*. 1823. *Sämmtliche Schriften*. Vols. 13, 14.
Shakespeare, William. *Twelfth Night*. [1623]. Ed. Rex Gibson. Cambridge: Cambridge UP, 1993.
Showalter, Elaine. *The Female Malady: Women, Madness and English Culture 1830–1980*. London: Virago, 1987.
―――. "Feminist Criticism in the Wilderness." *The New Feminist Criticism: Essays on Women, Literature and Theory*. Ed. Showalter. London: Virago, 1986, 243–70.
Silz, Walter. *Hölderlin's "Hyperion": A Critical Reading*. Philadelphia: U of Pennsylvania P, 1969.
Smith-Rosenberg, Carroll. "The Hysterical Woman: Sex Roles and Role Conflict in Nineteenth-Century America." *Disorderly Conduct: A Vision of Gender in Victorian America* [1985]. Oxford: Oxford UP, 1986. 197–216.
Staël, Germaine de. *Corinne ou l'Italie*. 1807. Paris: Gallimard, 1985.
Stout, Janis P. *Strategies of Reticence: Silence and Meaning in the Works of Jane Austen, Willa Cather, Katherine Anne Porter, and Joan Didion*. Charlottesville: UP of Virginia, 1990.
Tarnow, Fanny. *Novellen*. Leipzig: Carl Fock, 1830.
―――. "Den mir Wohlwollenden" (dedication). *Auswahl aus Fanny Tarnows Schriften*. Leipzig: Focke, 1830. 1.
Veith, Ilza. *Hysteria: The History of a Disease*. Chicago: U of Chicago P, 1965.
Wägenbaur, Birgit. *Die Pathologie der Liebe: Literarische Weiblichkeitsentwürfe um 1800*. Berlin: Erich Schmidt, 1996.
Weber, Lilo. *"Fliegen und Zittern": Hysterie in Texten von Theodor Fontane, Hedwig Dohm, Gabriele Reuter und Minna Kautsky*. Bielefeld: Aisthesis, 1996.

The Reception of the Bluestockings by Eighteenth-Century German Women Writers

Hilary Brown

Enlightenment Germany had no contemporary equivalent to the English Bluestocking circle: a network of well-regarded, scholarly women who sought to further women's interests through their social and literary activities. The impact of the Bluestockings and their writings on German women writers is assessed here for the first time, with specific reference to Sophie von La Roche (1730–1807) and Julie Clodius (1750–1805). La Roche and Clodius translated Bluestocking texts for the particular benefit of their countrywomen. They were careful to present their translations in a manner that would make them acceptable to their day while, crucially, not sacrificing all of the feminist ideals that the English texts express. (HB)

Compared to their counterparts in other European countries, women in Enlightenment Germany made only tentative appeals for education and autonomy. Germany lacks beacons of early feminism such as Mary Astell (1666–1731), Olympe de Gouges (1748–1793), and Mary Wollstonecraft (1759–1797). Nonetheless, the rise of the woman writer in the second half of the eighteenth century coincided with an increase of interest in European culture among the privileged classes in Germany. Visits abroad became popular for both men and women of means. Travel literature and translations from French, English, Italian, and Spanish constituted an ever-larger portion of the literary market. It is not surprising that women writers were influenced by this cosmopolitan outlook and took particular note of the situation of their sex among other nations.

I want to consider here how two women, Sophie von La Roche (1730–1807) and Julie Clodius (1750–1805), responded to the English Bluestocking circle. Both La Roche and Clodius wrote about the erudite Englishwomen and translated their work. An examination of the role

played by La Roche and Clodius in the reception of the Bluestockings will demonstrate how women writers in Germany looked to pre-eminent women in other countries as they themselves gained opportunities to enter a more public sphere. La Roche and Clodius framed the Bluestocking texts in certain ways to make them accord better with less liberal attitudes toward learned women prevalent in their own country. However, not all the feminist impact of the texts is lost. Most significantly, La Roche and Clodius underline the possibilities for female intellectual community and female intellectual tradition both abroad and at home. This constitutes evidence of a feminist consciousness impinging on women in Germany at an earlier stage than might be expected.

* * *

The Bluestockings have been the focus of much research in recent years (e.g., Myers; Kelly) and it is important, first of all, to summarize the distinctiveness of their achievements and to define their particular brand of feminism. The Bluestockings emerged in the 1750s as a group of predominantly single or widowed middle- and upper-class women who strove to play a part in the intellectual life of the day. Their activities were centered around the London salons of Frances Boscawen (1719–1805), Elizabeth Vesey (?1715–1791), and the so-called 'Queen of the Blues' Elizabeth Montagu (1720–1800). Members of both sexes met in a strictly platonic spirit to substitute rational conversation for the more trivial pastimes usually expected of society ladies. This set their assemblies apart from the erotically charged salon model of seventeenth-century France. The women kept company on equal terms with men such as Samuel Johnson, David Garrick, Edmund Burke, Horace Walpole, and Joshua Reynolds.[1]

The name 'Bluestocking' seems to have been first associated with Benjamin Stillingfleet, who attended the gatherings in stockings made from blue worsted instead of the conventional black or white silk. It came to denote a symbolic rejection of accepted social expectations for women, and members of the group later referred to their "blue stocking doctrine" and "blue stocking philosophy" (Myers 8). Beyond the social meetings in London, the women established an extensive network of contacts that they maintained through visits and correspondence. They encouraged each other to publish and also acted as patrons of both male and female writers. The poet William Cowper, for example, endeavored to ingratiate himself with Elizabeth Montagu through his poem "On Mrs Montagu's Feather Hangings." Montagu did indeed underwrite his *Iliad* project by signing a subscription list for the translation and sending him

an encouraging letter (Kelly, *Bluestocking Feminism* 1: lxiv). Some of the Bluestockings were active in public life, notably as philanthropists who were particularly eager to help less fortunate women.[2]

The Bluestockings published a range of works, despite inhibitions about entering a male-dominated realm and earning money through their pens.[3] For example, the famed polyglot Elizabeth Carter (1717–1806) produced annotated translations of French and Italian criticism (both 1739), the first complete English version of Epictetus (1758), and two collections of her own poems (1738 and 1762). Montagu's main production was her *Essay on the Writings and Genius of Shakespear* (1769), which defended the national bard against attacks by Voltaire. Montagu persuaded Hester Chapone (1721–1801) to publish her *Letters on the Improvement of the Mind: Addressed to a Young Lady* (1773), an extremely popular educational tract, which was reprinted at least sixteen times in the next twenty-five years. Carter made known to the public the theological and didactic essays of Catherine Talbot (1721–1770) by issuing them posthumously at her own expense. Among the women who later had connections with the coterie were the writers Anna Barbauld (1743–1824), Fanny Burney (1752–1840), and Hannah More (1745–1833). Bluestocking works were well received by critics, and by the 1770s the group was much discussed in London circles. Inevitably, they were viewed with suspicion by some satirists, but in general they enjoyed the respect and admiration of many—including King George III and Queen Charlotte (Myers 246–89). The painter Richard Samuel depicted four of the Bluestockings in a work entitled "The Nine Living Muses of Great Britain." The painting was displayed at a Royal Academy exhibition in 1779, and is now owned by the National Portrait Gallery in London. It portrays the Bluestockings as part of a community of women, whose prominence in public life is a reflection on the progress of civilization (Eger).

The Bluestocking program has often been called a feminist program (e.g., Myers 121–50; Kelly, *Bluestocking Feminism* 1: ix–liv; Kelly, "Bluestocking Feminism"). The *OED* defines feminism as the "advocacy of the rights of women (based on the theory of equality of the sexes)." The Bluestockings were feminist in their own time, even if their thinking is less militant than that of their spiritual descendants. They did not have a "mission" as such but were united in that they shared similar concerns and objectives. They were aware of social injustices toward their sex and believed that women could be men's intellectual equals. They fostered a sense of female community and advocated women's interests, particularly the right to education. They did not hope to alter male hegemony in politics and law, but they did challenge the conventional

gender stereotypes of patriarchal courtly culture. To some extent, they gained acceptance for their demands by emphasizing their religious faith and lack of political engagement. Above all, they managed to negotiate a public space for the intellectual woman who could not easily be maligned as *précieuse* or Amazon.[4]

Feminist principles—particularly of the more intrepid first generation—are often voiced in their writings. For instance, Chapone's *Letters on the Improvement of the Mind* sets out a program for home education for girls to match what was taught to boys by their private tutors or schoolmasters. Rather than dwelling on women's decorative accomplishments or moral conduct and duties, as was common in other treatises of the period, Chapone radically proposes the study of languages, poetry, classical literature, natural sciences, astronomy, philosophy, geography, and history. She is careful to insist at the same time on the overall importance of religious devotion. Talbot's *Reflections on the Seven Days of the Week* (1770) offers a critique of organized religion, implying that it should be wrested out of the hands of the male establishment and domesticized or feminized to make it relevant for ordinary, day-to-day life (Kelly, "Bluestocking Feminism" 175). The Bluestockings did not always veil the authorship of their texts: Carter's Epictetus translation appeared under her own name, and she signed the dedication of her *Poems on Several Occasions* (1762).

As progressive female thinkers the Bluestockings did not stand alone in the eighteenth century but were part of a tradition. Radical proposals for women's education had already been set out in tracts such as Mary Astell's *A Serious Proposal to the Ladies, for the Advancement of Their True and Greatest Interest* (1694–97), and in *An Essay in Defence of the Female Sex* (1696), which was probably written by Judith Drake. Chapone's *Letters on the Improvement of the Mind* may have been modelled on Astell's *Proposal*. They also became an inspiration for ensuing generations, and women writers including Ann Yearsley, Mary Wollstonecraft, and Virginia Woolf acknowledged their debt to them.[5]

There does not seem to be any research to date on the impact of Bluestocking feminism on women in other countries. Sylvia Harcstark Myers comments that the term Bluestocking "passed into usage in France, Germany, and the United States, and women in these countries as well as in England became adherents to the cause" (288), but does not expand on this point. Current bibliographies of Bluestocking work in translation do not mention La Roche or Clodius (Kelly, *Bluestocking Feminism*). Yet circumstances in Germany make this a compelling subject of investigation—particularly in light of the position of women.

There was no equivalent to the Bluestocking circle in Germany at this time. In contrast to the situation in England or France, the laws and social customs in post-Reformation Germany allowed women much less freedom to dispute their traditional role as wife and mother. This can be ascribed in part to the fragmentary infrastructure of the German-speaking states, where travel and communication were more difficult and there was no obvious cultural center like London or Paris (Sagarra 406). The debate on women's education was fully under way by the middle of the eighteenth century. However, it has been demonstrated that the concept of female learnedness (*weibliche Gelehrsamkeit*) increasingly jarred with dominant imagines of femininity during the Age of Sensibility (Bovenschen). It was desirable for women to attain feminine accomplishments, but any interest in scholarly subjects, such as natural sciences, arithmetic, philosophy, or ancient languages, was ridiculed. Rousseau's profoundly influential *Emile* (1762), which was first translated into German in 1762, includes an invective against the mannish intellectual who neglects her domestic duties. The salon hostess is scorned:

> It is not proper, therefore, for a man of education to take a woman without any, nor consequently to choose one in a station in life which deprives her of that benefit. But I had rather a hundred times have a simple girl, meanly educated, than a learned and witty lady, who should come into my family to erect a literary tribunal, of which herself is president (Kenrick 4: 125).

One thinks, too, of Schiller's mockery of Ninon de Lenclos in his poem "Die berühmte Frau" (The Famous Woman, 1788). Ninon's husband bemoans having to live with the conceited, unnatural creature his wife has become:

> Wen hab' ich *nun*?—Beweinenswerter Tausch!
> Erwacht aus diesem Wonnerausch,
> Was ist von diesem Engel mir geblieben?
> Ein *starker* Geist in einem *zarten* Leib,
> Ein Zwitter zwischen Mann und Weib (269).[6]

Women who engaged in scholarly pursuits did so almost exclusively as the helpmate of a husband or male relative (Bennholdt-Thomsen and Guzzoni). Those who ventured into the world of letters tended to rely on a male mentor and rarely published under their own name.

Throughout the eighteenth century and into the nineteenth, French-style salon culture was a feature of intellectual life in Germany, but it was different in nature from the Bluestocking movement. Women played an important role in some of these salons and, in the early

Enlightenment, found support therein for their literary projects. In the 1730s Christiane Mariane von Ziegler (1695–1760), for example, was at the center of a group of "Amazons" in Leipzig who made assertions for women's right to write poetry (Goodman 106–36). Nevertheless, their actions, beliefs, and influence were not as wide-ranging as those of the Bluestockings: "With the exception of Ziegler, there is currently no indication that the Amazons sought to create a salon culture which would have decentralized social structures and undermined male hegemony" (Goodman 136). Ziegler's star, furthermore, had already faded by the early 1740s.

Later in the century, literary clubs for or including women were set up in various parts of the country. One such club, in Oldenburg, aimed to educate its female members but along the anti-revolutionary and anti-feminist lines prescribed by its male arbiters (Brandes). The salons of the Romantics afforded a new space for women to hold sway over intellectual interchange. Anna Amalia, Johanna Schopenhauer, Henriette Herz, and Rahel Varnhagen were among those who presided over gatherings attended by many luminaries of contemporary cultural and political life. The women may have had diverse reasons for establishing their salons, such as a commitment to aesthetic values or to the Romantic ideal of sociability. Yet they do not seem to have been driven by the same impulse toward the advancement of their sex that lay behind the Bluestocking program. In a few cases, aspiring women writers may have found encouragement or made contacts by frequenting these meetings. For example, Louise Brachmann, Caroline von Wolzogen, and Helmina von Chézy all sought out Caroline Pichler's soirées in Vienna (Seibert 235–38). But as a general rule, female guests were in a minority and, as Barbara Becker-Cantarino asserts, were inclined to develop rivalries rather than professional relationships (195). Women writers within the salon milieu certainly did not constitute a homogenous group or supportive female network as in England. Indeed, it has been suggested that the particular aptitude ascribed to women in the new "art" form of conversation had a detrimental effect on their literary productivity, given that Henriette Herz, for one, destroyed two novels and most of her letters (Purver 82). In recent years, some critics have interpreted Rahel Varnhagen's letter project as a conscious vehicle for self-representation and as an artistic legacy that challenges traditional notions of art and authorship (e.g., Schuller). One cannot help wondering if the significance of the Rahel documents has been aggrandized in a way that would not be necessary had she left behind the works of a Montagu or Carter.

* * *

Given these circumstances, then, how were the Bluestockings and their works received in Germany? A substantial number of their publications were translated into German and widely disseminated. On the whole, this was probably just a result of late eighteenth-century Anglophilia rather than an attempt to make known their achievements as female intellectuals. For example, Samuel Richardson had incorporated Carter's "Ode to Wisdom" into *Clarissa* (1747–48), and the German poet Johann Peter Uz issued a translation of the poem in 1757.[7] Montagu's *Essay on the Writings and Genius of Shakespear* was rendered into German in 1771 by the famous Shakespeare scholar Johann Joachim Eschenburg.[8] Eschenburg would not have known that the author of the *Essay* was a woman, as the work was not issued under Montagu's name until the fourth edition of 1777. Hannah More's play *Percy* was even staged in March 1779.[9] *Percy* is a tragedy based on a medieval legend in Thomas Percy's *Reliques of Ancient English Poetry,* which was one of the collections of English folk poetry that was just at this time enjoying considerable popularity in Germany.[10] References to the Bluestockings can also be found in journal articles by foreign correspondents, who appear primarily interested in reporting on the cultural scene in London and only offer moderate approbation of the women's activities.[11] The Bluestockings faded from view within the course of the nineteenth century, although the word "Blaustrumpf" entered more common usage and duly changed its meaning. In the period around 1800, "Blaustrumpf" was not associated with female intellectuals but denoted certain law or church officials who were required to wear blue-colored leg garments or, by association, an informer or traitor. It seems to have been the authors of the Young Germany movement who popularized the expression with its present-day negative connotations.[12] The male establishment was interested in the actual women or their writing for only a short period, and even then only as a result of—and in harmony with—the cultural *Zeitgeist*.

This makes the question of female responses to the Bluestockings all the more pertinent. It is impossible to know to what extent women at large were affected by their enterprises. The growing numbers of women readers among the privileged classes would have been significant consumers of imported literature. Further, they would have been increasingly abreast of foreign culture, as knowledge of modern languages was sanctioned as part of a feminine education. Even so, France was still more familiar than England, and women were more likely to be acquainted with the lives and loves of the French *salonières*. This remained the case even in the early nineteenth century. Sophie Mereau's essay on Ninon de Lenclos appeared in the 1802 edition of *Kalathiskos,*

for example, and her translations of Lenclos's letters in the *Journal für deutsche Frauen* of 1805.

Sophie von La Roche and Julie Clodius both show an inclination toward the foreign, and a particular penchant for things English. La Roche had been educated in French, had an Italian tutor, and taught herself English. As the wife of a prominent civil servant and courtier in Mainz, she was required to be familiar with current European cultural affairs. She had access to a range of newspapers and journals, was considerably well read in foreign literature, and used foreign settings in many of her novels and stories. Despite her cosmopolitanism she was, above all, an Anglophile (Maurer 142-81). Her journal *Pomona für Teutschlands Töchter* (1783-84) was intended from the first to embrace a European perspective. La Roche devoted certain issues to different countries, but admitted to her special fondness for England ("Ueber Engelland" 327). In a leading article on England, "Ueber Engelland," the Bluestockings come to the fore. *Pomona* also offered translations from various languages in its pages, including a letter by Talbot, two poems by Carter, and an extract from Chapone's *Letters on the Improvement of the Mind*.[13] Clodius, wife of the Leipzig professor Christian August Clodius, lived a more retired life about which little seems to be known, although she was apparently well-educated and acquired knowledge of English, French, and even Latin (Schindel 1: 99-101). In 1784, she published a translation of Carter's *Poems on Several Occasions*—along with the *Elegiac Sonnets* of the early Romantic poet Charlotte Smith—which subsequently enjoyed two reprints. The volume includes a preface introducing the two writers. This was the only work to appear during her lifetime. She also penned an epistolary novel entitled *Eduard Montrefrevil* (1806), an adaptation of an (unidentified) English work, which was published in the year following her death.

Nevertheless, it is difficult to ascertain how much La Roche and Clodius actually knew about the Bluestocking circle. There is no evidence that they had any personal contact with the English women. Montagu and Carter had made a visit to Germany in the late summer of 1763 (Hegeman), but there is no reason to assume that they would have met La Roche, who had not even begun her famed first novel, or the thirteen-year-old Clodius.[14] In *Pomona,* twenty years later, La Roche discusses More, Burney, Carter, Barbauld, and Montagu in succession, but does not draw any direct relation between them, although she does mention that Montagu's residence is esteemed to be a "palace of the arts and meeting-place for scholars" ("Ueber Engelland" 371). As well as referring to their publications, she offers anecdotal and general information on the women, which she may have chanced upon in English

periodicals. She comments on their high standing in England and cites a recent eulogy of Montagu. She was not to visit London herself until 1786, two years after the publication of *Pomona* ceased. Her diary shows that she was eager for an introduction to the great Montagu, but that this did not materialize. She hints again at Montagu's leading role in intellectual life, but does not refer to the Bluestockings per se. Sparser information does not reveal if Clodius ventured across the Channel. In the foreword to her translation, she states that she has no biographical information on Carter, but includes details of the Epictetus translation, which had been published in England twenty-six years earlier. Her involvement with Bluestocking feminism may well have been inspired by the texts alone.

* * *

To some extent, La Roche and Clodius approach the Bluestockings in the circumspect manner we would expect from women in Germany at this time. The apparently ambivalent attitudes expressed in *Pomona* toward women and learning have led critics to disagree on how radical the journal was (Weckel 102-03). *Pomona* was aimed at educating women along the Enlightenment lines of "*prodesse*" and "*delectare.*" La Roche champions expanding women's intellectual horizons, but still sees the place of women in the domestic sphere. In keeping with this agenda, La Roche tempers her accolade of the scholarly Englishwomen by emphasizing that Carter is most highly praised for her feminine virtues. She urges her readers:

> to read carefully the translation of Miss Carter's "Ode to Wisdom" and, while doing so, to consider how admirable it was for a young lady to devote her poetic skills to this subject. She has also done splendid translations from Greek, Italian, and French, and she is celebrated not only for her knowledge but also in particular for her modesty and charitableness ("Ueber Engelland" 370).

Likewise, Clodius is mindful of presenting the texts in a way that will not invite censure. For instance, the poems are rendered into more or less literal prose. In the absence of authoritative theories of translation in the eighteenth century, it was widespread practice to translate poetry into either prose or verse (Purdie). Yet the elevation of poetry to a genre requiring "genius" meant that many women avoided lyric forms. (Incidentally, the two Carter poems in *Pomona* are also in prose, while Uz's translation of the "Ode to Wisdom" is in verse.) Moreover, Carter's poems are often prefixed by short quotations in Greek or Latin, which Clodius omits, possibly wary of the taboos surrounding classical

scholarship. It is also conspicuous that there are three pieces she does not touch. The first two she excludes are Carter's English translations of a *sonetto* and a *canzone* by the Italian poet Pietro Metastasio, which appear in Carter's collection in parallel with the original Italian. Clodius may have decided that it would look cumbersome to print an Italian, English, and German version next to one another. The other piece she excludes is a poem entitled "A Dialogue," which constitutes a spirited exchange between the body (male) and mind (female), characterized respectively as husband and wife. The body complains of being neglected when the mind is busy, while the mind feels constrained by the demands made on it by the body. On one level, the poem thematizes in a general sense the strains of mental activity and looks forward to the release of the soul in death. But the use of the husband/wife metaphor adds another dimension. The poem is not only pleading for women's intellectual freedom but implying criticism of the institution of marriage. The mind has the last word:

> I've a Friend, answers *Mind,* who, tho' slow, is yet sure,
> And will rid me, at last, of your insolent Power:
> Will knock down your Mud Walls, the whole Fabric demolish,
> And at once your strong Holds and my Slav'ry abolish:
> And while in the Dust your dull Ruins decay,
> I'll snap off my Chains, and fly freely away (Kelly, *Bluestocking Feminism* 2: 354).[15]

Some of Carter's contemporaries objected to the poem and Clodius may likewise have considered it too extreme for her collection.

Despite the fact that they made these concessions, the engagement of La Roche and Clodius with the Bluestockings was still an act of boldness. Introducing translated texts to a German readership would have passed as an acceptably feminine activity for women in the late eighteenth century, but the apparently ingenuous role of the translator has frequently been exploited to communicate obliquely politicized discourse (Stark). For women at the time, the act of translation circumvented the direct risks or taboos of original authorship, providing a shield for identifying with and promoting potentially controversial texts. The tradition of women translating texts they would not have dared to write themselves goes back to Ziegler (Goodman 166–67). Bluestocking writing clearly displays strong traits of female learnedness and may have been chosen as an implicit challenge to dominant gender discourses. Both writers subtly countenance being learned (*gelehrt*) over accomplished (*gebildet*) by selecting words with unmistakable resonance in the context of this topical debate. La Roche inserts one of Carter's poems,

"To ——" which she calls "Ode an eine Lady in London," extolling the virtue of a female friend's learning:

> The vain Coquet, whose empty Pride
> A fading Face supplies,
> May justly dread the wintry Gloom,
> Where all it's [sic] Glory dies.
>
> Leave such a Ruin to deplore,
> To fading Forms confin'd:
> Nor Age, nor Wrinkles discompose
> One Feature of the Mind (Carter 60).

La Roche translates the second stanza in the following way: "Du aber beweine nicht einen Verlust, der sich auf vergängliche *Bildung* einschränkt.—Denn weder Alter noch Runzeln zerstören den mindesten Zug des Geistes" (284; emphasis added). This lends support to the scholars who hold that *Pomona* was ahead of its time in its advocacy of women's learning (e.g., Nenon 155-63). Clodius explains that Carter's Epictetus translation is "furnished with a *learned* introduction and also some notes" (n. pag.; emphasis added).

Furthermore, both La Roche and Clodius specifically address a female readership and comment that the texts have something special to communicate to their readers. La Roche upholds the Bluestockings as a model, commenting in her article on England:

> I hope my fair readers are content for now to be introduced to the merits of our sex, because by focusing on this I am teaching them to become better acquainted with their own talents and perhaps I am awakening in them the noble ambition to strive for new heights of knowledge or to engage in useful occupations in the best way they can ("Ueber Engelland" 374).

In the preface to her translation, Clodius, while emphasizing in that ubiquitous fashion that some casual translation has not interfered with her domestic duties, cordially recommends Carter to her countrywomen:

> The woman behind the translation of this volume used a few hours of her spare time to render these female poems into German, so that she could share the joy she experienced reading them with those of her female compatriots who perhaps do not know the originals (n. pag.).

The fact that she tones down some aspects of her source text itself shows an awareness of its avant-gardism. Indeed, women's poetry in Germany in the second half of the eighteenth century tended not to

reveal great knowledge or rigorous academic schooling (Halperin 5). In the 1780s, when La Roche's and Clodius's Bluestocking texts appeared, there were few prominent women poets. Philippine Gatterer Engelhard (1756–1831) is an exception: she stylized herself as an untrained "natural poet" who "even after her first poems were published...did not know what iambic verse was" (Dawson, "Philippine" 191).[16] The type of women's poetry that dominated at least until the early nineteenth century dealt in a rather undistinguished way with the personal, quotidian aspects of themes such as religion, nature, love, and even housework (Evers). Thus the subject matter of Carter's poems must have seemed to German readers out of place for a woman poet. Carter's erudition, reflected, for example, in the many classical references within the poems themselves, is still transmitted in German translation. For instance, Carter's "Ode to Wisdom" is constructed around Greek imagery and alludes to Pallas, Cytherea, Plato, and Illisus. The virtues of reason and intellect, especially for women, are a recurrent theme. By choosing to translate these particular poems, Clodius implies that she is in sympathy with such sentiments. It would have been evident to female readers that the sonnets of Charlotte Smith also reveal no small measure of erudition, encompassing, for instance, reworkings of Metastasio and Petrarch.

In addition, in their choice of material, La Roche and Clodius lay stress on female solidarity. As Myers discusses in relation to the Bluestockings, the notion of sisterhood is an important stage in the development of feminist consciousness (121). The Bluestocking texts that appear in *Pomona* are mostly written for women. For example, La Roche includes Chapone's educational advice to her niece from *Letters on the Improvement of the Mind*. The emphasis on sisterhood in Chapone's letter is accentuated by the way it is translated, when compared with the earlier—possibly male-authored—version of the complete text. Chapone's work had appeared in a German translation in 1774. La Roche knew of the translation and, although it was published anonymously, presumes it is by a man ("Von einem englischen Buch" 341). The tone of the *Pomona* translation is less formal and more affectionate. An extract from the English work and a comparison of the two different German versions will illustrate the point. Chapone wrote: "but, comfort yourself with the assurance that a taste for history will grow and improve by reading" (Kelly, *Bluestocking Feminism* 3: 355). The 1774 German edition reads: "Trösten Sie Sich jedoch mit der Versicherung, daß der Geschmack an der Geschichte durch das Lesen zunehmen und mehr ausgebessert werden wird" (*Briefe* 221). The *Pomona* translation renders the same sentence thus: "Aber ich hoffe, du ermunterst dich,

mein Kind! durch die Versicherung, daß der Geschmack an der ernsthaften Geschichte während dem Lesen wächßt und gefällt" ("Von einem englischen Buch" 341-42).

Six of the poems Clodius translates invoke women in the titles, and many more that do not are clearly addressed to women. There is a two-poem dialogic sequence between "Eliza" and a female friend on the subject of artistic ambition. In the first poem, the friend recounts how she lacks courage to pursue her ventures, even with Eliza's encouragement. Eliza then replies, urging her to persist and evoking a picture of the female muses who will help her on her way (Carter 41-44). Another typical poem that Clodius translates is addressed "To Miss —— From her GUARDIAN ANGEL" and insists on the rewards of a life of the mind:

> Seek not from Charms of mortal Birth
> To purchase empty Fame:
> With early Wisdom learn to trace
> Thy Being's nobler Aim (Carter 46).[17]

As in the works in *Pomona,* women are giving advice to other women. The texts encapsulate the spirit of the Bluestocking movement. By making them available in German in publications intended for women, La Roche and Clodius are creating a sense of female intellectual community that perhaps, for them, did not exist in reality.

In fact, their choice of Bluestocking texts reflects their general interest in (English) women writers. La Roche's first novel, *The History of Lady Sophia Sternheim* (*Geschichte des Fräuleins von Sternheim,* 1771), may have drawn in its portrayal of a female utopia on *Millenium Hall* (1762) by Sarah Scott, who did not mix as such in Bluestocking circles but was the sister of Elizabeth Montagu (Brown). During her visit to London in 1786, La Roche was delighted to have the opportunity to take tea with Fanny Burney. In *Mein Schreibetisch* (My Writing Desk, 1799), La Roche contemplates her "pleasure in reading English novels and desire to know of everything that has issued from a female pen" (191-92). In the same work, she makes a record of titles she finds interesting, and includes novels by Charlotte Smith, Anna Barbauld, and Hester Piozzi—the latter, too, had loose connections with the Bluestockings. As for Clodius, the only other writer we can be sure she translated was significantly also a woman, i.e., Charlotte Smith.

Furthermore, in their engagement with the Bluestockings, both La Roche and Clodius are attempting to establish continuity between women in the past and those in the present. In her themed issues on France, England, and Italy, La Roche charts native traditions of prominent

female figures.[18] Writing the history of women was not a new concept: in Germany there had been a plethora of seventeenth- and eighteenth-century catalogues of women (Wood), which recall, of course, Boccaccio, Christine de Pisan, and the *querelles des femmes*. La Roche was not the only female journal editor to adopt the practice, nor the only one to turn her gaze abroad (Weckel 532-85). Charlotte Hezel in the *Wochenblatt für's Schöne Geschlecht* (1779), for instance, composed seven biographical sketches of academically minded women from Germany (2), France (3), England (1), and the Netherlands (1).[19] By and large, the female editors view their historical subjects with a degree of distance. Hezel, for example, is not emotive in her descriptions, but factual and objective (Weckel 556). This, however, is not the case with La Roche, who devotes a fourth issue of *Pomona* to Germany, hoping by this stage to have more information on learned women in her own country. She is anxious to uncover a female intellectual tradition in Germany to parallel that in other countries:

> I notice that in this issue, when I wanted to talk about German women, I have adopted quite a different tone from when I was talking about France, England, and Italy. I am almost talking more about the deeds of Germany's daughters than about the splendor of their knowledge.... But we have evidence that even in the good old days women were exercising their knowledge ("Ueber Teutschland" 741-42).

Her representation of the Bluestockings and their background thus has a direct bearing on her attempt to fix her own genealogy as a woman of letters.

The same can be said—albeit more speculatively—of Clodius. One of the poems by Carter that she translated, "On the Death of Mrs Rowe," is a paean to the poet Elizabeth Rowe, alias Philomela. It begins with an observation on the customary obloquy of female poets:

> OFT' did Intrigue it's [sic] guilty Arts unite,
> To blacken the Records of female Wit:
> The tuneful Song lost ev'ry modest Grace,
> And lawless Freedoms triumph'd in their Place (Kelly, *Bluestocking Feminism* 2: 349).[20]

Yet Rowe won her laurels through her virtue and devoutness, thereby creating new paradigms for literary women that Carter hopes to emulate. Rowe was an important figure in helping to win respectability for women entering the literary profession in eighteenth-century England, following the often scandalous reception of earlier writers like Aphra Behn

and Delarivier Manley (Todd 50). By the act of translation, Clodius indirectly marks out her place within the same line of venerable female literati. Both she and La Roche turn to traditions of learned women abroad to suggest possibilities for women in Germany too:

> Fixt on my Soul shall thy Example grow,
> And be my Genius and my Guide below;
> To this I'll point my first, my noblest Views,
> Thy spotless Verse shall regulate my Muse.
> And O forgive, tho' faint the Transcript be,
> That copies an Original like thee:
> My justest Pride, my best Attempt for Fame,
> That joins my own to *Philomela's* Name (Kelly, *Bluestocking Feminism* 2: 351).[21]

* * *

According to Ruth P. Dawson, the first two women in Germany to show signs of even a moderate feminist consciousness were Marianne Ehrmann and Emilie Berlepsch in the 1790s ("'And This Shield'" 157–74). However, as we have seen, already a decade earlier Sophie von La Roche and Julie Clodius brought their countrywomen into contact with the feminist program of the English Bluestocking circle. They did this in part through the medium of translation—many years prior to Mereau's commensurately bold translations of Ninon de Lenclos (Purdy). They couched their translations in terms that would make them acceptable to their day. But their support for the learned lady is not even tainted by the light-hearted ambivalence of Droste-Hülshoff's later *Perdu! Oder Dichter, Verleger und Blaustrümpfe* (Lost! or Writers, Publishers, and Bluestockings, written 1840, published 1900). They dared to look beyond the restrictive idealization of their sex in late eighteenth-century Germany and used the model of the intellectual Bluestockings to help form an identity as writing women and a tradition of women's writing.

Notes

I am grateful to the German Academic Exchange Service (DAAD) and to Gonville and Caius College, Cambridge, for generous research and travel grants.

[1] According to Kelly, the egalitarian spirit of Bluestocking meetings emerged out of a movement toward cultural and social change in

eighteenth-century England, namely the Enlightened progression from aristocratic and courtly culture to modern gentry capitalism. The inclusion of women in social discourse was a step along the Humean way to a civil society (Kelly, "Bluestocking Feminism").

[2] See, for example, Larson. Kelly has interpreted their philanthropy as an attempt at "feminizing" the established social order and thus as an intrinsic part of their feminist activities (Kelly, "Bluestocking Feminism" 168–89).

[3] Many texts have been reprinted in Kelly's recent six-volume edition (*Bluestocking Feminism*).

[4] See Kelly's general introduction (Kelly, *Bluestocking Feminism* 1: lv-lviii.). For a discussion of Carter's particular achievements on this front, see Williams.

[5] Ann Yearsley, who enjoyed for a time the patronage of Hannah More, also published *Poems of Several Occasions* (1787). (In fact, Carter's *Poems on Several Occasions* itself recalls a collection with the same title by her friend and muse Elizabeth Rowe that had been published in 1696.) Mary Wollstonecraft paid tribute to Chapone in *A Vindication of the Rights of Women* (1792). Over a century later, Virginia Woolf emphasizes in *A Room of One's Own* (1929) their role in creating a female literary tradition in England, writing affectionately of "Eliza Carter—the valiant old woman who tied a bell to her bedstead in order that she might wake early and learn Greek" (66).

[6] "What have I left?—Ah! transformation fell! / As from me fades th' intoxicating spell, / What of my angel now remains? / A virile spirit, but arrayed / In sexless form—nor man nor maid" (Arnold-Forster 81).

[7] Samuel Richardson had not attributed the "Ode to Wisdom" to Carter. It appeared in *Clarissa* complete with musical setting. The first German translator of the novel, Johann David Michaelis, left it out. Uz issued it separately in parallel text format with music, stating that it had come from *Clarissa* and thus clearly seeking to cash in on the Richardson craze.

[8] The *Essay* was influential in promoting a perception of Shakespeare as a natural and original genius and national poet, and fed into German theories of genius. Herder, for instance, read Eschenburg's translation and incorporated ideas from it into the second draft of his own essay on Shakespeare (1773). It has been noted that "Montagu discust [*sic*]...the difference between the Greek drama and the Elizabethan, using phrases and examples that we think of as typically Herderian" (Price 296–97). There are strong echoes of Montagu in Christian Friedrich von Blankenburg's *Versuch über den Roman* (1774). He copied Montagu's method of giving substantial

quotations from Shakespeare's dramas and may have derived some of his views of the great English dramatist from her (Schioler 161, 163).

[9] Price and Price call attention to a staging of the play in Germany (160) but I have not been able to uncover any further information. There is no mention of the production in Richel. *Percy,* produced by Garrick in 1777, had been a huge success in London and turned its author into something of a celebrity, so it is quite conceivable that the fame of the author and play then spread abroad.

[10] See Boyd. There were also German versions of Chapone's *Letters on the Improvement of the Mind* (1773; trans. 1774) and *Fidelia* (1776; trans. 1776), and Hannah More's *Essays on Various Subjects* (1777; trans. 1778) and *Sacred Dramas* (1782; trans. 1787 by Christian Felix Weisse). According to Price and Price, *Fidelia* was the only work attributed to a named Bluestocking. Some of these works were seized on by the Weidmann publishing house in Leipzig, one of the most active and successful producers of English translations in this period: the Bluestocking works were probably chosen as part of a wider strategy to satisfy the Anglophile market.

[11] See "Auszüge aus Briefen" and Johann Christian Hüttner's articles in *London und Paris* ("Gelehrte Bildung," "Gelehrte weibliche Beschäftigungen," "Fortsetzung"). For background information on *London and Paris,* see Riggert.

[12] See the entries under "Blaustrumpf" in Joachim Heinrich Campe's *Wörterbuch der deutschen Sprache* (1807) and the Duden *Herkunftswörterbuch.*

[13] The Talbot letter is a translation of "Letter to her Cousin, Miss —— Talbot." The Carter poems are "Ode to Wisdom" and "To ——." Except for the latter poem, which is in Carter, all the originals of the *Pomona* texts can be found in Kelly, *Bluestocking Feminism.*

[14] Montagu and Carter were in Northern Europe from June to September 1763. They only spent a few days in Germany, visiting Aachen, Cologne, Bonn, and Düsseldorf, and they did not go further south than Bonn. By 1763, the La Roches were dividing their time between Warthausen and Zabergäu, both in Baden-Württemberg.

[15] Freeman lends weight to this interpretation by placing the poem within contemporary writings and practices pertaining to gender relations. She shows, for instance, how Carter seems to be reversing a tradition of body-soul dialogues stretching back to Plato, in which the soul or reason is always male. The final stanza may allude to marriage laws: "in eighteenth-century England the death of a husband signified a passage into power for a wife. Widowhood represented the first time in a woman's life when she was not under the legal authority of either a father or a husband.... The poem thus concludes defiantly and in an almost celebratory mood that

anticipates, with no small delight, the inevitable death of both a body and a husband, and the consequent liberation of a mind and a wife" (56).

[16] It is true that there were some eighteenth-century women poets who achieved particular distinctions, such as Anna Luise Karsch (1722-91), Gabriele Baumberg (1766-1839), and Sophie Mereau (1770-1806) (Harper and Ives), but none of these were publishing in the 1780s. The uneducated Karsch had been praised for her skill in deriving inspiration from classical poetry, a skill she had been encouraged in by the anacreontic poet Gleim. However, the 'feminine' theme of love is still dominant in her poems, as it is in the poems of Baumberg and Mereau. In contrast, romantic love is not a theme that interests Carter.

[17] Clodius's translation reads: "Suche nicht von den Vorzügen irrdischen Standes leeren Ruhm herzuleiten. Mit früher Weisheit lerne deines Daseyns edlerm Endzweck nachzuspüren" (Clodius 62).

[18] For example, La Roche refers to French women such as the letter-writer Marie de Rabutin-Chantal, Marquise de Sévigné, and the novelists Madeleine de Scudéry and Marie Jeanne Riccoboni. When surveying Italy, La Roche mentions, among others, the physicist Laura Bassi and the physicist, mathematician, and translator Marie Angela Ardinghelli.

[19] The women Hezel chooses are Anna Luise Karsch and Luise Gottsched from Germany, the writer Madame de Gomez, classicist Anne Dacier and nun Heliose from France, the playwright Catherine Cockburn from England, and the scholar Anna Maria van Schurmann from the Netherlands (Weckel 548). It is interesting that none of the Bluestockings makes an appearance—the space given to French women suggests again that they were more widely known.

[20] Clodius's translation reads: "Oft vereinigte buhlerische List alle ihre verbrecherischen Künste um den Ruhm des weiblichen Witzes zu beflecken. Der harmonische Gesang verlor jede bescheidene Grazie, und zügellose Freyheit triumphirte an ihrer Stelle" (Clodius 15).

[21] Clodius's translation reads: "dein Beyspiel [soll] fest in meiner Seele haften, und hienieden mein Genius und mein Führer seyn. Hierauf will ich meine erste, meine edelste Absicht richten, die untadelhaften Werke deiner Muse, sollen die meinigen bilden. Und, o vergieb mir die schwache Nachahmung, die ein Urbild, wie das deinige, nachschildert. Mein gerechtester Stolz, mein eifrigstes Bestreben nach Ruhm sey, daß mein Nahme sich mit Philomelens Nahme vereinige" (Clodius 17-18).

Works Cited

Arnold-Forster, E.P., trans. *The Poems of Schiller*. London: Heinemann, 1901.
"Auszüge aus Briefen." *Deutsches Museum* 2.11 (Nov. 1777): 471–75.
Becker-Cantarino, Barbara. *Schriftstellerinnen der Romantik*. München: Beck, 2000.
Bennholdt-Thomsen, Anke, and Alfredo Guzzoni. "Gelehrte Arbeit von Frauen: Möglichkeiten und Grenzen im Deutschland des 18. Jahrhunderts." *Querelles* 1 (1996): 48–76.
Blanckenburg, Friedrich von. *Versuch über den Roman*. 1774. Stuttgart: Metzler, 1965.
Bovenschen, Silvia. *Die imaginierte Weiblichkeit: Exemplarische Untersuchungen zu kulturgeschichtlichen und literarischen Präsentationsformen des Weiblichen*. Frankfurt a.M.: Suhrkamp, 1979.
Boyd, E.M.I. "The Influence of Percy's 'Reliques of Ancient English Poetry' on German Literature." *Modern Language Quarterly* 7 (1904): 80–99.
Brandes, Helga. "Die 'Literarische Damen-Gesellschaft' in Oldenburg zur Zeit der Französischen Revolution." *Französische Revolution und deutsche Öffentlichkeit: Wandlungen in Presse und Alltagskultur am Ende des 18. Jahrhunderts*. Ed. Holger Böning. München: Saur, 1992. 439–51.
Briefe zur Ausbildung des Gemüths, an ein junges Frauenzimmer gerichtet. Leipzig: Weidmann, 1774.
Brown, Hilary. "Sarah Scott, Sophie von La Roche, and the Female Utopian Tradition." *Journal of English and Germanic Philology* 100: 4 (Oct. 2001): 469–81.
Campe, Joachim Heinrich, ed. *Wörterbuch der Deutschen Sprache*. 5 vols. Braunschweig: Schulbuchhandlung, 1807.
Carter, Elizabeth. *Poems on Several Occasions*. London: Rivington, 1762.
[Clodius, Julie]. *Gedichte von Elisabeth Carter, und Charlotte Smith. Aus dem Englischen übersezt*. Dresden: Breitkopf, 1787.
Dawson, Ruth P. "'And This Shield is Called Self-Reliance': Emerging Feminist Consciousness in the Late Eighteenth Century." *German Women in the Eighteenth and Nineteenth Centuries: A Social and Literary History*. Ed. Ruth-Ellen B. Joeres and Mary Jo Maynes. Bloomington: Indiana UP, 1986. 157–74.
———. "Philippine Gatterer Engelhard." *Bitter Healing: German Women Writers 1700–1830*. Ed. Jeannine Blackwell and Susanne Zantop. Lincoln: U of Nebraska P, 1990. 163–80.
Duden Herkünftswörterbuch. Mannheim: Duden, 1989.

Eger, Elizabeth. "The Nine Living Muses of Great Britain: Women, Reason and Literary Community in Eighteenth-Century Britain." Diss. Cambridge U, 1999.

Evers, Barbara. *Frauenlyrik um 1800: Studien zu Gedichtbeiträgen in Almanachen und Taschenbüchern der Romantik und Biedermeierzeit*. Bochum: Brockmeyer, 1991.

Freeman, Lisa A. "A Dialogue: Elizabeth Carter's Passion for the Female Mind." *Women's Poetry in the Enlightenment: The Making of a Canon, 1730-1820*. Ed. Isobel Armstrong and Virginia Blain. Basingstoke, England: Macmillan, 1999. 50-63.

Goodman, Katherine R. *Amazons and Apprentices: Women and the German Parnassus in the Early Enlightenment*. Rochester, NY: Camden House, 1999.

Halperin, Natalie. *Die deutschen Schriftstellerinnen in der zweiten Hälfte des 18. Jahrhunderts*. Quakenbrück: Trute, 1935.

Harper, Anthony J., and Margaret C. Ives. *Sappho in the Shadows. Essays on the Work of German Women Poets in the Age of Goethe (1749-1832)*. Bern: Lang, 2000.

Hegeman, Daniel V. "Three English Bluestockings visit Germany." *Kentucky Foreign Language Quarterly* 4.2 (1957): 57-73.

[Hüttner, Johann Christian]. "Fortsetzung über die Beschäftigungen der Londnerinnen Schriftstellerinnen." *London und Paris* 7.3 (1801): 204-08.

―――. "Gelehrte Bildung der Engländerinnen, (blue stockings)." *London und Paris* 4.8 (1799): 291-99.

―――. "Gelehrte weibliche Beschäftigungen." *London und Paris* 7.1 (1801): 27-32.

Kelly, Gary. "Bluestocking Feminism." *Women, Writing and the Public Sphere, 1700-1830*. Ed. Elizabeth Eger, et al. Cambridge: Cambridge UP, 2001. 163-80.

Kelly, Gary, et al., eds. *Bluestocking Feminism: Writings of the Bluestocking Circle, 1738-1785*. 6 vols. London: Pickering and Chatto, 1999.

[Kenrick, William], trans. *Emilius and Sophia: Or, a New System of Education*. 4 vols. London: Becket and de Hondt, 1762-63.

La Roche, Sophie von. "Brief der Mis Talbot an ein neugebohrnes Kind." *Pomona für Teutschlands Töchter* 1.4 (Apr. 1783): 380-82.

―――. *Mein Schreibetisch*. 1799. Karben: Wild, 1996.

―――. "Ode an die Weisheit von Mis Carter." *Pomona für Teutschlands Töchter* 1.4 (Apr. 1783): 383-86.

―――. "Ode an eine Lady in London von Miß Carter." *Pomona für Teutschlands Töchter* 3.3 (Mar. 1784): 283-85.

———. "Ueber Engelland." *Pomona für Teutschlands Töchter* 1.4 (Apr. 1783): 323-76.

———. "Ueber Teutschland." *Pomona für Teutschlands Töchter* 2.8 (Aug. 1783): 725-64.

———. "Von einem englischen Buch." *Pomona für Teutschlands Töchter* 3.4 (Apr. 1784): 340-48.

Larson, Edith Sedgwick. "A Measure of Power: The Personal Charity of Elizabeth Montagu." *Studies in Eighteenth-Century Culture* 16 (1986): 197-210.

Maurer, Michael. *Aufklärung und Anglophilie in Deutschland*. Göttingen: Vandenhoeck and Ruprecht, 1987.

Myers, Sylvia Harcstark. *The Bluestocking Circle: Women, Friendship, and the Life of the Mind in Eighteenth-Century England*. Oxford: Clarendon Press, 1990.

Nenon, Monika. *Autorschaft und Frauenbildung: Das Beispiel Sophie von La Roche*. Würzburg: Königshausen and Neumann, 1988.

Price, Lawrence Marsden. *The Reception of English Literature in Germany*. Berkeley: U of California P, 1932.

Price, Mary Bell, and Lawrence Marsden Price. *The Publication of English Literature in Germany in the Eighteenth Century*. Berkeley: U of California P, 1934.

Purdie, Edna. "Some Problems of Translation in the Eighteenth Century in Germany." *English Studies* 30 (1949): 191-205.

Purdy, Daniel. "Sophie Mereau's Authorial Masquerades and the Subversion of Romantic *Poesie*." *Women in German Yearbook 13*. Ed. Sara Friedrichsmeyer and Patricia Herminghouse. Lincoln: U of Nebraska P, 1997. 29-48.

Purver, Judith. "Revolution, Romanticism, Restoration (1789-1830)." *A History of Women's Writing in Germany, Austria and Switzerland*. Ed. Jo Catling. Cambridge: Cambridge UP, 2000. 68-87.

Richel, Veronica C. *The German Stage, 1767-1890. A Directory of Playwrights and Plays*. New York: Greenwood, 1988.

Riggert, Ellen. *Die Zeitschrift "London und Paris" als Quelle englischer Zeitverhältnisse um die Wende des 18. und 19. Jahrhunderts*. Göttingen: Wurm, 1934.

Sagarra, Eda. *A Social History of Germany 1648-1914*. London: Methuen, 1977.

Schiller, Friedrich. *Gedichte*. Ed. Georg Kurscheidt. Frankfurt a.M.: Deutscher Klassiker Verlag, 1992.

Schindel, Karl Wilhelm Otto von. *Die deutschen Schriftstellerinnen des neunzehnten Jahrhunderts*. 3 vols. 1823-25. Hildesheim: Olms, 1978.

Schioler, Margarethe C. "Blankenburg's Advocacy of Shakespeare." *Monatshefte für Deutschen Unterricht* 42 (1950): 161–65.
Schuller, Marianne. "Das andere Gedächtnis." *Im Unterschied: Lesen, Korrespondieren, Adressieren*. Ed. Marianne Schuller. Frankfurt a.M.: Verlag Neue Kritik, 1990. 143–57.
Seibert, Peter. *Der literarische Salon: Literatur und Geselligkeit zwischen Aufklärung und Vormärz*. Stuttgart: Metzler, 1993.
Stark, Susanne. *'Behind Inverted Commas': Translation and Anglo-German Cultural Relations in the Nineteenth Century*. Clevedon, England: Multilingual Matters, 1999.
Todd, Janet. *The Sign of Angellica: Women, Writing, and Fiction 1660–1800*. London: Virago, 1989.
Uz, Johann Peter. *Ode an die Weisheit; Nebst dem Englischen Grundtext und der Musik. Aus dem Englischen der Clarissa*. Berlin: n.p., 1757.
Weckel, Ulrike. *Zwischen Häuslichkeit und Öffentlichkeit: Die ersten deutschen Frauenzeitschriften im späten 18. Jahrhundert und ihr Publikum*. Tübingen: Niemeyer, 1998.
Williams, Carolyn D. "Poetry, Pudding, and Epictetus: The Consistency of Elizabeth Carter." *Tradition in Transition: Women Writers, Marginal Texts, and the Eighteenth-Century Canon*. Ed. Alvaro Ribeiro, S.J., and James G. Basker. Oxford: Clarendon Press, 1996. 3–24.
Wood, Jean M. "Das 'Gelahrte Frauenzimmer' und die deutschen Frauenlexika 1631–1743." *Res Publica Litteraria. Die Institutionen der Gelehrsamkeit in der frühen Neuzeit*. Ed. Sebastian Neumeister and Conrad Wiedenmann. 2 vols. Wiesbaden: in Kommission bei Harrassowitz, 1987. 2: 577–87.
Woolf, Virginia. *A Room of One's Own*. 1929. London: Penguin, 1945.

Nineteenth-Century German Literary Women's Reception of Madame de Staël

Judith E. Martin

This essay examines Madame de Staël's impact on German women writers from Romanticism to the *Vormärz,* including Caroline Paulus, F.H. Unger, Johanna Schopenhauer, Ida Hahn-Hahn, and Luise Mühlbach. I argue that these German women refer in their novels to Staël's exemplary life and to her influential stories of politically engaged and artistic heroines in order to authorize their own discourses on art and politics. These authors' intertextual responses to Staël's powerful statements on women's social and artistic potential reflect their ambivalent positions regarding women's cultural role, and show that Staël's example inspired their development of a female authorial identity. (JEM)

Reactions to Madame de Staël and her writings by influential German men of letters, including Goethe, Schiller, Jean Paul, E.T.A. Hoffmann, and A.W. Schlegel, have long been documented and continue to be the subject of literary scholarship.[1] As yet, however, scant attention has been paid to the numerous German women authors who not only commented on Staël in letters and book reviews, but whose novels also contain intertextual references to her life and works.[2] As Europe's most prominent woman author of the period around 1800, Germaine de Staël (1766–1817) exerted a profound impact on subsequent German literary women, including Friederike Helene Unger, Caroline Paulus, Johanna Schopenhauer, Ida Hahn-Hahn, and Luise Mühlbach. Staël's influential stories of politically engaged and artistic heroines shaped the historical development of the German novel by inspiring these German women authors to write on women's role in public culture and politics. German women's responses to Staël and her novels shed light on the authors' positions concerning the controversial issue of women's participation in the public sphere. Moreover, these writers' references to Staël and her

literary characters indicate that her example fostered their development of a self-consciously female authorial identity, corroborating Kari Lokke's premise that Staël played a role "as an originary figure in the history of Western women's self-definition of poetic identity" ("Sibylline Leaves" 159).

The concept of intertextuality helps define German women's complex relationship to Staël and their dynamic process of reading and reformulating her literary models. Bakhtin's dialogic theory of discourse, for example, underscores the intertextual dimension of narrative by considering every utterance a response to previous utterances. Based on Bakhtin's concept of dialogism, which conceives of the literary text "as a rejoinder in a given dialogue" (274), my analysis will examine these German women's novels as dialogic responses to Staël's powerful statements on women's role in art and politics in her novels. Bakhtin's notion of dialogism is useful for examining women's writing because it foregrounds the "differentiated socio-ideological position of the author" within discourse (300).[3] A feminist Bahktinian approach takes into account the specific relationship of a gendered speaker to multivocal discourse in a given epoch. In addition, Bakhtin's focus on the social context of an utterance is particularly valuable to feminist literary criticism, for it provides a model for reading intertexts within their broader historical and sociological contexts (Eigler 191). Analyzing these German women's intertextual references to Staël not only reconstructs an important element of the international literary-historical context of their novels, but also illuminates the authors' positions in relationship to the socio-historical context of nineteenth-century discussions of gender and authorship.

In keeping with Bakhtin's shift in emphasis away from sources of influence to the process of an author's "further creative development of another's... discourse in a new context and under new conditions" (347), I want to demonstrate the significance of Staël's discourses of politics and female creativity for German women writers, while acknowledging their independent and intentional transformations of her models within their own German cultural and historical contexts. In examining German women's responses to influential literary precursors, it is important, as Joeres has recently asserted, to strike a balance between, on the one hand, viewing German women authors as passive products of discourse and, on the other, attributing too much agency to them (33). They do exhibit some degree of agency in their obvious business savvy in capitalizing on the widespread reputation of Staël and her literary creations. Furthermore, German women consciously enter into a dialogic relationship with Staël's utterances on women's cultural role in order to validate

their own discourses on art and politics. In fact, even a conservative Biedermeier novel such as Johanna Schopenhauer's *Gabriele* can be shown to express the writer's ambition to authorize her own creative endeavors through intertextual references to *Corinne*.

Staël as Female Icon of Politics and Art

Events in the aftermath of the French Revolution propelled Staël to international prominence as an outspoken opponent of Napoleon. In 1802 the Emperor, who feared and resented her influential salon, banned her from Paris. During her exile Staël traveled extensively throughout Germany in 1803–04 and 1807, meeting leading authors and intellectuals.[4] Besides her major critical works, *De la littérature* (1800) and *De l'Allemagne* (1813), Staël contributed two novels to Romantic literature, *Delphine* (1802) and *Corinne, ou l'Italie* (1807). Each novel focuses on a female protagonist who came to represent a new literary model for intellectual and artistic heroines.[5]

The fictional characters in *Delphine* and *Corinne,* in defiance of contemporary gender conventions, express the desire to profit from the ideals of the Revolution and the Enlightenment. Delphine openly supports the new political ideals of freedom and republicanism, while Corinne leads a public, independent artist's existence outside of bourgeois family and marriage. The epistolary novel *Delphine,* set against the background of the French Revolution, recounts the ill-fated love between Delphine and Léonce, who are separated because he enters an arranged marriage out of a strong sense of family duty. In her decidedly political opinions the protagonist Delphine differs from the typically beautiful, talented, and virtuous heroine of the sentimental novel. Although conventional in certain respects, *Delphine* contains letters that resemble political-philosophical essays on contemporary issues, ranging from revolutionary ideals and republicanism to divorce and religion. Staël's most famous novel, *Corinne,* also combines novel with travelogue and love intrigue with discussions of Italian art, politics, history, social customs, and national character. Corinne represents the grandiose figure of the female artist as genius, portrayed for the first time in such heroic and tragic proportions. She is raised in Italy by her artistic mother until the mother's early death, after which she accompanies her father to England. Stifled by conservative English society, Corinne eventually renounces her family name and flees to Italy, where she lives independently as a celebrated poet. In a grand vision, Staël crowns her Corinne with a laurel wreath at the Capitol in Rome. But in spite of achieving fame as a poet, she and her art suffer an early demise after

her fiancé Oswald marries her more feminine rival. Corinne's tragic fate exemplified for contemporary women writers the female artist's irreconcilable conflict between public success and personal happiness in marriage.[6]

The revolutionary ideals of equality and freedom that Staël propounded in her writings inspired German women authors who sought self-development and expression in a less constricting social role. For the German women writers who responded to Staël in their novels—a group that spans two generations from Romanticism to the *Vormärz*— Staël and her literary creations shaped fictional representations of female citizens and artists. Staël's poet *Corinne,* in particular, resonated with German women writers, who struggled with prejudices against them. As scholars have demonstrated, for nineteenth-century German women the step into authorship and publication represented a departure from the accepted norms of a merely domestic, private feminine role (Joeres 15, 32). Defying the ideological boundaries that separated private and public spheres of activity prompted many German women authors to adopt cautious narrative strategies, modest, apologetic authorial poses, or even to publish pseudonomously (Kord; Tebben 26–27). Not surprisingly, these authors' responses to Staël vacillate between emulation and timid refraction of her models, expressing their contradictory positions within competing discourses on women's cultural role. In spite of persistent public criticism of women authors, the early decades of the nineteenth century witnessed the rise of a class of professional German women writers, whose novels mark tentative steps toward artistic and professional self-assurance (Tebben). Although German women's responses to Staël reflect the continuing ambivalence many felt in their public role as writers, they nevertheless aligned themselves with her prominent example to resist ideologies excluding them from artistic activity. German women's changing reactions to Staël and her fictions over several decades reveal the significance of the leading female icon of politics and art for their developing sense of self as professional writers engaged in the public sphere.

In analyzing intertextual responses to Staël by Paulus, Unger, Schopenhauer, Hahn-Hahn, and Mühlbach, I want to illustrate a historical progression from politicization of the domestic novel in the wake of the Napoleonic wars through Biedermeier conservatism to *Vormärz* defiance of convention. In the first decade of the nineteenth century Paulus and Unger, echoing Staël's political engagement, experimented with the sentimental epistolary novel as a vehicle to comment on contemporary politics. In the following three decades, a number of other authors, including Schopenhauer, Hahn-Hahn, and Mühlbach, followed Staël's literary

example in *Corinne* and ventured to write novels about women artists in an era when artist novels typically focused on men. Examining these authors' reception of Staël's life and texts contributes to a fuller understanding of how they represent themselves as both creative and political.

Early Responses: Politics and National Identity in the Sentimental Novel

In the first decade of the new century, Staël's international political stature left its mark on works by Caroline Paulus and Friederike Helene Unger. Like Staël, Paulus and Unger transform the sentimental epistolary genre into a vehicle for venturing into the public masculine domains of politics and philosophy. All three authors link domestic situations to political history and thematize issues of national identity. Paulus's *Wilhelm Dumont: Ein einfacher Roman* (Wilhelm Dumont: A Simple Novel, 1805) responds to *Delphine's* political content, whereas in *Die Franzosen in Berlin* (The French in Berlin, 1809), Unger incorporates interrelated elements from Staël's life and her novel *Corinne*. Paulus's and Unger's novels transgressed the thematic limitations imposed by the literary critical establishment on women's writing by actively intervening in contemporary political and aesthetic discussions in their novels.[7]

Caroline Paulus (1767–1844), who was acquainted with Goethe and the Schlegels, is a largely forgotten but intriguing figure of German Romanticism. She is primarily remembered in literary history for Goethe's review of her novel *Wilhelm Dumont*. The plot of this little-known work follows the sentimental conventions of the epistolary novel, presenting the story of Adelaide and Wilhelm, who are separated by Adelaide's marriage to Eduard, a rich older admirer. Paulus establishes a direct intertextual relationship with *Delphine* by including a discussion of that novel, in which she introduces two of her central themes: a critique of gender relations and the contrast between French and German national identity. Like Staël, Paulus links her rejection of political absolutism to a critique of male tyranny, but she incorporates Staël's political framework and critique of gender limitations into her own project of German cultural resistance to French hegemony.

Both *Delphine* and *Wilhelm Dumont* tell the conventional story of two lovers separated by a marriage of convenience, but revolutionary events, which remain in the background except for a few key scenes, insert a political subtext. As Nancy Armstrong has shown in *Desire and Domestic Fiction,* familial and romantic situations in the domestic novel are often invested with political meaning. Similarly, recent Staël scholars read *Delphine* as a novel of the Revolution, underscoring Staël's political engagement in investing her lovers with antithetical

aristocratic and revolutionary ideals.[8] Paulus follows Staël's oblique use of politics in creating a heroine who embodies enlightened republican ideas. Furthermore, the relationship between Adelaide and Eduard is reminiscent of the political conflict between the lovers in *Delphine*. These relationships reflect the struggle between aristocratic and bourgeois values. Paulus's novel implicitly supports a more egalitarian social order in its criticism of Eduard's antipathy to the democratic ideals of the Revolution. The opposition between the characters of Eduard and Wilhelm further emphasizes Paulus's rejection of absolutism.[9]

Although Paulus shares Staël's preference for republicanism, she represents French national character and political models as duplicitous, emphasizing intrigue rather than revolutionary potential in French politics. Paulus first touches on the theme of national character in the discussion of *Delphine*. Herr M, the writer who comments most extensively on the novel, concedes that "it remained free of all national characteristics that are always so detestable to us Germans" (72). The opposition between French and German national characteristics, which Paulus develops through several French characters and the heroine's visit to Paris, conveys growing German national consciousness under Napoleon's occupation. This dichotomy also expresses Paulus's personal hatred of Bonaparte, whose rule over her native Württemberg she resented (Reichlin-Meldegg 2: 192).

Paulus's deployment of cultural clichés of French duplicity in contrast to German sincerity intersects with her critique of sexual politics. Paulus, like Staël in *Delphine,* criticizes women's socialization by demonstrating that their powerless role in marriage induces them to become dishonest. In constructing her heroine Adelaide, Paulus responds to Staël's contradictory representations of femininity and sexual politics in her characters Delphine and Mme de Vernon. Adelaide's denunciation of marriages of convenience, in which a woman "must...become false" (86), contains an intertextual reference to the words of Staël's older character Mme de Vernon, who claims that "le sort des femmes les condamnoit à fausseté" (II: letter 41; "a woman's fate condemned her to duplicity" Goldberger 171). In the embedded discussion of *Delphine,* Paulus singles out the character of Mme de Vernon for praise in comparison to the exaggerated main characters (72). Mme de Vernon, who was educated by an unenlightened guardian who viewed women as playthings and forced to marry a man she could neither love nor respect, learned to consider the art of dissimulation "comme le seul moyen de defense qui restait aux femmes, contre l'injustice de leurs maîtres" (II: 41; "as the only defense left to women against the injustice of their masters" Goldberger 171). Adelaide's socialization echoes this lesson

that women must dissimulate. In her youth, her father cautions her to hide her true feelings, but Adelaide, a representative of the new, enlightened generation, emphasizes her inability to do so: "I was incapable of even the least dissimulation" (39). Later, during her marriage, Adelaide insists on her integrity: "I cannot be untrue" (146). Adelaide's language echoes Mme de Vernon's words, "dissimulation" and "fausseté," but, like Delphine, Adelaide asserts a new ethos of feminine virtue. She represents a virtuous German heroine, whose honesty Paulus privileges as a German national trait in order to legitimate her critique of gender roles in marriage. Despite her claim in the subtitle that this is a "simple novel," Paulus negotiates German and French discourses on gender, national identity, and political history in order to express her own positions on contemporary issues and events, as well as to establish herself as an intellectually informed writer.

In marked contrast to Paulus, who relies on cultural clichés of national character, Unger counters such stereotypes, basing her cosmopolitan discourse on national identity and politics on Staël's internationalism. Unger (1741–1813) was ideally situated to be informed of Staël's activities and writings, due to her role as the director (after the death of her husband Johann Friedrich Unger in 1804) of the Unger publishing house in Berlin that originally issued the German translation of *Corinne*. She was the author of the highly successful *Julchen Grünthal* (1784), as well as a number of other novels.[10] In her late novel *Die Franzosen in Berlin* (1809) Unger deviates far more radically from the conventions of the sentimental epistolary novel than do Paulus in *Wilhelm Dumont* and Staël in *Delphine*. *Die Franzosen,* although epistolary in form, contains none of the typical themes of familial or romantic relationships. Instead the widowed narrator Serene manages her household during the French occupation of Berlin and describes the political events unfolding around her. Serene, who hosts an international salon, comments extensively on national character and on aspects of French and German history and culture. As Zantop has observed, *Die Franzosen* presents an experimental generic fusion of the epistolary novel and the traditionally male-defined genre of the historical-political essay ("Aus der Not" 144).

For Unger, Staël stood as an "exemplar of the engaged intellectual" (Tenenbaum 226), who insisted that a writer should play a political role (Montfort 118). She combined the dual roles of author of the domestic novel with that of political commentator. A passage from Unger's 1808 correspondence with A.W. Schlegel reveals her admiration for Staël and her awareness of Staël's salon at Coppet near Geneva as a center of intellectual exchange:

> I had made a nice little plan based on reports in the newspaper that you would live in Weimar for a while.... I wanted, among other things, to send you my Pauline [novel by Unger (1800)] and this was supposed to introduce me to Mme de Staël; ...but now you are flying through Germany to your charming Copet (sic.), and I must put it off.... If I ever manage to cast off my burden and dig myself out of the sand, I will flee to the place that always meets my yearning: to Copet. Would I find welcome? Of course I would bring merely a heart along; there is already a wealth of intellect there, which I would draw on, like souls [die Existencen] at the living source (Körner, letter 264, 553).

Unger's longing to visit Coppet reflects her desire for involvement in international dialogue on culture and politics. Unable to go there in person, she nonetheless attempted to contribute to this dialogue through her text.

Unger models her cosmopolitan strategies in *Die Franzosen* on Staël's international Coppet salon, which was known as a center of intellectual opposition to Napoleon's chauvinist cultural politics, as well as on Corinne's fictional salon in Rome.[11] Zantop has made the insightful observation that Unger refers to the model of the *salonnière* in creating her narrator Serene ("Aus der Not" 145), suggesting a connection between *Die Franzosen* and *Corinne*. As several scholars have argued, the social institution of the salon was located within both the private and the public realms.[12] In *Die Franzosen,* the line between public and private disappears under wartime conditions as the occupying French army invades the domain of the private house. Unger thus transforms the feminine interior space of the boudoir into a public arena (Zantop, "Aus der Not" 146). Susan Tenenbaum's interpretation of Corinne as Staël's expansion of the role of *salonnière* to that of a politically engaged "presider over an international society of dialogue" also sheds light on similarities between Corinne and Serene (227–28). Unger's Serene follows Corinne in exercising her role as *salonnière* to promote international dialogue. The international gathering of military officers in Serene's house engages in salon activities, including reading and performing plays, but her guests primarily converse about politics, culture, and national character. Moreover, as Tenenbaum has noted, Corinne's dual Italian-English background symbolizes Staël's inclusion of the "other" in her cultural and political discourse (228). Serene also recalls Staël's Corinne in acting to reduce national prejudices through providing cross-cultural encounters with foreigners in her informal salon. By attempting to combine national feelings of pride in the distinctiveness of German culture with openness to the other, Unger, like Staël, integrates

the other into her discourse rather than excluding it as a hated and feared category. By adapting Staël's cosmopolitanism to her own political context, she authorized her opposition to nationalist orthodoxies. Her own dual French-German heritage undoubtedly affected this construction of an imagined international community in Serene's salon.

In a wealth of anecdotes, portraits, and comparisons between the French and the Germans Unger develops her ideal of cosmopolitanism. She first sets this forth in her epigraph, and in a later letter portrays Mme de Staël as the embodiment of this principle. The first five lines of the epigraph, by the eighteenth-century novelist and fabulist Jean-Pierre Claris de Florian, outline Unger's guiding themes:

> Loin de moi, ces préjugés vulgaires,
> Sources de haine et de division!
> En tous païs tous les bon coeurs sont frères.
> Mais sans haïr les autres nations,
> On peut aimer et respecter la sienne" (1).[13]

Unger stresses cultural commonalities in spite of national differences in character and seeks to break down prejudices and hatred while cultivating a positive national identity for Germany. By portraying the occupying French soldiers as humane, civilized, and courteous, Unger attempts to deconstruct the image of the French as enemy (Zantop, "Aus der Not" 144), and to transcend the contradiction between cosmopolitanism and nationalism. She wants to counteract German feelings of inferiority in relation to French culture and civilization by describing educated French officers who value German literature, philosophy, science, and military history.

Unger presents Staël as the epitome of French recognition of German originality. "It is impossible," writes Serene of Staël, "that a German could surpass her in love of German literature, in feeling for our originality, in deep respect for our philosophical spirit. She herself asserts that a thousand times more light reigns over literary and aesthetic subjects in Germany than in France, and the latter cannot at all be compared with Germany" (202).[14] Yet Staël's significance for Unger's narrative exceeds mere appreciation for German culture: she also represents Unger's ideal of cosmopolitanism by combining the attributes of German depth and French vivacity. In Unger's representation of nationalities, Staël represents a synthesis of the two national identities, revealing that they are not irremediably opposed to one another.

Staël's cultural impact as political activist and writer undoubtedly affected Unger's reflections on the troubled relationship between the female author and the political sphere. *Die Franzosen* reflects on female

subjectivity and on female authorship in particular, evincing tensions between the strategies of conforming and resisting that were typical of women's writing of the period.[15] While boldly engaging in discourses of politics through her subject matter, Unger simultaneously denies any political intentions through the modest and apologetic statements of her narrator. Notwithstanding these disclaimers, the narrator comments on historical events, including the French Revolution and the Thirty Years' War. Furthermore, as Zantop shows, Unger recasts female subjectivity by expanding concepts of feminine virtue to encompass traits such as tolerance, courage, steadfastness, discipline, and education. Through this redefinition, female domestic virtue comes to resemble male public virtue, and the housewife is transformed into a citizen, just as the woman author is fashioned into a political commentator ("Aus der Not" 144–45).

In *Die Franzosen* Unger drew on the overlapping strands of Staël's exemplary life and the cosmopolitan political import of *Corinne,* building on Staël's international status to authorize her own political discourse. Unger's and Paulus's very different results in assimilating Staël's models reflect the complex interrelationships between their personal literary projects, their individual backgrounds and politics, and Staël's own developing oeuvre. Writing during a decade of war and upheaval, Paulus and Unger not surprisingly incorporate politics and national character into their epistolary novels. While these themes do not disappear in later decades, most intertextual references to Staël in German women's novels after the publication of *Corinne,* from Romanticism through the Biedermeier and *Vormärz* periods, focus on Staël's representation of female artistry.

Corinne and German Artist Heroines

German women's female artist novels present an experimental generic fusion of the (by this time) traditionally "feminine" sentimental novel with the "masculine" artist novel.[16] Inspired by Staël's *Corinne,* German authors combined the Romantic themes of the *Künstlerroman* with conventions of the sentimental novel and later of the *Vormärz* social novel. German women who wrote artist novels responded to Staël's depiction of Italy as a utopian space for fostering female creativity and they endowed their creative heroines to varying degrees with Corinne's romantic enthusiasm and melancholy. Biedermeier novels such as Johanna Schopenhauer's *Gabriele* (1819–20) enclose the female artist in a conventionally moralistic framework in which feminine modesty and virtue are rewarded and transgressions of gender role norms severely

punished. Schopenhauer rejects enthusiasm and melancholy for her heroine, but the theme of Italy, which on the surface may appear to provide little more than atmosphere, serves to link her selfless heroine to the more audacious Corinne. In the more progressive period of the *Vormärz* Ida Hahn-Hahn and Luise Mühlbach surpass the constraints of the domestic novel to depict emancipated artistic heroines.[17]

Several contemporary critics, including Karl Ludwig von Knebel and Wolfgang Menzel, noted parallels between Staël's and Schopenhauer's lives and their novels *Corinne* and *Gabriele*.[18] In light of the conventional story of female renunciation in *Gabriele*, it is perhaps surprising that this novel refers both directly and indirectly to *Corinne*. Although Johanna Schopenhauer does not follow Staël in creating a full-fledged artist protagonist, *Corinne* is present as intertextual background. By incorporating certain elements of *Corinne* into her text, Schopenhauer refers readers to that more rebellious heroine. The *Corinne* intertext constructs a feminist subtext in a novel whose surface plot is conventional. The narrator refers to the brilliant socialite Aurelia as a second "Korinna" (24) but eventually reveals Aurelia's initial superiority as superficial, the result of careful training rather than innate talent. Ultimately, however, the unassuming heroine Gabriele emerges as Corinne's true spiritual sister, although Schopenhauer modifies Staël's audacious and celebrated heroine to conform to the generic requirements of the sentimental novel in the tradition of Rousseau and La Roche. Like the heroines of these novels, Gabriele renounces her own desires and suffers virtuously.

Because of Gabriele's demonstrative renunciation at several key junctures, the novel has been classified by most critics, from the time of its publication to the present, as an *Entsagungsroman,* or novel of renunciation. This categorization seems justified by surface events. Yet in spite of Gabriele's renunciation of self and love, some recent critics interpret the novel as an implicit criticism of the heroine's excessive self-abnegation. Fetting maintains that the author subtly questions Gabriele's renunciation through the narrator Ernesto (130–33). Kontje carries this view of the novel a step further, asserting that it is an *Anti-Entsagungsroman*: it decries female renunciation as preached by Gabriele's mother at the same time that it denounces paternal tyranny.[19] Schopenhauer's references to *Corinne* lend support to Fetting's and Kontje's readings of *Gabriele* as an implicit criticism of the model of feminine self-sacrifice.

Gabriele's childhood and education resemble Corinne's, at least in spirit. Gabriele is raised by her mother, who imparts to her all the benefits of the brilliant education she had received in Rome. Under her mother's training, Gabriele develops into a Corinne figure in her talent

for dancing, singing, conversation, and storytelling. Echoing Corinne's fate, the early death of Gabriele's mother exposes her to her father's control. Moreover, Schopenhauer also echoes Staël's theme of Italy as an idealized space of female creative development. Although Gabriele herself never goes to Italy, she is mentored first by her mother and then by Ernesto, both of whom are imbued with the artistic ideals of the land of art. But while Corinne is able, at least for a time, to escape the constraints of patriarchy in Italy, Gabriele, by contrast, remains confined in the haunted paternal mansion and the marriage dictated by her father. Yet all the characters she loves live in Rome, recalling Corinne's independent artistic existence there: Ernesto painted and taught Gabriele's mother there; Ottokar works there; and Hippolit travels to Italy on a *Bildungsreise*.[20] Thus in Gabriele's fictional world, Italy exists merely as a memory of her mother's legacy and as a projection of Gabriele's longing for love, freedom, creativity, and passion.[21] By constructing this lost instance of a creative utopia, Schopenhauer subtly inserts the memory of an Italy reminiscent of Corinne's into the fabric of her text. Gabriele also recalls Corinne in that she, too, presides over a salon in which extensive discussions of art take place.[22] This element, together with the evocation of Italy, suggests a reference to Corinne's salon in Rome.[23] Schopenhauer no doubt counted on the recognition effect that these allusions to Staël's novel would have had for her readers.

Gabriele is not an artist novel in the strict sense, for the protagonist does not pursue an artistic career. Although Gabriele captivates the social salons of the residence with her talent for music, the visual arts, and storytelling, she neither publishes nor performs in a public venue like Corinne. Themes of art and its relationship to life are nonetheless central to the text, but in Gabriele's life, unlike Corinne's, art serves a compensatory rather than a liberatory function. Art comforts and compensates the heroine for her self-sacrifice, while simultaneously enabling her to resign herself to her fate, much as religion might (Bürger, *Leben Schreiben,* 75–79; "Die mittlere Sphäre" 371). This compensatory role of art reveals the fundamental difference in the conception of art and of women's creative potential that separates Schopenhauer's Biedermeier tale of female confinement from Corinne's heroic romantic effort to escape gendered social constraints.

Schopenhauer's ambivalent response to Staël's vision is revealed in the contradictory ending of the story. On the one hand, the death of Schopenhauer's dutiful and self-abnegating Gabriele echoes that of the more rebellious Corinne, for both heroines are ultimately consumed by and die of their unfulfilled passion. At the same time Schopenhauer may have found in *Corinne* a model for Gabriele's renunciation, for Staël's

Corinne also renounces Oswald.[24] She does so, however, not merely out of a sense of duty or because she feels betrayed by him, but because she realizes that marriage and art are incompatible for women. Nevertheless Corinne, in stark contrast to Gabriele, rails against her fate, rejecting a merely compensatory function for art in her life. For her heroine Schopenhauer adopts neither Corinne's rage nor her intense creative impulse. Instead, in reworking Staël's themes of art and femininity, Schopenhauer flattens the unresolved tensions in Staël's novel between resignation and rebellion and thus domesticates the talents of her Corinne figure, transforming her genius into mere art appreciation. Although Schopenhauer imparts to her heroine several of Corinne's qualities, diluted though they may be, Gabriele attains neither Corinne's heights of enthusiasm nor her depths of despair.

Fictional Artists in the *Vormärz*

Female artist figures of the *Vormärz* period contrast sharply with the conservative Biedermeier heroine Gabriele. Although more than three decades had elapsed since the publication of *Corinne,* these artist protagonists still reveal the shaping influence of Staël's myth of female creative genius. The generation of *Vormärz* authors, born in the first two decades of the century, would most likely have read *Corinne* in their youth. This was the case for Luise Mühlbach, who recounts in her memoirs a conversation between herself and Ida Hahn-Hahn, in which both admit their secret aspirations to become famous writers. Clara Müller (who later used the pseudonym Luise Mühlbach) was at the time about twelve years old, and Ida Hahn was twenty-two and not yet married. The young Clara, after confiding her dreams to Ida, binds her to secrecy, because her father disapproves of women writing. In describing her literary aspirations, Clara invokes Corinne's triumphant crowning with the laurel wreath:

> Then I had admitted to her with shining eyes that my greatest desire was to be a writer, and if I ever, like Corinna (at that time I had read Corinna by Mme de Staël), if I could be crowned like Corinna at the Capitol in Rome, then I would happily die the very next day, if only I could take my laurel wreath into the casket with me (Ebersberger 138).

Mühlbach recalls that Countess Ida admitted to sharing her dreams of glory, and the two future authors vowed "to become writers and not to let anyone in the world keep us from it" (139). Reading *Corinne* was a formative experience for Mühlbach and Hahn-Hahn in their youth.

Staël's heroic artist inspired their dreams of literary success and shaped the contours of both writers' fictional artist protagonists.[25]

While scholarship on *Vormärz* authors has focused on the significance of George Sand's ideas and novels for their work (Möhrmann 55-59; McNicholl and Wilhelms 215), because their artistic and sexually liberated characters resemble Sand's, their works also reflect the earlier legacy of *Corinne*. As we will see, both Mühlbach and Hahn-Hahn assimilate elements of Staël's famous description of Corinne at the Capitol in Rome into their fictional female artists:

> At last four white horses drawing Corinne's chariot made their way into the midst of the throng.... She was dressed like Domenichino's sibyl, an Indian turban wound round her head, intertwined with hair of the most beautiful black.... Her arms were ravishingly beautiful; her tall full figure, reminiscent of Greek statuary, vigorously conveyed youth and happiness. In her expression there was something inspired.... She seemed...a priestess of Apollo.... The closer she came to the Capitol...the stronger the people's admiration grew (Goldberger 21-22).

Around 1840 Hahn-Hahn and Mühlbach each published novels featuring a female artist. Like Staël, they construct the identity of the woman artist within interrelated conflicts between art and society and art and love, further developing Staël's social criticism of prejudices against women artists. The authors of the *Vormärz,* however, influenced by the emancipatory feminist ideas of their own era, launch a more overt attack on gender constraints. They advance a more radical message of female emancipation from social convention and present heroines who exhibit a more highly developed sense of individual identity. Consequently their artists are less dependent than Corinne on the notion of a grand passion. Corinne, in spite of her originality, is modeled on the beautiful, idealized heroine of the sentimental novel, a literary convention that the *Vormärz* women writers reject. They do not subscribe to the model of renunciation; instead, their demands for independence and self-fulfillment take precedence over duty. Indeed, both Hahn-Hahn's *Gräfin Faustine* (The Countess Faustine, 1841) and Mühlbach's *Der Zögling der Natur* (The Pupil of Nature, 1842) present mature women artists who are far from virtuous.

The more famous of these novels, Hahn-Hahn's *Faustine,* represents a Young German or *Vormärz* incarnation of Corinne. Hahn-Hahn's shockingly non-traditional heroine expresses the author's radical criticism of the institution of marriage and its attendant sexual mores. In Faustine's insistence on her right to dissolve relationships and form new

ones according to her desire and the demands of her creative development, Hahn-Hahn far surpasses Staël's plea for free love and the primacy of feeling over convention in *Corinne*. Sengle calls *Gräfin Faustine* "a difficult to define ragout of Byron, Jean Paul, and the French influences" (2: 881). Of these French influences he mentions only George Sand, whom he refers to as Hahn-Hahn's model (1: 234). Faustine certainly owes much to Lélia; as an actively producing artist, however, she also exhibits striking similarities to Corinne.

A number of parallels indicate that Hahn-Hahn incorporated elements of Staël's discourse on the woman artist into her text. Faustine, like Corinne, is an extraordinary woman and a gifted artist. Her talent expresses itself primarily in painting, but she also writes and publishes poetry. Faustine's widespread reputation as an artist recalls Staël's uniquely grandiose vision of female artistic fame. Faustine also shares Corinne's "thirst for fame" (*"Ruhmdurst"* 229). A specific reference to Corinne appears in Faustine's artistic beginnings as an *"Improvisatorin"* during adolescence. Her talent for poetic improvisation in her youth and subsequent development into an original poet suggest that Faustine's later life represents Hahn-Hahn's continuation of Corinne's story. Faustine's artistic development parallels Corinne's in that she escapes from an oppressive family relationship to the freer atmosphere of Italy where her art flourishes. After her marriage Faustine lives in Florence and later dies in a convent in Rome, cities that recall the scenes of Corinne's glorious success and tragic demise. Furthermore, Hahn-Hahn, like Staël, employs the image of the sibyl in order to evoke the attributes of genius for her heroine. Her husband Mengen characterizes her as "this Sybil with the gaze of a seer and lips of a prophet" (220). The poetic image of the sibyl served to legitimate female cultural production, and women authors employed it to justify women's participation in the prophetic role of the artist in society.

Hahn-Hahn's reinterpretation of Corinne's story explores a new relationship between female creativity and romantic, sexual love. In an alternative approach to romantic attachments, Faustine lives out the two relationships that Corinne envisioned with Oswald: living together as lovers, or in a traditional marriage. A discussion between Faustine and her husband Mengen about Corinne and Oswald's relationship supports a parallel reading of the two artists. Mengen reports, "We once spoke about Corinne, in which we liked everything else better than the actual love story; and I expressed my amazement at how such a brilliant creature could love this melancholy Oswald" (227). Faustine concurs: "That Corinne should die over this melancholy Oswald! That is completely incomprehensible to me! To live for love, to live or die for the

beloved, as it may happen, that's all the same! —But certainly not to die because a man no longer loves me!" (227). Faustine criticizes Corinne for dying over lost love, asserting her right to move from one man to another as her personal development dictates. She justifies this unorthodox behavior by redefining love: "Love is dedicating oneself to an object; but must the object necessarily remain the same?" (227). Accordingly, Faustine experiments first with a companionate relationship with Andlau, and then with marriage to Mengen. Each alliance initially spurs her to periods of intense artistic productivity, but eventually she rejects both in her pursuit of artistic perfection. Faustine nevertheless temporarily attains what Corinne vainly longed for—an integration of art and love in relationships that foster her artistic development.

Hahn-Hahn thus links female creativity and sexuality, but without Corinne's debilitating emotional dependence. Love brought about Corinne's downfall as an artist, as she became confined to the pathological condition of unrequited love (Wägenbaur 126). Faustine, by contrast, never suffers Corinne's emotional dependence and concomitant loss of freedom. Whereas Corinne's art is annihilated by her grief over the loss of her one great passion, Faustine eventually renounces art in spite of enjoying fame and love. She makes this decision independently of her relationships with men, based solely on the realization that she can never achieve artistic perfection.

Hahn-Hahn's representation of Faustine's marriage polemicizes against Corinne's dream of a traditional marriage, presenting it as a threat to the female artist. While *Corinne* shows how the lack of love can destroy a woman's creativity, *Faustine* demonstrates that the experience of love in a traditional marriage can do so too, because the woman artist loses her autonomy. When her marriage becomes a hindrance to her creative development (Taeger 258), Faustine rejects it and enters a convent. Yet even in contemplation of the absolute she does not find the peace she desires, and she dies not long after taking the veil. As a Faustian figure, she is driven from within to explore any avenue that can further her search for perfection and the absolute, and she continues striving independently of her relationships with men. Faustine's inner insatiability applies equally to art and to love, and she is eventually destroyed, more by her own feverish genius than by society, when her restless seeking turns inward and consumes her. Hahn-Hahn claims the right of her female Faust not to find ultimate fulfillment in love, as would befit an ideal "feminine" woman. Her death appears not merely as a failure; rather it reveals her to be a true artist in that she must progress alone toward death. Hahn-Hahn insists on the

primacy of the woman artist's search for identity and creativity over all other social considerations and relationships.

Luise Mühlbach's female artists exceed even Faustine's independence in love. Mühlbach constructed several fictional female artists who appear as counterparts to Corinne. The narrative "Die Künstlerin" (The Woman Artist) in *Frauenschicksal* (Women's Fate, 1839) presents a female artist who, like Corinne, suffers from her status as a social outsider. But Catharina, a famous opera singer who will play a secondary role in *Der Zögling der Natur,* most closely resembles Corinne. Catharina appears in several respects to be a literary descendent of Corinne. A Roman who studied her art in Naples, Catharina's dark beauty resembles Corinne's. Her dark curls and full figure, as well as her noble bearing, all recall Corinne's appearance at the Capitol. In addition, several other indirect references to Corinne's triumph in Rome suggest an affinity between these two artist figures. Her lover Antonio remarks, for example, on the Rome of antiquity, where poets and artists were crowned at the Capitol, rendering them immortal like the gods. The crowd's enthusiastic response to Catharina's performance also echoes Corinne's popularity with the throngs of Romans in the street. In a variation of Corinne's triumphant chariot ride through the streets of Rome, Catharina rides through Palermo in a wagon drawn by the common people of the city. Although the scope of Catharina's fame and the importance of her art to her identity are reminiscent of Corinne, she displays none of Corinne's feminine modesty. Instead, Catharina is a singularly forceful, even egotistical character, who enjoys having royalty at her beck and call. Mühlbach portrays her artist at the height of her talent and influence, rather than depicting any diminishing of her creative powers. Catharina, unlike Corinne, survives the loss of love because she freely chooses art over love.

Mühlbach rewrites the myth of Corinne to reflect her own liberal social concerns. Catharina is far more emancipated, both sexually and emotionally. She is a *femme libre* who enters into a sexual relationship with Antonio and then laughs at him when he suggests that they marry to make their bond eternal. As Möhrmann has remarked, Mühlbach's artist expresses a new consciousness of female independence and self-confidence. Catharina's greater independence consists in not seeking happiness merely from the love of a man. Rather, she has her own interests and desires that pertain to her identity as an artist (Möhrmann 68). Thus Catharina tells Antonio, "I love my art, in fact, I burn for it, and can never leave it.... I love you, but my art is more important to me, and in serving it, I cannot subject myself to you" (152). And when

Antonio asks her to retreat to the peace of nature with him she refuses, explaining, "Love alone does not make one happy" (223).

In constructing this portrait of the woman artist, Mühlbach not only revises Corinne's dependence on love, but also departs radically from the ideal of the innocent, modest heroine. As Möhrmann points out, Mühlbach counters the cliché of women's superior capacity for love (68). Indeed, after Antonio departs to the country with a submissive woman, Catharina sheds a few tears, but then, determined not to pine over him, plans a party to assure herself that the enjoyment of her fame outweighs the loss to her heart. The reader last encounters Catharina cheerfully celebrating her popularity. In contrast to Corinne, Catharina is protected from grief over lost love through her art.[26]

The conflict between art and love in the female artist novel illuminates tensions between competing conceptions of feminine identity. As McNicholl and Wilhelms argue, even the audacious heroines of the *Vormärz* reveal authorial fears of the loss of femininity, conveying women writers' ambivalence in their public role as authors (229). Thus Faustine dies an early death and Catharina is summarily replaced in the hero's affections by a properly feminine woman. In spite of this continuing ambivalence vis-à-vis a public role as artist, Mühlbach and Hahn-Hahn envision a woman artist's identity independent of romantic love. These *Vormärz* authors reject the Romantic myth of the abandoned woman, which, as Lokke notes, is prevalent throughout nineteenth-century European women's poetry in images of Ariadne, Sappho, and Corinne ("Poetry"). In contrast to the tragically abandoned poet Corinne, Hahn-Hahn's and Mühlbach's heroines abandon men in their search for artistic transcendence.

Conclusion

In focusing on German women's intertextual echoes of Staël, my aim is to (re)place their novels into the international, cosmopolitan cultural context in which the authors themselves positioned their writings. By responding to Staël and her texts, these literary women claimed a place for themselves in a self-consciously female European tradition. However, they confront and transform Staël's influential patterns of female genius and political activism within their own cultural and political context. Paulus, who follows Staël's use of a political frame, nevertheless expresses her personal opposition to Napoleon by juxtaposing French and German national character, while Unger, by contrast, adopts Staël's cosmopolitan consciousness to counteract hatred of the French in Germany. Authors as diverse as Unger and Schopenhauer depict salon

activities reminiscent of Staël to legitimate female engagement in the political and cultural realms. Hahn-Hahn and Mühlbach powerfully rewrite Staël's example of the female artist by attempting to resolve Corinne's irreconcilable conflict between love and art.

These authors' forays into the public spheres of politics and art reconfigured the generic boundaries of the domestic novel and the artist novel, as well as the gender limitations of conventional femininity. Their literary texts shed light on a crucial phase in German literary women's developing sense of self as writers, artists, and citizens. Whether German women expressed their responses to Staël through conservative or controversial narrative strategies, their novels document their self-positioning within contemporary discussions concerning women's social and artistic potential. This cultural reception of Staël's life and writings inspired German women to challenge the notion that women were incapable of genius; her exemplary status encouraged them to defy women's exclusion from public artistic activity and political commentary.

Notes

The translations are my own unless otherwise noted. I am grateful to Lynne Tatlock for her guidance on this research, and I would like to thank Carol Anne Costabile-Heming for commenting on several drafts of this essay.

[1] See, for example, Götze; Kappler; Maeder-Metcalf; Behler.

[2] See Hoock-Demarle. Both men's and women's comments focused on Staël's personal image, national stereotypes, and gender, as well as literary elements, but women were, in general, less condescending than men. For a more extensive discussion of men's and women's comments on Staël, see Martin ("German Women").

[3] For a discussion of feminist criticism and Bakhtin's dialogism, see Hohne and Wussow; Bauer and McKinstry; Eigler.

[4] Her books were widely read in Germany and translations of her novels appeared almost simultaneously with the French originals. *Corinne* was translated by Dorothea Schlegel. See Kappler and Maeder-Metcalf.

[5] Götze asserts that in Germany women were especially interested in the "neuen Typus des Weibes" depicted in *Delphine* (30).

[6] Staël's bold myth of the exceptional woman of genius inspired several generations of European and American writers, including Maria Edgeworth; George Eliot, whose character Maggie Tulliver reads *Corinne;* Margaret Fuller, who was called the "Yankee Corinna"; Mary Shelley; and Constance

Fenimore Woolson. See, for example, Moers; Butler and Colvin; Gutwirth; Torsney; Lokke.

[7] On Paulus see Kammler (110), and on Unger, see Zantop ("Afterword" 392 and "Aus der Not" 146).

[8] On the role of the Revolution in *Delphine* see Balayé, Sourian, Coulet, and Kadish.

[9] Their characters correspond to a political symbolism that juxtaposes republican morality and counterrevolutionary intrigue. Peitsch describes the metaphoric use in revolutionary rhetoric of this moral schema to figure political positions (259).

[10] On Unger's biography and writings, see Zantop "Afterword."

[11] In *Corinne* Staël presents her cosmopolitan vision of European culture. *De l'Allemagne* is also international in scope. In it Staël counteracts Napoleon's cultural and political chauvinism by praising German cultural contributions.

[12] See, for example, the contributions to *Literate Women and the French Revolution,* ed. Catherine R. Montfort.

[13] "Far from me, these vulgar prejudices, source of hate and division! In all countries all good hearts are brothers, but without hating other nations, one can love and respect one's own."

[14] Here Unger undoubtedly refers to Staël's work-in-progress, *On Germany (De l'Allemagne),* which was anxiously awaited among literary circles in Germany, who were kept apprised of its progress by A.W. Schlegel, who worked closely with Staël. See Martin ("German Women" 52).

[15] Zantop, for example, stresses that pressures on women writers who wanted access to the literary marketplace required them to employ "eine Reihe taktischer Anpassungsmanöver," which made their texts appear conventional ("Aus der Not" 145).

[16] Joeres points out the radicality of German women's choice of genres such as autobiography that were understood to be suitable for men, but not women (90). This applies equally to women's selection of the artist novel.

[17] Two other artist novels by Caroline Auguste Fischer and Caroline Pichler also reveal the influence of *Corinne.* Fischer's Romantic novel *Margarethe* (1812) decries social obstacles to female creativity, anticipating the social concerns of *Vormärz* authors. Pichler's *Frauenwürde* (1818) is similar to *Gabriele* in expressing a conservative moral, but it presents two opposing female artist figures who reveal tensions in the woman artist's identity. For a discussion of Fischer's *Margarethe* see Runge, and for an examination of Staël's influence on Fischer and on Pichler's *Frauenwürde* see Martin "Between Exaltation and Melancholy."

[18] Menzel (434); on Knebel's comments, see Houben (201).

[19] Kontje argues that Gabriele's admission of her passion just before her death reveals the falsity of her mother's doctrine of female renunciation (128–29).

[20] See also Köhler (191).

[21] Kontje, arguing against reading Gabriele merely as a figure of renunciation, remarks in this connection that she "does not so much give up her desire as she displaces it into the imaginary realm, and it is this displacement that enables her to survive an otherwise impossible marriage" (126). I would maintain that Italy constitutes the primary location of her desire in this imaginary realm. Köhler also shows that Italy, like most of the physical spaces in the novel, acquires symbolic meaning, not topographical location (190).

[22] Critics have noted the autobiographical connection of this aspect of the novel to Schopenhauer's own Weimar salon, where artists read, recited, performed, and discussed their works. See, for example, Köhler (184 f). In addition, Köhler compares this aspect of Schopenhauer's novel to Goethe's *Wahlverwandtschaften*. Schopenhauer, however, develops the salon activities of her characters more extensively than does Goethe in his novel.

[23] Kontje claims that there are no "imagined international communities" in *Gabriele* (123), but her imagined surrogate family includes a strong Italian component.

[24] Critics often relate Schopenhauer's concept of *Entsagung* in *Gabriele* to Goethe's treatment of this theme in the *Wahlverwandtschaften*.

[25] In a letter from 1856 the by then well-established author Luise Mühlbach again mentions the significance of Corinne for her development as a writer. She describes to the publisher Georg Cotta her meeting with his father, when she was "kaum vierzehn Jahre und nichts sehnlicher wünschend wie Corinna auf dem Capitol [gekrönt zu werden]." Quoted by Tönnesen (217).

[26] Burkhard has observed that the female artists Corinne and Franz Grillparzer's Sappho die from the loss of love, while Goethe's male poet Tasso survives by clinging to his art (140).

Works Cited

Armstrong, Nancy. *Desire and Domestic Fiction: A Political History of the Novel*. New York: Oxford UP, 1987.

Bakhtin, M.M. *The Dialogic Imagination: Four Essays*. Ed. Michael Holquist. Trans. Caryl Emerson and Michael Holquist. Austin: U of Texas P, 1981.

Balayé, Simone. *"Delphine,* roman des Lumières: pour une lecture politique." *Le siècle de Voltaire: Hommage à René Pomeau.* Vol. 1. Ed. Christiane Mervaud and Sylvain Menant. Oxford: Alden Press, 1987. 37-46.

Bauer, Dale M., and Susan Jaret McKinstry, eds. *Feminism, Bakhtin, and the Dialogic.* Albany: SUNY P, 1991.

Behler, Ernst. "Madame de Staël and Goethe." *The Spirit of Poesy.* Ed. Richard Block and Peter Fenves. Evanston: Northwestern UP, 2000. 131-49.

Bürger, Christa. *Leben Schreiben: Die Klassik, die Romantik und der Ort der Frauen.* Stuttgart: Metzler, 1990.

———. "'Die mittlere Sphäre': Sophie Mereau—Schriftstellerin im klassischen Weimar." *Deutsche Literatur von Frauen.* 2 vols. Ed. Gisela Brinker-Gabler. München: Beck, 1988. I: 366-88.

Burkhard, Marianne. "Love, Creativity and Female Role: Grillparzer's 'Sappho' and Staël's 'Corinne' between Art and Cultural Norm." *Jahrbuch für Internationale Germanistik* 16.2 (1984): 128-46.

Butler, Marilyn, and Christina Colvin. "Maria Edgeworth et Delphine." *Cahiers Staëliens* 26-27 (1979): 77-91.

Coulet, Henri. "Révolution et roman selon Mme de Staël." *Revue d'Histoire Littéraire de la France* 4 (1987): 638-60.

Ebersberger, Thea, ed. *Erinnerungsblätter aus dem Leben Luise Mühlbach's.* Leipzig: H. Schmidt & C. Günther, 1902.

Eigler, Friederike. "Feminist Criticism and Bakhtin's Dialogic Principle: Making the Transition from Theory to Textual Analysis." *Women in German Yearbook* 11. Ed. Sara Friedrichsmeyer and Patricia Herminghouse. Lincoln: U of Nebraska P, 1995. 189-203.

Fetting, Friederike. *"Ich fand in mir eine Welt." Eine sozial- und literaturgeschichtliche Untersuchung zur deutschen Romanschriftstellerin um 1800: Charlotte von Kalb, Caroline von Wolzogen, Sophie Mereau-Brentano, Johanna Schopenhauer.* München: Wilhelm Fink, 1992.

Fischer, Caroline Auguste. *Margarethe: Roman.* 1812. Hildesheim: Georg Olms Verlag, 1989.

Goethe, Johann Wolfgang von. Review of *Bekenntnisse einer schönen Seele, von ihr selbst geschrieben, Melanie, das Findelkind,* and *Wilhelm Dumont. Goethe. Berliner Ausgabe. Kunsttheoretische Schriften und Übersetzungen.* 17 vols. Berlin: Aufbau-Verlag, 1965-1970. 17: 410-21.

Goldberger, Avriel H., trans. *Corinne, or Italy.* By Madame de Staël. New Brunswick: Rutgers UP, 1987.

———. *Delphine.* By Madame de Staël. DeKalb: Northern Illinois UP, 1995.

Götze, Alfred. *Ein Fremder Gast: Frau von Staël in Deutschland, 1803–04.* Jena: Walter Biedermann, 1928.

Gutwirth, Madelyn. *Madame de Staël, Novelist: The Emergence of the Artist as Woman.* Urbana: U of Illinois P, 1978.

Hahn-Hahn, Ida Gräfin. *Gräfin Faustine.* 1841. Nachwort von Annemarie Taeger. Bonn: Bouvier, 1986.

Hohne, Karen, and Helen Wussow, eds. *A Dialogue of Voices: Feminist Literary Theory and Bakhtin.* Minneapolis: U of Minnesota P, 1994.

Hoock-Demarle, Marie-Claire. "Madame de Staël et les femmes allemandes, un malentendu positif." *Cahiers Staëliens* 35 (1984): 9–40.

Houben, H.H., ed. *Damals in Weimar: Erinnerungen und Briefe von und an Johanna Schopenhauer.* 2nd ed. Berlin: Rembrandt-Verlag, 1929.

Joeres, Ruth Ellen B. *Respectability and Deviance: Nineteenth-Century German Women Writers and the Ambiguity of Representation.* Chicago: U of Chicago P, 1998.

Kadish, Doris Y. *Politicizing Gender: Narrative Strategies in the Aftermath of the French Revolution.* New Brunswick: Rutgers UP, 1991.

Kammler, Eva. *Zwischen Professionalisierung und Dilettantismus: Romane und ihre Autorinnen um 1800.* Opladen: Westdeutscher Verlag, 1992.

Kappler, Arno. Afterword. *Corinna oder Italien.* By Germaine de Staël. Trans. Dorothea Schlegel. München: Winkler, 1979. 523–58.

Köhler, Astrid. *Salonkultur im klassischen Weimar: Geselligkeit als Lebensform und literarisches Konzept.* Stuttgart: M & P, 1996.

Kontje, Todd. *Women, the Novel, and the German Nation 1771–1871: Domestic Fiction in the Fatherland.* Cambridge: Cambridge UP, 1998.

Kord, Susanne. *Sich einen Namen machen: Anonymität und weibliche Autorschaft 1700–1900.* Stuttgart: Metzler, 1996.

Körner, Josef, ed. *Krisenjahre der Frühromantik.* 2 vols. Bern: Francke, 1969.

Lokke, Kari. "Poetry as Self-Consumption: Günderode, Hemans, and Landon." *Romantic Poetry.* Ed. Angela Esterhammer. Amsterdam: John Benjamins, 2002. 91–111.

———. "Sibylline Leaves: Mary Shelley's *Valperga* and the Legacy of Corinne." *Cultural Interactions in the Romantic Age.* Ed. Gregory Maertz. Albany: State University of New York P, 1998. 157–73.

Maeder-Metcalf, Beate. *Germaine de Staël Romancière.* Frankfurt a.M.: Peter Lang, 1995.

Martin, Judith E. "Between Exaltation and Melancholy: Corinne and the Female Artist Novel in Nineteenth-Century Germany." *Journal of the Association for the Interdisciplinary Study of the Arts* (Spring 2000): 29–50.

———. "German Women Writers Read Madame de Staël: Cultural and Sexual Politics in German Women's Novels from Romanticism to the *Vormärz*." Diss. Washington University, 1999.

McNicholl, Rachel, and Kerstin Wilhelms. "Romane von Frauen." *Hansers Sozialgeschichte der deutschen Literatur vom 16. Jahrhundert bis zur Gegenwart.* Vol. 5. *Zwischen Restauration und Revolution. 1815-1848.* Ed. Gert Sautermeister and Ulrich Schmid. München: Carl Hanser, 1998. 210-33.

Menzel, Wolfgang. *Geschichte der Deutschen Dichtung von der ältesten bis auf die neueste Zeit.* Vol. 3. Leipzig: Louis Zander, 1895.

Moers, Ellen. *Literary Women.* Garden City, NY: Doubleday, 1976.

Möhrmann, Renate. *Die andere Frau: Emanzipationsansätze deutscher Schriftstellerinnen im Vorfeld der Achtundvierziger-Revolution.* Stuttgart: Metzler, 1977.

Montfort, Catherine R. "From Private to Public Sphere: The Case of Mme de Sévigné and Mme de Staël." *Literate Women and the French Revolution of 1789.* Ed. Catherine R. Montfort. Birmingham, AL: Summa Publications, 1994. 111-26.

Mühlbach, Luise. *Frauenschicksal.* Altona: Hammerich, 1839.

———. *Der Zögling der Natur.* Altona: Hammerich, 1842.

Paulus, Caroline. *Wilhelm Dumont: Ein einfacher Roman.* Lübeck: Bohn, 1805.

Peitsch, Helmut. "Die Revolution im Familienroman: Aktuelles politisches Thema und konventionelle Romanstruktur in Therese Hubers *Die Familie Seldorf.*" *Jahrbuch der deutschen Schillergesellschaft* 28 (1984): 248-69.

Pichler, Caroline. *Frauenwürde: Schriften von Caroline Pichler.* Stuttgart: A.F. Macklot, 1828. Vols. 23-30.

Reichlin-Meldegg, Karl Alexander Freiherr. *Heinrich Eberhard Gottlob Paulus und seine Zeit, nach dessen literarischem Nachlasse, bisher ungedrucktem Briefwechsel und mündlichen Mittheilungen dargestellt.* 2 vols. Stuttgart, 1853.

Runge, Anita. "Wenn Schillers Geist einen weiblichen Körper belebt: Emanzipation und künstlerisches Selbstverständnis in den Romanen und Erzählungen Caroline Auguste Fischers." *Untersuchungen zum Roman von Frauen um 1800.* Ed. Helga Gallas and Magdalene Heuser. Tübingen: Niemeyer, 1990. 184-202.

Schopenhauer, Johanna. *Gabriele: Ein Roman.* 1819. Ed. Stephan Koranyi. München: Deutscher Taschenbuch Verlag, 1985.

Sengle, Friedrich. *Biedermeierzeit.* 2 vols. Stuttgart: Metzler, 1972.

Sourian, Eve. "*Delphine* and the Principles of 1789: 'Freedom, Beloved Freedom.'" *Germaine de Staël: Crossing the Borders.* Ed. Madelyn

Gutwirth, Avriel Goldberger, and Karyna Szmurlo. New Brunswick: Rutgers UP, 1991. 42–51.

Staël, Germaine de. *Corinna oder Italien*. 1807. Ed. Arno Kappler. Trans. Dorothea Schlegel. München: Winkler, 1979.

———. *Delphine*. 1802. Ed. Simone Balayé and Lucia Omacini. Geneva: Droz, 1987.

Taeger, Annemarie. Afterword. *Gräfin Faustine*. By Ida Hahn-Hahn. Bonn: Bouvier, 1986. 245–68.

Tebben, Karin. "Soziokulturelle Bedingungen weiblicher Schriftkultur im 18. und 19. Jahrhundert. Zur Einleitung." *Beruf: Schriftstellerin. Schreibende Frauen im 18. und 19. Jahrhundert*. Ed. Karin Tebben. Göttingen: Vandenhoeck und Ruprecht, 1998. 10–46.

Tenenbaum, Susan. "Liberating Exchanges: Mme de Staël and the Uses of Comparison." Montfort. 225–36.

Tönnesen, Cornelia. "'Überhaupt hat sie eine kecke, ungezügelte Phantasie.' Luise Mühlbach (1814–1873)." Tebben. 215–43.

Torsney, Cheryl B. *Constance Fenimore Woolson: The Grief of Artistry*. Athens: U of Georgia P, 1989.

Unger, Friederike Helene. *Die Franzosen in Berlin oder Serene an Clementinen in den Jahren 1806, 7, 8: Ein Sittengemälde*. Leipzig, 1809.

Wägenbaur, Birgit. *Die Pathologie der Liebe: Literarische Weiblichkeitsentwürfe um 1800*. Berlin: Erich Schmidt, 1996.

Zantop, Susanne. Afterword. *Bekenntnisse einer schönen Seele: Von ihr selbst geschrieben*. By Friederike Helene Unger. Hildesheim: Georg Olms, 1991. 385–416.

———. "Aus der Not eine Tugend...: Tugendgebot und Öffentlichkeit bei Friederike Helene Unger." *Untersuchungen zum Roman von Frauen um 1800*. Ed. Helga Gallas and Magdalene Heuser. Tübingen: Max Niemeyer, 1990. 132–47.

Capturing Hawai'i's Rare Beauty: Scientific Desire and Precolonial Ambivalence in E.T.A. Hoffmann's "Haimatochare"

Valerie Weinstein

E.T.A. Hoffmann's 1819 epistolary short story "Haimatochare" depicts the desires of two natural scientists on a mission to Hawai'i that leads to their tragic downfall. In this tale, the colonial encounter becomes the site onto which preexisting, contagious, and eventually fatal passions are transferred. The story thus produces an intense ambivalence, a complex and fascinating mix of fear and desire, toward European colonialism. My reading both begins to untangle the mesh of lust, horror, parody, and epistemological pursuits in this vexing text and suggests that more study of the ambivalence of German precolonial narratives can enrich our understanding of German discourses of nation, empire, race, and sex. (VW)

A parody written by E.T.A. Hoffmann in 1819 about two scientists on an expedition to Hawai'i, "Haimatochare" is "precolonial" in relationship to the status of the particular space and native people described as well as to the German context of the text's publication.[1] The text explicitly treats, and emerges in, a broader colonial context where European nations already have colonized and are continuing to colonize the far reaches of the globe. Yet "Haimatochare" does not directly describe either the process of colonization or the author's experience of contact with potentially colonized spaces or cultures. So, while the story refers to British colonial authorities and takes place in the increasingly coveted Pacific, real-world conditions for author, audience, and setting are not exactly "colonial." For Hoffmann and his German contemporaries, the question of whether or not to colonize remained open, and Hoffmann's text responds to this question in a complex, ambivalent manner.

The profound ambivalence of this text could productively complicate the discussion of German precolonial discourse initiated by Russell

Berman and Susanne Zantop in their respective analyses of "colonial discourse"[2] and "colonial fantasy."[3] Compared to most of the texts read by Berman and Zantop, this story's stance regarding colonialism is much less clear. It is not easily identifiable as "emancipatory reason" or "instrumental rationality" (Berman), nor is it a fantasy that expresses either "latent colonialism" or resistance (Zantop), but is rather a fascinating fusion of both. I would argue that more study of texts that are as complex, contradictory, and ambivalent as Hoffmann's will complement what we already know about German precolonial discourse and allow us better to heed Zantop's call to examine pre-twentieth-century German discourses of race and nation in ways that acknowledge and examine both racism and colonialism, yet that are not fundamentally tainted by assumptions about the inevitability of colonialism, German colonial brutality, and the Holocaust (16).

"Haimatochare" was recently called a tale "almost wholly neglected" by the academy (McGlathery 166). This story has probably received so little scholarly attention because, although both charming and intriguing, it seems to raise many more questions than it answers. Christa-Maria Beardsley argues that the story parodies science by linking it with grotesquely excessive emotion (300–06). There is no doubt that "Haimatochare" parodies scientific explorations and that it does so via strangely sexualized discourse. Yet Beardsley's brief reading does not fully account for this truly vexing tale. She does not explain the possible functions of Hoffmann's mockery of science. Nor does her claim that emotion makes the parody grotesque fully account for Hoffmann's deployment of sexual discourse. Moreover, Beardsley does not consider any functions of the text's Pacific setting beyond its location of the parody in a real rather than in a fantastic world (300).

Postcolonial scholarship, however, suggests that a sexualized critique of science in a precolonial context warrants analysis more attentive to that context. Anneliese Moore illuminates Hoffmann's copious references to persons, places, and events in European colonial and Hawai'ian post-contact history in her account of "Haimatochare" as the first piece of Hawai'ian fiction (13–27).[4] Moore's research makes clear that the tale's precolonial setting is intrinsic to its narrative, although she does not develop a literary or cultural analysis of the text beyond her thorough presentation of its relationship to historic figures, places, events, and texts. Nevertheless, the many connections unearthed by Moore also imply that it must be particularly significant that this sexually and emotionally charged persiflage of science takes place in a precolonial space. In the following analysis, I will address this nexus as well as show that the baffling complexity and deep-rooted ambivalence[5]

of "Haimatochare" are inextricable from its precolonial status. This will not only provide a more comprehensive reading of a fascinating, yet little-known text, but it will also allow me to suggest that more consideration of complexity and ambivalence in German precolonial texts could enrich our ongoing discussions of German colonial discourse.

"Haimatochare" shares its name with the lovely Hawai'ian islander who is a catalyst for the story's drama. Conceived in collaboration with Hoffmann's friend, the poet and naturalist Adelbert von Chamisso,[6] the name "Haimatochare" means "delighting in blood" in ancient Greek, although it is meant to be easily mistaken for that of a maiden from the South Seas (*E.T.A. Hoffmanns Briefwechsel* 2: 202).[7] The seduction, deception, and destruction embodied in this figure's name epitomize her functions and those of the narrative itself. A series of letters charts the rapid escalation of hostilities between the naturalists Brougthon and Menzies, two dear friends on an expedition to O'ahu. It soon becomes clear that the tension is caused by Menzies' having stolen "the prettiest, handsomest, loveliest island beauty [*Insulanerin*]" from Brougthon (Moore 6; Hoffmann 672), which leads to the men killing one another in a duel. Only from a later letter by their captain does the reader learn that Haimatochare is not a woman but a new species of insect, something between a human pubic "crab" louse (*Filzlaus*) eaten [!] by "Hottentots" and Greenlanders and a horned parasite that feeds on birds (Latin: Hoffmann 678; English: Moore, "Haimatochare" 10; German: Beardsley 304–05, *Briefwechsel* 201).[8] Blamed for the death of two eminent scholars, this lovely louse is afforded a formal naval burial at sea by captain, crew, and a Hawai'ian retinue.

Although all the figures in Hoffmann's story recognize that Haimatochare is a bug, the epistolary form of the story and the ambiguous language of the naturalists' letters serve to conceal Haimatochare's insect identity from the reader initially. The reader's confusion between native woman and parasitic insect does not merely make "Haimatochare" more surprising, ironic, and funny (all of which it does). This confusion also performs critical functions, calling the reader's attention to discursive and affective slippages that blur the distinctions between sexual desire, the pursuit of "natural history," and the desire for colonial possession. The story thus challenges the innocence of the natural scientist within the framework of larger colonial projects[9] and mocks the homosocial bonds it construes as supporting that framework. The perplexing identity of the bug, both deceptive and inscrutable, and its consequences within the narrative also have another function: they figure precolonial cultural contact as both seductive and contagious. In doing so, the text expresses

an underlying ambivalence that relates to "Haimatochare's" precolonial status.

* * *

Haimatochare's identity is hidden from the reader by both language and narrative structure, whereby the reader is duped into thinking that s/he has a truthful and accurate picture of events. In the foreword, Hoffmann claims to have received the letters that follow from Chamisso and intends to present them because the unhappy fate of two naturalists is worth public notice (3). This brief paragraph, signed by Hoffmann, creates an illusion that the author is offering straightforward documentation of actual events. His liberal use of historical names and places may have supported the story's "pretense of authenticity" as well (Moore 14). The letters themselves both perpetuate the illusion of integrity and create the subjective framework that allows the story to disguise its main object. By unfolding the events in a fragmentary, subjective way, the letters, which claim the authority of firsthand accounts, leave essential information unsaid. When Brougthon accuses Menzies of having stolen Haimatochare, the fact that she is an insect—obvious to both of them—is not mentioned. This leaves the reader to interpret the men's highly charged prose otherwise.

The naturalists never mention explicitly what they already know (that Haimatochare is a bug), and the letters include that information only when they announce the results of the duel (Beardsley 300). By deferring the disclosure of Haimatochare's identity, the narrative temporarily perpetuates the reader's misunderstanding, already established in letter number four, from Menzies to his friend Edward Johnstone in London (Beardsley 302). In this letter, Menzies tells his friend that he is "the happiest human under the sun" and shares "[his] rapture, [his] undescribable delight" (Moore 5-6; Hoffmann 671). He describes the scene where he went into the woods to find an unusual nocturnal butterfly, but found Haimatochare instead. This passage uses deceptive terminology to hide that Haimatochare is a bug—calling her an "Insulanerin." More notably, it relies on erotically evocative images of "fragrant herbs" and "multicolored tapestry" and words like "sultry" and "voluptuous" to describe the tropical forest in which Haimatochare is found. Menzies' reactions include "mysterious awe," "ecstasy," breathlessness, and being "frozen" in place. The meeting itself is construed in terms of magic, desire, and physical compulsion, as when Menzies writes: "Then I was drawn, as if by invisible hands, into a thicket whence there came murmurs and whispers like tender pledges of

love" (Moore 6; Hoffman 672). The intense language and imagery of this passage toy with the reader's expectations regarding Haimatochare's identity and put into play a desire that will be discussed further below.

Beardsley notes that it is this passage that misleads the reader, "if one doesn't immediately weigh each word" (302), and she points out the clues that would disclose Haimatochare's identity to the discerning reader: her bed on a dove's wing, her tiny chamber papered in gold, the scientists' desire in this and other letters to own her and to eternalize her in annals (Beardsley 303). Despite these vexing details, the dominant tone in the passage is one of a passionate encounter, leading the reader to assume that the female native (*Insulanerin*) depicted is a beautiful woman, not a parasite. The sultry environment, the language of lust, physical and psychological compulsion, the descriptions of the breathtaking, treasured islander, and the lack of control that Menzies describes in words and expresses in his shuddering, stuttering prose (broken irregularly by hyphens and exclamation), all recall descriptions of sexual encounters. Indeed, the passionate language of the naturalists' letters and the climax of their passion in a fatal duel resemble discourses and behaviors more associated with sexual desire and competition than with scientific discovery. Brougthon accuses Menzies of being "in the grip of another foolish, even criminal, passion" (Moore 7; Hoffmann 673-74), of having betrayed their friendship because of "the unfortunate passion" that led him to steal Haimatochare (Moore 8; Hoffmann 675). Menzies counters these attacks, claiming Haimatochare should be his because he was the first "to cast eyes on her lovingly" and that Brougthon is "deluded by the basest jealousy" (Moore 8-9; Hoffmann 675). This rhetoric, like the letter describing the discovery of Haimatochare, initially disguises the arthropodan nature of their love object while it links the thirst for scientific knowledge with sexual desire.

Through the scientists' discourse, Hoffmann posits the existence of a passion that precedes the arrival of the expedition on Oʻahu and that is cathected only later onto the landscape and the creatures in it. The language of the scientists' first letters to the governor, requesting space for both of them aboard the *Discovery,* already suggests that strong emotions yield fruitful scientific inquiry. They describe their friendship in terms of scientific productivity and love. Menzies writes: "This wish [to visit Hawaiʻi] has renewed itself doubly, because we, Mr. Brougthon and I, by way of the same science, by way of the same research, are most closely bound and for a long time have been used to jointly approaching our observations and, through instantaneous sharing of them, being on hand for one another" (Hoffmann 666-67, my translation). Brougthon echoes his intensity: "Only with him, only when he

shares my efforts with the usual love, am I able to accomplish what is expected of me" (Hoffmann 667, my translation).[10] Indeed, it is on these grounds that the governor gives them permission: "With tender pleasure I notice how science, my gentlemen, has befriended the two of you so tenderly with one another, that out of this beautiful bond, out of this joint striving, only the richest, most marvelous results can be expected" (Hoffmann 667, my translation). Although these letters do not construe Brougthon's and Menzies' relationship as a sexual one, the language of the letters certainly invests it with intense intimacy, an intimacy conceived as the source of their scientific achievements. Passionate friendship and joint research promise beautiful results.[11]

By the time Menzies writes to his friend Johnstone from the ship (letter three), his passionate language has partially shifted objects from his scientific friendship to the ship's destination: "You are right, my dear friend, the last time I wrote to you I really was afflicted by some fits of melancholy. Life at Port Jackson had become an utter boredom and I was painfully longing for my splendid paradise, the lovely island of O-Wahu, from which I had only recently departed" (Moore 3; Hoffmann 667–68). This claim depicts Menzies as emotionally agitated with desire for Oʻahu. He has not, however, entirely abandoned his attitude toward Brougthon, as we can see in the following claim: "My friend Brougthon, a learned and good-natured man, alone was able to brighten my days at Port Jackson and to keep me responsive [*empfänglich*] to the demands of science. But he too was longing to leave Port Jackson," which, Menzies adds, offered their research impulse (*Forschungstrieb*) little nourishment (Moore 3; Hoffmann 668). The two share the desire to undertake a voyage, yet, in the absence of the object of Menzies' stronger desire, it is Brougthon who can stimulate him and keep him receptive. The language makes this allegedly professional claim sound subtly erotic. The desire in this letter shifts back and forth among the desire for knowledge, for his fellow scientist, and for Oʻahu itself. Menzies tells an anecdote about an entomologist who was more interested in observing a bug than in noticing the visit of his long lost brother. Menzies disavows having this kind of passion only to wax poetic about the "most marvelous and mysterious" world of insects (Moore 5; Hoffmann 670), then closes by questioning his own motives and desires:

> Maybe...only the instinct of my investigative mind is driving me irresistibly to O-Wahu. Maybe...I am compelled by a premonition of an imminent, most unusual occurrence!—Yes, Edward, at this very moment I am seized by this notion with such a force that I am unable to continue this letter.... In my mind it is stated clearly that

on O-Wahu there is waiting for me either the greatest happiness or inevitable ruin (Moore 5; Hoffmann 671).

This passage makes the shape of Menzies' intense passion less than clear. His research compulsion blends with a suspense and an anticipation so strong that they take his words away, just as they will do again in the letter where he talks about having found Haimatochare. Thus, before he ever reaches Oʻahu's shores, the stage is set for his fatal desire.

We can read the blatant, polymorphous desires that Hoffmann ascribes to his fictional naturalists in counterpoint to the travel narratives by naturalists examined by Mary Louise Pratt in *Imperial Eyes: Travel Writing and Transculturation*. Pratt argues that the work of European naturalists in the eighteenth and nineteenth centuries played a major role in the integration of non-European parts of the globe into European systems of knowledge and power. By the second half of the eighteenth century, the naturalist had become a standard protagonist of (widely read) travel narratives, which began to take on standard features. "Naturalizing" and descriptions of flora and fauna become part of the narrative structure. European scientists integrate what they encounter into European orders and paradigms (27–33). At the same time, "[h]ere [in the "anti-conquest" narratives of natural history] is to be found a utopian image of a European bourgeois subject simultaneously innocent and imperial, asserting a harmless hegemonic vision that installs no apparatus of domination" (34). According to Pratt, as "anti-conquest" narratives, naturalists' writings deploy *multiple* strategies of innocence, including sexual innocence: "Unlike such antecedents as the conquistador and the hunter, the figure of the naturalist-hero has a certain impotence or androgyny about him" (56).

The naturalists' texts in "Haimatochare" thus stand out in contrast to these standard narratives of natural history. An alleged documentation of naturalists on an expedition to Hawaiʻi, "Haimatochare" relies on familiar figures and structures and makes similar reality claims. As in contemporary travel writing, "Haimatochare" is structured around a scene of "naturalizing"—the seductive scene of discovery described above. Yet, where the act of classifying specimens typically appears as rational, systematic, and innocent and masks its hegemonic functions, in "Haimatochare," by contrast, it becomes the site of passionate and fatal contention, pointing toward the high stakes involved. The most interesting manner in which "Haimatochare" differs from most travel accounts of its day is its sexualization of the naturalists' desires. Impotence is replaced by obsessive passion construed as fatal, if not pathological. The

intensification of passions furthermore turns the androgyny described by Pratt into an intimate homosocial, if not homoerotic, relationship between the two scientists, catapulting the predominantly male enterprise of global exploration into a contentious position in relationship to nineteenth-century European sexual morality.[12] Moreover, the scene of naturalizing turns into a lusty abduction that makes the reader initially wonder whether or not, as in Kleist's *Marquise von O,* the dashes mask an unacknowledged rape (Kleist 2: 106), or whether Menzies' "blasphemous passion" might lead to a permanent relationship with an island girl. By way of its sexualization, the scientific expedition in "Haimatochare" looks anything but objective, harmless, and impotent.

"Haimatochare" depicts a process whereby the intense desires of the naturalists (for Hawai'i, for knowledge, for each other) are transferred on to a single object, a bug that the reader is meant to mistake for a native woman. Not only does this compromise the political and sexual innocence of the natural scientist, but it also seems to perpetuate well-known misogynist and racist stereotypes of women and natives being less-than-human (in this case, easily interchangeable with a parasite). Yet the text's deployment of these discourses is complicated. "Haimatochare" conflates the categories of Hawai'ian islander and woman insofar as all the Europeans in the story are male and the only islanders who play an important role in the narrative are Haimatochare and Queen Kahumanu [sic], who is infatuated with Menzies (673, 680). Native woman and bug are conflated more obviously in the confusion created around Haimatochare. By way of these slippages, the text introduces a fantasy of precolonial contact as the site of heterosexual desire.[13] The European men desire the "island beauty" and the native queen desires a European man.[14] Any fantasy of heterosexual fulfillment via the colonial encounter, however, is thwarted, for as the queen pines away for Menzies, he and Brougthon are fighting over a bug. The relationship between Brougthon and Menzies keeps the reader from witnessing either heterosexual or intercultural union and steers the narrative toward tragedy.

Brougthon, Menzies, and Haimatochare form an imbalanced erotic triangle, where what is at stake is the love, loyalty, and rivalry between the two men.[15] The impassioned letters between the two men make such a focus explicit, whereas they never discuss Haimatochare as a being with agency or desires. She is merely something to be dragged out of the forest, locked in a golden chamber, and fought over. The text represents this asymmetry in a blatant and caricatured manner, as when—akin to many similar statements in both naturalists' letters—Brougthon writes to Menzies, "Surrender Haimatochare to me and I shall take you to my heart as my most loyal, most intimate friend...."

Yes, I shall call the rape of Haimatochare a heedless act only, and not a disloyal and criminal one," accenting the importance of the men's bond over the well-being of Haimatochare (Moore 8; Hoffmann 675). Her wishes are conspicuously absent from their discussion, in a way that might strike readers as perplexing until they realize that the conflict is over a bug. The rhetorical hyperbole, the blatant lack of Haimatochare's voice, and the obfuscation of her identity in the two-way exchange of letters that nevertheless describes a triangle exaggerate the interchangeability of women, natives, and insects within European male social systems, the uneven distribution of power in these systems, and the strong bonds between men that these third parties are intended to mediate. This exaggeration not only calls attention to these unequal structures, but also combines with the story's absurdity and humor to mock them.

The charged letters between Brougthon and Menzies initially seem to expose homosocial bonds that are infused with homoerotic desire, which they and the admiralty construe as promoting science and imperial exploration, and which Hoffmann represents as thwarting a potential colonial encounter. The letters seem to show that this desire has been temporarily displaced onto a native woman, and that this beautiful, desirable woman actually functions not only as a safe haven for eroticism but also as a passive, feminine commodity in a "traffic in women" meant to increase the stature of and bond between two males (cf. Rubin). Then it is revealed that it is a previously unclassified tropical insect, the object of exploration and discovery, that functions as such currency. Like a woman, Haimatochare becomes a third through which the scientists can negotiate power and their own intimate bond. As the hyperbolic language of the letters calls attention to this social structure, the reader's confusion highlights the interchangeability of women, natives, and the objects of natural history within such power structures. The conflict between the men, their eventual demise, and the shift in blame that results in Haimatochare's execution all underscore how unstable and destructive such asymmetrical triangles are. Moreover, the description of the despondent mourners in the final letter, which foregrounds the mourning Queen Kahumanu, seems to evoke the possibilities lost as long as European men's relationships with women, natives, and nature are really about relationships between themselves (680). While this particular contact has gone sour, Hoffmann leaves open the potential for other kinds of intercultural contacts.

By turning a woman into a bug, Hoffmann calls attention to a triangular structure where women, natives, and the natural world function as unequal third parties through which power and desire

between European men are negotiated. Despite the importance of this triangle and the seeming insignificance of the object in the third point, what Haimatochare is must shape any interpretation of this text. With the sudden revelation of Haimatochare's true identity, readers are faced with a debacle of grotesque proportions, where the size and nature of the object of competition and desire (Haimatochare) seem utterly incommensurate with the reactions she causes. This incommensurability and the insect's seeming insignificance support the text's parody of science and its critique of the role of European desires and male homosocial bonds in the exploration of the non-European world. It construes the scientists' pursuits as not only passionate but also both frivolous and fatal. Likewise, by characterizing this previously unclassified insect as a liminal creature who spreads lust, it helps recast the precolonial encounter as seductive and dangerous.

The threats of rape and of intercultural intercourse buried in Brougthon's and Menzies' ambiguous language are displaced by the perverse revelation that the naturalists' object of desire is not a woman but a previously unclassified insect closely related to a *pubic* louse, an association that further characterizes the scientists' desires as unhealthy. The destruction caused by this parasite clearly refers to the lice infestations that did plague European voyages (Moore 21). Haimatochare's vermin identity and seductive appeal may also indirectly refer to the "virgin soil" epidemics caused by European exploration, and the role of maritime expeditions in spreading sexually transmitted (and other) diseases around the globe. Although the epidemics in the New World and the Pacific were demographically more devastating[16] than the syphilis purportedly brought home to Europe,[17] syphilis was a widespread and feared disease in Europe. Moreover, by the early nineteenth century Europeans had long recognized that syphilis and gonorrhea, not yet understood as two distinct diseases (Quétel 82–83), were sexually transmitted (Quétel 10; Allen 43); the (contested) theory that syphilis came from the New World had also been in circulation since the early sixteenth century (Quétel 4, 35, 37, 40; Allen 55). In addition, Europeans were fully aware that their voyages of exploration were spreading syphilis. "Cook's crews were so enfeebled by venereal disease just before leaving Tahiti for Hawai'i [during the first voyage in 1778] that there were 'scarce hands enough to do duty on board,'" and they brought syphilis, tuberculosis, and other diseases with them when they "discovered" Hawai'i (Stannard 70). When the Cook voyage returned to Hawai'i a mere ten months later, William Ellis, the second mate of the *Discovery*'s[18] surgeon, wrote: "We found the venereal disease raging among those poor people, in a violent degree, some of whom were infected most

terribly; and it was the opinion of most, that we, in our former visit, had been the cause of this irreparable injury" (Stannard 69). Although the historical reality was that Europeans brought devastating epidemics of syphilis and gonorrhea to Hawai'i (Stannard 69–74), "Haimatochare," drawing loosely on discourses of disease and contact, seems to implicate both Hawai'i and European exploration in the transfer of sexually transmitted diseases. Brougthon's and Menzies' preexisting desires lead them to bring home a bug from the tropics that is both unique and related to a pubic louse found everywhere from Greenland to South Africa and that seems to infect her beholders with a particularly virulent form of desire.

The narrative does not entirely blame the naturalists for their own unfortunate demise. It distributes the blame more evenly by construing Haimatochare as a vector of infectious desire. Of all the figures in the story, only the Governor of New South Wales, upon hearing the news, attributes the debacle entirely to the scientists. He asks: "Is it possible that passion for science can drive man to the point of forgetting what he owes to friendship, even to society in general?" (Moore 11; Hoffmann 679) By contrast, the figures who come into contact with Haimatochare on O'ahu interpret the bug herself as the source of this desire, and their behavior reinforces their position. Brougthon and Menzies view her as a beautiful creature worth dying for, and describe her in the most seductive terms. In Captain Bligh's letter to the governor describing the cause and outcome of the duel, he adds his own comments to Menzies' Latin description of the bug:

> Out of these insinuations by Herr Menzies, Your Excellency already will deign to judge how unique in its own way the creature is, and I may, ignoring that I am not actually a naturalist, well add that the insect, observed attentively through a magnifying glass, has something most unusually attractive that can be attributed exquisitely to the shiny eyes, the beautifully colored back, a certain charming lightness of movement otherwise not at all characteristic of such creatures (Hoffmann 678–79, my translation).

The captain's compulsion to describe Haimatochare further, his run-on prose, the odd breakdown of his language toward the end of the passage, and his characterization of her as "most unusually attractive" (*ganz ungemein anziehend*), which reveal that he has partially succumbed to her allure, blame her for the seduction and death of the scientists almost as explicitly as his following comments do. Bligh asks the governor if he should pack and ship Haimatochare to a museum or "send it to the bottom of the ocean for having caused the death of two excellent men"

(Moore 11; Hoffmann 679). The ceremony where this takes place provokes an odd outburst of emotion—a three-gun salute, a moving eulogy by the first mate, the mourning bellows of the royal retinue, and the tears of the entire crew. All the fuss about the bug—like her vampiric name—figures her as the provocation for excessive emotion. Not only do the characters in the story blame Haimatochare for the scientists' excesses, but their own emotional breakdowns imply that they, during their limited contact with the bug, have been infected as well.

But what, exactly, is this creature that infects others with desire and destruction? The scientists desire to name and classify Haimatochare, yet the text depicts her as both in-between and exceeding previous Western categories of knowledge.[19] Not even the reader knows who or what Haimatochare is until well into the story. Then, all that we can know for certain is that she belongs to the world "of those strange and often inscrutable creatures which form the transition, the link, between both [plants and animals]" (Moore 5; Hoffmann 671). Namely, she is an insect, one of the "liberated flowers" that so fascinate Menzies because of their intermediate status (Hoffmann 671). Yet even among these transitional creatures, this particular creature is unique, exotic, and unclassifiable. Bligh reports that first mate Davis, who has some knowledge of natural history, interprets the insect as a unique deviation from all previously discovered lice (Hoffmann 14). Although Haimatochare seems to be a new species, contrary to the Linnaean system—well in place before the date of our story—Menzies does not give her a proper genus and species name in Latin. Instead, he coins a name in ancient Greek, writes an absurdly long Latin description, and places her between *pediculus pubescens* and *nirmus crassicornis*. This placement not only makes her unique among other species, and situates her both in-between and outside existing genera, but also construes her as outside Western classification systems altogether. Menzies' failure to name her appropriately and his blathering description underscore that she is something that Western taxonomic terminology cannot really grasp. Moreover, Hoffman echoes Haimatochare's epistemological elusiveness in the structure of the story by misleading the reader to mistake her for a woman, and even after unveiling the mistake never providing a final, clear, and cohesive account of what, exactly, she is. Haimatochare's unknowability features as prominently in the text as the desires she both attracts and inspires. This implies that Menzies' desire, obsession, and resulting downfall may in part derive from an incommensurability of the Hawai'ian world to Western conceptions and, perhaps, a sensual excess that Western systems cannot contain.

Although the story depicts Haimatochare as a vehicle of desire, it also renders her, via her ineffable status, horrific and monstrous. In *The Philosophy of Horror or Paradoxes of the Heart,* Noël Carroll defines the monster as an "extraordinary character in our ordinary world" (16) who is both "threatening *and* impure" (28), a description that clearly applies to our blood-sucking siren. As already discussed, the frame narrative and historical references insist on the story's real-life setting, and after Brougthon's and Menzies' deaths, the threat posed by Haimatochare should be obvious. The impurities of monsters "are often associated with contamination—sicknesses, disease, and the plague—and often accompanied by infectious vermin—rats, insects and the like" (Carroll 28), a description that applies well to a bloodsucker between a pubic louse and an avian parasite, whom the narrative construes as an agent of infection. To account for the impurity that characterizes monstrous representations, Carroll uses anthropologist Mary Douglas's *Purity and Danger,* which "correlates reactions of impurity with the transgression or violation of schemes of cultural categorization" (Carroll 31). The confounding of categories characterizes the impurity and, when combined with threat, the horror of the monster (Carroll 32). Therefore, Haimatochare—a liminal figure who defies Western cultural categorization, hides from the reader behind a narratively constructed veil of epistemological uncertainty, and infects others with contagious, fatal desire—is, quite simply, a monster, and as such, a figure not only of desire, but also of horror.

But is this seductive island creature, this delicate louse who, according to her name, "delights" in blood, the actual agent of this emotive—if not strictly "sexual"—disease? This would explain the Europeans' strange behavior, but there is another figure strangely touched by the events in "Haimatochare." Queen Kahumanu is depicted as also having been rendered emotionally unstable. Yet this instability does not result from contact with the louse, whom she does not encounter until its execution, but rather from contact with Europeans and European objects. In letter five, Brougthon writes that Kahumanu has become enthralled by the gold-embroidered, red cloak given her by the visitors, and obsessively practices ways to behave when wearing it. Once cheerful and charming, she has become pathetically melancholy, and can only be soothed by Brougthon's giving her broiled fish and gin or rum. Moreover, she has developed a very public crush on Menzies, and often hugs him and calls him affectionate names (Hoffmann 673). Colonial objects seem to drive Kahumanu to extreme emotion. The European cloak, embroidered in red and gold, which evokes traditional Hawai'ian featherwork, and thus a mix of European materials and handiwork and

Hawai'ian motifs, jolts her out of her previous cheerfulness and into a perplexing and disturbing series of moods. Only roasted fish and gin or rum—liquors associated with British colonialism—administered by one of the scientists can mollify her. The other scientist more explicitly ignites her passion, and his death drives her to a particularly bloody and grotesquely sexual form of mourning, one that warps the traditional mourning custom of self-mutilation (Moore 21): she bores a large shark's tooth into her behind (Hoffmann 16). For both the Europeans and for Kahumanu, the events of the story result in high passions and spilled blood.

From a contemporary perspective, it is tempting to interpret the parasite, a bloodsucker who weakens the host, as a metaphor for the colonizer draining the colony of resources in order to strengthen the imperial center. But this does not seem to be what is going on here. Both the English and the Hawai'ians are left poorer by the fictional visit of the *Discovery*. We see their recognition of this in their shared mourning described in Bligh's final letter, a loud and weighty affair incommensurate with the execution of a single insect. I would suggest that this is because the story construes the infectious desire as spawned neither uniquely by the European men's pre-existing fantasies and homosocial bonds nor solely by an aberrant and monstrous insect that strangely comes to stand for Hawai'i's seductive, excessive, and uncontainable natural beauty, but rather by the intercultural contact itself—by the attempt of two incommensurate cultures and systems to grasp one another. The letters depict primarily the European side of the contact, where feverish sexual and epistemological desires meet their doom via an exotic "monster" who exceeds their systems of knowledge. Nevertheless, their descriptions of Kahumanu provide an opportunity for the text to construe the natives as also encountering something new, seductive, dangerous, and unfathomable. Only this explains the rapid and pervasive spread of passions that inflict losses on all sides.

* * *

"Haimatochare" characterizes its scientific protagonists as dangerously desiring subjects whose endeavors are far from innocent, and whose intense desires predate the moment of contact and contribute to the destructive situation caused by that contact. Initially, then, the scientists' desires in "Haimatochare" seem consistent with Susanne Zantop's thesis in *Colonial Fantasies* that analysis of precolonial discourses reveals colonial fantasies and desires that may have indirectly influenced actual colonial encounters. The passion in Menzies' early

letters reveals desires that shape the fatal outcome of his "naturalizing." It therefore would seem that Hoffmann's tale, particularly in light of its claims to authenticity, seeks to expose how such pre-existing fantasies and desires taint European encounters with the non-European world. Such an interpretation is not entirely false. "Haimatochare" is clearly critical of Brougthon's and Menzies' motives and desires. By depicting scientists as dangerously desiring subjects, "Haimatochare" seems to expose the "colonial fantasies" of scientists and thus the soft underbelly of natural history, an area where Germans (Humboldt, Förster, Chamisso, and others) *did* participate in the colonial enterprise.

Yet, because Zantop names "stories of sexual conquest and surrender" in her list of "colonial fantasies" (2), we might also suspect that "Haimatochare" constitutes a colonial fantasy of its own. "Haimatochare" does not merely call attention to the passions inherent in natural history; it also stages a fantasy of contact where the "nature" encountered is seductive and horrific, where there is a problematic conflation of and confusion between that nature and the human population, and where it is the British in particular, rather than Europeans in general or German scientists specifically, who are the objects of criticism. In this fantasy, the scene in the forest that looks like "sexual conquest and surrender" turns out to be an encounter that ignites foolhardy and fatal passions—killing their object and those who compete for it. As shown above, this encounter problematizes the discipline of natural history, the multiple desires around colonial contact, and a social structure that subordinates natives, nature, and women to the bonds and rivalry between European men. If we recall, however, that the naturalists' desire for the bug is transferred to her in part from the naturalists' earlier desire for O'ahu (see above), and in part from their homosocial competition and desire, we might also read the events in "Haimatochare" as a metaphor for the colonial powers vying for not-yet-colonized territory in the Pacific (as, for example, England, Russia, and the United States vied for Hawai'i). In this light, one might interpret the perverse conquest and surrender depicted in Haimatochare as showing that colonial competition will have tragic outcomes for both the competitors and the objects of desire because of the passions spawned by intercultural contact. In this case, the colonial "fantasy" seems to be more like a colonial nightmare, warning against colonial desire, rather than an expression of "latent colonialism."

This seemingly fitting interpretation, however, is complicated by the fact that Germans are conspicuously absent from Hoffmann's story. The use of English names[20] and references to English colonial authorities (the governor of New South Wales) place this fictional expedition entirely

within the English imperial project. The sexually polluted contact depicted in "Haimatochare" is thereby marked as English. As Zantop has demonstrated, discourses that criticized earlier colonial regimes (English, Spanish, French, etc.) were common in German precolonial texts and cleared the way for fantasies of better German colonizers (Zantop 8, 40, 120). In this discursive and historical context, Hoffmann's mockery of the British could have indirectly contributed to broader discourses that condemned English imperialism with the fantasy of installing German colonies in its place. Although "Haimatochare" does not seem to promote even latent colonial ambition (the attempt to possess the native comes across as deluded, depraved, and dangerous), the queen's unfulfilled desire seems to invite the possibility (or the fantasy) for the reader of future, more successful encounters and liaisons between Pacific islanders and Europeans.

"Haimatochare" depicts the precolonial encounter as an unknowable site of ambiguity, excess, desire, and horror. It criticizes colonial desires as it depicts their object as uncannily attractive. In doing so, like "colonial fantasies," it speaks to the lack of "German" colonies in a fictional and affective register. Yet, as it does so, it confronts any "unspecific drive for colonial possession" (Zantop 2) with a horrific fantasy of contact that is sexually, emotionally, and epistemologically challenging—not to mention fatal. Meanwhile, it diffuses the intensity of this ambivalent conflict with its overall parodic tone. "Haimatochare" depicts, stimulates, and mocks both the desire for and the fear of colonial possession. While the parody can be read as criticism and thus as partially consistent with the horror of the colonial encounter, the comic pleasure works in tandem with the exoticism and titillation that this text deploys to render that same encounter attractive to the reader. Moreover, the text's overall approach to the colonial situation is marked by an ambivalent tension between seriousness and irreverence. Thus, it is difficult to characterize this complex and contradictory piece of precolonial literature as anything but ambivalent.

The ambivalence of Hoffmann's text is not unique,[21] and although we cannot know for certain before more analyses have been done, I hypothesize that we will find that ambivalence toward colonialism is widespread in German precolonial discourse. Evidence of this, however, would only open up further areas of inquiry. More rigorous analyses of widespread discourses of *both fear of and desire for* colonial contact can only enrich our understandings of German discourses of race and nation, as can the careful examination of the many texts that cannot be identified immediately as pro(to)- or anti-colonial. The more nuanced our own analyses of German discourses of race, nation, and empire become, the

better we will be able to explain the real outcomes of German history as well as recognize the other potentials buried in it.

Notes

I presented an earlier version of this essay at the Women in German conference in October 2001 and owe hearty thanks to the many there who provided thoughtful and substantial feedback. Many thanks are also due to Patricia Herminghouse, Ruth-Ellen Joeres, and the anonymous readers of my manuscript, who have all been insightful and supportive. My colleagues at UNR, Horst Lange, Frank Tobin, and John Pettey, have been especially helpful, challenging me to refine my argument and helping me to track the elusive *pediculus pubescens*. Thanks also to Odila Triebel for calling my attention to this story and to Leslie Adelson and Christopher Clark for their careful reading and thoughtful feedback. I cannot thank them enough.

For English citations from "Haimatochare," I am relying mostly on Anneliese Moore's published translation, except where her choices have obscured a word or phrasing I find essential to my reading. In such cases, I have provided my own translation, also marked as such. All other translations from German are my own.

[1] In 1819, Hawai'i was not yet a colony (and would not be until US annexation in 1898), and Germany had neither become a nation nor acquired a colonial empire.

[2] "Colonial discourse," according to Russell Berman, is "the linguistic articulation of the process through which the non-European cultures were integrated into a Europe-based system of administration" (8). Thus, Berman defines "colonial discourse" as a body of texts that directly describes and expresses the European imperial project. The direct relationship between "colonial discourse" and manifest colonialism is also evident in Berman's choice of texts that reflect the "experience of space...and the experience of alterity by the [European] traveler" (4) and that allow him to address "how German travelers in the non-European world—especially to regions that would come under the sway of European colonization—encountered alterity and came to grips with it (or not)" (5). "Haimatochare" is therefore not, strictly speaking, "colonial discourse," as Berman defines it, because it describes neither the experience of contact nor the process of colonization.

[3] Susanne Zantop defines "colonial fantasies" as "both full-fledged stories ('fantasies') and a peculiar imaginative configuration ('fantasy')" that express "'latent colonialism,'...an unspecific drive for colonial possession" (2).

[4] Moore refers to Philip K. Ige's definition of "Hawai'ian fiction" as fiction about Hawai'i that "mirrors" "something of the place, the people or the spirit...whether in the romantic or naturalistic or realistic modes" (39, qtd. in Moore 25). Moore's English translation and discussion of "Haimatochare" are intended to disprove Ige's and other scholars' assumptions that James Jackson Jarves's *Kiana: a tradition of Hawaii* (1857) is the first piece of Hawai'ian fiction.

[5] By "ambivalent," I do *not* mean the "ambivalence" of colonial discourse theorized throughout the work of Homi Bhabha. First, my methodological approach for this analysis is not a psychoanalytic one, and at this time I am not attempting to explain my observations via a discussion of complex psychic structures. Instead, I am noting a phenomenon of "both...and...," a pervasive tone of both desire and fear, and attempting to situate that within a specific cultural context. Bhabha's "ambivalence" is a fetishistic recognition and disavowal of difference, perpetuated by repetition and slippage, that characterizes the discourse and power of the colonizer, but that also creates the conditions for potential disruption of that power in the "mimic" or "hybrid" discourse of the colonized. It is contingent upon a real historical and discursive relationship between colonizer and colonized and presupposes a specular and dialogic (if unequal) relationship between them. Bhabha's ambivalence is discursive, affective, and structural. Because precolonial German literature emerges from a different historical context, it lacks the structural preconditions for this type of ambivalence.

[6] For a detailed historical and philological examination of Chamisso's contributions to the story and their relationship to his own Pacific travels and to actual historical persons, places, and events, see Anneliese Moore, "E.T.A. Hoffmann's *Haimatochare*," and "Hawaii in a Nutshell."

[7] All future references to this source will refer to *Briefwechsel*.

[8] The Latin *pediculus pubescens* seems to mean a little pubescent louse, not a pubic louse. When deciphered alongside taxonomic classifications of a number of other creatures (*pediculus humanus, glyptopscelis pubescens, hylaeus pubescens*, etc.), it would have to refer to a bloodsucking louse of the family *anoplura* that is covered with downy hair. In contemporary taxonomy, the louse that infects humans is called *pediculus humanus* and the crab louse is the *phthirus pubis*. Nevertheless, a pubic crab infestation is still called Pediculosis, suggesting that the crab louse was once classified in the genus *pediculae*. Therefore, the sources seem to be correct that Hoffmann's baffling classification is indeed a reference to the pubic crab louse.

[9] The discipline of natural history, its implication in European imperialism, and discourses that construct and deploy the "innocence" of the natural historian are important issues throughout Marie Louise Pratt's *Imperial Eyes*. I discuss this in relationship to Chamisso's writing on his journey as

naturalist for the Kotzebue expedition in "*Reise um die Welt*: the Complexities and Complicities of Adelbert von Chamisso's Anti-Conquest Narratives." For more developed discussions of science in German imperialism, see Zimmerman; Penny.

[10] We also find traces of this intense friendship in letter number seven, from Brougthon to Menzies. On the one hand, this letter reads as if Menzies had stolen (a woman) Haimatochare from him. On the other, Brougthon's language suggests the disappointment of a jilted lover: "But no!—I will not yet despair in doubt of your virtuousness, I am still determined to believe that your loyal heart will conquer the unfortunate passion which carried you away in a sudden frenzy!" (Moore 8; Hoffmann 675).

[11] The passion in Brougthon and Menzies' letters is consistent with some contemporary discourses of male friendship. In his discussion of Heinrich von Kleist's letters to Ernst von Pfuel, Joachim Pfeiffer argues that the "cult of friendship," which arose in the eighteenth century and continued well into the nineteenth century (215), with its sentimental and aesthetic concerns and conventions, provided a discursive space for the linguistic expression of male homoeroticism (215–27). At this time (in the late eighteenth and early nineteenth century), according to Alice Kuzniar, the "dichotomy of hetero- and homosexual" was not yet fixed (27–28). Discussing several essays in the volume *Outing Goethe and His Age* in which feminist and queer readings intersect, Kuzniar writes: "By noting the sexuality underlying homosocial bonding, these articles furthermore reinforce the argument that an erotic intimacy and intensity pervade male friendships, familial ties, rivalry, and role-modeling during this period" (27).

[12] Despite the presence of "homosexual circles" in Berlin in the late eighteenth and early nineteenth century (Kuzniar 8), of which Hoffmann would likely have been aware, the early nineteenth century also is the site of an "epistemic shift," where "overt male erotic friendships begin to face more pronounced stigmatization" (Kuzniar 17).

It would be fruitful to consider to what extent Alexander von Humboldt's homosexuality may play into his natural-history narratives or may be read intertextually with Hoffmann's portrayal of Brougthon and Menzies' relationship. Although Pratt briefly mentions Humboldt's homosexual relationships in a note, she doesn't consider in what ways they might be relevant to travel narratives and natural history (240 n. 10).

[13] Heterosexual desire and heterosexual structures like the family or conquering the virgin are a fundamental component of many of the texts and fantasies discussed by Zantop.

[14] Ruth Dawson, from the University of Hawai'i at Manoa, told me at the 2001 Women in German conference that tales of the Pacific island "queen" in love with the European explorer were widespread in late

eighteenth- and early nineteenth-century travel narratives and suggested that such tales represent fantasies of being desirable to native women and also fantasies of power and status, for the pursuer (fictional or not) is always turned by the writer into a "queen."

[15] My analysis of this triangle and of Brougthon's and Menzies' relationship is informed by Eve Sedgwick's influential work on erotic triangles and male homosociality.

[16] Syphilis was among the many diseases that European contact brought to Hawai'i and that decimated the native population (Stannard 7, 69–70; Native Hawaiians Study Commission 39). Exactly how many native Hawai'ians there were before Capt. James Cook's arrival is hotly contested (somewhere between a low of 200,000 and a high of 800,000), but by the early 1890s the native Hawai'ian population had been reduced to around 40,000 (Stannard 31).

[17] The theory that the virulent form of syphilis came from the Amerindians is contested by some contemporary scholars (Garrett 246).

[18] The *Discovery* in Haimatochare refers to both Cook's ship *Discovery* and Capt. George Vancouver's ship, likewise named *Discovery* (Moore 17).

[19] This conflict between a European desire to classify and European categories and that which they encounter in the native shapes colonial discourses, as we can see in J.M. Coetzee's discussion of "Idleness in South Africa" (12–35). "Haimatochare" can be read as a parody of this kind of desire to classify and the challenge posed to it by the unclassifiable native.

[20] Although Menzies' name may not sound particularly English, it is borrowed from Archibald Menzies, the botanist on Vancouver's ship (Moore 17).

[21] See, for example, my analysis of Chamisso's *Reise um die Welt*.

Works Cited

Beardsley, Christa-Maria. *E.T.A. Hoffmanns Tierfiguren im Kontext der Romantik: Die poetisch-ästhetische und die gesellschaftliche Funktion der Tiere bei Hoffmann und in der Romantik*. Bonn: Bouvier, 1985.

Berman, Russell. *Enlightenment or Empire: Colonial Discourse in German Culture*. Lincoln: U of Nebraska P, 1998.

Bhabha, Homi. *The Location of Culture*. New York: Routledge, 1994.

Carroll, Noël. *The Philosophy of Horror or Paradoxes of the Heart*. New York: Routledge, 1990.

Coetzee, J. M. *White Writing: On the Culture of Letters in South Africa*. New Haven: Yale UP, 1988.

E.T.A. Hoffmanns Briefwechsel. 3 vols. Ed. Hans von Müller and Friedrich Schnapp. München: Winkler, 1968.
Garrett, Laurie. *The Coming Plague: Newly Emerging Diseases in a World Out of Balance.* New York: Penguin, 1994.
Hoffmann, E.T.A. "Haimatochare." *Sämtliche Werke.* Vol. 3. Ed. Hartmut Steinecke. Frankfurt a.M.: Deutscher Klassiker Verlag, 1985. 666-80.
Ige, Philip K. "Paradise and Melting Pot," Diss. Columbia U, 1968.
Kleist, Heinrich von. "Die Marquise von O." *Sämtliche Werke und Briefe.* Vol. 2. Ed. Helmut Sembdner. München: Carl Hanser Verlag, 1965. 103-43.
Kuzniar, Alice A. "Introduction." *Outing Goethe and His Age.* Stanford: Stanford UP, 1996. 1-32.
McGlathery, James M. *E.T.A. Hoffmann.* New York: Twayne, 1997.
Moore, Anneliese W. "E.T.A. Hoffmann's Haimatochare: Translation and Commentary." *Hawaiian Journal of History* 12 (1978): 2-12.
_____. "Hawaii in a Nutshell—E.T.A. Hoffmann's Haimatochare." *Hawaiian Journal of History* 12 (1978): 13-27.
Native Hawaiians Study Commission. *Report on the Culture, Needs and Concerns of Native Hawaiians: Pursuant to Public Law 96-565, Title III.* Washington DC: The Commission, 1983.
Penny, H. Glenn. "Cosmopolitan Visions and Municipal Displays: Museums, Markets, and the Ethnographic Project in Germany, 1868-1914." Diss. U of Illinois at Urbana-Champaign, 1999.
Pfeiffer, Joachim. "Friendship and Gender: The Aesthetic Construction of Subjectivity in Kleist." *Outing Goethe and His Age.* Ed. Alice Kuzniar. Stanford: Stanford UP, 1996. 215-27.
Pratt, Mary Louise. *Imperial Eyes: Travel Writing and Transculturation.* New York: Routledge, 1992.
Rubin, Gayle. "The Traffic in Women: Notes on the 'Political Economy' of Sex." *Toward an Anthropology of Women.* Ed. Rayna R. Reiter. New York: Monthly Review Press, 1975. 157-210.
Sedgwick, Eve. *Between Men: English Literature and Male Homosocial Desire.* New York: Columbia UP, 1985.
Stannard, David E. *Before the Horror: The Population of Hawai'i on the Eve of Western Contact.* Honolulu: U of Hawai'i P, 1989.
Weinstein, Valerie. "*Reise um die Welt*: The Complexities and Complicities of Adelbert von Chamisso's Anti-Conquest Narratives." *German Quarterly* 72.4 (Fall 1999): 377-95.
Zantop, Susanne. *Colonial Fantasies: Conquest, Family, and Nation in Precolonial Germany, 1770-1870.* Durham: Duke UP, 1997.
Zimmerman, Andrew. *Anthropology and Antihumanism in Imperial Germany.* Chicago: U of Chicago P, 2001.

Amalia Schoppe's *Die Colonisten* and the "menace of mimicry"

Judith Wilson

Amalia Schoppe (1791–1858) was well known as an editor, publicist, and popular author in her own time, but she was soon forgotten. She *is* accorded a place in German literary history as the mentor of Friedrich Hebbel, but rarely as a writer, and until now there has been little response to calls for a reassessment of her work. Here I examine just one of Schoppe's books, the two-volume novel *Die Colonisten* (The Colonists, 1836). The text draws on traditional topoi of the time in what appears to be a conventional script reaffirming the values of middle-class European society. Drawing on the popular legend of Inkle and Yarico and the concept of mimicry elaborated in Bhabha's *The Location of Culture,* I attempt to show how the text, in a sophisticated double-voiced discourse, links colonization and middle-class gender relations. Such a reading challenges previous interpretations of the text and the unqualified dismissal of Schoppe's work as trivial and insignificant. (JW)

In his commemoration of the life of "Schenectady's most prolific author," Amalia Schoppe (1791–1858), George Danton, a professor at Union College in Schenectady, New York, where Schoppe spent her last years, characterized her life and achievement in the following way (1939):

> Amalia Schoppe, née Weise, was a minor German authoress. Her voluminous works are no longer read, and no one, even during her lifetime, considered their literary value very seriously. She belongs to that type of popular writer who, while living, has a certain vogue, but who is quickly "dated," and who almost immediately passes into oblivion.... She was distinctly a moral writer, and her popularity was primarily due to her didacticism.... But if Frau Schoppe is of slight importance as a creative artist, she does, nevertheless, have a definite significance in the history of world

literature through her association with the dramatist, Hebbel....
The woman deserves more than a word of praise for what she did
for a starving genius... (425).

Popular, moral, didactic, second-rate—the measure of worth of a piece of writing was the literary canon; those who did not measure up were, like Europe's primitive others, bound for extinction. Danton's comments were intended as a celebration; a condemnation could hardly have been more damning, but he was right about Schoppe's fate as a writer.[1] She *is* accorded a place in German literary history, but normally as the overzealous mentor of the "starving" Friedrich Hebbel in the shadow of whose carefully guarded genius she is often judged both as a person, and as a writer.[2] The impact of Hebbel scholarship on the assessment of both is evident in the odd mixture of praise and deprecation in the Schoppe entry in Goedecke's *Grundrisz zur Geschichte der deutschen Dichtung* (Outline of the History of German Literature, 1910): "We will retain a fond memory not so much of the productive, but mediocre authoress, but of the kindly, if limited and narrow patroness of the young Hebbel" (414).

In her own lifetime Schoppe was a well-known editor, publicist, and popular author.[3] Her first published works, a small selection of poems, appeared in Kerner's *Poetischer Almanach für das Jahr 1812* and several more were published in Uhland and Fouqué's *Deutscher Dichterwald* (A Forest of German Poets) in the following year. From this modest, albeit ambitious beginning she turned to writing as a profession and livelihood in 1821 when she left her husband, an unstable alcoholic, who was no longer able to provide for the family. In a writing career spanning the next thirty years, she engaged in a vast range of activities: editing two magazines—the fashion magazine, *Neue Pariser Modeblätter* (1827–45) and the young people's weekly, *Iduna* (1831–38)—making regular contributions to numerous journals and newspapers, among them Cotta's highly regarded *Morgenblatt für gebildete Stände*; and producing translations and a number of practical manuals. In between, she wrote some two hundred novels and stories, an output that brought her ambivalent admiration: at least she hasn't forgotten how to cook, said Kerner (1844);[4] critical castigation: her pen has overtaken her good sense, said Menzel (1830);[5] and satirical scorn: "she can knit a novel as easily as she can a stocking," Schoppe is alleged to have claimed of herself (1846).[6] Nevertheless, this "script manic"[7] novel knitter retained her position among the top third of the popular writers in the German lending libraries for almost two-thirds of the nineteenth century.[8]

After her death, however, only three of her books were republished, and now her work is indeed virtually forgotten.[9] Despite the growth of interest in popular culture and the extensive reclamation work of feminist scholarship since the 1970s, there has been little response to the few calls for a reassessment of Schoppe's work.[10] As a contribution to that process I want to examine just one of her books, the two-volume novel *Die Colonisten* (The Colonists, 1836). The novel is significant in the German-Australian context as the first known work of German literature to present the perspective of the Australian Aborigines on colonization (Corkhill 42), but it is also of potential interest to feminist scholars as an early exploration of the connection between colonization and middle-class gender relations.[11] In a reading that draws on the popular legend of Inkle and Yarico and the concept of mimicry elaborated by Homi K. Bhabha in *The Location of Culture* (1994) I will attempt to show how the text, in a sophisticated "double-voiced discourse,"[12] links the discourse of savagery and the discourse of femininity and exposes the nether side of the European vision of the other, its impact on "savages" and women. In drawing attention to its transgressive dimension, my reading challenges previous interpretations of the text and the unqualified dismissal of Schoppe's work as trivial and unworthy of more serious consideration.[13]

Set in the penal colony of New South Wales during the governorship of Captain Bligh, *Die Colonisten* is a combination of historical and exotic novel, adventure and love story. Its main focus is the platonic relationship between a disaffected, guilt-ridden European deportee, Arthur Shelly, and a beautiful Aboriginal girl, Daringha, in whose love and devotion Shelly finds temporary solace. Their story unfolds against a background of conspiracy and conflict as officers and deportees plot to depose the governor and Daringha's tribe unites with a more powerful rival tribe in a bid to destroy the European settlement and reclaim Aboriginal tribal lands. While order is restored in the colony, the love story ends tragically when Shelly falls in love with the governor's daughter, Olivia, and Daringha, in a desperate attempt to regain his affection, poisons him with what she believes is a love potion.

In the nineteenth century, popular literature focused increasingly on the difficulties of reconciling the desire for an earthly paradise with colonial reality. The tragic consequences of the incompatibility of European and indigenous cultures found poignant expression in the story of Inkle and Yarico, one of the most popular narratives of the eighteenth century.[14] The location was often changed and the story embellished to correspond with political purpose and popular taste, but almost all versions of the Inkle and Yarico story were based on the same narrative

constellation—an Englishman, Inkle, is shipwrecked on a foreign shore; he is found and cared for by a native girl, Yarico, who falls in love with him; with Yarico's assistance, Inkle is rescued by an English ship; on his return to civilization Inkle sells Yarico into slavery (Hulme 227). A story of love, trust, and treachery, this, along with Aphra Behn's *Oroonoko* (1688), became one of the stock legends taken up by the anti-slavery movement (Hulme 231).

By the time Schoppe's book was written, Inkle and Yarico were almost forgotten (Hulme 227), but there are sufficient similarities between her story and the Inkle-Yarico legend to suggest an intertextual connection between the two and enable a reading of the Schoppe text as a variation on the Inkle-Yarico theme. Shelly is, of course, not literally shipwrecked, but is, as a result of his role in his family's demise, a social and psychological castaway. He earns the trust of Daringha's tribe, the Gouia-Gal, by rescuing Daringha, who does not save him, but through her love restores his sense of self and enables him to forget his guilt. With her assistance Shelly is able to arrange a rescue mission to save the governor's son Frederik—who is to be put to death for breaking an Aboriginal taboo—from the wrath of the Aborigines. Later he saves his own and the governor's family from the rebellious deportees who storm Governor Bligh's house. Shelly betrays Daringha's trust not by selling her into slavery, but by exploiting her affection and desire to do his will and by showing a strange lack of regard for her feelings, her commitment to her own people, and her fate.

In Schoppe's text, however, Shelly is provided with motives that render his behavior intelligible, and in the course of the narrative he is transformed into an engaging, if troubled hero. In the second volume of the story he is given the opportunity to vindicate himself and regain the reader's sympathy and confidence by confessing his sins and assuming some responsibility for his family's situation. His choice of Olivia over Daringha, and, with it, his final rejection of the alternative that Daringha represents, does seem in its tragic inevitability to underline the impossibility of such primitivist fantasies and imply a reaffirmation of European values:

> I can no longer escape the circle into which I have been cast as a result of my birth and the circumstances of my early life. I have come to know needs that nature alone, to which you want to lead me back, can no longer satisfy.... The happiness you offer me would paralyze [my soul] (II: 296–97).

Particularly if one aligns one's perspective with that of the text's male protagonist, it appears to be little more than a new variation on an

old theme, a conventional sentimental story of unrequited love,[15] given fresh color and appeal by an exotic setting, which is how Anselm Maler interprets it in a 1978 article. For Maler, who explicitly equates the representation of the "hero" with the text's ideology and reading strategy (203), the novel is a classical example of the commodification of culture, a book of set pieces written to cater to the conceit, evasions, and comfort of the conservative restoration reader. It plays with the possibilities of exotic escapism, but crosses no boundaries and offers no challenge to the social order or to middle-class mores. Shelly's behavior is dictated by the requirements of the middle-class moral code and, in accord with expectations of the restoration reader, he is drawn back into the realm of Biedermeier domesticity after a tantalizing interlude in the wilderness (201–07).[16] Alan Corkhill's reading of the text in *Antipodean Encounters* (1990) is more differentiated. Corkhill, the only other critic to examine the text in more detail, draws attention to its critique of escapism and primitivism and its engagement with the situation of the colonized, but he ultimately concurs with Maler's view, criticizing the text both for its literary flaws and its emancipatory deficiencies (33–43). Unlike Maler, he acknowledges the importance of the female characters in the text, but, however noble, they remain for him "singularly unliberated," steeled by middle-class virtue against the liberatory inroads of "vulgar lust" (41).

If they were to sell, texts like Schoppe's did, of course, have to comply with publishers' demands and readers' expectations,[17] and it is often difficult in such texts to determine where compliance with convention implies sympathy, and where collusion is mere simulation. Bhabha's concept of mimicry helps to draw the distinction. Mimicry, in his account, is not a form of narcissistic identification, but both an imperfect strategy of colonial control and a means of eluding that control. For Bhabha "the menace of mimicry" lies in the partial or inappropriate replication of colonial discourse; the distorted refraction of the colonial imperative renders it hybrid, exposes its ambivalence, and opens up spaces of potential subversion and resistance. Given a performance by the native, the colonial script becomes a parody that alienates and challenges the authority of the script itself (85–93).[18]

There are signals in *Die Colonisten* that draw attention to a dimension of the text that transcends that of plot and character: its intertextual connections to other "wilderness" narratives, both ethnographic and literary. Frederik's out-of-character remark—"There was in fact something so appealing, so piquant about your life in the wilderness that it would be a worthy subject for the pen of an enthusiastic writer" (I: 121–22)—is an example. It is not possible here to trace the voices that

echo in the text back to specific sources,[19] but they resonate in the topoi on which the text draws, and it is likely that these were familiar to the better-educated reading public.[20] It is to these I now wish to turn, using Bhabha's concept of mimicry to show how, through a mimetic performance or narrative dramatization of the effects of such topoi, the text challenges the authority of the discourse of which they are part and encourages a reading that is much more subversive.

* * *

One of the dominant topoi in narratives of discovery, both in travel reports and the adventure literature based on them, is the arcadian topos. From classical times this topos has served both as an expression of the desire for a return of a Golden Age, and as a critical mirror of the imperfections of European society.[21] The traditional centerpiece of the arcadian idyll was the *loecus amoenus* (pleasurable place, place of pleasure), a natural setting composed of trees, a meadow, a spring or brook, in the Romantic version possibly a waterfall, the song of birds, a gentle breeze (Curtius 195).

Schoppe employs this combination of conventional elements in the narrator's description of the Australian wilderness, which is imagined here from the protagonist's perspective as a Romantic "Natur-Einsamkeit" (a secluded natural refuge):

> Arthur left the hut... and fled out into the beautiful wilderness, into a secluded natural retreat the like of which would probably rarely be found in Europe. Bidiai's hut... was the only one within many hours' walking distance, and as far as the eye could see across the almost immeasurable plain, there were no other human dwellings, in fact no humans at all. Far to the southwest rose the blue mountains, enclosing the panorama that spread out before Arthur's eyes, while in the east the sea resembled a silver belt, extending between the mainland and the horizon and finally merging with it.... The deep stillness was only disturbed by the roar of a waterfall that fell from a considerable height into the valley, at first booming, foaming and thundering, then becoming slower and quieter, until it finally turned into a murmuring stream, and every so often the silence was broken by the cooing of a green turtle dove that had made its nest high up in the sparse foliage of a eucalyptus tree... (I: 26-27).

Scenes like these fired the European imagination and made the prospect of colonization attractive. Symptomatically, Shelly's arcadian dream

gives way almost immediately to a Crusoe-like colonial vision infused with the pedagogical paternalism of the Enlightenment:

> In the wilderness he often had a beautiful dream, which, however, vanished all too quickly. On the most beautiful, the most fertile part of the expansive plain, near a murmuring stream, under the canopy of casuarina trees, he wanted to build a hut. There he would take Daringha as his wife and loyal companion. To work for her, to improve her mind, extend her knowledge, arouse the divine spark of her intellect and transform it into a bright flame, to free her from the constraints of superstition, that seemed to him then a worthy task (I: 28).

In the conflicts and harsh realities of colonization such idylls began to lose their attraction. In Schoppe's text the possibility of regaining paradise has already lost its credibility, if not yet its escapist appeal. Shelly, a latecomer, is aware of the illusoriness of his arcadian retreat, is attracted by it, but repeatedly abandons the dream of establishing himself there. Each time he is drawn back to the colony it is as if he wilfully destroys the paradise that, for him, however desirable, is an untenable fantasy:

> But suddenly he was seized by a longing for his own people and family, and needs arose again which, in his delusion, he believed he had extinguished, and which, because they were of a purely intellectual nature, could only be satisfied in the midst of civilization. He left the wilderness, destroyed the paradise he had dreamed of (I: 28–29).

Shelly's vacillation makes the ambivalence of the colonial quest visible: if paradise is a mere fantasy, then reality demands that it must be destroyed. In popular literature growing skepticism about the realizability of arcadian fantasies often found expression in the inevitable destruction of the paradise, through its exposure as a place of terror rather than bliss or its inability to withstand disaster from without or dissolution from within (Koebner 23 f.). In the colonies themselves the inevitability of the destruction of the desired "paradise" often served to legitimate the actual destruction of the realms with which it had been associated. In Schoppe's text it is for Shelly but a short step from a symbolic gesture to his active, if regretful participation in the destruction of the realm, which for him is a projection, for the colonists the object of the colonial project. His lost paradise, the Aborigines' home, does not self-destruct; the colonists destroy it in response to his act of betrayal and their own desire to rid themselves of the Aborigines and take possession of their land.

In his study of colonial relations in the Caribbean, Peter Hulme reads the Inkle-Yarico story as a mythical representation of the final phase of the colonial encounter in this region (227), a representation with a political subtext based on the issue of hospitality (249). For him it is a "concessionary narrative," which "goes some way towards recognizing a native point of view and offering a critique of European behaviour," but which fails to address the key issue, the consequences of the infringement of the laws of hospitality for native populations. Yarico's fate is an individual tragedy; Inkle deserts her, but does not endanger the territory of her people. The issue of hospitality is obscured by the "deserted heroine motif" (253 f.).

Re-read in the light of Hulme's interpretation of the Inkle-Yarico story, *Die Colonisten* is a far more uncompromising text. Contrary to Maler's claim, it does not avoid problematic topics (203); it mimics the script of colonial desire and disenchantment and exposes the aggression the script often screens, showing the violence of the colonial encounter when disillusionment combines with acquisitive desire. The social consequences of the colonial encounter are not suppressed in a purely personal drama. Not only Daringha suffers; her people are driven from their traditional lands and virtually annihilated. The issue of hospitality is not masked; it is central to the two tribal leaders' condemnation of European bad faith, a condemnation that runs like a refrain through the text:

> When they approached us with flattering words and declarations of friendship we responded with friendship and received them hospitably; we allowed them to still their thirst from our springs, to eat the fruits of our trees, the roots of our soil; we let them take the animals of our forests, the fish of our waters; at night our maidens shared their bed when they came into our midst, and when they entered them, tired from hunting, our huts gave them protection from the searing rays of the great star.
>
> One might have thought that the great favors we showed them would have aroused the feeling of gratitude in their hearts; but far from being thankful, they do nothing but plot our downfall and the total extermination of our tribes (I: 210).

Another topos that dominated the discourse of discovery was "the savage," noble or ignoble, since antiquity a central concept in the attempt to define the external and internal boundaries of European civilization. The topos of the noble savage provided a frame of reference for the critique of European society, but it also played an important role in fantasies of assimilation; its ignoble counterpart served to affirm European superiority and to justify the conquest and dispossession of those

regarded as less capable and deserving. Noble was distinguished from ignoble by skin color and physiognomy, which in turn were interpreted as signifiers of character and culture. The noble savage corresponded most closely with European notions of beauty, being typically well built, of lighter complexion with symmetrical features, a fine nose, and small mouth. S/he was traditionally associated with freedom, harmony with nature, lack of care, and innocence, i.e., potential for civilization. The ignoble savage was invariably dark and "ugly" with a broad nose, thick bulbous lips, and woolly hair. This appearance was thought to reflect an impenetrable darkness of intellect, lack of progress, lack of law, cruelty, and treachery. In the discovery of the Americas the Indians were cast, at least initially, in the role of noble savage, while the role of ignoble antagonist fell to the Caribs. With the exploration of the Pacific the script of cultural difference did not change, only the actors; the Tahitians joined the Indians, the Fuegans and the Australian Aborigines the Caribs.[22]

Sentimental literature contributed to the proliferation and persistence of such cultural stereotypes, and initially Schoppe's text appears to be no exception. Daringha has all of the physical and moral attributes of the noble savage:

> Nothing compared with the grace and litheness of her limbs, whose every movement was visible as they were only partially covered by a light garment, and whose charms were all the greater the less she was aware of them. Although in color close to that of southern Europeans, her skin could almost be described as transparent...; a lively red colored her soft, rounded brown cheeks, while her lips were a slightly deeper hue; the large, beautifully formed eyes were more light brown than black, and one felt one could see through them into Daringha's soul (I: 36).
>
> This is how nature had created woman, all love and devotion, and it was civilization which had caused her degeneration, had robbed her of her sacred innocence... (I: 44).

Her brother, Bidiai, by way of contrast, has the flattened nose, wide nostrils, bushy beard, wild black eyes, thick bulging lips, and intemperate passions of the typical ignoble savage.

But in the course of the narrative the border between noble and ignoble becomes blurred; the stereotypes lose their "fixity".[23] Daringha, through her alliance with European culture, loses her innocence and falls victim to such ignoble sentiments as jealousy and the desire to eliminate her rival, sentiments that incur the censure of Shelly and his sister, apparently with the support of the narrator. Bidiai, on the other hand, through the challenge he presents to the European colonists, gains in

stature as the noble and courageous leader of his dispossessed people. The European rescue mission is sanctioned in their own eyes by recourse to the topos of the ignoble savage—the Aborigines are seen as bloodthirsty, suspicious, cruel, barbaric, and brutish cannibals, but confronted with the devastation wrought by the Europeans, the Aborigines turn the mirror around; in their view the ignoble savages are the treacherous and vindictive Europeans, barbarians who have no understanding of and no respect for tribal custom. The narrator, who slips from one perspective to the other, apparently supporting each view with equal conviction, leaves the reader to adjudicate, but in doing so, enables a telling comparison. In this restaging of the colonial encounter from the perspective of the colonized, the racial stereotype, the marker of cultural difference, is displaced and its strategic function revealed. Through this doubling, mimicry turns to menace when a resemblance is exposed that the stereotype disavows. If there is no difference between colonizers and the colonized, colonial authority loses its ground, and conquest its legitimacy.

Daringha is typical of the noble savages of sentimental literature, who were commonly set apart from other members of their own tribe. As exotic, but Europeanized hybrids, "a reformed, recognizable Other...almost the same but not quite" (Bhabha 86), they assumed an intermediate status that made them perfect intermediaries in fantasies of cultural integration or assimilation. One of the most famous of these cultural mediators was the Indian princess, Pocahontas, who rescued an Englishman from her own people, later adopted English culture and religion, married an Englishman, and was even introduced to the English court. By virtue of her nobility, purity, and innocence Pocahontas became the focus of a myth that celebrated the superiority of European culture and the love of the non-European for the European (Hulme 137 f.). Daringha has obviously been cast in this mold.[24] But, unlike Pocahontas, she is not able to fulfill a role that requires her willingly to embrace European culture and relinquish her own. Although Shelly's family accepts her, she is not assimilated into European culture; she does not reject it, but she cannot identify with it. Unhomed she is homeless, in a no-man's land in which she belongs neither to one culture nor to the other:[25] "She was troubled by the dark, painful feeling that she had been torn from her natural condition and had become like a creature both male and female, one of the homeless on earth" (I: 112).

In demonstrating the unworkability of assimilation, the text reflects the skepticism about the possibility of cultural integration that arose in the wake of bloody uprisings in the colonies,[26] but it goes further, exposing the colonizers' vested interest in the myth of the noble savage. If

Daringha were assimilated she would not only lose her innocence, but also her usefulness. Shelly, employing a typical argument from what Walter Veit has called the European superiority complex (4), defines himself against the realm of nature:

> He was seized by the strangeness...of the thought, that he alone of the many and varied organic creatures was the only thinking one, the only one capable of embracing Heaven and earth, for which there was not only a present, but also a future and a past; for whoever is not aware of both, does not have them (I: 34–35).

This argument was often used in the discourse of cultural demarcation, where savagery was associated with lack of reflection and hence the inability to transcend the present moment.[27]

But nature is the realm to which Daringha belongs and in which her value for him resides; if she is to retain her value she must remain where she is. Despite the pain he might cause her, Shelly, in a rather abrupt turnabout, abandons his civilizing vision. He justifies his decision by a seemingly laudable desire to protect her from the corruption of European society, but also, in a sudden lapse of faith, by his inability to bridge the cultural gap that separates them:

> He did not want to tear her from the circumstances into which she had been born, from the golden freedom that was her sole priceless possession; he did not want to infect her with the corruption of the civilized world as he was not able to give her access to the intellectual treasures that seemed at least to provide some compensation for the lost paradise of the innocent heart (I: 54).

Despite the transformation that Shelly observes in Daringha when she is in the settlement, he resorts to a similar argument when trying to justify his choice of Olivia and again when trying to persuade Daringha to rescue her. When Daringha refuses to renounce him and accept her lot, his sister is quick to judge her in similar terms.

Yet it is Daringha who alerts Shelly to the danger of revenge if her people are permitted to return to their native lands, knowing that in doing so she is destroying any chance she may have of rejoining them, and it is also she who, during the deportees' uprising, leads Shelly's family, and Olivia, to safety, using her knowledge of the wilderness to provide them with food and shelter. The repeated reference to Daringha's inferiority in the face of her courage and self-denial draws attention to the legitimizing function of the inferiority argument. To maintain the myth of European superior intelligence, the savage, however noble, must be kept in a state of innocence and ignorance, or,

failing that, meet a timely end: the noble savage is only useful if "almost the same but not quite," or dead.[28]

In conventional sentimental versions of the intercultural encounter the non-European often meets a fatal end, but the European survivor returns and is reintegrated into European civilization (Pratt 87). In Schoppe's text the colonists return to rebuild the colony, while Olivia returns to Europe, but the text does not end on a note of positive affirmation. Olivia, on her return, turns nostalgically back to the past, preferring to dwell on painful memories rather than look to whatever the future might hold. The Shelly family is befallen by a bleak fatalism: "They wished, they hoped for nothing more; they continued to live because that was what fate had ordained" (II: 319).

But why the interest in the plight of the colonized? A version of the Inkle and Yarico story, on which many authors drew (Hulme 234), provides a possible explanation. This account, published by Richard Steele in *The Spectator* in 1711, was not presented in the interests of the anti-slavery cause, but in a polemical retort aimed at demonstrating that women are more faithful than men (Davis 11). According to Lawrence Price, the author of the most extensive Inkle-Yarico study, this aspect of the story was lost in the following century when interest shifted to the issue of slavery and the question of Christian morality (9). In conclusion I want to consider how the issues of fidelity and slavery are linked in a context that, in my view, serves as a metaphor for middle-class gender relations.[29]

* * *

Sigrid Weigel's article, "Die nahe Fremde—das Territorium des 'Weiblichen': Zum Verhältnis von 'Wilden' und 'Frauen' im Diskurs der Aufklärung" (The Relationship of Gender Differences and Cultural Differences: The Example of the European Discourse of the Enlightenment, 1987),[30] is one of an increasing number of recent studies to explore the connection between savages and women in the conceptualization of the civilized male European. Weigel shows that the connection between the two was often made not by direct comparison, but via attributes commonly ascribed to both: their association with nature, childhood, and innocence, i.e., what they lacked in comparison with the civilized European or the enlightened man of reason. These attributes took on positive or negative connotations, depending on their role in the projections of the male European subject, and they were modified in different historical circumstances. As the indigenous populations of newly discovered countries were, from the time of the first voyages of

discovery, cast as noble savages or treacherous cannibals, so nature was often represented as the body of a woman, a source of life and pleasure, but also of destruction. Woman, in turn, took on the attributes associated with nature and was represented both as seductress and demon. With the Enlightenment reconceptualization of nature as a realm of human control these topoi were modified to underline reason, civilization, and progress. The savage was seen historically as the other of the civilized European, woman developmentally as the moral and intellectual other of the superior man of reason, and both as suitable objects of the civilizing mission. It was at this time that female identity was reconceptualized using such regulatory notions as innocence, shame, grace, and virtue (180).

Woman's nature defined in terms of male need was enshrined in literary texts—Rousseau's *Émile* (1762) is just one well-known example—as well as in pedagogical, anthropological, legal, and philosophical treatises, such as Fichte's *Deduktion der Ehe* (Deduction of Marriage, 1798):

> Her own worth is based on the fact that she gives herself totally to her husband, and that she, without reservation, abandons herself to him and loses herself in him.... She lives and works only united with him, under his eyes and in his affairs. She has ceased to lead the life of an individual, her life has become a part of his life... (312–13).

The image of the noble savage and the image of woman as servant and saint intersect in the figure of Daringha, who embodies natural innocence, love, and devotion. While Fichte is concerned with the relations of the sexes within marriage, Daringha's behavior mirrors almost exactly the self-abnegation and self-abandonment that he describes and prescribes as the natural role of the married woman in relation to her husband, and it is here that her attraction lies for Shelly. Her selfless devotion and adoration mirror back to him "the better part of himself" (I: 56), an ideal self untainted by past pain and guilt. But if Daringha plays her role well, she does not play it perfectly, for she, the child of nature, is not steeled by the constraints of middle-class modesty; she is unaware of them. She shows no reluctance to express her affection, but to keep his mirror intact Shelly must protect her virtue and restrain her desire, albeit without destroying it. Through his own lack of response he succeeds and so imposes on her the ideal of modesty and innocence that ensures his control and shields him from an awareness of the exploitative nature of their relationship. He does not return her affection, but at the same time does not prevent its articulation, thus ensuring the

constant echo of unconditional love, which he alone requires and which requires no response on his part.

When Governor Bligh visits the Shelly family in Rose Hill he finds the family gathered for breakfast in an idyllic scene that encapsulates what Corkhill has described as the "home and hearth" mentality of the Biedermeier period (39). And indeed the idyll would be perfect were it not for the inclusion of an element that is alien to the "homeliness" of the Biedermeier hearth: Daringha's presence in this white European family fantasy undercuts its comfortable familiarity. The position she assumes in the scene is the one normally reserved in such representations for the master's devoted children, or his dog.

While the discourse of femininity enshrined devotion as a quality not imposed, but preordained by woman's nature and therefore willingly embraced by women as their destiny, the subjugation of women in other societies was regarded as a mark of their lack of civilization. When Frederik suggests that Shelly take Daringha to the colony as his mistress and transform her into a servant when he no longer finds her attractive, Shelly responds with disgust and indignation:

> So this was how he was to reward Daringha's love, this love of which he didn't even feel worthy?... He was to take this free child of the wilderness, this pure daughter of nature and deliver her into slavery.... [O]nly a heartless egoist could make such suggestions.... [N]ow he was seized by a feeling of horror just thinking how far such Europeans debase the women who give themselves to them in love—and even more themselves—when they turn into quivering slaves those who had previously ruled like queens over them and their senses (I: 54-55).

But Daringha, ordered by Shelly, against her will, to collect medicinal herbs for Frederik's wounds, answers: "Deine Sklavin gehorcht" (Your slave will obey, I: 22). In similar situations throughout the text she responds with the words "your slave," nowhere with more anguish and resentment than when he implores her to save the life of the woman who has taken her place in his affections. The repetition of the reference to slavery draws attention to what her role actually requires, transforming the discourse of European civility into a parody. Shelly, the enlightened European, does not perceive the pain and irony in Daringha's response to his commands and remains unaware that, in accepting and exploiting her devotion, he is no different from the "heartless egoists" for whom he expresses such contempt.

In *Imperial Eyes,* her study of travel writing and the process of transculturation, Mary Louise Pratt discusses the changing role of sentimental

literature in the colonial enterprise. According to Pratt, abolitionism and American independence required the re-imagining of European supremacy in terms other than conquest and slavery. Sentimental literature provided an appropriate medium in the romantic love plot, where intercultural relations could be recast and exploitation and conflict replaced by consent and willful submission. But in these allegories of romantic love, a fundamental dimension of colonial practice disappeared: exploitation (97). This dimension is reintroduced in Schoppe's text, but transposed to the context of gender relations. While the female characters are, on the whole, represented more positively than their male counterparts, *Die Colonisten* offers not so much a "felicitous display of noble femininity" (Corkhill 41) as an indirect reckoning with ignoble masculinity and the masculine discourses of femininity and romantic love that reflect and guarantee male superiority and reduce women to mirrors and slaves. "...poison, even from the hands of Nature?" Shelly cries in disbelief before he dies, but he accepts his demise as his just desserts for spurning the gifts Daringha had offered him. Significantly the last word he utters is *"Schuld"* (guilt, II: 316–17).

Reciprocity, or lack of it, is central to both the tragic love story and the doomed relations between the Aborigines and the colonists. The black witch mother, Warri Wir, the vengeful fury of the story, constantly returns to this theme and ultimately has the last word. Cast as the abject other of the piece, she plays her role to perfection. Not satisfied with menace, she is intent on murder; and she alone achieves the object of her desire: revenge. Poisoned by her encounter with European civilization, reviled by Shelly as a *"Giftmischerin"* (poisoner), she poisons. Through Daringha, "the hands of Nature," she avenges the death of her children and the plight of her people at European hands, as well as Daringha's unnatural "enslavement" and her betrayal. Is she "the angry aspect" of the betrayed Daringha, her monstrous other?[31] The text gives no answer, but Warri Wir's curses recall the final verse of an earlier rendering of the Inkle and Yarico story, Gellert's *Inkle und Yarico* (1746), and ring with its pathos:

> "Kill you, you think I want to kill you with one quick blow? Would that be punishment enough for you, the violator of the sacred law of hospitality? For you who has betrayed and led to their deaths those who loved you and trusted you? For you who drove us from our good home, which gave us everything we needed in abundance? For you who forced our leader...to bow his proud head under the yoke of servitude? For you who seduced Daringha with your flattery to betray her brothers and serve you as a slave?" (II: 12–3).

In the Gellert poem the faithless Inkle is reviled in terms that are remarkably similar:

> Oh Inkle! You barbarian, for whom there is no equal;
> May all the world read of your affront!
> The greatest honesty, the utmost loyalty
> You, villain, reward with slavery?
> A maiden who risked her own life for you,
> who snatched you from death, and renounced her people,
> who crossed the sea with you, and for all her attractions
> had the best heart, you trade out of miserliness?
> Be proud! No rogue will threaten your reputation;
> It will never be possible to match your vice.[32]

Warri Wir's triumph is hollow, for she has no one with whom she can share it, but she is allowed to relish her revenge with demonic abandon before disappearing, forgotten, but unchallenged, into the wilderness.

In the advertisement that accompanies the first volume of *Die Colonisten,* Schoppe's works are promoted as novels that any mother can place in the hand of her daughters without a second thought. Schoppe was no early feminist[33]—her comments about herself, women's obligations, and women writers display the ambiguities and contradictions typical of many women writers of her time[34]—but my reading of *Die Colonisten* suggests that the confidence expressed here in her reliability as a safe author was, if not disingenuous, certainly ill founded. Far from pandering to the restoration reader's need for escape and reassurance, this text, in linking colonization and middle-class gender relations, challenges two of the dominant discourses of the time, the discourses of civility and femininity. *Die Colonisten* also displays a complexity and deviance that challenge previous assessments of Schoppe's work as shallow and insignificant.

Notes

My thanks to the reviewers of an earlier version of this manuscript and to Patricia Herminghouse for comments, corrections, and suggestions. Unless otherwise indicated, all translations from German are my own.

[1] This was a fate that Schoppe shared with many other women writers of her time. In her article "Women and the Literary Enterprise in Nineteenth-Century Germany" (1986), Patricia Herminghouse estimates that a quarter to a third of literary authors in the nineteenth century were women

(79). That a significant number have since been recovered is largely due to the research of feminist scholars, but many, like Schoppe, have yet to find a place in contemporary literary history.

² As editor of the magazine *Neue Pariser Modeblätter,* it was Schoppe who recognized Hebbel's promise, published his poems, and secured the support he needed to escape the confines of his native Wesselburen. Their relationship soured when Hebbel's position of dependence began to gall and Schoppe overplayed her role as mentor and guardian by expressing her disapproval of his liaison with the milliner, Elise Lensing (Schleucher 151 f.). An acrimonious dispute ensued that has been perpetuated by Hebbel scholars, concerned to secure his stature and reputation, often, it seems, at her expense.

³ For a well-documented account of Schoppe's life and works, see Thomsen.

⁴ Qtd. in Thomsen (177).

⁵ In his review of Schoppe's novel, *Waldemar* (1829), which appeared in Cotta's *Morgenblatt* (1830), the critic Wolfgang Menzel remarks on her "tremendous productivity," but goes on to compare her with "the women who become so absorbed in their letters that, in the end, they no longer know what they are writing. Their pen overtakes their good sense" (99). In a letter to Karl Winkler (1838) Schoppe later observes, with indignation but obvious enjoyment, that Mr. Menzel can find nothing good to say about anything women have written, yet he has always given her considerable praise as Adalbert von Schonen [one of Schoppe's male pseudonyms] and even held her up as model (qtd. in Thomsen 179).

⁶ In *Respectability and Deviance,* Ruth-Ellen Boetcher Joeres uses a satirical report on a fictitious conference of German women writers, allegedly held in Weimar in 1846, to illustrate the way in which women writers were "labeled" in the nineteenth century. In the satire Schoppe is cast as a knitter who calls for a delay so she can count her stitches before making her conference contribution. In a summary of her speech she is reported to claim equal facility in the knitting of stockings and novels (1–2).

⁷ Hebbel scholars' dismissal of Schoppe's literary outpourings culminated in her pathologization by Hugo Matthiesen as a "Skriptomanin" (a script manic) (qtd. in Schleucher 240). In his article "Australien im deutschen Überseeroman" (1990), Corkhill perpetuates this view, introducing Schoppe as "die skriptomanische Hamburgerin" (the script manic from Hamburg, 38).

⁸ From 1815 to 1848 Schoppe held twenty-second place in Martino's list of the hundred most popular lending library authors (based on 62 catalogues, pp. 276–77); for the period 1849–88 she was still ranked forty-second out of 150 (based on 46 catalogues, pp. 404–06).

[9] See Thomsen (161). The works that were republished were a collection of fairy tales and legends, a letter writing manual for women, and a collection of stories for children.

[10] In 1963 the Hebbel scholar Heinz Stolte attempted to redress the balance in the Hebbel-Schoppe debate, giving a more sympathetic account of Schoppe's life and work and drawing attention to her contribution to literature for children and adolescents. There was no significant response to Stolte's appeal until 1978 when Kurt Schleucher published a carefully researched, but semi-fictional comparison of her life with that of Johanna Schopenhauer. In 1990 Alan Corkhill confirmed that she has yet to be accorded "her rightful place" in German literary history (33). The first substantial attempt to assess Schoppe's contribution in its own right is the 1994 article by Hagen Thomsen, "Amalia Schoppe—Anatomie einer biedermeierlichen 'Literaturfabrik.'" In it Thomsen attempts to establish to what extent Schoppe's works fall within, to what extent they transcend the boundaries of conventional popular literature and also looks at the gender roles transmitted in some of her texts. Although *Die Colonisten* is not included in his examination, he does draw attention to a number of works that he considers to be "untypical" and hence more significant.

[11] Other novels and stories by Schoppe with colonial settings include *Die Minen von Pasco* (1826), *Die Auswanderer nach Brasilien, oder die Hütte am Gigitonhonha* (1828), *Robinson in Australien* (1843), *Der Prophet* (1846), and *Die Holsteiner in Amerika* (1858).

[12] Bakhtin's central concepts are summarized and discussed by Graham Allen in *Intertextuality* (8–61). "Double-voiced discourse" conveys the idea that all utterances are shot through with prior utterances and competing interpretations (212).

[13] In *Bitter Healing: German Women Writers from 1700 to 1830*, Jeannine Blackwell and Susanne Zantop point to the need to develop new reading techniques for the texts like Schoppe's, techniques more responsive to the less obvious transgressive potential of works written, of necessity, within the parameters imposed by publishers and the reading public (6). Schoppe was certainly aware of these constraints and their cost. In a private communication about the fate of her novel *Leonard, oder die Verirrungen des Schmerzes* (1827), she laments: "The book was finished, it was good, I liked it, but I knew that it would displease the public, on which I after all depend enormously, for in it all the storms of passion rage uncontrollably.... It was not what a *woman* could have written—and so I patiently put my manuscript in the fire and wrote another...: a very ordinary book that many will read because the conclusion is reminiscent of Zacharias Werner.... There you have it, that is the curse that afflicts women's writing" (qtd. in Thomsen 178).

[14] In all there were forty-five different versions of the story (in English, French, and German), a number of which were translated into other European languages; it was also transformed into poems, sketches, plays, ballets, pantomimes, and musicals. Twenty-one of the original works were produced in the German-speaking world, where interest in the story was most constant; even Goethe toyed with the idea of transforming it into a play. The best-known works in German were poems, Gellert's "Inkle und Yarico" (1746) and Gessner's "Inkel und Yarico, zweyter Teil" (1756) (see Hulme 227; Price 75 f.).

[15] For discussions of the role of the sentimental romance in the colonial enterprise, see Klotz (24–65) and Zantop (99–163).

[16] Maler's criticisms are typical of those commonly levelled at popular culture, particularly at sentimental fiction. For a brief discussion of the typical assessment, see Klotz (24–29).

[17] Menzel's *Waldemar* review gives some indication what this actually meant for women writers. The denial of motherly love and the denigration of the holy sacrament of marriage, which in his view Schoppe's novel represents without criticism, is something one does not expect of a woman who claims to be educated and has herself written educational texts. Whereas men represent unnatural behavior with an irony and cynicism that show it as an exception, women who follow the male example lack this distance and represent the exception as if it were the rule. He claims that only women who have lost touch with nature will be receptive to such "Unnatur der Grundsätze" and turn to art, above all to the works of women writers (99).

[18] Bhabha's concepts of ambivalence and hybridity clearly owe much to Bakhtin's work on dialogism. However, while both assume that every utterance is double-voiced and hence dialogical, Bhabha focuses particularly on the utterance as a performance and on the effects it produces. In its performative distancing or displacement the doubleness of discourse becomes visible and its dialogicity can be activated (see Bhabha 2, 50, 88).

[19] As Thomsen has noted, Schoppe was not given to naming her sources (172), and by 1836 there was sufficient material available on Australia to make it extremely difficult to identify the texts she actually used. My investigations thus far indicate that she probably drew on David Collins' *An Account of the English Colony in New South Wales* (translated into German in 1799), particularly regarding the life and customs of the Aborigines. Most of her Aboriginal cast figure in Collins' account, and a number of Aboriginal expressions in her text are also found there. It is also possible that she used Georg Forster's *Reise um die Welt* (1778–80). This would explain the curious blending of Aboriginal and Polynesian practices in her text and the representation of Norfolk Island as the ideal site for a new and better social order. Schoppe never visited Australia, but she did consider emigrating

there if she managed to secure the early release of her third son who had been imprisoned for embezzlement (Schleucher 300).

[20] Maler, too, draws attention to this aspect of the text, but he dismisses it as a marketing ploy aimed to engage and flatter the educated middle-class reader (205).

[21] The role of topoi in the European response to new worlds and experiences is examined by Veit.

[22] For a succinct discussion of the noble savage myth, see Borsboom.

[23] See Bhabha (66). "An important feature of colonial discourse is its dependence on the concept of 'fixity' in the ideological construction of otherness. Fixity as the sign of cultural/historical/racial difference ...connotes rigidity and an unchanging order as well as disorder, degeneracy and daemonic repetition."

[24] As Corkhill has noted, Daringha is not at all typical of her tribe, having rather the attributes commonly associated with Polynesian women. For him this is an example of the anthropological distortions in the text (36); in my view the conflation of Polynesian and Australian in Daringha's representation has less to do with anthropological imprecision than with literary convention.

[25] In Bhabha's predilection for the state of "in-betweenness" he tends to ignore the other side of cultural deracination. For him "to be unhomed is not to be homeless" (9).

[26] See the chapter "Betrothal and Divorce; or, Revolution in the House" in Zantop (141–63).

[27] An example is de la Condamine's description of the savages of South America as "...solely preoccupied with the present, and totally ruled by it; with no concern for the future, unable to plan and reflect..." (qtd. in Weigel 174).

[28] Mary Louise Pratt makes a similar point about allegories of cultural harmony in a postslavery society. They never complete themselves, she asserts, because it was neither in the interest of the pro- nor the anti-slavery cause that they do so. The non-European is hence disposed of, a victim of the genre (100).

[29] In her study of colonial fantasies, Zantop draws attention to the common conflation of foreign and domestic spheres in the colonial imaginary and the interchangeability of each sphere as a metaphor for the other (5–6).

[30] This is the title of an English version of Weigel's article that was delivered as a lecture on a lecture tour in Australia in 1987. To my knowledge the English manuscript has not been published.

[31] In Gilbert and Gubar's *The Madwoman in the Attic,* Bertha is described as Jane Eyre's double, "the angry aspect of the orphan child."

Quoting Claire Rosenfeld, they make the point that novelists using doubles frequently juxtapose a socially acceptable personality and its uninhibited, sometimes criminal other (360).

[32] For the German version of the poem, see Price 78.

[33] In her letters Schoppe, for example, complains bitterly about attitudes toward women's education, but in *Erinnerungen aus meinem Leben* (1838) she claims to have rejected her stepfather's proposal that she study medicine because she did not want to become a "Zwitterwesen, das nicht Mann noch Weib sei" (qtd. in Thomsen 176). It is interesting to note that Daringha employs the same metaphor to describe her homelessness (I: 112).

[34] For a wide-ranging discussion of the problems of representation and self-representation for nineteenth-century women writers, see Joeres.

Works Cited

Allen, Graham. *Intertextuality*. London: Routledge, 2000.

Bhabha, Homi K. *The Location of Culture*. London: Routledge, 1994.

Blackwell, Jeannine, and Susanne Zantop, eds. *Bitter Healing: German Women Writers from 1700 to 1830: An Anthology*. Lincoln: U of Nebraska P, 1990.

Borsboom, Ad. "The Savage in European Social Thought: A Prelude to the Conceptualization of the Divergent Peoples and Cultures of Australia and Oceania." *Bijdragen tot de Taal-Land- en Volkenkunde* 144.4 (1988): 419–32.

Collins, David. *An Account of the English Colony in New South Wales*. Terry Hills: Reed, 1975.

Corkhill, Alan. *Antipodean Encounters: Australia and the German Literary Imagination 1754–1918*. Bern: Lang, 1990.

―――. "'Das unbekannte Südland': Australien im deutschen Überseeroman des 19. Jahrhunderts." *Exotische Welt in populären Lektüren*. Ed. Anselm Maler. Tübingen: Niemeyer, 1990. 35–49.

Curtius, Ernst Robert. *European Literature and the Latin Middle Ages*. Trans. Willard R. Trask. London: Routledge, 1953.

Danton, George H. "Amalie Weise Schoppe: Schenectady's Most Prolific Author." *New York History* 20 (1939): 425–36.

Davis, David Brion. *The Problem of Slavery in Western Culture*. Ithaca: Cornell UP, 1966.

Fichte, Johann Gottlieb. "Deduktion der Ehe." *Sämmtliche Werke*. Vol. 3. Ed. J.H. Fichte. Leipzig: Mayer & Müller, 1962. 304–18.

Forster, Georg. *Reise um die Welt*. 1778–80. Frankfurt a.M.: Insel, 1983.

Gellert, Christian Fürchtegott. *Fabeln und Erzählungen.* Ed. Siegfried Scheibe. Tübingen: Niemeyer, 1966. 88–92.

Gessner, Salomon. *Sämmtliche Schriften.* Vol. 2. Leipzig: Fleischer, 1841. 135–47.

Gilbert, Sandra M., and Susan Gubar. *The Madwoman in the Attic.* New Haven: Yale UP, 1979.

Herminghouse, Patricia. "Women and the Literary Enterprise in Nineteenth-Century Germany." *German Women in the Eighteenth and Nineteenth Centuries: A Social and Literary History.* Ed. Ruth-Ellen Boetcher Joeres and Mary Jo Maynes. Bloomington: Indiana UP, 1986. 78–94.

Hulme, Peter. *Colonial Encounters: Europe and the Native Caribbean, 1492–1797.* London: Methuen, 1986.

Joeres, Ruth-Ellen Boetcher. *Respectability and Deviance: Nineteenth-Century German Women Writers and the Ambiguity of Representation.* Chicago: U of Chicago P, 1998.

Klotz, Marcia: "White Women and the Dark Continent: Gender and Sexuality in German Colonial Discourse from the Sentimental Novel to the Fascist Film." Diss. Stanford U, 1994.

Koebner, Thomas. "Das verbotene Paradies: Fünf Anmerkungen zum Südsee-Traum in der Literatur." *Arcadia* 18 (1983): 21–38.

Maler, Anselm. "Exotische Hütten: Im Paradies des Populärromans zwischen Restauration und Revolution." *Literatur ist Utopie.* Ed. Gert Ueding. Frankfurt a.M.: Suhrkamp, 1978. 189–220.

Martino, Alberto. *Die deutsche Leihbibliothek.* Wiesbaden: Harrassowitz, 1990.

Menzel, Wolfgang. "Waldemar: Ein Roman von Amalie Schoppe." *Literaturblatt* 25. *Morgenblatt für gebildete Stände.* Mikrofiche-Edition mit Handbuch. Nach dem Redaktionsexemplar im Cotta-Archiv (1830): 99–100.

Pratt, Mary Louise. *Imperial Eyes: Travel Writing and Transculturation.* New York: Routledge, 1992.

Price, Lawrence. *Inkle and Yarico Album.* Berkeley: U of California P, 1937.

Schleucher, Kurt. *Das Leben der Amalia Schoppe und Johanna Schopenhauer.* Darmstadt: Turris, 1978.

Schoppe, Amalia. *Die Auswanderer nach Brasilien, oder die Hütte am Gigitonhonha.* Berlin: Ameling, 1828.

———. *Die Colonisten.* 2 vols. Leipzig: Focke, 1836.

———. *Erinnerungen aus meinem Leben.* Altona: Hammerich, 1838.

———. *Die Holsteiner in Amerika.* Stuttgart: Chelius, 1858.

———. *Die Minen von Pasco.* Leipzig: Taubert, 1826.

———. *Der Prophet.* Jena: Luden, 1846.

———. *Robinson in Australien.* Heidelberg: Engelmann, 1843.
Stolte, Heinz. "Amalie Schoppe: Ein Beitrag zur Beurteilung ihrer Persönlichkeit." *Hebbel Jahrbuch* (1963): 149-79.
Thomsen, Hargen. "Amalia Schoppe—Anatomie einer biedermeierlichen 'Literaturfabrik.'" *Nordelbingen: Beiträge zur Kunst- und Kulturgeschichte* 63 (1994): 161-204.
Veit, Walter. "The Topoi of the European Imagining." *Arcadia* 18 (1983): 1-21.
Weigel, Sigrid. "Die nahe Fremde—das Territorium des 'Weiblichen': Zum Verhältnis von 'Wilden' und 'Frauen' im Diskurs der Aufklärung." *Die andere Welt: Studien zum Exotismus.* Ed. Thomas Koebner and Gerhart Pickerodt. Frankfurt a.M.: Athenäum, 1987. 171-200.
Worton, Michael, and Judith Still, eds. *Intertextuality: Theories and Practices.* Manchester: Manchester UP, 1990. 1-45.
Zantop, Susanne. *Colonial Fantasies: Conquest, Family, and Nation in Precolonial Germany 1770-1870.* Durham, NC: Duke UP, 1997.

Else Lasker-Schüler: Writing Hysteria

Jennifer Redmann

An examination of Else Lasker-Schüler's connection to the discourse of hysteria so pervasive in her day tells us much about how she viewed herself as a woman and an author. Images and metaphors of hysteria figure within Lasker-Schüler's prose texts "Der Fakir" and "Arthur Aronymus," and her autobiographical essays "Lasker-Schüler contra B. und Genossen" and "Only for Children over Five Years" can be analyzed within the context of the case history as literary genre. In writing about her own illness and that of her fictional characters, Lasker-Schüler both criticizes the gender relations of her time and invokes the repressed desires and radical possibilities inherent in the language of hysteria. (JR)

The word "hysteria" evokes a complex of images associated with the turn of the last century: fin-de-siècle drawing rooms populated by nervous women, fainting spells, convulsions, paralysis, and nervous ticks, Anna O. and Dora, Charcot and Freud, hypnosis and the "talking cure." But hysteria has a history that extends back to ancient times and, as Elaine Showalter argues in *Hystories: Hysterical Epidemics and Modern Media*, forward to the present day, for although it may be known by other names, hysteria is no less prevalent in today's society than it was a century ago.[1]

As a physical disorder, hysteria is associated with a long list of ailments, but its symptoms (and the explanations for them) have evolved over time, adapting to an ever-changing historical and cultural context. What was considered demonic possession in the year 1000 might be labeled "Multiple Personality Disorder" in the year 2000, and in both cases the diagnosis must be read within a given "network of medical, supernatural, religious, and aesthetic discourses" (Bronfen 102). Hysteria can take many forms, but, as Showalter writes, it "cuts across historical periods and national boundaries, poses fundamental questions about gender and culture, and offers insights into *language, narrative,*

and representation" (*Hystories* 7, my emphasis). This discursive dimension of hysteria makes it interesting for scholars of literature: an examination of Else Lasker-Schüler's connection to the discourse of hysteria (which was particularly pervasive in her day) tells us much about how she viewed herself as a woman and an author.

> For five years, because it was recognized too late, I was very, very sick on account of Dr. Lasker, I had a fever day and night, my life and my physical ability to work are weakened. I cannot earn money from outside employment, although I have completely recovered. It was devastating for me. If I didn't have a child, I would wander about or put an end to it all, the world can survive without poems by ELSch (*Lieber* 91).

In this excerpt from a letter to publisher Kurt Wolff, undated but written around 1913, Else Lasker-Schüler offers a brief version of her marriage to Dr. Berthold Lasker and its negative impact on her life. The couple married in Lasker-Schüler's hometown, Elberfeld, in 1894 and moved to Berlin that year. Few details are known about the marriage, aside from the fact that Lasker-Schüler was not well suited to a quiet life of bourgeois homemaking. In 1896, she began taking painting lessons and set up her own studio; in 1899, she left her husband to join the circle of young bohemian artists surrounding Peter Hille and published her first poems; in 1903, she and Lasker were legally divorced.

It is unclear whether Lasker-Schüler actually suffered from a lengthy illness during her marriage to Lasker, and if so, what the nature of it may have been, but it is possible that she suffered from hysteria. From the eighteenth century on, the spread of hysteria parallels the rise of bourgeois culture. By the late nineteenth century, hysteria had reached epidemic proportions, and Else Lasker-Schüler corresponded to the stereotype of the typical patient: she was a young, middle-class woman with artistic inclinations and little to keep her occupied. Indeed, in many respects, Lasker-Schüler shares much in common with Bertha Pappenheim, also known as "Anna O.," the subject of Josef Breuer's case history in his and Freud's *Studies on Hysteria (Studien über Hysterie,* 1895).

Like Else Lasker-Schüler, Pappenheim was born into a well-to-do, middle-class Jewish family. Breuer describes her as a highly gifted young woman with a vivid imagination and a love of storytelling, but no formal education. "This girl, who was bubbling over with intellectual vitality, led an extremely monotonous existence in her puritanically-minded family," Breuer writes. "She embellished her life...by indulging in systematic day-dreaming, which she described as her 'private

theater'" (22). At the conclusion of his case history, Breuer identifies these two factors—a monotonous life and habitual day-dreaming—as decisive factors in the transformation of a "completely healthy girl" into a hysteric (41). Pappenheim's symptoms included hallucinations, paralysis, insomnia, sleepwalking, and hearing and speech disturbances. But whereas Breuer identifies an unhealthy imagination as the soil from which Pappenheim's hysterical symptoms emerged, historian Marion Kaplan offers a different reading of the case history, explaining that the "socially confining, intellectually stifling, politically and legally constricting conditions faced by women of her class and era and the particular intellectual vitality, social commitment and sense of justice of Bertha Pappenheim interacted to produce Anna O" (101).

The question of whether or not the five-year "fever" Lasker-Schüler writes of in her letter manifested itself in symptoms of hysteria is impossible to answer and ultimately unimportant. Significant, however, is the fact that Lasker-Schüler draws on the discourse of hysteria when she describes her married life in terms of an illness. Only by putting an end to her relationship with Berthold Lasker, by trading the financial security he provided for an impoverished bohemian life in cafés and rented rooms, was Lasker-Schüler able, in her mind, to recover.

If, as seemed to be the case with Bertha Pappenheim, intellectual frustration and lack of freedom led Lasker-Schüler to associate marriage with illness (with the body's symptoms voicing an inexpressible psychic anguish), then her turn to poetry could be viewed as a personal "writing cure."[2] The title of one of Lasker-Schüler's first published poems, "Verwelkte Myrten" (Wilted Myrtle, 1899), refers to an ancient symbol of fertility that is often woven into a bride's wreath or bouquet. In the poem, however, the plant, like the poet's own marriage during that time, is dying. The lyrical self compares the poem's "you" to a "grey, sunless day" descending onto "young roses" ("Bist wie der graue, sonnenlose Tag, / Der sündig sich auf junge Rosen legt"). The final lines read: "You trampled my young soul to death / And returned to your cold existence" ("Du tratest meine junge Seele tot / Und kehrtest in Dein kaltes Sein zurück" 10). The soul of the lyrical self may have been trampled to death, but in the poem it is resurrected and finds its voice. As these lines demonstrate, the poet Lasker-Schüler has little in common with the silenced hysteric, for unlike Anna O., Emmy von N., Elisabeth von R., and all of the other women whose case histories appear in the pages of *Studies on Hysteria,* the author can use literature to make herself heard.

In the years following her divorce, Else Lasker-Schüler became a well-known, even notorious figure in the Berlin coffeehouse scene,

described, for example, by Kurt Pinthus as "black-eyed, black-haired, small and dark, wearing bizarre jewellry [sic] and always in the throes of some passionate love-affair" (72). She created a fictional character called the Prince of Thebes and assumed that identity herself; even her calling cards bore the title "Jussuf Prinz von Theben." But whereas some were fascinated by Lasker-Schüler and impressed with her work, others found her (and her literature) strange, disturbing, or even insane. In 1910, the *Rheinisch-Westfälische Zeitung* printed Lasker-Schüler's poem "Leise sagen" (Say softly) along with the commentary: "a complete softening of the brain (*vollständige Gehirnerweichung*) is what we hear the reader—say softly" (qtd. in Dick 240).[3] And in a 1914 letter written to a former schoolmate, Walter Benjamin related an uncomfortable encounter with Lasker-Schüler in Berlin's Café des Westens: "In conversation, she is empty and sick—hysterical" (qtd. in Klüsener and Pfäfflin 125). As these statements reveal, although Lasker-Schüler's poetic language has little in common with hysterical speech (which, when it occurred at all, was considered unreliable and incoherent[4]), the very presence of Lasker-Schüler's body and her language in the public sphere of early twentieth-century Berlin was clearly viewed by some as inappropriate, threatening, and therefore degenerate, sick, or hysterical.

Which Else Lasker-Schüler, then, was the hysteric? The young doctor's wife who felt sickened by her bourgeois life or the flamboyant coffeehouse author who claimed to be an Egyptian prince? Regardless of whether or not Lasker-Schüler *actually* suffered from hysteria, this question points to the complex nature of hysteria as a cultural discourse with multiple meanings and ever-evolving interpretations.

By the late nineteenth century, a wide array of meanings had come to be associated with hysteria. As indicated by the origins of the word, from the Greek *hystera*, "womb," hysteria has always been a women's ailment. However, as Mark Micale explains in a concise history of the disorder, only in the nineteenth century does the concept of a "hysterical temperament" develop. "According to this notion, hysteria was defined less by a physical symptomatology than a set of highly negative character traits. These traits included eccentricity, impulsiveness, emotionality, coquettishness, deceitfulness, and hypersexuality" (24). Hysteria thus came to represent—in the minds of male observers—a pathology inherent in the "irrational, capricious, unpredictable nature of Woman" (68).

In *The History of Sexuality,* Michel Foucault derives from the term "hysteria" a new phrase—the "hysterization of woman"—to define the nineteenth-century development of a gendered discourse of sexuality.

> It is worth remembering that the first figure to be invested by the deployment of sexuality, one of the first to be "sexualized," was the "idle" woman. She inhabited the outer edge of the "world," in which she always had to appear as a value, and of the family, where she was assigned a new destiny charged with conjugal and parental obligations. Thus there emerged the "nervous" woman, the woman afflicted with "vapors"; in this figure, the hysterization of woman found its anchorage point (121).

The idea of the "nervous" woman, a lady constantly on the verge of a hysterical fit, provided a cultural underpinning for the division of the sexes into separate spheres. The pressures to conform to rigid and often contradictory ideals of woman may have led some nineteenth-century women to develop hysterical symptoms as a means of escape. At the same time, as Elaine Showalter argues in *The Female Malady,* any woman who chose to defy gender conventions and leave the sphere of the home was also considered hysterical.

The stereotype of the physically and emotionally fragile hysteric, along with the view that every female, by virtue of her anatomy, had hysterical tendencies, served to oppress all women. But that does not mean that hysteria was not a real disorder with real physical symptoms. In Freud's view, the hysteric's symptoms bore symbolic meaning and through them, the patient acted out traumatic memories and experiences, usually of a sexual origin. In writing about the case of Anna O., Dianne Hunter explains:

> In the process of talking herself out to Breuer, Pappenheim converted a nonverbal message, expressed in body language or pantomime and called a hysterical symptom, into a verbal language. That is, her narratives converted or translated a message from one language into another. She was a psychodramatist, complete with appropriate scenic arrangements for the reproduction of crucial events; and she devised the method of narrating back piece by piece the story of each symptom to reach its source.... She restaged the origins of her symptoms in order to undo them (102).

In this way, hysteria acts as a means of self-representation, with the "restaging" of the origins of the symptoms functioning as a form of self-performance. Elisabeth Bronfen describes hysteria as a "mode of communication" that always involves "a theatrical manifestation" (40). As the hysteric acts out traumatic memories and unconscious desires, she expresses feelings that shape who she is and who she wants to be, particularly with respect to gender. At the core of all systems of identity, Bronfen argues, lies "a traumatic kernel," and thus, in attempting

to communicate overwhelming and traumatic experiences, hysteria functions as "a structuring of the subject, as a strategy using multiple self-fashionings" (35). In the hysterical performance, the hysteric is able to articulate unrealized, unspeakable dimensions of self, the beings she desires but cannot be, her fundamental feelings of otherness. Thus even as the hysteric enacts societal definitions of femininity, albeit in an exaggerated manner, her disruptive performance also functions as a form of resistance to those same confining expectations of women.

Although it is unlikely that Else Lasker-Schüler actually suffered from the physical symptoms associated with hysteria in turn-of-the-century Germany, images and metaphors of hysteria prevalent at that time, as well as the cultural stereotype of the hysterical woman, figure prominently within two of her prose texts: "Der Fakir" (The Fakir, 1908) and "Arthur Aronymus: Die Geschichte meines Vaters" (Arthur Aronymus: The Story of My Father, 1932). In these works, Lasker-Schüler draws on the discourse of hysteria in writing female characters who fall ill in response to trauma. This hysterical illness represents a story-within-a-story which, when viewed within the context of hysteria as cultural discourse, offers the reader insight into both text and author.

* * *

"Der Fakir," first published on 6 November 1908 in the newspaper *Morgen* and later included in the book *Der Prinz von Theben* (The Prince of Thebes, 1914), features the three favorite daughters of the Emir of Afghanistan (Schalôme, Singâle, and Lilâme), one of whom, Schalôme, falls ill in order to escape her impending marriage. Schalôme is Lasker-Schüler's orientalized spelling of Salomé, the fin-de-siècle's most notorious dancer, made famous through Oscar Wilde's play and Richard Strauss's opera. Like the hysteric, Salomé embodies every contradictory characteristic of turn-of-the-century woman: she is at once fascinating and frightening, desirable and repelling. And like Salomé's "Dance of the Seven Veils," the hysteric's dance tells stories of its own.[5]

In "Der Fakir," the unnamed first-person female narrator describes a visit to the court of the Emir of Afghanistan, her mother's cousin. It seems that she had never before been invited because the Emir feared she would put strange ideas into the heads of his three daughters. As the narrator explains, "We dreamers from Baghdad have long had a bad influence on the daughters of foreign palaces" (112). Nevertheless, the narrator is allowed to share a room with the Emir's daughters, all of whom are emotionally troubled—they experience nightmares and

hallucinations that cause them to cry out in the night. The cause of this disturbance is the arrival of a strange relative, the Fakir; a snake charmer, the Fakir appears to be half animal himself. He receives, for instance, only "sniffed, leftover food...in an earthen dog's dish," and he also sleeps outside, "on his lively sack of snakes, which stand up and curve into a hill, only to sink back with a yielding stretch under the weight of the sleeper." Finally, like a dog in heat, through his body odor he awakens sexual feelings in the young men and women of the court: "The insides of the young men are tortured and the daughters of the city sip secretly at his smell; their bodies open like brown and yellow roses" (113).

The Fakir represents a frighteningly foreign, animalistic sexuality divorced of any human feeling. It threatens to seduce all who come in contact with it, including the narrator:

> I was startled when I saw the Fakir in my mirror as I applied make-up; he sat on the wall of the courtyard and kissed his snakes. He stuck one of them, which yielded wildly to him, halfway into his grey, creeping mouth. Since then I look fearfully at the three sisters during the night to see whether my screaming has frightened them (113).

The association of the snake with the phallus, already alluded to in a passage quoted above (snakes that "stand up"), is solidified in this image of the Fakir allowing the wild, submissive serpent to penetrate his mouth. The Emir's daughter Schalôme, who is engaged to marry an Indian prince, transfers this frightening portrayal of the Fakir's evil, masculine sexuality to her bridegroom. When the narrator asks, "Schalôme, how do you dream of [your betrothed] during the night?" she replies, "My uncle's snakes always come and strangle my dream." Within the context of this dream, the Fakir's snakes could be interpreted as a literal symbol of man's ability to silence woman. Schâlome then falls ill: "Schalôme's gentle hands tremble, she drops everything on the carpet, she has St. Vitus' dance. Every evening the Fakir plays his flute in the courtyard. Schalôme's face dances to his notes" (114).

A snake also plays a central role in Breuer's case study of Bertha Pappenheim, for it was the hallucinatory image of a snake (emerging from the wall of her father's sickroom in order to bite him) that triggered the onset of her hysterical symptoms: "She tried to keep the snake off, but it was as though she was paralyzed. Her right arm, over the back of the chair, had gone to sleep and had become anaesthetic and paretic; and when she looked at it, the fingers turned into little snakes with death's heads (the nails)" (38). In her mind, Pappenheim sees her

body subsumed and destroyed by the snake she fears, although it remains unclear in Breuer's case history just what the animal represents. (Breuer offers only a literal interpretation, explaining that his patient probably feared some snakes in the Pappenheim garden.[6]) If we interpret Pappenheim's snake phobia along the lines of Lasker-Schüler's image of the snake as phallus in "Der Fakir," we could connect Pappenheim's anxieties to a fear of sexual relations in marriage, of subordinating herself to a husband and the loss of self that such an act can entail.

Lasker-Schüler herself draws on the image of a snake in her autobiographical essay "Etwas von mir" (Something of Me, 1930). She explains that she married her first husband in order to save herself from threatening snakes:

> Once during class, a huge snake lay on the floor of the room in which I had to study. Only years later was it revealed who put it there. Of course it was an act of revenge, because in the excitement of a game of cops-and-robbers, I bit a small playmate's nose off. Since then I've had an aversion to hypocrisy. For that reason, when I was sixteen years old, I decided to marry a kind of marten (*Marderart*) that kills snakes...(188).

The image of the snake offered here, as well as in "Der Fakir," represents a sexualized masculine threat to feminine strength and autonomy. Schalôme counters this threat through illness, St. Vitus' dance, as a form of resistance, just as many middle-class women responded to the sexual politics of their time by contracting hysteria. The symptoms of hysteria provided them with a means of escaping participation in the gender system and could be interpreted as an indirect protest against those social forces that curtailed women's access to a life outside of marriage.

* * *

We find another connection between hysteria and St. Vitus' dance in "Arthur Aronymus: Die Geschichte meines Vaters." Published in 1932, this prose text provided the basis for Lasker-Schüler's drama *Arthur Aronymus und seine Väter* (Arthur Aronymus and His Fathers). The story is set during the mid-nineteenth century in the Westphalian village of "Gäsecke" (Geseke) where Lasker-Schüler's father Aron Schüler (1825-1897), on whom the title character is based, was born. The plot of "Arthur Aronymus" is based loosely upon historical events that took place in Geseke in 1844: a six-month series of antisemitic pogroms that began when a Catholic clergyman converted a fourteen-year-old Jewish boy to Catholicism and his parents subsequently attempted to withdraw

him from the church. In her version of this story, Lasker-Schüler offers a critique of antisemitism and religious intolerance, a theme that culminates in a symbolic Passover dinner shared by Christians and Jews at one table. However, in the shadow of this ultimately uplifting tale is a very different, far less harmonious series of events centered around Arthur's hysterical sister, Dora.[7]

As the story opens on Christmas Eve, the family members, including Dora, are introduced. In keeping with family tradition, the father reads an account of a bloody pogrom carried out against the Jews on a Christmas Eve long past. All too familiar with the story, his twenty-three children soon grow restless, and Arthur begins a conversation with his sister Dora in her sign language: "Bubbly Dora, his older sister, had long communicated with him in her sign language, which only the two of them were able to understand" (244).

As with Bertha Pappenheim, Dora's "private" language could be interpreted as a sign of hysteria, and when her oldest sister Fanny becomes engaged, Dora does indeed become seriously ill.[8] Dora's sickness appears to be timed in order to prevent her sister from marrying, since it causes a brief postponement of the wedding. The disorder is described as follows:

> Poor little Dora, she could no longer sit quietly in her chair, for she had St. Vitus' dance. The doctor comforted the parents, claiming that it often occurred in *these* years. He prescribed valerian drops, 25 drops three times a day in half a glass of water, and ordered the girl a calming tea made of linden flowers, fennel, and camomile. Dora had become so strange, stared with her eyes and prayed half the night. Over and over she began her beseeching anew, afraid that she had forgotten to mention one of her siblings. Arthur Aronymus also once heard from his older brothers that she suffered from obsessions. She always bowed once, twice, three times with her shaking body before she picked a daisy or a buttercup from the meadow in the garden (253–54).

Although the narrator identifies Dora's sickness as St. Vitus' dance, the symptoms described in this passage bear an unmistakeable resemblance to those of the typical hysterical patient.[9] Hysteria, as the doctor in the text states, did indeed appear frequently "in *these* years," striking young women of Dora's age without warning or apparent cause. It then resulted in the kind of treatment the doctor prescribes: sedation and bed rest, along with the withdrawal of any and all stimuli.

The signs of Dora's sudden "strangeness" provide further evidence of her hysteria. She daydreams, seems completely out of touch with the world, experiences loss of memory. Her act of "praying half the night"

also recalls the Pappenheim case.[10] As Breuer explains, Pappenheim slept during the day and related her dreams and hallucinations at night: "I have already said that throughout the illness up to this point the patient fell into a somnolent state every afternoon and that after sunset this period passed into a deeper sleep—'clouds'.... After the deep sleep had lasted about an hour she grew restless, tossed to and fro, and kept repeating 'tormenting, tormenting,' with her eyes shut all the time" (28). Dora's inexplicable behavior in the garden also resembles the obsessive-compulsive activities typical of the hysterical patient. In addition, as the reader learns later on in the story, "the sick sister was afraid of ghosts" (257), a fear that corresponds to Pappenheim's nightmarish visions of "death's heads and skeletons" (27).

By identifying Dora's sickness as St. Vitus' dance, a disease originally connected with satanic possession, Lasker-Schüler places a relatively "modern" phenomenon—hysteria as defined within the context of psychoanalysis—into the longer history of hysteria as a form of persecution. And as we see in the following passage from "Arthur Aronymus," it is not simply women but particularly *Jewish* women who are subject to victimization.

> In Paderborn, exorcising the devil was the order of the day. Witches were burned or buried alive. And the creature with St. Vitus' dance was possessed by demons. And the evil spirits preferred to place themselves in virginal Jewish bodies. That's why Dora couldn't let herself be seen, even in her own garden; the residents of Gäsecke were constantly passing by. Too many had already observed her dancing back and forth. The people earnestly questioned everyone from the messengers to the milkmaid and cowherds of the estate: did Dora really eat "glass" and swallow "fire"? And they were afraid of the evil glance of the poor, good-natured girl. The parents heard too late that their child had been denounced by hateful, envious people, by the people of Gäsecke who were allowed to gather the fallen fruit from the grounds of the estate in the fall. The Christians of Gäsecke looked forward to the Christmas sensation, to "Dora at the stake" (254).

In this passage, the spectacle that Dora presents as she exhibits inappropriate behavior in the quasi-public space of the family garden results in her demonization and the call to destroy her. The people of Gäsecke feel threatened by her body, which is infected with both hysterical femininity and Jewishness, and project their fears onto a supernatural, evil force that supposedly inhabits it. This crisis situation leads the town pastor to suggest that Dora's burning as a witch could be averted if her father allowed his son Arthur to convert to Catholicism. The father

refuses, and Dora is eventually cured by a professor from Lippstadt. Although it is not explicitly stated, this doctor apparently restores Dora to health and "normality." She appears once more in the text as the family sits down to the Passover meal: "Then Dora came, and she seemed lovelier (*anmutiger*) than before her 'girls' illness' (*Mädchenkrankheit*)" (263). The "Dora problem" is solved by silencing her, by returning her to the sphere of proper, unambiguous femininity (she is shocked when Arthur sticks out his tongue at her, because she now "plays 'grown-up,'" 265). And thus, even though she is not actually burned as a witch, social forces do manage to destroy the Dora who spoke a secret language and lived in a world of her own imagination. That woman is transformed into one who goes respectably unnoticed.

* * *

In addition to the depictions of hysterical women in "Der Fakir" and "Arthur Aronymus," we find very different stories of hysteria in Lasker-Schüler's autobiographical essays "Lasker-Schüler contra B. und Genossen" (Lasker-Schüler vs. B. and Company, 1912) and "Nur für Kinder über fünf Jahre" (Only for Children over Five Years, 1927).

"Nur für Kinder über fünf Jahre" focuses on memories of traumatic experiences that caused the author/narrator to fall ill as a child. Breuer and Freud believed that for the hysteric, the transformation of her repressed memories into conscious language (with the help of the psychoanalyst) provided the key to recovery (6). We can therefore read Lasker-Schüler's transformation of memories into text as her own version of the hysteric's cure (through writing rather than talking), although it is important to note that Lasker-Schüler alone is responsible for the narrative of her illness. Unlike the hysterical patients described by Breuer and Freud in *Studies on Hysteria,* Lasker-Schüler has the ability to access her own memories and tell her own story. Indeed, she even goes so far as to parody the psychoanalytic process in the essay "Lasker-Schüler contra B. und Genossen," a text in which the author assumes a dual role as patient *and* psychoanalyst/narrator, thereby offering her own unique interpretation of the case history as literature.

The most famous example of the case history as a literary genre is certainly Freud's *Fragment of an Analysis of a Case of Hysteria* (first published in 1905 and better known as the "Dora" case). In discussing this work as an example of modernist narrative, Steven Marcus demonstrates how the case history can be read as literature, as "a kind or genre of writing—that is to say, a particular way of conceiving and constructing human experience in written language" (65). Freud himself

draws the connection between psychoanalysis and literature in a well-known passage from the case history of Elisabeth von R. in *Studies on Hysteria*:

> I have not always been a psychotherapist. Like other neuro-pathologists, I was trained to employ local diagnoses and electro-prognosis, and it still strikes me myself as strange that the case histories I write should read like short stories and that, as one might say, they lack the serious stamp of science. I must console myself with the reflection that the nature of the subject is evidently responsible for this, rather than any preference of my own (160).

The case history possesses literary qualities because of the nature of hysteria as Breuer and Freud understood it. In *Studies on Hysteria,* they identify hysteria's origins not in the nervous system, as had previously been believed, but in a patient's unresolved, psychic conflicts. Because she has repressed all memories of events that led to the conflicts and thus cannot articulate them, the hysterical patient converts them into physical symptoms. Some of the connections between trauma and symptom are direct and obvious (for example, a patient who was forced to eat as a child suffers gastric pains as an adult), others are more symbolic and thus open to interpretation (Breuer and Freud 4–6) and far more difficult to treat. In this sense, hysteria is a "malady through representation" (Williams 5).

Unlike Charcot, who focused exclusively on the physical manifestations of hysteria in his study of the disease at the Salpetrière clinic in Paris in the late nineteenth century (even going so far as to put the hysteric on display), Breuer and Freud searched for the origins of hysteria by *listening* to their patients rather than by *looking* at them. They encouraged the hysteric to tell the whole story of her life and illness, to talk about anything that came to mind, censoring nothing. In so doing, Breuer and Freud sought to access memories locked in the patient's unconscious (a method that came to be known as free association). Ideally, once traumatic memories had been brought to light, pieced together and interpreted by the analyst, the patient no longer exhibited the physical symptoms associated with the memory. In other words, as Breuer and Freud write, "hysterics suffer mainly from reminiscences" (7), and the cure requires a transformation of physical symptoms resulting from those painful past events into conscious speech. "At the end—at the successful end—one has come into possession of one's own story. It is a final act of self-appropriation, the appropriation of one's own history" (Marcus 71–72).

There is, however, a clear contradiction in this process: how can the hysteric come into possession of *her* story if her analyst writes it? Indeed, as Elaine Showalter explains, Breuer and Freud considered the hysteric's *inability* to tell a complete and ordered story of her life "the very *meaning* of hysteria" ("On Hysterical Narrative" 26). Because of the fragmentary, discontinuous, and incoherent nature of the hysteric's speech, the analyst's job was to edit, interpret, and transform it—by writing the case history—into a clear, logical, seamless whole. The resulting case history, however, is arguably not Dora's story, to cite the example of one well-known patient, but Freud's own. As Showalter points out, "His interpretations of her problem reflect his own obsessions with masturbation, adultery, and homosexuality. Thus the 'hysterical narrative' reflects Freud's hysteria rather than Dora's. She never becomes a subject, only the object of Freud's narrative" (27).

For Else Lasker-Schüler, however, the situation is very different. Fully aware of society's censorious diagnosis of her mental illness, she draws upon the case history genre as a means of countering that judgment. The uniqueness of Lasker-Schüler's relationship to the case history lies in the fact that she as author maintains control over her own story. In so doing, then, she is able to position herself as both subject (analyst) and object (analysand) of the text, thereby resolving the contradiction between passivity and activity inherent in the very concept of the woman writer.

* * *

"Lasker-Schüler contra B. und Genossen," first published in *Der Sturm* in 1912, was occasioned by a Berlin court trial for copyright infringement following the unauthorized publication of Lasker-Schüler's poem "Leise sagen" (Say softly) in the *Rheinisch-Westfälische Zeitung* on 6 July 1910. The court dismissed the case on the grounds that, as an example of "involuntary comedy" (*unfreiwilliger Komik*), the poem did not qualify for copyright, nor could anyone be expected to pay to publish it. On appeal, however, the case was decided in Lasker-Schüler's favor. In his essay "Deutsche Dichter und deutsche Richter" (German Poets and German Judges, 1914), the editor of *Der Sturm,* Lasker-Schüler's former husband Herwarth Walden, wrote about the court trial and claimed that, in addition to the *Rheinisch-Westfälische Zeitung,* the journal *Wahrheit* had also published one of Lasker-Schüler's poems ("Abel") without seeking permission or offering remuneration. Thus, it is either the editor of *Wahrheit,* Wilhelm Bruhn, or Berlin Judge Braun to whom the "B." in the title of Lasker-Schüler's essay refers.

The court's initial decision in favor of the *Rheinisch-Westfälische Zeitung* confirmed the newspaper's censure of "Leise sagen," as "a complete softening of the brain" (qtd. in Dick 240). Lasker-Schüler responds to this commentary in the opening of "Lasker-Schüler contra B. und Genossen":

> Ever since a number of newspapers created such a stir over my lyrical poem "Say Softly" and declared me mentally ill, a group of supporters has risen up around me and assumed the task of eliminating this dangerous claim with legal counterevidence. The result is: I am being observed, not only by a psychiatrist, but by myself as well (I wish I could bill myself something for it—) (269).

The first symptom of mental illness that Lasker-Schüler (the psychiatrist) observes in herself (the patient) is amnesia, but it takes a very specific form: she cannot remember the name of her great-grandfather, who was a "Sheik in Baghdad." She seeks to jog her memory in the "Oriental" department of an unnamed university, but to no avail: "I no longer have a memory, ever since the possibility of my softened brain was raised" (269). The "Sheik in Baghdad" appears as a character in Lasker-Schüler's story "Mschattre-Zimt, der jüdische Sultan," but the title is also a reference to the author's personal, artistic mythology: beginning after the turn of the century, she identified herself as both Else Lasker-Schüler and "Tino of Baghdad" (and later as "Prince Jussuf of Thebes" as well). It is precisely by "forgetting" these "Eastern" origins that Lasker-Schüler would meet society's standards for sanity, but she rejects this possibility by turning it on its head: the author describes her memory lapse as a symptom of mental illness triggered by the *accusation* of mental illness. In other words, the dismissal of her poetic project as a mere "softening of the brain" has resulted in a darkening of her artistic vision. "Since then, I can't feel any more either, I am groping (*ich taste*); the observatory (*Sternwarte*) of my heart is clouded" (269).

Lasker-Schüler pays a visit to her psychiatrist, Dr. Ziegenbart, a man with a red goatee who has been hired by the newspapers to observe her.[11] She remarks that she has trouble talking—a classic symptom of hysteria: "Speaking has become difficult for me; if only I could sing! Then I could say everything much better. But I sang too young, the young bloom of my voice box was not fixed" (270). This longing to return to childhood is a theme that runs through much of Lasker-Schüler's work; in the context of this essay, childhood represents a time in which one is not held to standards of sanity and artistic visions can flourish. At the same time, the author pokes fun at the psychoanalytic treatment of

hysterics (i.e., the recovery of repressed childhood memories) by describing the infantilization of the patient. She asks the psychiatrist to take her for a walk in his baby carriage, and he gives her a rattle, although "I would have much preferred the rubber doll to put in my mouth" (270).

As narrator, Lasker-Schüler takes over the psychiatrist's role in her treatment and speaks for him. She quotes him directly only once, and she even goes so far as to observe *him,* to describe his surroundings and make comments on his relationship with his wife. She determines the course of their session together by bringing a letter she once wrote to a "British bosom friend" named Mabel. (Like Lasker-Schüler in her own country, Mabel is a foreigner who speaks a different language.) Even before the author reads the letter aloud, she explains its significance: "Ever since I wrote this letter, my heart has been streaked with grey" (270). Instead of allowing the psychiatrist to "read" and then "write" her, as Breuer and Freud did with their case histories of hysterical women, by presenting the letter, Lasker-Schüler assumes control of the psychoanalytic process and offers her own written account of her life within the larger story of the essay as whole.

The letter opens with the description of an idyllic scene in which the child Else is surrounded by her family during the afternoon coffee hour. The author then contrasts this safe and secure childhood home ("We sit close together, like an island, all of one piece," 270) with unsuccessful attempts as an adult to recover it, such as "[w]hen I married the first time. But I fell while entering the house and injured my knees, they have been bleeding ever since" (270-71). In two other instances, in the homes of her fiancé and her admirers, she is treated without honor or kindness, like an outsider, and she closes the letter by explaining that she no longer desires her childhood home, for she is Robinson (Crusoe), the hero she knew as a child from the cover of Defoe's novel.

This letter reveals a great deal about the challenges Lasker-Schüler faced as she attempted to reconcile conflicting desires for a familial home with the life of the isolated, heroic artist. The psychiatrist, however, questions her only about the identities of the men mentioned in the letter. He then dismisses his patient as healthy and she returns home. However, the impact of society's rejection of her poetry on the grounds of mental illness remains with her, resulting in a form of self-negation: "I can no longer see myself, I can no longer bear my portrait in mirrors..." (272). These lines echo the central stanza of the poem "Leise sagen," the work that inspired the epithet "softening of the brain": "Im Spiegel der Bäche / Finde ich mein Bild nicht mehr" (In the mirror of brooks / I can no longer find my image, 161). At the conclusion of the

essay, the narrator comforts herself by imagining the arrival of her lover. She and he are like two winged angels, she writes, like Adam and Eve, like two flowers behind the hedge, like two rubies in the emperor's ring, like two jackals (273). In the eyes of society, her poetry and her poetic mind may be hysterical or insane, but the author remains defiantly true to her artistic vision, even in the face of criticism and misunderstanding.

* * *

In her autobiographical essay, "Nur für Kinder über fünf Jahre," first published in 1927 and later under the title "Der letzte Schultag" ("The Last Day of School") in the volume *Concert* (*Konzert,* 1932), Lasker-Schüler invokes the case history genre in describing a series of traumatic childhood experiences connected with her education that culminate in illness and her withdrawal from school at the age of eleven. In the opening pages of the essay, the author explains that, fortunately, most of the memories of her school days have "healed over in my memory." However, the trauma of her educational experience does indeed remain with her in the form of recurring nightmares:

> But I haven't yet entirely overcome the horrors of school; how often at night my school principal, Mr. Chimney, has appeared to me in a dream as a real chimney in a frock coat, and I think I'm going to suffocate in smoke and soot. That is called nightmares, and it is no fun to dream that way (83).

Like Freud, who structures Dora's case history around his patient's dreams, Lasker-Schüler offers an interpretation of her troubling dream, explaining how Principal Chimney frequently appeared in the classroom unannounced, pipe in hand, to check the pupils' work. Young Else found this situation so frightening that "the arithmetic problems that I had finally understood fell back down into my stomach, and I gulped and sobbed and had to stand in the corner" (83).

In relating these events to a sympathetic reader, the author undertakes a written version of the "talking cure," a term coined by Anna O. to describe how she was able to relieve her hysterical symptoms by narrating her traumatic stories, dreams, and visions to Dr. Breuer. Anna O. also called the "talking cure" "chimney sweeping" (Breuer and Freud 30). Similarly, as Lasker-Schüler recounts and interprets her dreams of Principal Chimney, along with other painful memories of her school days, she seeks to clear away the "smoke and soot" that continue to suffocate her emotionally, even decades later.

Lasker-Schüler continues her reminiscences, recalling how she hated to leave the flower gardens and go in to complete her school exercises, especially when she had to write essays ("For my essay on 'Frederick the Great' I had received a failing grade," 87). We soon learn, however, that young Else did indeed have a talent and fascination for language, but only in the context of the exotically poetic, not the scientific or factual. In geography class, for example,

> I was only interested in the African rivers because they rhymed. And they flowed like water from my lips: Senegal and Gambia, Neger or Dcholiba, Zaire and Orange River, Nile and Zambesi. With this poem I earned my first and only praise (87).

The essay later reveals that Lasker-Schüler's fascination with language and poetry came to her through her mother, a great lover of literature.

> My dear mother read a lot; books papered the four walls of her little living room. Sometimes it seemed to me at lunch that she was thinking of some woman or some knight from the novel she was reading. At those times her eyes were opened wide and seemed to see so far, as if to the other end of the world—or high over the water, as in powerful birds who would like to fly far away (89).

This poignant passage describes a woman trapped within the bookshelf-lined walls of her bourgeois existence, with brief, imaginary journeys to the far-away worlds of her imagination providing the sole means of escape. In the final pages of the essay, the mother's desire to flee the sphere of her day-to-day existence triggers a traumatic experience for Else, one that leads to her withdrawal from public school. One day, her mother leaves the house and walks into the forest; when she does not return in time for supper, Else's father and siblings begin searching for her. Else, however, chooses to await her mother from a lookout post atop the tower of the house. When she sees her mother coming slowly, sadly down the hill, Else jumps over the railing of the tower to reach her more quickly. Fortunately, she is not injured, for she lands in the awning over a lower window "as safe as in my mother's arms" (90). The fall, however, is not without serious consequences:

> I was rescued from the parachute by my second brother, who belonged to the volunteer fire department. My brother carried me on his broad shoulders from step to step, from air to air—I had such tremors through my body—down the long, frightening ladder.—I had come down with St. Vitus' dance. The nice doctor thought it was a result of the fright I had received! From that time on he called me: "lively little kid!" But I knew that I had gotten St.

Vitus' dance from something entirely different—from the first grief in my life, that not even the loveliest parental home had been able to prevent. However, because of that, I did not have to go to school anymore (90–91).

The disease St. Vitus' dance (Greek *chorea Sancti Viti*) is better known to speakers of English as Sydenham's chorea. It is a temporary disorder of the parts of the brain that control movement and coordination, resulting in uncontrollable, purposeless, and non-repetitive movements that are wandering and jerky. Additional symptoms include facial grimacing, muscular weakness, and speech difficulties. The disease generally affects children, more often girls than boys, between the ages of seven and fourteen years. Although the disease was first described by Thomas Sydenham (1624–1689)[12] in 1686, its cause, a delayed complication of a streptococcal infection, was not identified until the late nineteenth century. Recovery usually occurs between three and six months without lasting effects.

Given this description, it is very possible that Else Lasker-Schüler suffered from Sydenham's chorea at age eleven and fully recovered, but one can also draw some interesting connections to hysteria. In the late nineteenth century, various forms of hysteria were named choreas because they looked like dance, and in fact, members of Charcot's circle sometimes called movements associated with hysteria St. Vitus' dance (see McCarren 749). The term St. Vitus' dance has its origins in medieval times, when it was associated with demonic possession,[13] a tradition that Lasker-Schüler drew upon for the Dora story in "Arthur Aronymus: Die Geschichte meines Vaters." Contracting St. Vitus' dance had serious consequences for women in the Middle Ages, since, as with hysteria, the convulsions associated with the disease were considered *stigmata diaboli,* marks of the devil. As a result, victims were hunted and persecuted as witches, subjected to torture or even executed (see Micale 20–21). In tracing the history of hysteria, G.S. Rousseau writes, "substitute 'nervous' or 'neurotic' for 'demonically possessed,' and a remarkable parallel between this early modern world and our own develops" (99).

With the story of her accident and how she contracted St. Vitus' dance, Lasker-Schüler creates a case history of her own illness. She dismisses the doctor's opinion of what caused the disease, explaining instead that it resulted from a specific emotional trauma, from the "first grief of my life" (91). As readers and interpreters we can only speculate on what constituted that "first grief"—the fear of the loss of her mother, perhaps, or a vision of her mother's impending death (which took place

in 1890, when Else Schüler was twenty-one years old). As Adrienne Rich has so eloquently written, a daughter's separation from and loss of the mother constitutes one of the most powerful, and least regarded, events of human experience:

> The loss of the daughter to the mother, the mother to the daughter, is the essential female tragedy. We acknowledge Lear (father-daughter split), Hamlet (son and mother), and Oedipus (son and mother) as great embodiments of the human tragedy; but there is no presently enduring recognition of mother-daughter passion and rapture (237).

Viewed from a slightly different perspective, this trauma might imply Else Lasker-Schüler's first childhood realization that she was destined not only to lose the "loveliest parental home," but also to share in her mother's *unhappy* fate as bourgeois wife trapped within it. In this context, young Else's jump from the tower could be seen as a fall from childhood innocence into knowledge of the patriarchal order and sexual difference, as well as a rejection of that knowledge. By contracting St. Vitus' dance, an illness that can be interpreted as a form of hysteria, eleven-year-old Else no longer had to attend school and was thereby able to defy the social forces that employed intimidation and punishment in shaping a child's "appropriate" identity.[14]

* * *

By thematizing hysteria in her literary work, Else Lasker-Schüler offers a critique of the gender system of late nineteenth- and early twentieth-century European society. At the same time, in describing her own traumas and illnesses, she uses the writing process as a form of the cathartic "talking cure." Unlike hysterical patients of the turn of the century, however, Lasker-Schüler has the ability to create her own literary case history, thereby controlling the discourse of hysteria. In so doing, she assumes the roles of patient and doctor, female and male, and invokes the repressed desires and radical possibilities inherent in the language of hysteria. Lasker-Schüler describes the hysterical body, but she also allows the hysteric to tell her own story.

Notes

With the exception of passages from "Only for Children over Five Years" (translator Jean M. Snook's title is "The Last Day of School"), all translations from Lasker-Schüler's works are my own.

[1] In an essay on "women's illnesses" throughout history, Christina von Braun draws a connection between turn-of-the-century hysteria and the prevalence of anorexia among women in today's society (121–24).

[2] Elaine Showalter also uses this term to describe Charlotte Perkins Gilman's text *The Yellow Wallpaper*. "In creating a narrative of her hysterical condition," Showalter explains, "[Gilman] no longer had to embody illness directly but could represent it in her text" (*Hystories* 93).

[3] As Sigrid Bauschinger explains, the newspaper printed the poem without the author's permission and refused to pay her for it, claiming that the poem didn't qualify as literature. A lengthy court battle ensued (71–72). Lasker-Schüler responded in her essay "Lasker-Schüler contra B. und Genossen."

[4] See Williams (6).

[5] Markus Hallensleben discusses the importance of dance as a metaphor within Lasker-Schüler's work as a whole: "Dance is at once a language body (*Sprachkörper*) and language of the body (*Sprache des Körpers*)" (94). He also references the work of several other scholars who have dealt with this theme, including Hermann (144–51).

[6] Freud would later criticize Breuer for refusing to acknowledge sexuality as a key aspect of hysteria—indeed, Breuer described his patient Bertha Pappenheim as "asexual." Freud later remembered, however, that Breuer was forced to leave the case because of Pappenheim's "hysterical pregnancy": she claimed that she was to give birth to Breuer's baby. Breuer does not mention this in his case study, which concludes with Anna O.'s successful recovery.

[7] Of course, the name "Dora" has unmistakeable connections to psychoanalysis and hysteria, for it is the pseudonym that Sigmund Freud chose for Ida Bauer, subject of his *Fragment of an Analysis of a Case of Hysteria* (1905). In *The Psychopathology of Everyday Life,* Freud explains that he named his patient after his sister Rosa's nursemaid, whom he knew as Dora. Only as an adult did he learn that the nursemaid's real name was Rosa, and that his family called her Dora to avoid confusion with his sister. "'Poor people,' I [Freud] remarked in pity, 'they cannot even keep their own names!'... When the next day I was looking for a name for someone who could not keep her own, 'Dora' was the only one to occur to me" (qtd. in Sprengnether 255).

[8] Judith Kuckart also interprets Dora's St. Vitus' dance in terms of hysteria, but views it not within the historical context of turn-of-the-century images of the hysteric, but as an essentialized form of resistance to (masculine) knowledge and reason, which is rooted in the female body (82–83).

[9] Iris Hermann also discusses the reference to hysteria in this passage, but she focuses on the poetological possibilities inherent in hysteria as a metaphor of performance (118).

[10] After sitting at her sick father's bedside one night, Pappenheim had a vision of a snake coming toward her. Wanting desperately to pray, she could recall only a child's nursery rhyme in English, after which she continued to speak and think in that language (26).

[11] The psychiatrist with the red goatee is apparently a reference to Alfred Döblin (Dick 240).

[12] Thomas Sydenham is also an important figure in the history of hysteria, for he was the first to establish a neurological basis for the disease (see Micale 22).

[13] St. Vitus, the patron saint of dancers and patients with movement disorders, was particularly honored in Westphalia, the area of Germany in which Lasker-Schüler's father was born. During the Middle Ages, infertile and hysterical women made pilgrimages to the St. Vitus Chapel near Zabern, and many carried "St. Vitus letters" (*Veitsbriefe*) to protect against the disease (see Bächtold-Stäubli 1540–42).

[14] It is not clear whether Lasker-Schüler did indeed leave school at age eleven. Although class rolls do not exist that could verify unequivocally during what years she attended the school in question, several statements that Lasker-Schüler makes about her education in "Nur für Kinder über fünf Jahre" suggest that she could not possibly have left as early as 1880, when she would have been eleven years old. For instance, she mentions both her arithmetic teacher, Mr. Gramm, and her English teacher. If we assume that Lasker-Schüler entered school at the age of seven, she could only have completed the first four grades by age eleven. School records show, however, that in the late 1870s and early 1880s, Gramm taught only in the fifth grade and higher, and English was offered only as of the seventh grade (see Abresch). Furthermore, in an essay published in 1926 entitled "Erinnerungen" (Memories), Lasker-Schüler recalls her brother Paul's death and the fact that the girls at school were envious of her black armband and bead necklace (123). Paul Schüler died in 1882 at the age of twenty-one, when Else Schüler was thirteen years old.

Works Cited

Abresch, Johannes. "Schülerin Else." *Romerike Berge: Zeitschrift für das bergische Land* 45.1 (1995): 12–17.

Bächtold-Stäubli, Hanns, and E. Hoffmann-Krayer, eds. *Handwörterbuch des deutschen Aberglaubens*. Vol. 8. Berlin: Walter de Gruyter, 1929–1930.

Bauschinger, Sigrid. "Else Lasker-Schüler (1869–1954): 'Völlige Gehirnerweichung.'" *Wahnsinnsfrauen*. Vol. 2. Ed. Sibylle Duda and Luise F. Pusch. Frankfurt a.M.: Suhrkamp, 1996. 71–99.

Braun, Christina von. "'Frauenkrankheiten' als Spiegelbild der Geschichte." *Von der Auffälligkeit des Leibes*. Ed. Farideh Akashe-Böhme. Frankfurt a.M.: Suhrkamp, 1995. 98–129.

Breuer, Josef, and Sigmund Freud. *Studies on Hysteria. Standard Edition of the Complete Psychological Works of Sigmund Freud*. Vol. 2. Trans. and ed. James Strachey. London: Hogarth, 1955.

Bronfen, Elisabeth. *The Knotted Subject: Hysteria and Its Discontents*. Princeton: Princeton UP, 1998.

Dick, Ricarda, ed. *Else Lasker-Schüler: Werke und Briefe*. Vol. 3.2 (*Anmerkungen zur Prosa 1903–1920*). Frankfurt a.M.: Jüdischer Verlag, 1998.

Foucault, Michel. *The History of Sexuality, Vol. I: An Introduction*. Trans. Robert Hurley. New York: Vintage, 1990.

Freud, Sigmund. *A Case Study of Hysteria, Three Essays on Sexuality, and Other Works. Standard Edition of the Complete Psychological Works of Sigmund Freud*. Vol. 7. Trans. and ed. James Strachey. London: Hogarth, 1953. 3–122.

Hallensleben, Markus. *Else Lasker-Schüler: Avantgardismus und Kunstinszenierung*. Tübingen: Francke, 2000.

Hermann, Iris. *Raum—Körper—Schrift: Mythopoetische Verfahrensweisen in der Prosa Else Lasker-Schülers*. Paderborn: Igel Verlag Wissenschaft, 1997.

Hunter, Dianne. "Hysteria, Psychoanalysis, and Feminism: The Case of Anna O." The *(M)other Tongue: Essays in Feminist Psychological Interpretation*. Ed. Shirley Nelson Garner, Claire Kahane, and Madelon Sprengnether. Ithaca: Cornell UP, 1985.

Kaplan, Marion A. "Anna O. and Bertha Pappenheim: An Historical Perspective." *Anna O.: Fourteen Contemporary Reinterpretations*. Ed. Max Rosenbaum and Melvin Muroff. New York: The Free Press, 1984.

Klüsener, Erika, and Friedrich Pfäfflin, eds. "Else Lasker-Schüler, 1869–1945." *Marbacher Magazin* 71 (1995).

Kuckart, Judith. *Im Spiegel der Bäche finde ich mein Bild nicht mehr: Gratwanderung einer anderen Ästhetik der Dichterin Else Lasker-Schüler*. Frankfurt a.M.: Fischer, 1985.

Lasker-Schüler, Else. "Arthur Aronymus: Die Geschichte meines Vaters." *Werke und Briefe*. Vol. 4.1 (Prosa 1921–1945). Ed. Karl Jürgen Skrodzki and Itta Shedletzky. Frankfurt a.M.: Jüdischer Verlag, 2001. 239–66.

———. "Erinnerungen." *Werke und Briefe* 4.1: 122–24.

———. "Etwas von mir." *Werke und Briefe* 4.1: 188–89.
———. "Der Fakir." *Werke und Briefe*. Vol. 3.1 (Prosa 1903–1920). Ed. Ricarda Dick. Frankfurt a.M.: Jüdischer Verlag, 1998. 112–15.
———. "Lasker-Schüler contra B. und Genossen." *Werke und Briefe* 3.1: 269–73.
———. "The Last Day of School." *Concert*. Trans. Jean M. Snook. Lincoln: U of Nebraska P, 1994. 83–91.
———. "Leise sagen." *Werke und Briefe*. Vol. 1.1 (Gedichte). Ed. Karl Jürgen Skrodzki and Norbert Oellers. Frankfurt a.M.: Jüdischer Verlag, 1996. 161.
———. *Lieber gestreifter Tiger: Briefe von Else Lasker-Schüler*. Vol. 1. Ed. Margarete Kupper. München: Kösel, 1969.
———. "Nur für Kinder über fünf Jahre." *Werke und Briefe* 4.1: 142–48.
———. "Verwelkte Myrten." *Werke und Briefe* 1.1: 10.
Marcus, Steven. "Freud and Dora: Story, History, Case History." In *Dora's Case: Freud—Hysteria—Feminism*. Ed. Charles Bernheimer and Claire Kahane. New York: Columbia UP, 1985. 56–91.
McCarren, Felicia. "The 'Symptomatic Act' Circa 1900: Hysteria, Hypnosis, Electricity, Dance." *Critical Inquiry* 21 (1995): 748–74.
Micale, Mark S. *Approaching Hysteria: Disease and Its Interpretations*. Princeton: Princeton UP, 1995.
Pinthus, Kurt. "Leipzig and Early Expressionism." *The Era of German Expressionism*. Ed. Paul Raabe. Trans. J.M. Ritchie. London: John Calder, 1980. 67–76.
Rich, Adrienne. *Of Woman Born: Motherhood as Experience and Institution*. New York: Norton, 1986.
Rousseau, G.S. "'A Strange Pathology': Hysteria in the Early Modern World, 1500–1800." *Hysteria beyond Freud*. Berkeley: U of California P, 1993. 91–221.
Showalter, Elaine. *Hystories: Hysterical Epidemics and Modern Media*. New York: Columbia UP, 1997.
———. "On Hysterical Narrative." *Narrative* 1 (1993): 24–35.
———. *The Female Malady: Women, Madness, and English Culture, 1830–1980*. New York: Penguin, 1985.
Sprengnether, Madelon. "Enforcing Oedipus: Freud and Dora." *In Dora's Case: Freud—Hysteria—Feminism*. Ed. Charles Bernheimer and Claire Kahane. New York: Columbia UP, 1985. 254–75.
Williams, Linda Ruth. *Critical Desire: Psychoanalysis and the Literary Subject*. London: Edward Arnold, 1995.

Ethnicity and Gender in Else Lasker-Schüler's "Oriental" Stories: "Der Amokläufer" ("Tschandragupta") and "Ached Bey"

Herbert Uerlings

In her two prose works *Die Nächte Tino von Bagdads* (The Nights of Tino of Baghdad, 1907) and *Der Prinz von Theben* (The Prince of Thebes, 1914) Else Lasker-Schüler thematizes the connection of ethnicity, gender, and art in an imaginary Oriental setting. An examination of these two stories shows the sophistication with which she undermines any notion of unambiguous identity, whether ethnic or sexual, and the implications of her challenge to images of Jewish femininity for her conception of art and her position within the avant-garde of classical modernity. Lasker-Schüler's productive intertextual connection to Heine and her critical distance to cultural Zionism (Martin Buber) are analyzed with regard to the German-Jewish history of ideas. (HU)

In her two prose works *Die Nächte Tino von Bagdads* (The Nights of Tino of Baghdad, 1907) and *Der Prinz von Theben* (The Prince of Thebes, 1914) Else Lasker-Schüler thematizes the connection of ethnicity, gender, and art in an imaginary Oriental setting. Her stories are marked by a high degree of intertextuality and allusion, play and disguise, as well as an irony that is at times playful or painful. While these characteristics complicate any interpretation of the texts, they also create the unique tone that characterizes her prose.

Recent scholarship, in particular studies by Atterholt, Berman, Hedgepeth, Heizer, O'Brien, and Redmann, has read Lasker-Schüler's oeuvre both as an investigation of representations of gender, especially femininity, and as a contribution to a Jewish minority discourse. My argument proceeds from these presuppositions. With an eye toward the stories "Der Amokläufer" (The Madman, 1910) and "Ached Bey" (1907), I examine the overlap of ethnicity and gender: to what extent

does Lasker-Schüler probe images of Jewish femininity and what can we conclude from this with regard to her views on art?[1] Common to both stories—indeed a frequent configuration in Lasker-Schüler's texts—is a narrated world initially dominated by a father figure. He represents a patriarchal order whose limit(ation)s are dissolved when a female figure within the father's "domain" is conjoined with a "foreigner" from a different culture.

"Der Amokläufer"

At first glance, "Der Amokläufer" seems to be a straightforward story: Tschandragupta, a heathen king, feels a longing for the Jews ("Sehnsucht nach den Juden," 129); he visits them and wants to make a sacrifice to Jehovah, but is hindered by the high priest. As a result, the foreigner goes berserk and only stops when Schlôme, the daughter of the high priest, becomes one of his victims. On closer inspection, however, the situation becomes more confusing. Tschandragupta is not just a "heathen": son of a Jewish mother, he is also a Jew, and while some hail him as an "angel," others condemn him as "Schaitân" (129), the Arab word for devil. Schlôme, in turn, is not just his victim, but also the driving force of the events, and ultimately her death seems not only a demise, but also the fulfillment she has wished for. As in many of her narratives, Lasker-Schüler here creates ambiguities by changing configurations, overlaying oppositions, and neglecting the characters' motivation. Questions that then arise are: Whose point of view is this? Is there even a unified narrative point of view? This confusing game with oppositions is joined by a host of intertextual references. The theme of the story, however, remains relatively insignificant; of central importance is her concern with stereotypes that combine antisemitism and sexual phantasies in a number of intertexts.[2]

Thus the name of the female protagonist refers to the Salome tradition: "Schlôme" is historically a hybrid reconstruction of "Salome"[3] as is the configuration of the three characters: the opposition between the holy stranger ("heiliger Fremdling," 129), on the one hand, and the threatened leader of the Jews (the father figure) and his daughter, on the other. Furthermore, Salome's eroticism and passionate dancing play a key role in Lasker-Schüler's story. In fact, Schlôme appears three times in an erotic pose: first before Jehovah; then before the people, showing them her unveiled face for the first time (131) and goading them to revolt against the high priest; and finally approaching, "smilingly, ever closer to the deadly kiss" (132)—another characteristic detail of the Salome tradition.

The most obvious departure is the conclusion of the story: the foreigner does not fall victim to the Salome figure, nor is she punished. The couple, by way of its union, becomes instead *one* figure whose aggression is directed, successfully, against the father figure and his order. Even this, however, could be related to the Salome tradition, which includes the dethronement of Herod by Herodias/Salome. Since the Middle Ages Salome has embodied the identification of the desiring woman with the wandering Jewess, the female counterpart to Ahasver. This association of antisemitism and antifeminism surfaces again in many treatments around 1900, right up to the equation of the Jewish woman with the femme fatale.

This tradition is adapted and undone by Lasker-Schüler in "Der Amokläufer." Nor is she alone here: she can look back to other famous variations like those of Oscar Wilde, Gustave Flaubert, Friedrich Hebbel, or especially the reinterpretation by Heinrich Heine, who was held in high regard by Lasker-Schüler's parents.[4] Heine attached particular importance to the "heathen sensuality" of the "eternal Jewess" Herodias in *Atta Troll* and even made her a figure of identification for himself as the Jew in exile.

In Heine, and even more in Wilde, the "holy stranger" is also a penitent and ascetic who anxiously rejects the beauty, lust, and passion associated with "woman." Lasker-Schüler intensifies this model as the opposition between the longing for Jehovah and the erotic desire released at the end. The latter is first awakened in Schlôme and the women of the city under clearly "heathen" premises that point to India: the name "Tschandragupta" invokes the Indian Gupta dynasty.[5] And in a brief surreal passage with parodic overtones, the foreigner is likened to an erotic figure in the Hindi Pantheon: "Limbs had grown from the limbs of his limbs, which were entwined in desire, like the many-armed idols of his homeland" (130). Those "idols" soon enter the city in the form of "forbidden games" and "little heathen love gods," setting free among the women an erotic desire that culminates in the union of Schlôme with Tschandragupta.

Such a distinct syncretism in treatments of the Salome story can only be found in Heine, who linked Herodias with the ancient Diana and the nordic Abunde. But he left it as a trio under the leadership of the Jewess. Lasker-Schüler's syncretism, with its St. John figure and an Indian ruler and/or deity, goes beyond this. This notable "Indian" dimension reflects back on the woman: her erotic exposure in the dance and her sacrifice to her lover, with its religious connotations, evoke the bayadere, the female figure who is central to the German reception of

Indian culture. It also recalls the connection between Orientalism and Expressionist dance around 1900.

The ending of "Der Amokläufer," however, negates the traditional affirmative representation of female sacrifice and the "beautiful corpse": it is only the high priest's rejection of both the foreigner and of Schlôme's wishes that leads to the monstrous Day of Atonement where people instead of lambs are sacrificed.[6] This explains why the union of Tschandragupta and Schlôme is not what it seems at first: heathen barbarism or a betrayal of the Jewish tradition. At this point the diegesis seems to coincide for the first time with the actions and wishes of the woman. The sexual union of the protagonists is given a religious solemnity in the themes of the *Song of Solomon* and Lasker-Schüler's Zebaoth poems: "Over the names of the savage fathers imprinted in heathen signs and images on Tschandragupta's flesh runs Schlôme's consecrated sweetness, down his loins like rose-colored strained honey." This linking of flesh and consecration, heathendom and Judaism corresponds to Tschandragupta's desire: "Ecstatically, he carries between his teeth his last victim, her body over Jericho" (132). The union of the two is described in monstrous and sadomasochistic terms. This staging of violence, directed against the patriarchal order, can only be understood as a conscious exaggeration. The monstrous is an expression of the violence needed for their union to overcome the old order.

The destruction of this old order manifests itself as the decentering of gender roles and of religious/cultural/ethnic demarcations. The decentering of gender roles is not only inscribed in the reversal of traditional codes in the sexual act in which Schlôme's initiative is emphasized. It is also apparent in Tschandragupta's transgendering ("Tschandragupta steps out of the high priest's house, in Schlôme's veils, like the women of the city"), in his taking a woman's place in the temple ("behind the grille"), and above all in the slightly ironic address: "O and his character, fumbling lovingly like a woman carrying a child" (132). This is not just a reversal of gender roles. Tschandragupta and the incorporated Schlôme embody a third gender, a hybrid that defies conventional oppositions: "No one hinders the change in Meleh's grandson. Not even the high priest ["der tempelalte Knecht"] in his greying ceremonial robe" (132).[7]

As the gender opposition is dissolved, so is the opposition of heathendom and piety, of idolatry and monotheism. The Hindu god figure—erotically charged and coded as male—sits with the women in the temple, a madman is pregnant with his last victim as if to re-create it, a killer whose prayers among the believers sound like the "gentle cooing of a dove" (132) but bring a chill to the women around him.

The fact that this character is called "Meleh's grandson" at the end reminds us that Tschandragupta was clearly made "foreign" from the beginning although he embodies a blend, syncretism, a hybrid. Tschandragupta is "Meleh's grandson," offspring of a Jewish king, through his mother, Meleh's daughter. His "longing for the Jews," which leads to the union with Schlôme, originates with a Jewish woman who once desired Tschandragupta's father ("She lures him over the sea") and followed him to "his heathen land" in secrecy. Schlôme and Tschandragupta thus repeat a transgression of cultural and religious borders that had happened before, but was condemned, forgotten, and repressed ("son of the apostate woman," 129). These transgressions are not about changing a cultural identity or assimilating the other. Both characters, Tschandragupta as well as Schlôme, feel alienated and thus depart from their respective cultural origins. The alterity embodied in Tschandragupta/Schlôme is not ultimately integrated: it remains as a challenge to the religiously based "Jewish" order.

Lasker-Schüler works with antisemitic stereotypes not only in the figure of Schlôme, but also in her representation of the male characters, the high priest, and Tschandragupta. Tschandragupta covers the hill of Jehovah's temple with gold and embosses "a living piece of his neck like the most precious coin of the Jewish land and lays the breathing gold to that which has burned out" (131). It is obvious that Tschandragupta is not interested in the material value of gold won through laborious effort (130). He wants to glorify the Temple Mount. The "breathing gold" should be understood as a symbolic self-sacrifice with a religious motivation. The people do not think of the material value of the gold, either. Seeing the "shining hill," they shout: "The sun has fallen from the heavens!" and take it as a religious sign. Schlôme reacts in similar fashion and asks her father to fulfill "the pious wish" (131) of the young man. The high priest, however, rejects both the sacrifice as well as the people's interpretation of it and his daughter's wish. The "hardhearted heart of the priest" (130) will not be moved. However, he wants the gold to be collected so carefully that "not a grain is lost" (131). This is striking because he had not paid any attention to previous offerings. The order seems to be taken literally: every particle of gold is collected. What is lost, however, is "the living coin of golden flesh and blood," which is what Tschandragupta and the narrator consider the true value, the actual meaning of the sacrificial act. If the high priest reduces the offering to its material value, which is indicated by his instruction to pick up the gold very carefully, we can relate this theme and its representation to two possible intertexts that are both associated with antisemitism.

First, the exchange of live flesh for dead matter recalls tales about a pact with the devil such as the tales of the "cold heart." The "hardhearted heart" might be a conscious allusion to this motif. The protagonist in these tales gives his heart or soul in exchange for material wealth, which turns out to be a kind of living death. The "devil" is, in fact, named in "Der Amokläufer" when the seer of the Jews calls Tschandragupta "Schaitân." This has to be seen, however, as a characterization that is undermined by the narrator: driven by a religious desire, the foreigner does not fall for appearances like the protagonists of those devil's pact tales who always represent aspects of evil. The real "Schaitân" in terms of Lasker-Schüler's use of the tradition is not the foreigner, but the high priest who exchanges the living, spiritual gold for its material value. Such a link between the subject of the devil's pact and the stereotype of the avaricious Jew is not new. It is striking, however, that Lasker-Schüler pointedly directs it toward the figure of the high priest, who eventually appears as the loser, much like the figure of the devil in the literary tradition.

A possibly more prominent intertext is the story of Shylock. Lasker-Schüler alludes to the "haggling Jew" not only with the exchange of living flesh for gold/money, but also with a Jewish father who wants to prohibit the relationship between his daughter and a heathen "foreigner." Both strands of the plot are part of the Shylock theme, and the high priest of "Der Amokläufer" indeed has features of a Shylock figure. Of course he is not a profiteer who insists on getting his pound of human flesh: Lasker-Schüler's high priest favors gold over flesh. This difference, however, is deceptive; a closer look reveals basic similarities. In Lasker-Schüler live flesh is also entrusted to the Jewish character; here, too, the Jew performs an inhuman exchange after a literal interpretation of an agreement; similarly, a supposedly impassable cultural/religious border must be maintained. And like Shylock, the high priest will lose his daughter over the exchange of human flesh for gold/money, only to find himself completely isolated at the end. Lasker-Schüler's portrayal of the Jewish father and high priest as a Shylock figure could not be more malicious.

However, this use of antisemitic stereotypes in characterizing her own people is not unique in Lasker-Schüler. At the beginning of her essay "Der Antisemitismus" (Antisemitism), written in 1939 in Jerusalem, she employs the metaphors of "heart of stone" (*"Steinherz"*) and "mercenary soul" (*"Geldseele"*) again:

> I consider antisemitism a legacy passed on from father to son. A bequest with which the heir only rarely knows how to deal. Instead

of destroying the worthless, false treasure that was bequeathed to him and threatens to impoverish his mind and soul, he is at pains to keep it in the strong-room of his heart, so that he can occasionally spend it lavishly. That is how the devilish thalers of the inherited wealth lead their owner to bankruptcy of the soul. As usual, every coin is passed down from parents or the nation—with a spiteful grimace (68).

Lasker-Schüler goes on to say that she was subjected to antisemitic animosity by her Christian environment during her school days. Yet the essay goes on to point out that Jews were often as bad as Christians with regard to the commandment of neighborly love: "After escaping from the manslaughter of antisemitism I am sometimes torn by the distrustful claws of my own people" (72). She draws a parallel between antisemitism and traits of her own people: both can be deadly for her, and their disregard of the commandment of neighborly love is expressed in the image of the "devilish thalers."

The depiction of the high priest in "Der Amokläufer" is initially ambivalent. His stance toward Tschandragupta is mixed: he rejects him but holds him dear ("*lieb*," 131) as well. As in other material on Salome, this corresponds with Herod's behavior toward John: the leader of the Jews brings the stranger into his own home to protect him, but also to isolate him from his followers and thus to protect himself and his rule. Above all, taking a stranger into one's home in the Salome stories expresses the accused's sense that the accuser is right, that the troublemaker is a prophet, and that something presumably strange is actually part of oneself. References to stories of the devil's pact and the Shylock material serve a similar function, one by which Lasker-Schüler consciously develops antisemitic stereotypes into a self-characterization.

The representation of the antagonist Tschandragupta, also associated with antisemitic clichés, is similarly about decentering the opposition of "self" and "other." Tschandragupta is not only a "heathen," but also a Jew. More precisely, he is a highly sexualized Jewish man whose hunger leads to an excess and whose "ultimate victim" (132), Schlôme, is maimed in a cannibalistic murder and rape. With this Lasker-Schüler invokes the antisemitic association of "Jewish man" and "perverse" sexuality. Around 1900, Jack the Ripper was paradigmatic as the whore killer with Jewish connotations (see Frayling, esp. 199 ff., and Gilman). It was Lasker-Schüler herself who in her letters called attention to the link between the madman (*Amokläufer*) and Jack the Ripper, saying: "I am the madman,...there is hardly anything that I have not killed in my hand, every law whenever it does not happen to suit me, and everything made for the burgher's convenience."[8]

Else Lasker-Schüler thus sometimes consciously employs antisemitic stereotypes in her writings. This is not uncommon within Jewish literature and is no sign of "Jewish self-hatred" in Lasker-Schüler. One might even explain it biographically as the result of suffering under Jewish contemporaries, those with whom she was friends and whom she admired, a circumstance that grew worse when she was in exile. My aim, however, is to describe it here as part of her literary technique. Lasker-Schüler uses antisemitic clichés and simultaneously undermines them in her deconstruction of "Jewish" and "bourgeois" orders. In particular, she draws on the potential for violence and repression contained in those stereotypes. In "Der Amokläufer" she does this by letting Schlôme refuse the sacrifice demanded by her father; instead Schlôme produces a slaughter with Jack the Ripper, thus providing a parodistic, monstrous, blasphemous counter-image to the "beautiful corpse" that disempowers the old sovereign.

"Ached Bey"

The configuration in "Ached Bey" is analogous to the one in "Der Amokläufer." Here, too, a daughter comes into conflict with a rigid "paternal" law that delineates sharply between self and other, believers and non-believers, loyalty and betrayal. And here, too, an engagement with a "foreigner" destabilizes this order. The positions, however, are filled differently in this story: the father figure is a caliph, the uncle of the young princess Tino of Baghdad, so their culture is not Jewish but Arab-Muslim. Consequently, the foreigner's origin is now different, namely Jewish.

The bond of ethnicity and gender is thematized early on because the caliph is dreaming about "Naëmi," the "Jewess of his youth," when the story opens. The "black Naëmi rose" (73) is the leitmotif of the narrative, and one notices at once that distinct oppositions are destabilized. Unlike "Der Amokläufer," this story has been the subject of previous scholarship.[9] My own comments will focus on a neglected aspect: the name of the Jewess in "Ached Bey," Naëmi (or Naomi[10]), refers to the famous progenitor of David. The female protagonist, however, seems to have a problematic function.

The caliph's reminiscence of Naëmi leads seamlessly to the beheading of the so-called "traitors." What is more: the dreamy act of remembering the woman is thematically associated with the caliph's "big hand" (73). It is the index of his power, which can acknowledge the salute of passing caravans, authorize the execution of a death sentence, and stand metonymically for the sexual act.

Such a linking between an image of the feminine and patriarchal power exists already in Heinrich Heine's poem "Ali Bey" (1839), which Lasker-Schüler quotes here.[11] Heine also writes about an oriental tyrant who, "blessed in the arms of girls," enjoys a "foretaste of joy paradisal." Then "Ali Bey, the Faith's defender" is called to battle against the crusaders.

> Während er die Frankenköpfe
> Dutzendweis heruntersäbelt,
> Lächelt er wie ein Verliebter,
> Ja, er lächelt sanft and zärtlich.[12]

Loving and killing are the same thing to both rulers, to the extent that they are determined by an eroticism of domination, ownership, and power. The women in Ali Bey's realm, "Odalisks, as fair as houris," vigorously promote this vision of "paradise."

This, it seems, is initially done by Tino of Baghdad, who has been allured by the "scent of the black Naëmi rose" that floats towards her. The scent draws her to the caliph's side where "unveiled" (73), as it is emphasized, she takes the place of the "Jewess of his youth." An overlaying of images follows—shared smoking of opium and shared "dreams," a shared night, and incestuous union ("My uncle's big hand flutters in my lap," 73),[13] the spectacle of an execution, and gender masquerade: accompanying the caliph to the decapitations, Tino wears "boys' clothing" and "his dagger with the emerald-inlaid hilt" (73). Heine's model of female complicity with patriarchal power is here assimilated and made more poignant. It is also made more dynamic in that Lasker-Schüler sets two opposites into motion: believers versus non-believers (already present in Heine), and a static image of the feminine versus an individual woman (not present in Heine).

"Naëmi" thus has an ambivalent function: until the middle of the narrative she appears as an accomplice to power, annulling the foreign. She fulfills this function, however, as a static image, as a dreamy memory of the caliph in which women hold the same place that is given to Tino. Matters take a dramatic turn after the Jewish foreigner has been executed. The spurt of blood from the beheading becomes a source of inspiration for Tino of Baghdad: "I never heard a more eternal stream. It sings, like the priests of Jehovah on their feast days, like Moses's peak on Mount Sinai. / In the palace my uncle the caliph lies dead on his big hand" (73).

This shift from the caliph toward the foreigner is not a withdrawal from Naëmi. On the contrary, Naëmi remains a model for Tino of Baghdad, who becomes a poet. This gives "Naëmi" another meaning, or

rather, only now is the meaning of the "foreign," dormant in this character from the very beginning, set free. Because at the end, the Jewish foreigner, poetry, and Tino of Baghdad—alienated from her origins—come together under the auspices of Naëmi. Being "foreign" is now equal to being "Jewish" and therefore a "poet." In this sense even the Arab-Muslim princess can be "Jewish," i.e., she can compose poetry whose power stems from the remembrance of murdered ancestors. That is possible only as a revolt against the order of the paternal world—precisely this is at the heart of Lasker-Schüler's reinterpretation of the biblical story.

The biblical Naëmi or Naomi and her daughter-in-law Ruth exemplify the woman beholden to the legacy of the fathers in faith, trust, and love. Naomi acts in this spirit when she and Ruth return to Israel after Elimelech and her sons have died. On the one hand, she complies with the duties of the "redeemer," preventing the sale of the inherited property and redeeming Ruth's land (see Lev. 25.23-25, 47-49). On the other, she complies with the levirate that would have the deceased man's closest relative marry the widow so the deceased will have offspring and his name will not be lost for Israel (see Deut. 25.5-10). Naomi (and Ruth) thus stand for the woman who puts her life in the service of the patrilinear law, making sure "to raise up the name of the dead upon his inheritance" (Ruth 4.5). By complying with these laws, Naomi eventually becomes the (symbolic) progenitor of David.

Naomi's return to the land of the fathers, accompanied by the Moabite Ruth, means more, however. Elimelech's emigration has also been interpreted as an act of betrayal for which the Lord punishes him severely with the loss of his two sons (Kristeva 70). Ruth, by contrast, earns praise for letting go of her own people and joining the Jews. This shows that God's grace can apply to foreigners, too. Yet it also shows—at least it can be argued—that such religious universalism demands (conversion and) assimilation.[14]

This is at first exaggerated in Lasker-Schüler's "Ached Bey." The caliph's memory of Naëmi is bound up with the complete exclusion of alterity, annihilation of the "other," and the continuation of patriarchal rule. However, after the caliph's death there is no assimilation on the part of the foreigner forsaking alterity. Rather, there is talk about the development of alien qualities. There is no center at the story's ending, only the tension between spaces and characters. The first-person narrator and successor of Naëmi has features of both a Ruth figure and Princess Tino of Baghdad; and like Ruth she begins a relationship with a Jewish man. This relationship, however, is a merely symbolic one, an act of remembrance, and—unlike Ruth—Tino does not leave her people for it.

Analogously, the man who—unlike Boaz—is not in the midst of his own people is consequently called "foreigner" (*Fremdling*) until the end. Tino's behavior, too, belies the programmatic name Naëmi—she is not "pleasant" and "lovely." She does not fulfill the function that Naomi and Ruth did by looking for the "redeemer." The redeemer and the levirate play no role, and Tino of Baghdad does not become a genealogical progenitor of Jewish history. The peacefulness that characterizes the Book of Ruth is missing completely.

The "Jewish legacy" in Lasker-Schüler is not defined by names of the fathers but rather by betraying a father figure who has built his power on the murderous exclusion of others. This disempowerment corresponds to a kind of poetry that draws on the murdered "ancestors." Among those ancestors are the static image of Naëmi, the Jewish foreigner, even the caliph—not just because he is the only character in Tino's family line but also because his "lips" (74) were like those of a poet when he dreamed about Naëmi. He is thus associated with the world of poetry, even if he has denied and resisted it. A literary-historical perspective is fruitful here. The caliph dreams about the Jewess of his youth, and he later encounters a Jewish foreigner whom he orders to be beheaded after hesitating several times. This suggests that the Jewish "foreigner" is the unrecognized offspring of the caliph and Naëmi.[15] There is no conclusive proof for this speculation, yet the configuration bears a striking resemblance to the most famous German text about Christian-Jewish-Muslim coexistence: Lessing's *Nathan the Wise* (*Nathan der Weise*). There we find another oriental ruler, Saladin, who has captured a foreigner, the Templar, who has to face his execution. This bloodshed, however, is avoided in Lessing with the gradual recognition of kinship. Not so in Lasker-Schüler, where only the younger generation (and only the woman) realizes the familial bond after the foreigner's execution. A red thread in both texts is the question of what constitutes kinship beyond bloodlines and what prevents their acknowledgment. Lasker-Schüler's originary contribution is the daughter's necessary revolt against the violent order of the fathers.[16]

The conception of poetry sketched out in "Ached Bey" is also better understood by considering literary tradition. The first one to be identified as a Jew and a poet in the story is the foreigner, but then it is primarily Tino of Baghdad. "Pillars of fire" (74) rise out of her eyes, successors to the foreigner's "singing blood." These "pillars of fire" may recall the "letters of fire on the wall" of Heine's "Belshazzar" poem: it foretells to the ruler his impending death.[17] At this point in "Ached Bey" the caliph is already dead, but his death is connected to the singing, and together with the "pillars of fire" there appears a

"gloomy cloud over Baghdad" (74)—the city where the caliph had innocent people beheaded. Yet the cloud and the "pillars of fire" that are taken as an omen by the "people" of Baghdad and the "Jewish boys and girls" are above all a reference to the biblical pillar of clouds that changes into a pillar of fire at night, showing the people of Israel the way through the desert (Exod. 13. 21f.; 14. 19; Num. 14. 14). This pillar of fire continues to be mentioned later on as a visible sign of God's presence.[18]

Lasker-Schüler's context, however, is art, and the "pillars of fire" follow the singing of the poet (73). Lasker-Schüler is alluding to the biblical adaptation of the Orpheus legend, but in contrast to the Christian tradition the beheaded John/Orpheus character does not prefigure Christ as a revived Orpheus. It refers instead to the woman artist who will sing an anarchic song before Jehovah's temple, her "Moses's peak," in the next story ("Der Tempel Jehovah").

The "pillars of fire" thus recall Heine's famous poem "Jehuda ben Halevy" from the *Hebrew Melodies*. Heine's significant characterization of the Jewish model reads:

> Ja, er ward ein großer Dichter,
> Stern und Fackel seiner Zeit,
> Seines Volkes Licht and Leuchte,
> Eine wunderbare, große
>
> Feuersäule des Gesanges,
> Die der Schmerzenskarawane
> Israels vorangezogen
> In der Wüste des Exils (134).[19]

Heine's identification with Jehuda Halevy emphasizes the kinship of poetry and Jewishness, which is based on the split existence of each, i.e., both poet and Jew feel chosen (or marked), but this comes at the price of suffering. Such suffering is not just an effect but a feature of being a poet or being chosen. Heine presents the death of the poet as martyrdom and sacrifice, as crime and redemption. Jehuda ben Halevy is stabbed by an "impudent Saracen":

> Ruhig floß das Blut des Rabbi,
> Ruhig seinem Sang zu Ende
> Sang er, und sein sterbeletzter
> Seufzer war Jerusalem!—(148)[20]

An old legend, however, states that "the Saracen was really / Not an evil human being / But an angel in disguise" (669). The angel is ordered to bring "God's own favorite" without torment into the realm of the

blessed where upon his arrival Jehuda ben Halevy's own song ("synagogal nuptial song") is played so that it echoes: "L'khah dodi likras kallah" (670). It is the opening line of the Sabbath greeting: "Come, friend, meet the bride!"[21] The bride refers to Jerusalem as the lost and unreachable destiny signifying another reality.

Lasker-Schüler also works with the image of the loving couple, but the potential for reconciliation is even smaller here than it is in Heine. He ironizes it ("Prinzessin Sabbat") or relegates it to the legendary ("Jehuda ben Halevy"), leaving only the humiliating reality of Jewish life beyond doubt. "Der Amokläufer" closes with a monstrous union, "Ached Bey" with an "endless dance" (74).[22] The image of the passive bride is evoked in Schlôme, Naëmi, and Tino, only to be revoked.

A comparison with Heine's poems suggests that Lasker-Schüler offers a variation of the link he thematizes between Judaism and poetry, chosenness and suffering, retracting the comforting aspects of the *Hebrew Melodies*. A comparison with the biblical tale of Naomi and Ruth almost renders Lasker-Schüler's version a contrafactum, at least if one considers the traditional analysis of their story. She transforms the family story about a widow's redemption and the messianic history of Israel into a narrative that binds any renewal to rethinking the exclusion of the—cultural and sexual—other.

If Naomi remains a point of reference, it is because she has been re-evaluated as a figure who frees the dynamic of alterity instead of erasing it.[23] Lasker-Schüler is not alone in accentuating this dimension of the story of Naomi and Ruth.[24] Recently Julia Kristeva pointed out that the biblical account of the "insertion of foreignness at the root of Jewish royalty" (74) can be read in this fashion: "If David is *also* Ruth, if the sovereign is *also* a Moabite, peace of mind will then never be his lot but a constant quest for welcoming and going beyond the other in oneself" (77).

Conclusion and Contexts

In her stories, Lasker-Schüler works with representations of ethnicity, religion, and gender. She quotes familiar patterns, but subverts and decenters them through hybridizations. Her sophisticated citings of discourses integrate three literary strategies: overlapping intertextual references, the construction of a self-consciously imaginary Orient, and a narrative style with shifting or ambiguous points of view that deflect from authorial intentions and create the characteristic openness of meaning of her texts. The striking density of the intertextual references includes the Salome tradition, the work of Heine, and the biblical story of

Naomi and Ruth, as well as more exotic themes like the Indian Gupta dynasty or the stuff of popular thrillers like Jack the Ripper. Previous scholarship has sometimes been too quick to believe Lasker-Schüler's self-depiction as illiterate. It is safe to assume, on the other hand, that she also picked up many things that were "in the air," because they were the subject of debate among friends or something she encountered in art exhibits, theater and circus performances, vaudeville shows and movies. In this regard it would be necessary and useful to view my analysis and the wealth of allusions with an eye toward contemporary discussions and contexts.

I want to provide a tentative map for such a project by setting these considerations, theses, and hypotheses into the framework of ongoing and still-needed discussions about the historical place of Lasker-Schüler's early works. Here it is not my intent to treat these works as all alike, but rather to broaden our view and notice their many facets. My main hypothesis is that Lasker-Schüler's defamiliarizing quotations of the discourses of gender and ethnicity signify her concern with the concrete possibilities of identification for a German-Jewish woman at the beginning of the twentieth century, which she finds problematic because they depend on modes of exclusion. For Lasker-Schüler, the renewal of Jewishness depends on revising the kind of thinking that excludes the—cultural or sexual—other. This means that Lasker-Schüler's connection to existing religious, cultural, and poetic traditions (which are, of course, evident in her early work) can be evaluated appropriately only if one is aware of their refractions. Three contemporary contexts are of particular importance in this regard: Jewish self-understanding, the stereotype of the "beautiful Jewess," and the literary/artistic avant-garde.

Jewish Self-Understanding: "The Jew as Oriental"

The position of Lasker-Schüler's early work in the context of literary and cultural history has recently been determined primarily with regard to "cultural Zionism" and the debate about "the Jew as Oriental." At the heart of this debate by Martin Buber, Jakob Wassermann, and others was the attempt to find the essence of Jewishness, and a distinction was made between an "oriental" and an "occidental spirit." Juxtapositions, such as "motor" vs. "sensory," "spiritual" vs. "rationalistic," "idealistic" vs. "materialistic," etc., correspond to those terms. Lasker-Schüler participates in this discourse with her positive representations of "oriental" Jews. This vantage point privileges aspects of her work that define its alterity vis-à-vis discursive patterns of the Christian

majority. In this vein, Nina Berman has argued persuasively for understanding the books *Die Nächte Tino von Bagdads* and *Der Prinz von Theben* as "part of an affirmative minority discourse that helped to position the Jewish minority in Germany at the beginning of this century" (343): "In their self-confident proclamation of an 'oriental' alterity for Jews in Germany, these texts articulate a strategic position of otherness" (274). The question is where to draw the line between a strategic and an essentialist definition of otherness and how this differentiation is established. Mark H. Gelber has recently noted in this context that the themes and motives of Lasker-Schüler's early poems—perhaps unwittingly—betray a great affinity with "cultural Zionism" as it manifested itself in the journal *Ost und West* and in the circle around it. Gelber sees commonalities primarily in the three subjects that make up the title of his article: "Jewish, Erotic, Female." These concepts refer respectively to a rhetoric of "blood," the erotic charge of religious language, and the representation of "strong" women or suitable references to biblical texts. Because of those commonalities, Gelber argues, Lasker-Schüler could be appropriated by "cultural Zionism." Among the most fascinating qualities of stories like "Der Amokläufer" and "Ached Bey" is the fact that they resist such an appropriation by subverting the identifications and essentializations of such Jewish self-understanding.

The narratives that I have selected for analysis are by no means unique in this regard, and Lasker-Schüler uses the same strategy in non-fictional texts. An especially telling example would be her letter to Martin Buber from late 1913 / early 1914, in which she charges:

> A wolf came to you—a high priest with arrowed teeth...and—you spoke of literature—you read poems, and I do not like that. You are ashamed that George is a Jew—and are the Lord of Zion? I *hate* the Jews since I was David or Joseph—I hate the Jews because they disregard my language, because their ears are misshapen and they listen for dwarfishness and a Jewish accent. They eat too much, they should go hungry.[25]

This self-characterization as a wolf with "arrowed teeth" is reminscent of the figure of the *Amokläufer*, which here becomes an image of the author in enemy territory. The subsequent use of antisemitic clichés mirrors the same constellation. Judy Atterholt has shown that this passage, too, can be read as part of the debate about the "Oriental character of the Jews," the point being that Buber and Lasker-Schüler are in disagreement: she rejects the Zionist notion that all Jews share the "Oriental spirit" (see Atterholt 88–118).[26]

Buber seeks a source for Jewish renewal in the language and culture of the Hassidim, while Lasker-Schüler sees it in the spirit of art, the "Wildjude" (wild Jew)—as opposed to the unintellectual Jew who has internalized the values of rationalism and materialism. Stefan George, mistaken for a Jew by Lasker-Schüler, has *this* "Oriental spirit," whereas the non-artistic Jew Martin Buber does not. Buber clings to an essentialist distinction of Orient / Occident while Lasker-Schüler does not. A homogeneous Jewish character, as posited by cultural Zionism, is not reflected here: "Oriental spirit" can be found in the "Occident" as well. Lasker-Schüler thus positions herself confidently within a Jewish tradition.[27]

The "Beautiful Jewess"

Lasker-Schüler's erotic female, with her Jewish connotations and position in a foreign culture, refers to the "beautiful Jewess." For centuries this topos has been used by the gentile majority to express ambivalent attitudes toward both female sexuality and the potential for Jewish assimilation (see Krobb).

Lasker-Schüler's pointed father-daughter constellation invites a comparison with a most prominent "beautiful Jewess": Shylock's daughter Jessica, especially if we consider Heine's famous 1839 essay on her in his treatise "Shakespeare's Girls and Women." In a sense, Heine saved the father at the expense of his daughter. Jessica, who deserts her culture, is called a traitor who shares the blame for her father's lot. As a reason Heine names her carnal desire, which is not about her being Jewish but results from the fact that she is "only a daughter of Eve."[28] For her act of treason, Jessica even had to overcome the characteristic "chastity of the Jews" (275). Heine goes on to associate this "chastity" with a special Jewish knack for abstraction and a specific form of modernity that is characterized by cosmopolitanism, republicanism, and respect for the law.

Superficially, Martin Buber's version of the "beautiful Jewess," developed around 1900, has nothing in common with Heine's image. In his programmatic text "Das Zion der jüdischen Frau" (1901) Buber writes that the Jewish woman has to overcome her threefold "degeneration" in order to achieve the "Palestinian Zion" (29): "Degeneration of national character, degeneration of the house, degeneration of personality.[29] With an eye toward Jessica and Shylock, however, Buber, like Heine, sees a specific "guilt of the Jewess for the decline of her people" (34) whose root rests within the nature of woman: The "fanaticism of assimilation" is shared "most strongly by the women, who

snuggle up to the environment most easily and take on its ways. And when everyone follows the foreign, the inner expansion of Jewishness is paralyzed, one's own power is abolished, the family is destroyed, general solidarity is canceled, the autonomous culture is annihilated" (33). The "Zion" of the Jewish woman is thus based on the rejection of everything "other" and the identification with the "character of her tribe" (35). The return to the "Jewish home" (34) and the ideals of female modesty, motherliness, and love associated with it shall replace the "dull, jittery sloth" (33).

Lasker-Schüler refutes the binaries and essentialism of this Zionism as well as Heine's association of progressiveness, lawfulness, and female chastity. She chooses another tradition over this patriarchal one (exemplified in "Ached Bey" in the reference to Naomi/Naëmi): repudiation in the name of the other, admission of difference and alterity, the hybrid, and respect for the irreconcilable.

Avant-garde

A level of poetic or artistic self-reflection is common to both stories. The "endless dance" that closes "Ached Bey" and the Salome reference in "Der Amokläufer" express the contemporary inclination to regard Salome's dance as a poetic paradigm. To quote Silvia Volckmann's pointed interpretation: "Salome's dance asserts the domination of the body over the mind, thus rendering solid borders more fluent" (137).

This continues in the image of the artist as rapist and murderer, another commonplace in the avant-garde of the time, especially in the fine arts, albeit with very different implications (see Hoffmann-Curtius, et al.). Lasker-Schüler's primary influence may have been Kokoschka. His play *Mörder Hoffnung der Frauen* (Murderer, Hope of Women), first published in 1907, appeared in *Der Sturm* in 1910, the same year in which it also published "Der Amokläufer." But whereas Kokoschka stages a war of the sexes à la Weininger (see Jäger), Lasker-Schüler rewrites him, deconstructs his themes and their underlying oppositions. The way she takes apart images of ethnicity and gender recalls the montages of Hannah Höch's series *Aus einem ethnographischen Museum* (From a Museum of Ethnography, 1925–1929). More than offering points of identification, Lasker-Schüler (re)creates tropes of displacement, of endless motion. With regard to "femininity" and "Judaism" she seeks to escape the unsatisfactory alternatives of assimilation or insistence on one's own (femininity/Judaism) in order to reject possibilities of identification that are based on exclusion.

Translated by Joachim Ghislain

Notes

Unless otherwise indicated, all quotations from German sources have been rendered by the translator.

[1] The story "Der Amokläufer" was written in 1909 and appeared first on 10 March 1910 in *Der Sturm*; it was included later under the new title "Tschandragupta" in *Der Prinz von Theben*. "Ached Bey" is part of *Die Nächte Tino von Bagdads* (1907). My quotations refer to the edition *Werke und Briefe*, vol. 3.1, excellently annotated by Ricarda Dick.

[2] This may include a previously unknown text. In an undated letter to Jethro Bithell, Lasker-Schüler writes that her "Amokläufer" tells "neu, ganz neu eine uralte Geschichte vom Amokläufer dessen Mutter die entflohene Tochter des Melechs von Palästine war. Ich glaube es wenigstens" (Lasker-Schüler *Werke und Briefe* 3.2: 129). Ricarda Dick has warned me, however, that this might well be an invented reference by Lasker-Schüler.

[3] I am grateful to my Trier colleague Erika Timm, Professor of Yiddish Studies, for her linguistic expertise. To my knowledge, only Ricarda Dick has noted the reference to the name Salome (see Lasker-Schüler, *Werke und Briefe* 3.2: 111, 130).

[4] For Heine's importance for Lasker-Schüler, see Bauschinger (68) and Shedletzky.

[5] "Tschandragupta was an Indian king who ruled from 322 until 298 BC, founded the Maurja dynasty, and conquered large parts of northern India" (Dick, Lasker-Schüler, *Werke und Briefe* 3.2: 129). Keeping in mind the genealogical relations in the story, however, one might instead consider the later Gupta dynasty (320–540 AD) built on the former kingdom of Magadha where this Chandragupta ruled more than 600 years before. The Gupta rule began with Chandragupta I (320–ca. 330) and was continued and expanded considerably by his son and heir Samudragupta (ca. 330–375). Under his son Chandragupta II (ca. 375–413) the empire reached its prime: mathematics, the arts, music, and dance, as well as Hinduism and Sanskrit literature flowered, thus turning the age into India's classical period. Among the poets who lived and worked at the Gupta court was Kalidasa, whose major works were published in German around 1900. Some translations were new, others were reprinted, such as the drama *Sakuntala*, translated from the English by Georg Forster and highly appreciated in Germany after Goethe had praised it.

[6] This, combined with the phrase "Schlôme of Jericho," refers to another source: the story of the prostitute Rahab (see Josh. 2 and 5–6).

[7] The "tempelalte[r] Knecht" is the high priest. Given the use of the noun "Wandel" in Lasker-Schüler's poems, it is most likely to be

understood as "change" rather than "walk" (see Lasker-Schüler, *Werke und Briefe* 1.2: 597).

[8] Lasker-Schüler, "Lieber gestreifter Tiger" I: 48 (to Jethro Bithell, 25 December 1909). On 12 August 1910 she writes: "In my grimmest hours *I am* the fakir of Thebes (Jacques the Ripper). Shudder!" (73).

[9] See Schuller (41–55) and the detailed interpretation in Liska (95–100).

[10] The rendition "Naëmi" is from Luther's Bible translation; "Naomi" (German: "Noomi") is more common today. I retain Lasker-Schüler's "Naëmi," when I refer to the character in the story.

[11] See Heine (374 f.). The reference to Heine has been noted by Ricarda Dick in her commentary (see Lasker-Schüler *Werke und Briefe* 3.2: 93).

[12] "While his saber smites and severs / Frankish heads and helms by dozens, / Still he's smiling like a lover— / Ah, his smile is soft and tender" (Heine 375).

[13] For the aspects of incest, see Liska (97).

[14] Boaz replied, "I've been told all about what you have done for your mothers-in-law since the death of your husband—how you left your father and mother and your homeland and came to live with a people you did not know before. May the Lord repay you for what you have done. May you be richly rewarded by the Lord, the God of Israel, under whose wings you have come to take refuge" (Ruth 2.11-12). This complex is glossed over by Liska who was the first to point out the aspect of "alienness" in Naëmi/Naomi but read it simply as a "Zeichen der Versöhnung zwischen den Völkern und als Warnung gegen Vorurteile Fremden gegenüber" (96).

[15] Reiß-Suckow (225) surmises the same, although without consequences for her interpretation.

[16] Lessing's Enlightenment models remain within the frame of "reasonable fatherhood." The daughter figure Tino differs considerably from both Recha (the product of a successful education by her father) and her "sister" Sittah (the morally problematic Muslim who cannot be integrated into the "one" family). The significance of Lessing's *Nathan the Wise* in an intercultural perspective is primarily centered around the Templar's character and disposition (see Klüger).

[17] See Hallensleben (53). I was not able to look at Hallensleben's book before finishing this article. He, too, refers to the "Salomeic dance" at the story's end (52).

[18] See Exod. 33.9; 40.34-38; Num. 12.5; Num. 31.15; later mentionings in Neh. 9.12,19; Ps. 78.14; 99.7; 105.39; 1 Cor 10.1.

[19] "Yes, he was a mighty poet, / Star and beacon for his age, / Light and lamp among his people, / And a wonderful and mighty // Pillar of

poetic fire / In the vanguard of all Israel's / Caravan of woe and sorrow / In the desert waste of exile" (Draper 659).

[20] "Tranquil flowed the rabbi's lifeblood, / Tranquilly he sang his song out / To the end, and his last dying / Sigh breathed out: Jerusalem!—" (Draper 669).

[21] See Heine's "Princess Sabbath," the first poem of the *Hebrew Melodies,* which directly precedes "Jehuda ben Halevy." Heine's mistake is well-known: the song is not by Jehuda ben Samuel Halevi, as he was in fact called, but by Salomo Halevy Alkabez. For an interpretation, see Mach.

[22] This polarity remains, even if one considers the short narrative "Der Tempel Jehovas" as a kind of continuation of "Ached Bey," since it follows the latter directly (see Liska 100–02).

[23] The wordplay on the Latin name of the wood anemone—*anemone nemorosa*—and the biblical Naëmi may point to this development of alterity, as Liska has suggested: "The wood anemone is a seemingly harmless early spring flower; it contains, however, a deadly poison" (96). This moment of alterity plays a significant part in Lasker-Schüler's "Ruth" poems as well.

[24] One is reminded of Yvan Goll's great poem "Noemi," which appeared first in *Die Aktion* on 9 October 1916, and was subsequently published in different versions in other places, among them in *Menschheitsdämmerung* (1919). The analogies to Lasker-Schüler's "Ached Bey" are surprising. Hartberger summarizes her studies on Goll's poem with the conclusion that his Noemi appears as "the ultimate Jewess, the female critic of a failed androcracy" (95). It is precisely her alterity that opens the possibility to install Noemi "as a thematic figure of the whole history of the Jewish people and make her a critical juror who knows the beginning and applies it as a yardstick to everything that happens" (267). Nonetheless, the difference from Lasker-Schüler's conception of Naëmi (not considered by Hartberger) is a fundamental one: for Goll, Noemi embodies a pure origin providing a measure and guarantee for a new beginning, and her frame of reference is the "Spirit of Israel" that she invokes.

[25] "Ein Wolf war bei Ihnen—ein Oberpriester mit gepfeilten Zähnen...und—Sie sprachen von Literatur—Sie lasen Gedichte und ich mag das nicht. Sie schämen sich, daß George Jude ist—und sind der Herr von Zion? Ich *hasse* die Juden, da ich David war oder Joseph—ich hasse die Juden, weil sie meine Sprache mißachten, weil ihre Ohren verwachsen sind und sie nach Zwergerei horchen und Gemauschel. Sie fressen zu viel, sie sollten hungern" (Lasker-Schüler, "Lieber gestreifter Tiger" 1: 117).

[26] Lasker-Schüler probably did believe that Stefan George, whom she admired, was Jewish; this assumption was quite common at the time, but Buber knew it was mistaken. Atterholt is mistaken when she asserts that a gentile is knowingly granted "artistic Jewishness."

[27] I am aware that this does not answer all the questions that spring to mind when interpreting this letter, let alone all the questions that concern Lasker-Schüler's position in the contemporary discourse about Jewish identity. Atterholt pursues especially the devalorization of the Eastern Jews and the Yiddish language. She argues that Buber considered the language and culture of the Eastern Jews as more authentically Jewish than the German language and the attitudes and values transported by it. That must have provoked a German-speaking artist who created her own "creolic" mix, juxtaposing it in the quoted letter to the unaesthetic "Jewish" accent (111–18). Atterholt combines this with the thesis that Lasker-Schüler perpetuates the opposition of Sephardic and Ashkenazic Jews; the Spanish Jews are romanticized à la Heine, the Eastern Jews are devalorized (110). Her argument deserves consideration. I would contend, however, that Lasker-Schüler raises a question in "Der Wunderrabbiner von Barcelona" (1921) that is glossed over in its forerunner, Heine's "Der Rabbi von Bacherach": the question of guilt on the part of the rabbi and the young couple. See Shedletzky for this aspect of Lasker-Schüler's story.

[28] "Nur eine Tochter Evas" (Heine, *Shakespeares Mädchen und Frauen* 7: 171–293, here 257). For Heine's understanding of Jessica, see Jacobi (167 f.).

[29] "Entartung des Volkstums, Entartung des Hauses, Entartung der Persönlichkeit" (31).

Works Cited

Atterholt, Judy. *Gender, Ethnicity and the Crisis of Representation in Else Lasker-Schüler's Early Poetry and Prose.* Diss Stanford U., 1993.

Bauschinger, Sigrid. *Else Lasker-Schüler: Ihr Werk und ihre Zeit.* Heidelberg: Lothar Stiehm, 1980.

Berman, Nina. *Orientalismus, Kolonialismus und Moderne: Zum Bild des Orients in der deutschsprachigen Kultur um 1900.* Stuttgart: M & P, 1996.

Buber, Martin. "Das Zion der jüdischen Frau: Aus einer Ansprache." *Die jüdische Bewegung: Gesammelte Aufsätze und Ansprachen 1900–1915.* Berlin: Jüdischer Verlag, 1916. 28–38.

Draper, Hal. *The Complete Poems of Heinrich Heine: A Modern English Version.* Frankfurt a.M.: Suhrkamp/Insel, 1982.

Frayling, Christopher. "The House that Jack Built: Some Stereotypes of the Rapist in the History of Popular Culture." *Rape: A Historical and Social Enquiry.* Ed. Sylvana Tomaselli and Roy Porter. Oxford: Basil Blackwell, 1986. 175–215.

Gelber, Mark H. "Jewish, Erotic, Female: Else Lasker-Schüler in the Context of Cultural Zionism." *Else Lasker-Schüler: Ansichten und Perspektiven / Views and Reviews*. Ed. Ernst Schürer and Sonja Hedgepeth. Tübingen: Francke, 1999. 27–43.

Gilman, Sander L. *Sexuality: An Illustrated History: Representing the Sexual in Medicine and Culture from the Middle Ages to the Age of AIDS*. New York: John Wiley, 1989.

Goll, Yvan. "Noemi." *Menschheitsdämmerung: Ein Dokument des Expressionismus*. Ed. Kurt Pinthus. Reinbek: Rowohlt, 1974. 270–73.

Hallensleben, Markus. *Else Lasker-Schüler: Avantgardismus und Kunstinszenierung*. Tübingen: Francke, 2000.

Hartberger, Birgit. *Das biblische Ruth-Motiv in deutschen lyrischen Gedichten des 20. Jahrhunderts*. Altenberge: Oros, 1992.

Hedgepeth, Sonja. *"Überall blicke ich nach einem heimatlichen Boden aus": Exil im Werk Else Lasker-Schülers*. New York: Peter Lang, 1994.

Heine, Heinrich. *Sämtliche Schriften in 12 Bänden*. Ed. Klaus Briegleb. Frankfurt a.M.: Ullstein, 1981.

Heizer, Donna K. *Jewish-German Identity in the Orientalist Literature of Else Lasker-Schüler, Friedrich Wolf, and Franz Werfel*. Columbia, SC: Camden House, 1996.

Hoffmann-Curtius, Kathrin, Annelie Lütgens, and Uwe M. Schneede. *George Grosz: John, der Frauenmörder*. Hamburg: Hatje, 1993.

Jacobi, Ruth L. *Heinrich Heines jüdisches Erbe*. Bonn: Bouvier, 1978.

Jäger, Georg. "Kokoschkas *Mörder Hoffnung der Frauen*: Die Geburt des Theaters der Grausamkeit aus dem Geist der Wiener Jahrhundertwende." *Germanisch-Romanische Monatsschrift* N.F. 32.2 (1982): 215–33.

Klüger, Ruth. "Kreuzzug and Kinderträume in Lessings *Nathan der Weise*." *Katastrophen: Über deutsche Literatur*. Göttingen: Wallstein, 1994. 189–227.

Kokoschka, Oscar. *Mörder Hoffnung der Frauen*. Berlin: Verlag der Sturm, 1902.

Kristeva, Julia. *Strangers to Ourselves*. New York: Columbia UP, 1991.

Krobb, Florian. *Die schöne Jüdin: Jüdische Frauengestalten in der deutschsprachigen Erzählliteratur vom 17. Jahrhundert bis zum Ersten Weltkrieg*. Tübingen: Niemeyer, 1993.

Lasker-Schüler, Else. "Der Antisemitismus." *Verse und Prosa aus dem Nachlaß*. München: Deutscher Taschenbuch Verlag, 1986. 68–72.

——— . *Lieber gestreifter Tiger: Briefe von Else Lasker-Schüler*. Ed. Margarete Kupper. 2 vol. München: Kösel, 1969.

——— . *Werke and Briefe: Kritische Ausgabe*. Bd. 1.2: Gedichte. Anmerkungen. Bearbeitet von Karl Jürgen Skrodzki unter Mitarbeit von

Norbert Oellers. Frankfurt a.M.: Jüdischer Verlag im Suhrkamp Verlag, 1996. Bd. 3.1/2. Bearbeitet von Ricarda Dick. Frankfurt a.M.; Jüdischer Verlag im Suhrkamp Verlag, 1998 (Bd. 3.1: Prosa 1903-1920; Bd. 3.2: Prosa 1903-1920. Anmerkungen).

Liska, Vivian. *Die Dichterin and das schelmische Erhabene: Else Lasker-Schülers* Die Nächte Tino von Bagdads. Tübingen: Francke, 1998.

Mach, Dafna. "Heines *Prinzessin Sabbat*—hebräisch verkleidet." *Heine-Jahrbuch* 22 (1983): 96-120.

O'Brien, Mary-Elizabeth. "'Ich war verkleidet als Poet...ich bin Poetin!!'—The Masquerade of Gender in Else Lasker-Schüler's Work." *German Quarterly* 65.1 (1992): 1-17.

Redmann, Jennifer. *Imagining Selves: Gender and Identity in the Work of Else Lasker-Schüler*. Diss. U. of Wisconsin, 1996.

Reiß-Suckow, Christine. *"Wer wird mir Schöpfer sein!!" Die Entwicklung Else Lasker-Schülers als Künstlerin*. Konstanz: Hartung-Gorre, 1997.

Schuller, Marianne. "Maskeraden: Schrift, Bild und die Frage des Geschlechts in der frühen Prosa Else Lasker-Schülers." *Zwischen Schrift und Bild: Entwürfe des Weiblichen in literarischer Verfahrensweise*. Ed. Christine Krause, et al. Heidelberg: Mattes, 1994. 41-55.

Shedletzky, Itta. "Bacherach and Barcelona: On Else Lasker-Schüler's Relation to Heinrich Heine." *The Jewish Reception of Heinrich Heine*. Ed. Mark H. Gelber. Tübingen: Niemeyer 1992. 114-26.

Volckmann, Silvia. "Die Frau mit den zwei Köpfen: Der Mythos Salomé." *Don Juan und Femme fatale*. Ed. Helmut Kreuzer. München: Fink, 1994. 127-42.

Wolf, Ruth. "Versuch über Heines *Jehuda ben Halevy*." *Heine-Jahrbuch* 18 (1979): 84-98.

Arthur Schnitzler's *Fräulein Else* and the End of the Bourgeois Tragedy

Bettina Matthias

Schnitzler's novella *Fräulein Else* can be read as the last representative and "death-sentence" of the bourgeois tragedy. A comparison with Lessing's *Emilia Galotti* informs my reading of the later story and shows how new socio-economical realities have a major impact on the way the beautiful female body is treated in late bourgeois society. By ultimately taking possession of her body, the daughter wins her lonely fight against an objectifying male society that mandates a new literary form, the interior monologue. Additionally, striking similarities between Schnitzler's and Lessing's texts suggest that *Fräulein Else* is a conscious commentary on *Emilia Galotti*. (BM)

The noble daughter sells herself for the sake of her beloved father and ends up by finding great joy in it.—Arthur Schnitzler[1]

This is one of the possible scenarios that the heroine Else T. of Arthur Schnitzler's 1924 novella *Fräulein Else* tests in her head in response to her parents' plea to help remedy a disastrous financial situation that they are facing. As inconspicuous as this line seems in the context of Else's many approaches to her situation, it contains the core features of the dilemma with which this woman sees herself faced, exactly those features that have been at the center of many scholarly discussions about this novella and its main character. As the quotation suggests, *Fräulein Else* is Schnitzler's variation on the themes of female sexuality, the place of the daughter in the early twentieth-century family, and the impact of modern socio-economic realities, especially capitalism, on the private sphere and the family. These traits have led a few critics to view *Fräulein Else* in the context of the tradition of the bourgeois tragedy.[2] However, among all the critics who have detected a proximity between Schnitzler's novella and the bourgeois tragedy, William H. Rey is, to

my knowledge, the only one to claim a direct connection between the two. After a thorough examination of the father figure in *Fräulein Else,* he concludes that this novella is, in fact, "a late-bourgeois tragedy in prose" (63). However, Rey does not follow up on this important thought, as his "diagnosis" serves more as a justification for his positive assessment of Else's father than as an observation that warrants further investigation. It thus remains to examine to what extent Rey's assessment is correct or justified and what this would mean for our understanding of *Fräulein Else* as a socio-historical document from the first half of the twentieth century as well as a literary response to a century-old tradition and its cultural and social ramifications.

Before we can undertake any comparative reading, it is of course necessary to define the (sub-)genre of the bourgeois tragedy. As it is not the purpose here to discuss the bourgeois tragedy as a dramatic genre, that is, in poetological terms (which would require engaging in a discussion of eighteenth-century poetics), I will limit my definition to those aspects that will be pertinent for reading *Fräulein Else* as "a bourgeois tragedy in prose": the main character-constellation (father—daughter—"seducer"), the distribution of power within this constellation, and the ideological institution of the bourgeois family as the main "stage" on which the tragedy is acted out. In these three categories, the female body, i.e., the body of the daughter, emerges as the main site of attention over which individuals, the family as a group, and society negotiate their relationships. An inquiry into the status of this female body as subject to the domineering male gaze and the woman's self-positioning within this power structure will help to show how the bourgeois tragedy has developed and possibly come to an end by 1924, the year when *Fräulein Else* was published.

As Rey's statement suggests, the genre shifts in *Fräulein Else* are major since it is not just the dramatic conflict that changes, but the form in which it is presented as well. A discussion of *Fräulein Else* as the endpoint of the tradition of the bourgeois tragedy must thus also take into account the radical change in literary presentation from drama to prose. It is my contention that this shift is also a direct result of the changed social as well as cultural (and possibly literary) circumstances that already modified the dramatic conflict. This is even more interesting if one considers that only twenty-five years earlier, Schnitzler had published his play *Flirtations* (*Liebelei*), which Axel Fritz can still convincingly categorize as a late representative of the traditional bourgeois tragedy (305 ff.). It must thus be asked why Schnitzler refrained from writing *Fräulein Else* as a drama. The author himself answered this question in a letter to Stefan Zweig when he pointed out how well the

subject of *Fräulein Else* was suited for the form of the interior monologue, thus claiming that the material itself suggested the form that he gave it.[3] However, this is only part of the answer, and I will try to provide a more complex one in the course of this paper. Schnitzler decided to write a literary text that features certain key aspects of the traditional bourgeois tragedy and thus set us up for a specific literary experience. Yet he then disappoints these expectations by only partly fulfilling them, and I suggest that we have to read this "deception" as a conscious move that makes a more general statement about the possible dramatic qualities of bourgeois conflicts in Schnitzler's time.

In order to understand *Fräulein Else* as a late bourgeois tragedy, it will be helpful to read it in comparison with one of the established representatives of this genre in German literature such as Lessing's *Emilia Galotti,* arguably the best-known and first important bourgeois tragedy in German literature.[4] However, it is not just this pragmatic aspect that suggests *Emilia Galotti* for comparison. If one reads both texts carefully, striking similarities in the general dramatic set-up, dramatis personae, and even wording become visible that strongly suggest that Schnitzler's *Fräulein Else* is a direct response to or reworking of Lessing's older model, a finding that has been overlooked so far. Especially when we compare these similarities in the two texts, it will become possible to determine Schnitzler's take on the literary tradition that he challenges as well as the social realities that inform his later tale. My discussion will thus be divided into three parts: first, it will be necessary to provide a (working) definition of the bourgeois tragedy in order to point out those aspects that need to be examined in a comparative reading of Lessing's and Schnitzler's texts. This comparative reading will then lead to a discussion of *Fräulein Else* as the last representative of this sub-genre, which ultimately suggests the impossibility or death of the bourgeois tragedy in postwar literature.

The bourgeois tragedy emerged in the mid- to late eighteenth century in England, France, and Germany and grew out of the sub-genre of the domestic drama. After centuries in which tragedy was intrinsically bound to the idea of a state-drama with dramatic characters that belonged to the (high) aristocracy, the eighteenth century prepared for a change in dramatic focus. This shift has been associated with important developments in society that capitalism and early industrialization brought about, more specifically the empowerment of the bourgeoisie during that period. As poetological discussions of the time—such as the letters between Moses Mendelssohn and Gotthold E. Lessing or the latter's *Hamburg Dramaturgy*—show, authors and literary critics were not immediately ready to grant non-aristocratic classes representation on

the tragic stage. Dramatists struggled to reconcile Aristoteles' "laws" for the tragedy with the lower status of potential dramatic characters. Yet Denis Diderot, George Lillo, and Gotthold Ephraim Lessing overcame their own and their contemporaries' objections to portraying "lower-class" people and wrote plays whose power to move, to purify, and to scare—in short: to trigger catharsis—convinced the audiences.[5] The new tragic hero faces a situation in which her (it is mainly women who perish in these situations) loyalty and emotional bond to her family, especially to her father, are challenged by a potentially sexual attraction to a man who belongs to a socially superior group and who is thus taboo, both socially and morally. The conflict between love and duty, class and human emotions, family and outer world puts the heroine in a dilemma that always ends fatally: Sara Sampson dies in the end, Emilia Galotti commits assisted suicide, and Luise Miller (Schiller's *Love and Intrigue [Kabale und Liebe]*) is killed by her lover who, devoured by jealousy, misreads Luise's selfless renunciation of their love as betrayal.[6] In all of these plays, the young unmarried daughter faces a situation in which her virginal body becomes the site or fetish over which the men in her life fight for power. Recent feminist criticism has recognized the almost ironic self-destructive tendencies of the male-dominated bourgeoisie that would prefer to enslave or destroy the female body before handing it over to "the enemy."[7] In short, the two most important characteristics of the bourgeois tragedy are, in the words of Axel Fritz, "the threat to and preservation of female virtue" (threatened by the socially more privileged seducer-figure) and emphasis on the bourgeois duty to "recognize and preserve the class-difference as natural and God-given."[8]

In both instances, the female protagonist has little or no say in the way her fate is decided. Brainwashed by religious and patriarchal orders, Emilia Galotti voluntarily identifies with her father's grim prophecies regarding her life in court society when she blames herself for being seducible ("Seduction is the only real might"), for having "blood as youthful and warm as anyone's" (V.vii),[9] and she begs him to save her from the sexual corruption of this precious body when she pleads: "Give it to me, father, give me this dagger!" (V.vii).[10] Throughout the tragedy, Emilia is depicted as a flawless and bloodless ideal of beauty[11] whose existence is defined by aesthetic criteria, and whose beauty is posited as the signifier for her moral integrity and conformity to her father's ideals of virtue and autonomy. Given this lifeless status, it almost comes as an ironic surprise when the tragedy ends with the bloody and shocking killing of this woman.

It is only as an aestheticized untouchable body that Emilia is allowed to exist in society,[12] and "owning" this perfect daughter is the biggest advantage her father has vis-à-vis the outer world, particularly the Prince of Guastalla, who shall desire her in vain. However, Emilia's beautiful body also poses a threat to Odoardo's (social) autonomy as this outer world does not operate according to his moral imperatives and responds to her in erotic instead of aesthetic terms.[13] This response, in turn, arouses emotions in Emilia that corrupt the learned image that she has of herself. To give in to temptation would result in the devaluation of the symbolically important virginal body and consequently undermine the self-definition of Odoardo and, by proxy, his class, as autonomous and morally superior to the upper class.[14] To withdraw the dangerously beautiful Emilia from exposure to potential seduction is then the logical response to this insight. Father figure and seducer, family and public, (i.e., courtly) life, power and morals are clearly positioned antagonistically, and in an open battle for the ownership of the beautiful female body these antagonists clash to negotiate their place in society. The male gaze, insofar as it conveys and triggers erotic desire, is portrayed as contrary to moral integrity and threatens the "market value" of the virtuous daughter;[15] Painter Conti's and Count Appiani's appreciation of Emilia as an object of beauty serves to highlight the Prince's abject sexual interest in her, which is one of physical domination and—temporarily desired—ownership instead of eternal aesthetic and "wholistic" admiration: "Ah, beautiful work of art, is it true that I possess you? You would be a most beautiful masterpiece of nature no matter who owned you! What do you want for her, honest mother! What do you want, old grouch! Just ask, just ask! Most of all, I would rather buy you from yourself, you sorceress!" (I.v), exclaims the Prince when Conti presents him with the portrait that he made of Emilia Galotti. Yet the time is not ripe for such a businesslike deal between parents or possibly the "sorceress"[16] herself and the man who desires her. It will take another one hundred and fifty years for this arrangement to become possible. *Fräulein Else* will finally respond to this idea.

As in *Emilia Galotti,* the main conflict in *Fräulein Else* breaks out when the integrity of the young (virginal) female body is threatened by a male seducer-figure who seems to be socially superior to the young woman. To save her father from an impending imprisonment for embezzling 30,000 guilders from a trust fund, the nineteen-year-old Else T. is requested by her parents to approach a certain "Herr[n] von Dorsday," an old family acquaintance who happens to be vacationing at the same resort as Else, and ask him to lend her family this sum. After painful self-deliberations, Else decides to talk to Dorsday, who agrees to

provide the loan under the condition that Else grant him a fifteen-minute exclusive look at her naked body. As justification, Dorsday argues:

> You look at me as though I were crazy, Else. Perhaps I am slightly so. For there's magic in you, Else, that you yourself can't realize. You must understand, Else, that my request implies no insult. Yes—request, I say. Though to you it may seem dangerously like coercion. But I'm no coercionist. I'm only a man who has had many experiences—among others, this: that everything in the world has its price, and that anyone who gives away his money when he might receive a return for it is a consummate fool. And—parting with what I wish to buy at this time, Else, much as it is, will not make you poorer (154).

Faced with this offer or suggestion, Else subsequently struggles to find a viable way out of the situation. Strictly economically speaking, Dorsday's proposal makes complete sense. Giving away money for nothing is stupid, and Else would not lose any resources if she were to grant Dorsday that exclusive strip since his gaze would not leave any permanent visible marks on her body that would lower her future market value. Yet as much as society as a whole has been subjected to the new economic realities on which Dorsday's offer is based, they do not readily apply to the young daughter whose situation in and dependency on the father-dominated family has not substantially changed since 1770. Else is lacking any new and strong behavioral model with which to respond to Dorsday's obscene request. She is still first and foremost the daughter, her body is still caught in the male gaze that assigns value, she still finds herself in a situation where giving in to this kind of "seduction" would ruin her social situation and prospects for the future.

Yet the conflict has substantially changed: whereas Emilia and her beautiful body become the symbol of power over which the father (as the representative of bourgeois morals) and the seducer (as the representative of the corrupted upper class) fight, father- and seducer-figure in *Fräulein Else* have basically joined the same ideological camp. For both, Else has become a beautiful object with a high erotic market value; the father now tries to sell his daughter to the highest bidding competitor (or rather: tries to trade his daughter off for the loan he needs), and the seducer can openly bid for the possession of the desired body: its sight in the first instance, its physical possession in the long run.[17] If Else tries to protect herself from this kind of objectification and subjection to immorality in the traditional sense, she has to fight this battle alone. Neither her father nor her mother provides her with the ideologically motivated protection that Odoardo guarantees his daughter. From the

wording of the letter that Else's mother sends, it is obvious that both parents know very well the danger to which they expose their daughter: "So I wondered whether you could not do us a favor and speak to Dorsday.... He always liked you particularly.... Father was doubtful at first" (131–33). By first admitting their reservations and then dismissing them, Else's parents demonstrate that they have redefined the "rules of engagement" in this bourgeois family.[18] They exploit the traditionally vulnerable position of the loving daughter in order to capitalize on her beautiful body, thus realizing its erotic potential, which fathers like Odoardo Galotti still tried to keep under lock and key. Since all of these manipulations and transactions happen behind closed doors, the social reputation of the virginal daughter remains untouched, a major factor in her marketability as the potential wife of an "honorable" man, and the parents themselves can continue to claim their innocence.[19]

Under these rules, the Prince of Guastalla's wish to "buy the sorceress" from either her father or herself becomes a real possibility, and Dorsday's suggestion is nothing but the official offer, a rephrasing of the prince's thoughts in the context of a sober business deal. Both men are "enchanted" by the beautiful woman before their eyes—and the choice of words in Schnitzler's story leaves no doubt about the connection with Lessing's play.[20] The aristocratic ruler and patron of the arts at Lessing's time has turned into the capitalist par excellence who earns his money by trading in old paintings (thus not really working anymore, simply cashing in the accumulated value of some other man's labor). In addition, this capitalist seems to have bought himself an aristocratic name—"Vicomte d'Éperies"—which reinforces my assumption that Schnitzler openly plays with or alludes to the tradition of the bourgeois tragedy and its character conventions in this text.[21] Power no longer emanates from a public position or a title but merely from money. The socio-political critique that Lessing's play offers has turned into Schnitzler's sober assessment of an alienated society in which power has become almost arbitrary and corruption therefore omnipresent, yet anonymous. It is no accident that Schnitzler wants Else's father to be a lawyer, someone who negotiates conflicts for other people, and that this lawyer commits a crime by speculating with money from a trust.

All of these subtle details paint a picture of a society that has lost its immediacy and grown used to a degree of alienation that allows the individual to pursue his or her egotistical, often sexual goals in the sheltered realm of agreed-upon conventions. Else's cousin Paul can pursue his affair with the married Cissy von Mohr behind the comfortable shield of social conversation, Dorsday can approach Else with his chauvinist request under the pretext of a pleasant pre-dinner chat; and

had he been luckier with his speculations, Else's father would be a respectable and successful businessman whose cleverness would possibly be silently applauded. When Else, in the first sentences of the novella, decides to withdraw from the symbolic fashionable tennis game with her cousin Paul, she shows herself unwilling or unable to continue participating in the game of social interaction. Consequently, she makes herself vulnerable to this society's attacks on her integrity, such as the one that Dorsday presents.

The fact that Dorsday's offer triggers a major crisis in Else thus points to more than simply this young woman's shock at being treated like a slave or a prostitute.[22] What becomes clear at this point is that there is a major difference in values between the daughter and other, especially male, characters in this tale. This difference can be described as a paradigm shift from a middle-class society that is governed by moral and subject-centered concerns to a new society in which nothing but economic, that is capitalist interests (accumulation of wealth and pleasure) determine social interactions. This shift leaves the young unmarried woman in complete limbo as it does not offer a new or active role for her, at least not as long as she is still the naïve, loving daughter as defined by a century-old tradition. The tragic conflict has changed in nature—the tension between morals and drives is no longer there, father and seducer have become almost identical. The real conflict is for Else to reconcile her desire to obey and help her parents (inherited role of the daughter) and her refusal to let herself be subjected to the soulless laws of a business deal by both Dorsday and her parents.

For it is not the idea of exposing herself naked to a man that leads to Else's crisis. In her many daydreams and fantasies about herself as a "femme fatale," she repeatedly imagines herself "lying naked on marble steps," exposed to the gaze of young desiring men that she controls.[23] Conscious of her beauty, Else enjoys the idea of being seen and desired in a way that would have been improper for Emilia Galotti. Yet her rather "modern" enjoyment of her own body is conflicted. For one, the narcissistic pleasure of excluding the other from her body while inviting his gaze shows how much Else has internalized the traditional taboo of premarital physical contact for women. Instead, when she admires herself in the mirror, she seeks to reunify her inner self with her social, outer appearance, to overcome the split between subject and object:

> Am I really as beautiful as I look in that mirror? Oh, won't you come closer, pretty Fräulein? I want to kiss your blood-red lips. [I want to press your breasts against mine.[24]] What a pity that the

mirror comes between us. The cold mirror. How well we'd get on together. Isn't that so? We need nobody else (179).

The complete fusion of body and image, subject and object seems like the perfect state for Else, as it frees her from her social existence as the passive object of other people's gazes and participant in social games that she is not willing to play.[25]

As this passage shows, Else's perception of her own body and herself is guided mainly by ideals of the male gaze: she admires her red lips and her breasts and, earlier in the text, points out the beauty of her white shoulders, her neck, and her long legs—all attributes that make her desirable to men. Yet the adoption of these standards makes her existentially uneasy as she seems to feel that the result is a completely fragmented female body that points to the fragmented, mutilated existence of young women in a society that places a price-tag on everything.[26] Whereas Painter Conti could still systematically describe Emilia's body from her head down in one long paragraph—"[t]his head, this face, this brow, these eyes, this nose, this mouth, this chin, this throat, this bosom, this figure—this whole body has been from that time on my only model of womanly beauty" (I.v)—descriptions of Else's equally beautiful—and remarkably similar—body appear scattered throughout the text and require the synthesizing attention of the reader to rebuild what has been cut into pieces by those who look at her. Aestheticizing the female body—the primary strategy for Odoardo Galotti's handling of his daughter's body—no longer suffices in the early twentieth century in order to "protect" the woman from her male environment. Men each want a piece of her (depending on what they find most arousing in a woman), and if Else wants to keep her integrity or, rather, shield herself from the dismembering gaze of male admirers, she has to resort to a more drastic measure: positing her beautiful body as a dead body.

Whenever she reflects on her physical attractiveness, Else immediately invents a context or set-up in which she appears dead by association—lying naked on marble stairs leading into the water, thinking about her "Veronal" in the most unlikely instances, literally wrapping herself in insignias of death and dying (such as her black dress and coat), and describing herself in various ways that suggest violence and lifelessness (her blood-red lips, her snow-white skin etc.).[27] Highly aware of her powerlessness in the face of the male gaze that objectifies and fragments her, Else's response is that of withdrawal, first symbolically and rhetorically, ultimately in the suicide that follows her revolutionary act of self-exposure.[28] However, whereas Emilia's suicide is equally warranted by

a desperate need to withdraw from the threatening male gaze, Else's act is more emancipatory, even if self-destructive.

Personal antipathy for Dorsday, inherited shame, and possibly moral considerations may all play a role in Else's refusal to expose herself to this particular man. But it is the direct connection between nakedness and money, her being treated as a commodity and thus left completely powerless that most fuels her crisis. In her search for a way out of this impasse, she wishes: "If only I could spoil his pleasure somehow. If only someone else were present. Why not?" (168). And in fact, it is exactly this route that she chooses. By exposing herself naked to a whole group of people, Else undermines Dorsday's position of power as the one who dictates the situation without breaking the "contract" that they have. Dorsday's desired exclusive look at Else's body is transformed into a public spectacle, and she thus withdraws the power of the gaze from the individual to reassign it to the group, as a whole, in which any man's individual pleasure would be considered inappropriate. Else's naked body shocks exactly because it responds to the secret desires of this society while demystifying this body. She celebrates her smart victory over Dorsday, but she also overcomes the split between subject and object when, entranced by the sounds of Schumann's *Karneval,* she drops her cloak and experiences her body in a Dionysian moment that seems timeless:

> Right away.... Chills are running up and down my spine. She's playing on. How wonderful it is to be naked. Chills are running up and down my spine. She's playing on. She doesn't realize what's happening here. Nobody realizes it. No one sees me yet. Filou! Filou! Here I'm standing naked! Dorsday opens his eyes wide. At last he believes it (188–89).

In one blow, Else devalues her beautiful female body as potential "prey" for individual males, and it is only logical that her aunt and cousin think that she has gone mad. After all, the entire drama takes place only in Else's mind, and the sole person who could reveal the existential crisis that leads to her desperate move, Dorsday, will never speak up. In this respect, one could question the validity or success of the rebellious act, and some critics have in fact called Else's suicide an ultimate failure as it could easily be read as an act of madness or shame by her family.

In the context of this discussion, however, Else's dropping of the cloak marks a moment of no return in the literary history of the bourgeois daughter. As she exposes the body over which fathers, seducers, families, and societies have fought for centuries, she dismisses the cultural construct of the enigmatic, dangerous, and symbolic female body

that needs protection and against which society needs to be protected. Once exposed, any attempt to cover it up again and remove it to a room far from the scene is nothing but an almost pitiful effort to repair the damage that this act has done to the male ego of society. By neither sacrificing nor prostituting herself, Else has created a space for the female body that resists male domination and allows the fragmented body to become whole again.[29]

In view of these similarities between and developments from Lessing's *Emilia Galotti* to Schnitzler's *Fräulein Else,* we may ask why Schnitzler did not choose the dramatic form for his subject, which, in many ways, depicts constellations and conflicts similar to the older model. The answer is twofold. As the comparison to Lessing's tragedy has shown, major shifts in the daughter's position within the family, society, and particularly in relation to her father modified the nature of the daughter's conflict. Since father and seducer have ceased to function as antagonists in a society that no longer negotiates its moral standards, Else has no real support or support-group any more. Her dilemma is really hers alone. Her parents do not openly abandon her, but it is clear that communication between the members of this family has completely broken down: "Everything at home is settled in a jesting manner and yet none of us is really gay at heart. Each is really afraid of the other and each is all alone, by himself" (142). Whereas the Galotti family indulges in long dialogues reassuring each other of their shared moral interests, strengthening each other's moral backbone, Else's family does not appear to have a shared value system. The father seems to be a compulsive embezzler, the mother indulges in expensive dinner parties that are supposed to cover up the real financial situation of the family, and Else's brother Rudi is completely estranged from his family. It is no accident that Schnitzler chooses to set this story in a Swiss resort hotel where Else vacations with her distant relatives. The notion of "home" has long been lost for her; family is nothing but an accidental blood relation (with the slight exception of her cousin Paul, for whom Else has a special liking), and the absence of her parents as comforting safeguards of her emotional well-being could not be better represented than through their complete physical absence from the scene. It is only through letters and telegrams that they appear in this text. Although the mother at least still writes to her daughter, Else's father is completely absent, as he does not even add a line to his wife's letter, despite the fact that it is because of him that Else is asked to act. In turn, Else does not respond to her parents' missives at all—communication has turned into "briefings" in which Else receives well-phrased orders to which there is no possible response.

As there are no other people in whom Else could confide, this important aspect of the bourgeois tragedy and its dramatic texture is not available for *Fräulein Else*. Any communication is limited to the aforementioned social small talk, which has almost no content and merely serves to provide an agreeable atmosphere in which more physical or substantial interests can be pursued. The bourgeois tragedy as a conversational play in the style of Hofmannsthal is a contradiction in terms; negotiating ideologies would be too indecent and substantial a topic for social chatter. In the search for a way out, inner discussion and outer dialogue have nothing to do with each other any more, a phenomenon that Schnitzler marks clearly by his use of different typesets.

Yet, there is one dialogue with significant dramatic qualities: Else's conversation with Dorsday. Whereas in *Emilia Galotti,* such a dialogue would be left out of the dramatic flow (like the encounter between Emilia and the prince, which is only reported after the fact to serve as a topic for extended family discussions), *Fräulein Else* needs exactly this one dialogue to unsettle the main character completely. The direct confrontation stands in stark contrast to Else's otherwise indirect and alienated mode of life and engenders an avalanche of thoughts that lets us see the full extent of her confusion, despair, and isolation. This isolation is not only her personal one, but a reflection of the general loss of connectedness and communication in the early twentieth century, which scholars have pointed out in many studies. It is to this phenomenon that Peter Szondi relates the general crisis of drama around the turn of the century: the loss of what he calls the "space of the in-between," and *Fräulein Else* proves his point beautifully. People do not really talk to each other anymore in the society portrayed in this novella,[30] and without this kind of human interaction, there cannot be drama any more because it relies on the possibility of dialogue. This insight may have moved Schnitzler to recognize that the subject was really better suited for a text in prose instead of a drama. His conviction that communication through dialogue had failed in the twentieth century might even have been furthered by the experience of World War I, whose bloody reality proved all enlightened belief in the power of negotiation to be a fatal illusion and left Schnitzler somewhat emotionally shell-shocked.

However, we also have to consider one more factor that might very well have influenced Schnitzler's decision to write this bourgeois tragedy in the form of an interior monologue. Whereas the many dialogues and verbal exchanges in *Emilia Galotti* serve to lay out the whole dimension of the ideological battle that takes place in the play, we do not really know anything about the main character, Emilia. It often startles new

readers of this drama to see that the character that gives the play its name does not appear on stage until the sixth scene of the second act. Yet Emilia is rhetorically present from the first scene on, and the many men associated with her offer their very different constructs of this woman from the start. Framed by these constructs, Emilia has no space left to propose her own vision of herself, and even in the long dialogues that she has with her male counterparts, she never really lets us see her inner state of mind. After her terrifying encounter with the prince in church, she hastens to discuss it with her mother, who offers consolation and appeases her daughter enough for her to find the fitting preconceived "frame" within which she will deal with this experience. As a symbol of truth and integrity, Emilia cannot allow us any insights into a really conflicted psyche that could show her as weak or undecided.

Because Schnitzler's interest is obviously not in propagating a certain (bourgeois) ideology, his portrayal of the female protagonist must be different. Certainly influenced by the Freudian era's interest in the secrets of the soul, Schnitzler offers us a supposedly unfiltered insight into the psyche of a young woman who finds herself helpless in a dilemma that has its roots in a centuries-long tradition. In this sense, the interior monologue can be understood as the successor to the dramatic dialogue that has become impossible, an attempt to save dramatic tension when traditional drama can no longer provide it: the stage for the drama of the psyche can be nothing other than the psyche itself.

One hundred and fifty years after the emergence of the bourgeoisie as a self-determined social entity, Arthur Schnitzler shows how all those values by which this class had proudly defined itself have become corrupted by the all-pervasive influence of capitalism. Self-determination, Odoardo Galotti's highest value, really does not exist for the female part of the population, and the family, once the ideological haven of the bourgeois subject, has imploded. The daughter has lost her status as a symbol of morality and is now blatantly deployed as potential physical capital. Dialogue as a means to resolve conflicts has become impossible between members of an egocentric society and has made room for the mainly silent interior monologue in which the individual struggles to decide her fate in a world that has become devoid of positive meaningful encounters. As Schnitzler openly alludes to Lessing's bourgeois tragedy *Emilia Galotti* in his choice of character constellation, motives, and even wording, he ultimately deconstructs it in the early twentieth century. By publicly "unveiling" the virgin at the end of *Fräulein Else,* Schnitzler throws overboard the centuries-old notion of the enigmatic, beautiful female body in need of male protection. At the same time, these allusions also shed critical light onto *Emilia Galotti* and her "sisters" by

showing that even in 1770, there existed certain social structures that only a society interested in the preservation of male domination could sell as emancipatory.[31] Seen in this light, *Fräulein Else* is a "late bourgeois tragedy" without any utopian vision, the tragedy of bourgeois ideology after a century and a half of the bourgeoisie.

Notes

[1] *Fräulein Else*, 136. This and all following quotations are from Robert Simon's translation in the collection of Schnitzler's "Viennese Novelettes" listed in the works cited.

[2] Margaret Morse hints at this tradition in her analysis of the father-daughter relationship and especially the father figure in this text. Hartmut Scheible suggests a certain connection to the issue of Schnitzler's indebtedness to the Enlightenment and Lessing's intellectual legacy (*Arthur Schnitzler und die Aufklärung*); and Achim Aurnhammer stresses the general importance of intertextual references in *Fräulein Else* that inform both Else's thoughts as well as the monologue-novella as a whole.

[3] See Schnitzler to Zweig: "I am really happy that you like *Fräulein Else* so much. It is not really a 'trouvaille' since I have used the same [narrative] technique in *Leutnant Gustl*. In a way, it is even strange that I have used it so little since. It offers extraordinary possibilities. Yet, there are only a few 'sujets' that lend themselves to this technique, otherwise, I would most likely have used it more often" (*Briefe* 372–73, my translation).

[4] Some critics have argued that *Emilia Galotti* does not really qualify as a bourgeois tragedy, as the Galottis are part of the lower aristocracy. However, when one considers the values that are propagated by Odoardo and Emilia in this play, there can be no doubt that it is appropriate to classify it as a bourgeois tragedy.

[5] This is obviously a very simplified and shortened presentation of the multi-facetted debate that eighteenth-century critics held over this topic. My explanations here are heavily influenced by Peter Szondi's *Die Theorie des bürgerlichen Trauerspiels im 18. Jahrhundert*.

[6] McInnes points out that, despite the seemingly private character of the bourgeois tragedy's conflict, these dramas "attempted to embody in dramatic form an awareness of society as an enclosing, shaping force at work in every aspect and at every level of the individual's life, determining not just the conditions of his environment but also his most inward experience" (321). This assessment is important insofar as it points to a critical continuity within the genre on which Schnitzler builds in his later text.

[7] See, for example, Inge Stephan; Deborah Janson; also Richard Gray, "Picturing Emilia."

[8] See Fritz (306). In German the wording is slightly different as Fritz does not talk about "class" but "Stand" (estate), which would be more correct historically. However, as we are talking about a period in which the idea of class as an ideological entity slowly develops, I will continue to use this term with the warranted caution.

[9] Here and in all following quotations I am using Edward Dvoretzky's 1962 translation. The same translation was adopted by the German Book Center in their 1979 edition of this play in English.

[10] Throughout the drama, there is an obvious incestuous subtext accompanying Emilia and her father, and especially in this last scene, the phallic symbolism can leave no doubt about the fact that the morality plot is accompanied by an Oedipal or, rather, Elektra plot that makes the father's motivation to "protect" his daughter from the seducer even more problematic.

[11] See Painter Conti's eulogy of Emilia's appearance in his scene with the Prince in which he posits her as his "only model of womanly beauty" (I.iv).

[12] This idea—that the beautiful female body can only be tolerated in a male society when it is symbolically killed (by aesthetic idealization and/or removal)—is Elisabeth Bronfen's main argument in her study *Over Her Dead Body*. My reading of *Emilia Galotti* and *Fräulein Else* is highly informed by Bronfen's study; however, whereas her approach is mainly psychological (she labels Else a hysteric, for example, and bases her reading of this character on symptoms of this condition), I am interested instead in the development of this socio-cultural phenomenon from *Emilia Galotti* to *Fräulein Else*.

[13] For a detailed discussion of Emilia's problematic status as the object of the male (= eroticized) and the aesthetic (= idealized) gaze, see Prutti.

[14] It is important to stress this fact because Fritz's criterion of the necessary recognition and preservation of class difference as natural and God-given could easily be misunderstood as a lower-class decision not to challenge the hierarchy, thus accepting an inferior status vis-à-vis the upper classes. Schiller's *Love and Intrigue* (*Kabale und Liebe*) seems to point in that direction when Musician Miller warns his daughter not to aspire to too high a place in society. However, the pride that he displays in his own life and lifestyle also clearly shows his rejection of the concept that the upper classes should be considered better than his own.

[15] Even though the play suggests that the characters fight about moral integrity and the bourgeoisie's superiority over the aristocracy, the Appiani plot, as well as historical evidence, suggests that Odoardo's interest in preserving his daughter's innocence has a very real economic aspect to it. In

order to find a good—which would mean wealthy—marital prospect, young women had to be virgins so that any future husband could be sure of the paternity of a potential heir to his fortune.

[16] The translation of the German word "*Zauberin*" as "sorceress" seems slightly misleading as it suggests negative connotations. I would prefer the word "enchantress" or "magician" in this context.

[17] Elisabeth Bronfen summarizes the nature of Else's situation precisely when she writes: "*Fräulein Else* is a stark and explicit rendition of the undefined premarital woman posed as the site of an enigma, displayed as a supreme object of an erotic, an aesthetic and an economic speculation..." (281).

[18] I am using this term hesitantly as several aspects of this family make it problematic, most of all the fact that they are Jewish and have a special status in the history of the German-Austrian bourgeoisie, an issue that I cannot address here.

[19] Schnitzler discusses these moral double standards extensively in his play *La Ronde* (*Reigen*), especially in the central scene between the husband and his young wife.

[20] The English translations used here do not reflect this connection well. In Lessing's text, the Prince calls Emilia a "Zauberin" (see note 16); in *Fräulein Else,* Dorsday states: "Es geht ein Zauber von Ihnen aus..." (346). Both men are under the spell of these women's "magic," and an appropriate translation of the two texts should reflect this connection—the words "enchantment/enchantress" might be a viable alternative.

[21] It is interesting to note how Else reacts to Dorsday's presumed social superiority: "He's only a social climber. What good does your first-class tailor do you, Herr von Dorsday?—Dorsday, rather. I'm sure your name used to be something else" (127). And a little later, she defends her somewhat snobbish attitude toward the newly rich Dorsday who can never compensate for lacking a long family tradition: "Oh, I can permit myself a remark of this sort. Nobody notices it [that she is Jewish] in me. I'm even a blonde, a strawberry blonde, and Rudi [the brother] looks absolutely like an aristocrat" (135). All that is left of the old antagonism between aristocracy and bourgeoisie in the traditional bourgeois tragedy is a certain sense of cultural superiority on Else's side and the position of power in which the seducer finds himself, here because of financial prosperity.

[22] See: "He speaks as he would to a slave" (155), or "[t]he moon hasn't risen yet. It'll rise only for the performance, for the great performance on the meadow, when Herr von Dorsday bids his slave dance naked" (166); or: "[If I did that]—that would be like a woman from the Kärntnerstraße. No; I won't sell myself. Never" (158).

[23] See: "A villa on the Riviera with marble steps going into the sea. I am lying naked on the marble" (124, repeated on 166, 177, 179).

[24] For some reason this sentence is left out in the translation.

[25] Elisabeth Bronfen comments: "Undressing could then be read as her [Else's] first attempt to reach a narcissistic unity, a wholeness beyond disjunction and dissimulation, an effacement of the lack or division her feminine position is inscribed with. As she presses her red lips and her breast to the mirror, she invokes an obliteration of the difference between self-being and image..." (287). I agree with this reading; however, whereas Bronfen uses her observations to substantiate her claim that Else's monologue ultimately bears testimony to her death drive from the start, my interest in this passage is more in Else's approach to her own body as erotically enjoyable, an approach that marks a major shift in the woman's approach to herself from *Emilia Galotti*. By realizing her erotic power, she can start thinking about ways to undermine the domineering position the male spectator still holds: her solution will be the conscious withdrawal of that body through various tricks.

[26] In one of her fantasies about the way her striptease would be carried out, Else sees herself dancing naked with Dorsday's signed money order to her father in her hand (169).

[27] Bronfen: "The figure of excess inscribed into Schnitzler's text is not only such that the bride's situation is so hopeless that her only viable choice is death, but that she psychically lives through or anticipates many versions of death before its reality sets in" (288). Again, within Bronfen's main argument, this observation (in which she does not even include the symbolic stagings of death that I mention) serves to underline Else's death-drive in a situation of existential indetermination. For me, the aspect of "ruining it for the man" (see her idea to "spoil it for Dorsday," 168) is more important here as it ties in with Odoardo's challenge to the Prince at the end of *Emilia Galotti*. Bent over his daughter's dead bleeding body, Odoardo asks: "Well now, Prince! Do you still like her? Does she still excite your desires? Still, in this blood, which cries for revenge against you?" (V.viii). Only a pervert could be aroused by a dead female body.

[28] Scheible maintains that it is highly unlikely that Else dies at or after the end of her monologue because her dream-like utterances then resemble her dream on the park bench earlier in the story. However, the main point of the novella would be missed if she were to survive her own narrative (*Schnitzler* 118).

[29] It is in this final assessment that my reading of this novella really diverges from Bronfen's. Martens leaves more room for this rather positive assessment of Else's rebellious act: "The naked body in its transgressiveness stands for the negation of the idea of a consistent, coherent self which social

custom finds it convenient to uphold" (125). Even though she does not read Else's striptease in purely positive terms (and neither do I, since the result is her suicide), she recognizes the emancipatory potential in this act much more than Bronfen seems to.

[30] Even though the novella was published in 1924, several allusions to cultural events in Vienna suggest that the story takes place in 1896-97 (see Aurnhammer 502).

[31] This reading of *Fräulein Else* would perhaps make Schnitzler the earliest critic of *Emilia Galotti* to question the validity of this drama as promoting only positive bourgeois values in the late eighteenth century.

Works Cited

Alexander, Theodor W. "Arthur Schnitzler's Use of Mirrors." *Seminar* 14.3 (1978): 187-92.

Aurnhammer, Achim. "'Selig, wer in Träumen stirbt': Das literarisierte Leben und Sterben von *Fräulein Else*." *Euphorion* 77.4 (1983): 500-10.

Bronfen, Elisabeth. *Over Her Dead Body: Death, Femininity, and the Aesthetic*. New York: Routledge, 1992.

Fritz, Axel. "Vor den Vätern sterben die Töchter—Schnitzlers *Liebelei* und die Tradition des bürgerlichen Trauerspiels." *Text und Kontext* 10.2 (1982): 303-18.

Gray, Richard. "Picturing Emilia: Conflict of Representations and the Tragedy of Bourgeois Subjectivity in Lessing's *Emilia Galotti*." *Stations of the Divided Subject: Contestations and Ideological Legitimation in German Bourgeois Literature, 1770-1914*. Stanford: Stanford UP, 1995. 45-102.

Green, Jon D. "Music in Literature: Arthur Schnitzler's *Fräulein Else*." *New York Literary Forum* 10/11 (1983): 141-52.

Janson, Deborah. "The Emancipation Which Enslaved." *New German Review* 1 (1985): 15-27.

Lessing, Gotthold E. *Emilia Galotti* (1772). *Gesammelte Werke in zwei Bänden*. Vol. 1. München: Hanser, 1959. 551-625.

———. *Emilia Galotti: A Tragedy in Five Acts*. Trans. Edward Dvoretzky. New York: Ungar Publishing, 1962.

———. *Laokoon* (1766). *Gesammelte Werke in zwei Bänden*. Vol. 2. München: Hanser, 1959. 781-962.

Martens, Lorna. "Naked Bodies in Schnitzler's Late Prose Fiction." *Die Seele...ist ein weites Land: Kritische Beiträge zum Werk Arthur Schnitzlers*. Ed. Joseph Strelka. Bern: Peter Lang, 1996. 107-29.

McInnes, E.O. "'Eine bürgerliche Virginia?' Lessing's *Emilia Galotti* and the Development of the Bürgerliches Trauerspiel." *Orbis Litterarum* 39 (1984): 308–23.

Morris, Craig. "Der vollständige innere Monolog: eine erzählerlose Erzählung? Eine Untersuchung am Beispiel von *Leutnant Gustl* und *Fräulein Else*." *MAL* 31 (1998): 30–51.

Morse, Margaret. "Decadence and Social Change—Arthur Schnitzler's Work as an Ongoing Process of Deconstruction." *MAL* 10.2 (1977): 37–52.

Prutti, Brigitte. "Das Bild des Weiblichen und die Phantasie des Künstlers: Das Begehren des Prinzen in Lessings *Emilia Galotti*." *Zeitschrift für deutsche Philologie* 110.4 (1991): 481–505.

Rey, William H. *Arthur Schnitzlers späte Prosa als Gipfel seines Schaffens*. Berlin: Erich Schmidt, 1968.

Scheible, Hartmut. *Arthur Schnitzler*. Reinbek: Rowohlt, 1976.

———. *Arthur Schnitzler und die Aufklärung*. München: Fink, 1977.

Schiller, Friedrich. *Kabale und Liebe* (1782–83). *Dramen*. Vol. 1. Ed. Herbert Kraft. Frankfurt a.M.: Insel, 1966. 237–334.

Schnitzler, Arthur. *Briefe 1875–1912*. Ed. Therese Nickl and Heinrich Schnitzler. Frankfurt a.M.: Fischer, 1967.

———. *Fräulein Else*. *Gesammelte Werke*. Vol. 2. Frankfurt a.M.: Fischer, 1961. 324–81.

———. *Fräulein Else*. *Viennese Novelettes*. Trans. Robert A. Simon. New York: Simon and Schuster, 1931. 119–200.

Stephan, Inge. "'So ist die Tugend ein Gespenst': Frauenbild und Tugendbegriff im bürgerlichen Trauerspiel bei Lessing und Schiller." *Lessing Yearbook*. Vol. 17. (1985): 1–20.

Stephan, Inge, and Sigrid Weigel, eds. *Die verborgene Frau: Sechs Beiträge zu einer feministischen Literaturwissenschaft*. Berlin: Argument, 1983.

Szondi, Peter, et al. *Die Theorie des bürgerlichen Trauerspiels im 18. Jahrhundert: Der Kaufmann, der Hausvater und der Hofmeister*. Frankfurt a.M.: Suhrkamp, 1973.

———. *Theorie des modernen Dramas*. Frankfurt a.M.: Suhrkamp, 1986.

Webster-Goodwin, Sarah, and Bronfen, Elisabeth, eds. *Death and Representation*. Baltimore: Johns Hopkins UP, 1993.

ABOUT THE CONTRIBUTORS

Hilary Brown is a research student at Gonville and Caius College, Cambridge University, in England. She is currently writing a dissertation on Benedikte Naubert and her relations to English culture. Her research interests include German women writers in the eighteenth and nineteenth centuries and Anglo-German literary relations. She has published articles in the *Journal of English and Germanic Philology* (October 2001) and the *Modern Language Review* (July 2002).

Jeanette Clausen is Associate Vice Chancellor for Faculty Affairs and Professor of German at Indiana University-Purdue University Fort Wayne. She received her doctorate in Germanic Linguistics from Indiana University in 1975. Her most recent publication is the translation of Irmtraud Morgner's *The Life and Adventures of Trobadora Beatrice as Chronicled by Her Minstrel Laura: A Novel in Thirteen Books and Seven Intermezzos* (U of Nebraska P, 2000).

Ruth P. Dawson, Professor of Women's Studies at the University of Hawaii at Manoa, is grateful to the Stiftung Weimarer Klassik for the opportunity to study eighteenth-century German representations of Catherine the Great at the Anna Amalia Bibliothek in Weimar. Her book, *The Contested Quill: Literature by Women in Germany 1770–1880,* appeared in 2002 in the University of Delaware Press.

Lilian Faschinger was born in Carinthia, Austria. From 1975 to 1992, she worked as a part-time lecturer at Graz University, from which she earned her PhD in English literature. Since then she has been a freelance writer. Since 1983, she has published four novels, two volumes of short stories, and two volumes of poetry, in addition to writing several radio plays and dramas. Widely traveled, including several stints as writer-in-residence at US colleges and universities, she now lives in Vienna.

Patricia Herminghouse is Fuchs Professor emerita of German Studies at the University of Rochester. She has written widely on nineteenth- and twentieth-century German literature, the social contexts of women's

writing, and German émigrés in nineteenth-century America. Editor of the textbook anthology *Frauen im Mittelpunkt* and a series of writings by nineteenth-century German political émigrés in the US, she also coedited two volumes on GDR literature and, more recently, *Gender and Germanness: Cultural Constructions of Nation* (1998) as well as an anthology of *German Feminist Writings* from the seventeenth century to the present (2001).

Ruth-Ellen Boetcher Joeres is Professor of German and Women's Studies in the Department of German, Scandinavian, and Dutch at the University of Minnesota. Her research has focused on the social and literary history of German women from the eighteenth to twentieth centuries, on feminist theorizing, and increasingly on the role of personal narratives and the personal in academic writing. Her most recent book is *Respectability and Deviance: Nineteenth-Century German Women Writers and the Ambiguity of Representation*. She is presently at work on a volume of autobiographical and theoretical essays exploring the interrelationships between developments in the fields of German Studies and feminist inquiry.

Ellie Kennedy is a PhD candidate candidate in the Department of German, Queen's University, Kingston, Ontario, where she is writing a dissertation entitled "Genre Trouble: The Performative Picaresque and Female Identity in Contemporary Women's Narrative." She has published articles on Goethe's *Werther* and on Lilian Faschinger's *Magdalena Sünderin*. She has also written about graduate student activism in Canada for both web and print journals.

Barbara Kosta is Associate Professor in the Department of German Studies at the University of Arizona, where she teaches courses on German cinema and twentieth-century German literature and popular culture. She is the author of *Recasting Autobiography: Women's Counterfictions in Contemporary German Literature and Film* (Cornell UP, 1994) and has published on twentieth-century German women writers (Fleisser, Jelinek, Keun, Mitgutsch) and on German cinema. She is currently working on a book on Josef von Sternberg's *The Blue Angel* and coediting a collection of articles on gender and nation.

Judith E. Martin is Assistant Professor of German at Southwest Missouri State University in Springfield. She received her PhD in German and Comparative Literature from Washington University in St. Louis in 1999, with a dissertation on Madame de Staël's influence on

nineteenth-century German women writers. She has published on Staël and the female artist novel in Germany. Her present research investigates international contexts of nineteenth-century German women's writing and gender in the artist novel.

Bettina Matthias is Assistant Professor of German at Middlebury College in Vermont. She received her PhD from the University of Washington in 1998, and her dissertation, entitled *Masken des Lebens—Gesichter des Todes: Zum Verhältnis von Darstellung und Tod im erzählerischen Werk Arthur Schnitzlers,* was published in 1999. Her current research for a new book focuses on the hotel as literary space of choice in turn-of-the-century literature. She also works in the field of comparative studies between music and literature and is an active pianist as an accompanist in voice recitals.

Barbara Mennel is Assistant Professor for German Studies and Cinema Studies in the Department of Modern Languages and Linguistics at the University of Maryland, Baltimore County, as well as affiliate faculty of the Women's Studies Program. She has published on the films of Monika Treut, Rainer Werner Fassbinder, and Percy Adlon, as well as on the literary works of Ingeborg Bachmann. She is currently working on a book-length study entitled "When History Meets Fantasy: Masochism in Postwar German-Language Literature and Film."

Jennifer Redmann is Assistant Professor of German and Director of Women's and Gender Studies at Ripon College in Ripon, Wisconsin. She completed her PhD at the University of Wisconsin-Madison with a dissertation on Else Lasker-Schüler. Her teaching and research interests include late nineteenth- and early twentieth-century German literature, German-Jewish literature and culture, feminist literary criticism, Holocaust Studies, autobiography, and language pedagogy.

Anna Richards studied Modern Languages (French and German) as an undergraduate at Emmanuel College, Cambridge, then moved to Balliol College, Oxford where she completed an MPhil in European Literature and a DPhil in German Literature (1999). Since then she has been Lecturer in German Studies at Oxford Brookes University. She has published articles on German women writers from the late eighteenth to the early twentieth century, and is currently preparing her DPhil thesis on the theme of women's illness in German women's novels for publication.

About the Authors

Herbert Uerlings is Professor of German at the University of Trier, Germany, president of the *Internationale Novalis-Gesellschaft,* and co-director of Trier's interdisciplinary post-graduate colloquium "Identität und Differenz: Interkulturalität und Geschlechterdifferenz vom 18. Jahrhundert bis zur Gegenwart." Among his many publications on German literature from the eighteenth century to the present are *Poetiken der Interkulturalität: Haiti bei Kleist, Seghers, Müller, Buch und Fichte* (1997), and two coedited volumes: *Beschreiben und Erfinden: Figuren des Fremden vom 18. bis zum 20. Jahrhundert* (2000), and *Das Subjekt und die Anderen: Interkulturalität und Geschlechterdifferenz* (2001).

Valerie Weinstein received her PhD from Cornell University in 2000 and is an Assistant Professor of German at the University of Nevada, Reno. She is currently revising her dissertation into a book examining how mistaken identity films reconfigure discourses of gender, ethnicity, and sexuality in Germany before 1945. Her research interests also include postcolonial studies and German discourses about the Pacific and Pacific islanders. She has published on Adelbert von Chamisso's travel narratives, which, along with her article on Hoffmann, will eventually become part of a larger project.

Judith Wilson lectures in the Center for European Studies and General Linguistics at the University of Adelaide in South Australia. Her present research is focused on intercultural approaches to German Studies and German-Australian connections in the nineteenth century. She is currently writing a dissertation on the role of Australia as an imaginary space in the works of nineteenth-century German women writers. Amalia Schoppe is one of the writers included in this study.

NOTICE TO CONTRIBUTORS

The *Women in German Yearbook* is a refereed journal. Its publication is supported by the Coalition of Women in German. Contributions to the *Women in German Yearbook* are welcome at any time. The editors are interested in feminist approaches to all aspects of German literary, cultural, and language studies, including pedagogy, as well as in topics that involve the study of gender in different contexts: for example, work on colonialism and postcolonial theory, performance and performance theory, film and film theory, or on the contemporary cultural and political scene in German-speaking countries.

While the *Yearbook* accepts manuscripts for anonymous review in either English or German, binding commitment to publish will be contingent on submission of a final manuscript in English. The editors prefer that manuscripts not exceed 25 pages (typed, double-spaced), including notes. Please prepare manuscripts for anonymous review and follow the fifth edition (1999) of the *MLA Handbook* (separate notes from works cited). Send one paper copy of the manuscript (no e-mail attachments, please) to each editor:

Marjorie Gelus
Department of Foreign
 Languages
6000 J Street
California State University
Sacramento, CA 95819-6087

Phone: 916-278-6509
Fax: 916-278-5502
E-mail: gelus@csus.edu

Ruth-Ellen Boetcher Joeres
Department of German,
 Scandinavian, and Dutch
205 Folwell Hall
University of Minnesota
Minneapolis, MN 55455-0124

Phone: 612-625-9034
Fax: 612-624-8297
E-mail: joere001@tc.umn.edu

For membership/subscription information, contact Vibs Peterson, (Studies of Culture and Society, Howard Hall, Drake University, Des Moines, IA 50311; e-mail: vibs.petersen@drake.edu).